W9-CRI-044

Praise for

THE LOVELIEST WOMAN IN AMERICA

"For years Rosamond Pinchot has been waiting in the wings of American women's history. More than 'the loveliest,' she was one of the most courageous of her generation, marking a path into adventurous life. Now her granddaughter Bibi Gaston has brought her center stage in this fascinating and moving biographical memoir."
—Honor Moore, author of *The Bishop's Daughter*

"Engrossing. . . . Gaston is especially apt at examining the ties that bind husbands and wives, men and women. . . . It is not a perfect journey but not much in life is, and Gaston accepts that as she pulls together the disparate pieces of her family story and discovers much of herself in her grandmother's words." —Mary Houlihan, *Chicago Sun-Times*

"The discovery of her grandmother's diaries has taken Gaston on a journey not only of family and home but also of celebrity, politics, death, betrayal, and, eventually, understanding and hope. Highly recommended." —*Library Journal*

"This is perhaps the best book I've read in a decade. Beautifully written, the author's search for family information reveals great sadness, missed opportunities, lost love, famous friends, and emotional double-crosses that break one's heart. A big player in this book is the land . . . forests, waterfalls, and islands in Maine. The people in this book will stay with you for a long time. Bibi Gaston is a gifted storyteller and a brave heart." —Margo Howard, "Dear Margo" for Creators Syndicate

"Uncovers a family history long obscured by secrets and lies. . . . Functions well as a window into a largely vanished social and cultural structure. Heartfelt and accomplished." —*Kirkus Reviews*

"Makes for riveting reading. . . . A compelling story. . . . An exceptional biography." —*Santa Fe New Mexican*

"A fascinating memoir. . . . Her writing is deft and sure. It plumbs the stuff of life in a way that is, in turn, poetic, wry, humorous, and, above all, spoken with the voice of truth and compassion. . . . As a landscape architect, Bibi Gaston knows the topography of the earth. With *The Loveliest Woman in America*, she gives readers the topography of the heart of a family, and in it we find pieces of ourselves." —*Bangor Daily News*

"*The Loveliest Woman in America* is about a granddaughter's search through familial silence for the grandmother, a beautiful and troubled actress, who committed suicide in the early thirties, leaving two young sons and a powerful mystery. The book, wonderfully structured so the sense of time is mobile and continuous, moves back and forth through memory and discovery, [and] is a compelling story with characters of such life and particularity, they jump off the page. It is the story of a granddaughter's discovery of self as she uncovers her grandmother's life. A real page-turner." —Susan Shreve, author of
A Student of Living Things and *Warm Springs*

"*The Loveliest Woman in America* is a story for all women who strive and struggle to lead meaningful and purposeful lives. In moving prose, the author weaves her grandmother Rosamond Pinchot's deep connection to nature with that of her own. That connection becomes the constantly redeeming thread, weaving its way through the generations of a remarkable, passionate family whose legacy of service to the landscape and the environment are the DNA of today's conservation efforts."
—Sara Cedar Miller, Associate Vice President of Park Information,
Central Park Conservancy, Central Park historian and
park photographer

"Highly readable . . . compelling. . . . *The Loveliest Woman in America* can be read as a companion to not just the classic novels and plays of the first third of the twentieth century—*The House of Mirth, The Great Gatsby, Our Town, Appointment in Samarra*—but as a social history as well. . . . The book is not only an exhumation of the past but a meditation, which Ms. Gaston shares with the reader, as she contemplates her own life at midpassage." —*Wild River Review*

Gail Gaston

About the Author

BIBI GASTON is a practicing landscape architect. Her work, and writing journeys to the world's endangered places, can be found at www.bibigaston.com.

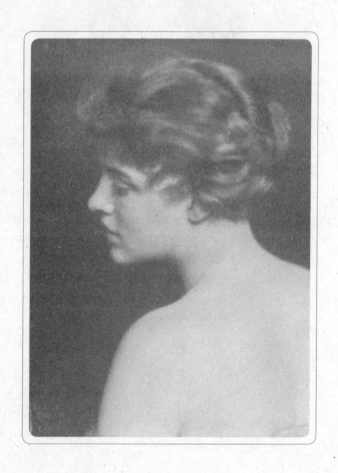

THE LOVELIEST WOMAN
IN AMERICA

A Tragic Actress, Her Lost Diaries,
and Her Granddaughter's
Search for Home

Bibi Gaston

HARPER ● PERENNIAL

NEW YORK ● LONDON ● TORONTO ● SYDNEY ● NEW DELHI ● AUCKLAND

For Rosamond and Little Billy

HARPER ● PERENNIAL

The quotation on p. 254 from the Thornton Wilder to Dame Sibyl Colefax letter appears with permission of Special Collections, Fales Library, New York University, and the Wilder Family LLC.

A hardcover edition of this book was published in 2008 by William Morrow, an imprint of HarperCollins Publishers.

HarperCollins books may be purchased for educational, business, or sales promotional use. For information please write: Special Markets Department, HarperCollins Publishers, 10 East 53rd Street, New York, NY 10022.

FIRST HARPER PERENNIAL EDITION PUBLISHED 2009.

Designed by Cassandra J. Pappas

Library of Congress Cataloging-in-Publication Data is available upon request.

ISBN 978-0-06-085771-4

09 10 11 12 13 WBC/RRD 10 9 8 7 6 5 4 3 2 1

Frontispiece: Rosamond by Dora Horovitz, Vienna

Contents

Requiem

I saw her lying there so calm and still,
With one camellia placed beside her head.
She looked the same, and yet, her soul and will
Being gone she did seem dead.
I thought if one so loved and beautiful
Should wish to leave, perhaps there was a voice
That called her back—and she was dutiful.
Somewhere the gods rejoice.
In some far place, where all the lovely things
Of earth are born, the gods no longer weep.
She has returned to them. And what she brings
We lose, but always keep.

—MARY PINCHOT (MEYER),
 Rosamond's sister, written in 1938,
 published in the *New York Times,* January 25, 1940

Author's Note

It is said that a suicide affects a family for ten generations. This is the story of three people over three generations who barely knew one another: my grandmother, my father, and myself. Under the best of circumstances, a parent shares sixty years of life with a child. My father spent nine years with his mother and I spent eight with him, which left a lot of time not knowing the story of one another's lives or the chronology of our days. In piecing together the story of my ancestors, I discovered that patterns proved more instructive than chronology. Separated by minutes or miles, patterns of family repeat.

The author requests the reader's patience. In the story you are about to read, chapters rotate between the three main characters, and time, like life, is sometimes cut short. The people we love appear, then disappear, then reappear. The reader is asked at times to take a leap: between generations, over continents, and, most important, of faith. Displacement, disjunctures, and ruptures have hidden advantages: far from home and what is familiar, we wander, we carry on, we look for clues. When lucky, we encounter each other in the most unlikely of places. We find where we fit in the pattern. With luck, we find what we are searching for.

CYCLE ONE

THE MIRACLE

For forty-three years, all I knew was that Rosamond was beautiful and that she had killed herself. I may have spent the rest of my life knowing just those two things and everything would have gone on the way things do. After all, who really needs to dredge up something you can't do anything about? But in the summer of 2003, I went back to the Forester's Pool in Pennsylvania where I had distributed my father's ashes in the waters where he had learned to fish and swim with his mother, Rosamond. That day, I was given a plain cardboard box containing a thousand pages of Rosamond's diaries that people thought had vanished. For seventy years, her diaries and scrapbooks languished in airplane hangars, flooding basements, and dusty closets. They disappeared into the dark corners of a family's pain. Retrieved from darkness, the diaries changed my life forever. Through them, I learned a good part of Rosamond's story and found a home in the words of my grandmother.

Like a bird sighted in the forest that everyone thought was extinct, Rosamond's scrapbooks and diaries just showed up. When I started digging around, her obituary also showed up. It told of her death at thirty-three, on the front page of the New York Times, above the fold. I could have placed everything on a shelf or in a closet for another seventy years and that might have been the end of it, but the artifacts were suddenly taking up a lot of room. I was confounded by the series of events that brought them to me, so, smitten by circumstance, I found myself piecing together Rosamond's brief but beautiful story. While discovering her life, I came to know the

members of two remarkable families, the Pinchots of Pennsylvania, a family I never knew was mine, and the Gastons of Massachusetts, who Rosamond said were "not good for the blossoming of the soul." I came to understand how Rosamond, the woman who had been called the loveliest in America, and my father, the enigma to end all enigmas, and I, a woman who had yet to find a place to call home, had each inherited the extremes of everything a family has to offer.

Rosamond. When I first heard it, her name made me think of all the roses in the world. Not just the cultivated hybrids that require a gardener or the finicky tea roses you see in all their perfumed perfection at a flower show, but the rambling floribunda and the rugosas that flourish where nothing else will, those wild shrub roses that flood our days and nights with scent and blossoms that fade all too quickly. She'd never had time to fade with the rest of us. Her name spoke of warmth and light and summer. When I see her name, I think of what we ourselves become when we are willing to love not just what is beautiful, but what is not always easy to love, what is wild, sometimes dangerous and rare.

I'd always been inquisitive, some say intrepid, so when I received the diaries, it was as if I'd discovered the Dead Sea Scrolls or excavated the underground passage to a secret golden room. There wasn't one thing about my family that didn't warrant a serious investigation. I was always searching for clues. After hearing at about five years old that Rosamond was beautiful and that she had killed herself, beauty and death went together, which said a lot about what might happen to a girl. Forty years later, I had grown up and I'd learned to separate beauty and death. I had also learned that Rosamond had wrung a lot of living out of thirty-three years. Much of it had been documented by her, except that the last four years of her diaries were missing. That seemed peculiar, of course. But what I found even more strange was that for some reason the diaries and scrapbooks were all handed to me.

The scrapbooks weren't small and colorful flipbooks people leave around the house so friends can take a peek at the kids; they were huge and heavy, embossed with her name, Rosamond Pinchot Gaston, in gold leaf across forest green covers. The letters are faded now, but through the scrapbooks, I came to know Rosamond like a character in a silent movie. The visuals were spectacular but the silence was deafening. The images struck me not only as beautiful but also as strikingly modern. Rosamond in what looks to be Chanel, Rosamond in overalls. Her look was time-less. They show her in silhouette against the Manhattan skyline, under Hollywood's fabulous houses of skylights, fishing in the streams of Pennsylvania, and walking her

dog on the Upper East Side as though it was yesterday. Her look was always chang-
ing. She could be Marilyn Monroe, an Olympic athlete, or Mata Hari; and in the
1920s and 1930s, New York had just as many faces. The city was vibrant and pulsat-
ing, and Rosamond's life straddled one of its more exuberant periods, the Jazz Age.
Not only was she a celebrity, she was also a remarkable sportswoman and eques-
trian. She lived a scintillating social life and could identify each tree in the forest. She
had legions of suitors who wanted to "make" her; she ran around New York City's
reservoir to stay slim; she dined with the likes of Dorothy Parker, Sinclair Lewis,
and George Gershwin. Her scrapbooks and diaries described a woman of many
sides. She knew fashion, politics, and birdcall. She was simple and sophisticated. She
could't be packaged or contained.

So why had no one in my family ever talked about her or shared even a single
detail of her life? It wasn't as if we lived in the old world where the bodies of suicides
were buried at night at the crossroads where it was thought that greater traffic would
keep the corpses down. Rosamond seemed to have slipped off the edge of the world.
There are a thousand ways of vanishing; a family's silence is one of them.

The women who knew her and might have opened up to me had long since died.
Her sons—my father, Bill, and his brother, Jim—were intent on circling the wag-
ons, a matter of omertà, of honor: if you don't talk about it, it will go away. After
she died, the men said what little needed to be said, set the limits of excavation, and
indulged their murky shades of silence. They behaved like gods. When the diaries
came to me, the first of her female offspring, I discovered what I had known all
along: that her death hurt, and hurt like that doesn't go away.

My father was nine when his mother died, and he left my family when I'd just
turned eight. I didn't see much of him after that. He'd roll up on Sundays in one of
his foreign cars, and I'd see him in the summer on the islands in Maine, but he
wasn't about to ruin a perfectly good time talking about the past. My mother
wouldn't have told me anything about Rosamond even if she knew the story. My
mother said she felt sorry for my father, that's why she'd married him. So no one
ever told me that Rosamond's death was the first in a string of family tragedies and
that Rosamond's half-sister Mary Pinchot Meyer, a mistress of President Kennedy's,
was shot dead on the towpath in Washington, D.C. Her cousin, Edie Sedgwick,
died of a drug overdose. There was no point in talking about Rosamond, or Mary,
or Edie. So I never knew or thought about the tragic legacy of women in my
family.

My father could never talk about his mother because he would have had to talk about what happened on January 24, 1938. After the accounting of who, what, where, when, and how, the papers recalled what everyone really wanted to hear about, the first strange and wonderful turning point in her life. They wanted to hear how she was innocent and how the whole world stretched out in front of her like a most beautiful garden. The day she was discovered onboard the Aquitania, *was, after all, the day her life suddenly changed and in a way, began. No one wanted to hear about my father. For him, there was just one buried sentence, that said she had left two boys, William Alexander Gaston, nine, and James Pinchot Gaston, six. Everyone read about him, but wanted to move on, so that's why, for a lifetime, my father never talked about his mother.*

ROSAMOND: 1923-1929

In the last days of October 1923, Rosamond Pinchot, age nineteen, and her mother, Gertrude, boarded the RMS *Aquitania* in Cherbourg, France, after having gone on a shopping expedition to Paris to buy a trousseau for Rosamond's debutante party, which was to be held in New York on December 20. Gertrude held tickets on her favorite Italian ship, but at the last minute, she and Rosamond were diverted to the British ship, the *Aquitania,* queen of the Cunard Line, also known by passengers as "The Ship Beautiful." On the same day, another passenger, Max Reinhardt, was also diverted to the *Aquitania.*

Fifty years old at the time, Reinhardt was Europe's greatest theatrical producer and a master craftsman of enormous, expensive, atmospheric spectacles. He was born Maximilian Goldmann to Jewish parents in Baden bei Wien, Austria-Hungary, in 1873. As a young man, Reinhardt became an actor, but pursued a passion for all the arts, including music, poetry, dance, and set design. In 1902, he became director of several theaters in Vienna and Berlin where, on average, he staged a remarkable twenty performances a year. Always searching for the perfect venue for his work, in 1918 he purchased the Schloss Leopoldskron, a derelict rococo castle in Salzburg, Austria, with commanding views of the Alps, high-ceilinged halls, ballrooms, a personal chapel, and vast

garden areas beside the Leopoldskroner Weiher, a small, shallow lake. Over the course of twenty years, Reinhardt transformed the Schloss into a splendid laboratory of stagecraft where he entertained the world's theatrical luminaries and developed a wide range of productions that dispatched deep, spiritual messages to a troubled world between wars. European theatergoers regarded Reinhardt as a genius who employed the theories of the composer Richard Wagner and German expressionism to create productions rich in symbolism and meaning. American theater audiences welcomed the day when Max Reinhardt would make his way to New York to stage a play on Broadway, which is why he boarded the *Aquitania* that day.

During the summer and fall of 1923, the short, handsome, dark-eyed Reinhardt ranged around Europe searching for a young woman to play the leading role in *The Miracle,* a pantomime he planned to stage at the urging of the German-born New York financier and patron of the arts, Otto Kahn. The play was based on the adventures of a wayward nun recounted in the medieval story of "Sister Beatrice." But by the end of October, after hundreds of auditions in Europe and America, Reinhardt hadn't had much luck in finding someone to play the part of the Nun. He sought a young woman who would draw theater-goers by the thousands, one whom audiences could relate to, who was vulnerable, perhaps a tender novice, but a novice who shone like a Grecian goddess or better yet, an Aryan. He was confident that his actress could be found. He would spot her with his "x-ray" eyes and pull her out of a crowd. He would mold and shape her quickly.

Reinhardt first spotted Rosamond, the five-foot, eleven-inch long-legged beauty with a crown of golden hair, shaped in a fashionable shingle cut, as she helped her mother onto a tender pulling up beside the *Aquitania* in Cherbourg. That afternoon, peering over the ship's rail, Reinhardt turned to his assistant Rudolf Kommer and the composer Einar Nilson and declared that Providence had diverted him to the *Aquitania*. He had found his Nun! For the next two days, he and his team furtively paced the decks and lurked behind corners in order to appraise their Nun from every angle. The *Aquitania* was a favorite ship of the moneyed "on tops" of the 1920s who cavorted in silks and feathers amid the emblems

and flourishes of Greek and Roman mythology. To please a seemingly bottomless thirst for champagne, shipboard romance, luxury, and nostalgia, there were big, fine cabins with porcelain baths for fresh water and saltwater, colorful rugs from the Orient, and spacious cupboard-trunks. The public gathering spaces featured swagged, columned, and porticoed dining rooms, a stage for an orchestra, perfectly proportioned halls with chandeliers, niches, painted lunettes, and even exterior garden rooms meant to evoke landscapes in the Cotswolds. Like hunters stalking a trophy elk, on the third day, Reinhardt and his team came out from hiding and made their move.

It was the first calm night aboard the *Aquitania* after a rough passage during which the passengers had turned green. Rosamund had emerged from her cabin, and was seated with her mother in the ship's high-ceilinged first-class dining hall, decorated in the style of Louis XVI. Reinhardt was seated across the room keeping an eye on his Nun. A panorama crowned the ceiling, a copy of Nicholas Poussin's *Triumph of Flora,* which depicted the romance between the goddess of springtime and Zephyr, god of the wind.

After dinner, a dance was held in the popular Garden Lounge that wrapped the ship's A deck. Perched in the corner, Reinhardt watched as Rosamond soared, glided, and pirouetted across the dance floor, observing her movements, strong yet graceful, half-human, half-animal. With the broad shoulders of her athletic father, Amos Pinchot, and her six-foot, one-inch uncle, the long-legged Governor Gifford Pinchot of Pennsylvania, Reinhardt said that it was as if she sprung from a race of gods. Rosamond's parents, Amos and Gertrude, were divorced when Rosamond was thirteen, still they both encouraged their daughter's pursuit of sports at Miss Chapin's School on the Upper East Side of Manhattan. They were proud of her good looks and competitive spirit. Had Amos been aboard the *Aquitania* that night, he surely would have noticed the three men in the corner.

Close to midnight, Reinhardt got up to leave the dance and sent Kommer, his emissary, to give Rosamond a message. As the music stopped, Rosamond's dance partner introduced her to Mr. Rudolf Kommer, who, in a few heavily accented words, told her that "Professor

Reinhardt," the director, was onboard on his way to New York to stage a giant production for theater magnates Morris Gest and F. Ray Comstock. Professor Reinhardt had been watching her, he said, and would like to speak to her about taking a role in *The Miracle*. Rosamond responded that she was not an actress, had no stage experience of any kind, and was only nineteen. Kommer was not easily dissuaded. He had his instructions and a meeting was to be held the next day.

Unfazed by the encounter, Rosamond went on dancing until well past midnight. She thought that when Reinhardt learned that she had no stage experience, he would no longer be interested. Besides, Reinhardt didn't speak English and hers was only a high school German, so much would be lost in translation. Reinhardt, however, wasn't worried. As a pantomime, her only speaking lines would be at the end of the three-hour performance when she would recite the Lord's Prayer.

Reinhardt first produced *The Miracle* in London in 1911. The play then traveled to seventeen European cities. But Broadway audiences, up to their ears in vaudeville and the Ziegfield follies, were ripe for a redemption story. Carl Jung and Sigmund Freud were becoming household names in New York, so the Nun's journey would traverse the symbolic landscape of dreams: of forest, castle, and cloister. Reinhardt would employ innovative set design and recruit a star-studded European cast. He expected a smash hit on the shores of America.

The next morning Reinhardt, Kommer, Rosamond, and Gertrude met in one of the ship's private salons, which was draped floor to ceiling in embroidered silk curtains of crimson and gold. A large gilded mirror hung in a recess, dominating the room and set off by cut-glass electric lights. Reinhardt introduced himself to Rosamond and Gertrude and recounted the legend of *The Miracle*.

A young nun named Megildis grows bored with her life in a medieval cloister and is lured into the forest by an evil piper. She embarks on a seven-year journey of joy and hardship. Men battle for her favors and die at her feet; she rescues a knight and finds worldly love in the arms of a count, a prince, and a crazed emperor. She wanders, always accompanied by the Piper, through mysterious landscapes, forests, palaces, and prisons. After her seven-year adventure, Megildis,

defeated in mind, body, and spirit, winds up back at the cloister where she repents, is forgiven, and is welcomed back to her former life. While Megildis was off on her romp, the Madonna, once a stone statue at the entrance to the cloister, had climbed down to take up the Nun's duties. Upon Megildis's return, the Madonna resumes her position and all is well.

Reinhardt concluded his description of the legend, observing Rosamond's profile, thinking her perfect for tragedy. But Rosamond knew little of tragedy and nothing about acting. At nineteen, she was planning her debutante party, followed by a Grenfell expedition to assist remote towns in Labrador, then perhaps a trip to Hawaii with her father and brother to learn to surf. She envisioned some vaguely imagined career having to do with the outdoors and sports.

Reinhardt left so that mother and daughter could confer. The esteemed professor had assuaged some of Gertrude's motherly reservations, but Rosamond was trembling. That night, alone in her cabin, she had a revelation:

> Suddenly, while I was sitting there alone, it came over me what a great chance I was missing by not making a great effort this time. I realized that at last something that I really wanted was being offered to me, and that it was a sort of laziness that prevented me from doing what was necessary. . . . The one thing that stood out clearly in my mind was that I wanted the part of the Nun more than I have ever wanted anything else before. So I got up and went to find Professor Reinhardt. He was finally located with the help of Mr. Kommer, and I told him that I was ready to try to act. I did not know what I was going to do, but I did know that Reinhardt did not understand English. So I began. Exactly what I said or how long it lasted I do not know, but I remember that I pretended to be talking to some third person, telling him how greatly I wanted the part, how well I could do it, and begging him to give it to me. It must have sounded like the appeal of a prisoner to be released. When it was over, I found that I had been crying without even knowing it. Like most people, I hated to be seen crying and had a horror of being laughed at for it. But Professor

Reinhardt did not laugh. He did not say anything for a minute or so, except "sehr gut."

By the time the *Aquitania* sailed into New York harbor, Reinhardt felt sure that he had found his Nun, but the final decision was up to the production's impresario, Morris Gest, one of New York's most relentless publicity hounds. While Reinhardt sought a transcendent stage presence, Gest sought exploitable glamour and ticket sales. If Reinhardt was right, his discovery would make Morris Gest a very happy man. Here was a young woman as beautiful as one could imagine, from a distinguished American family, who was sure to attract Manhattan's upper crust. Her mother hailed from the illustrious Sedgwicks of Massachusetts and the Minturns, a successful New York shipping family. Rosamond's father, Amos Pinchot, and his brother, Gifford Pinchot, were both millionaires, having inherited a fortune from their father, James Pinchot. However, what distinguished the brothers wasn't money. Encouraged by their father, they both turned toward public pursuits: politics, conservation, and philanthropy. Before becoming the governor of Pennsylvania, Rosamond's uncle Gifford had held the post as the first chief of the United States Forest Service under Theodore Roosevelt. Morris Gest couldn't wait to see the headlines:

ROSAMOND PINCHOT, DEBUTANTE, TO STAR IN BROADWAY'S
LARGEST PRODUCTION

This was showbiz. Showbiz required hoopla, so Gest would stage a massive publicity campaign of articles and advertisements. Everything would be bigger and better than New York had ever seen. He'd even market *The Miracle* with an exclusive product, "Parfum Miracle," the exquisite scent of wayward nuns. The quasi–holy water would be produced by Lentheric, Paris, in limited-edition bottles of obsidian flecked with gold.

Although Rosamond's mind was made up, her parents had reservations. But it was too late, the publicity machine was off and running.

The *New York Times* got wind of Reinhardt's shipboard discovery and reported the developments on page 1:

> Pinchot's Niece, 17 [*sic*], Picked as Nun in "The Miracle," by Reinhardt; Selects Girl With No Stage Experience the Moment She Passes Him on Ship; Calls Providence Guide.

The press reported Rosamond's age wrong, but no matter, this was a highly unusual and controversial assignment for an American debutante. Behind the scenes, Gest was haggling with Rosamond's mother and father over Rosamond's working hours, understudies, and substitutes. Finally agreeing to the Pinchots' requirements, Gest parted the waters and Rosamond was hired. There were backup nuns and sub-nuns but Rosamond Pinchot was to star as the number one Nun in Broadway's largest production to date, which was scheduled for an opening night— Christmas Eve, 1923.

Rehearsals began immediately at the Jolson Theatre on Seventh Avenue and West Fifty-eighth Street, home to the Moscow Art Theatre. Reinhardt had pulled off his *Miracle* before, but never at this scale or under such pressure to meet an opening night. Between cast, crew, and construction, seven hundred people were employed, three hundred of whom were dispatched to build sets of forest and cloister in three off-site studios. The young scenic designer, Norman Bel Geddes, quickly drew up plans to transform Carrerre and Hasting's Century Theatre on Central Park West, with its French modern interior, into a Rhineland cathedral complete with gothic gloom. Reinhardt challenged Bel Geddes to break down the age-old separation between actor and audience by doing away with the traditional stage, ridding the theater of its proscenium and turning its seats into pews. The audience wouldn't be an audience, it would be a throng of acolytes participating in a great medieval spectacle. Engelbert Humperdinck's score filled the nave and aisles with deafening organ music, bells, and the shouting of medieval crowds. Stained-glass windows were fabricated, animals were brought in, and seven hundred supernumeraries were instructed in the art of surging up and down the aisles as beggars, jesters, lepers, and lunatics. Meanwhile,

three thousand costumes were created, the incense tested and lit. The only thing left was to await Christmas Eve, when the audience would be led by candlelight to their pews.

Due to delays, Christmas Eve came and went. Morris Gest placated angry ticket holders by churning out a hurricane of press releases explaining that the wait was worth it and that the faithful would be rewarded. Among various ploys, he staged fake catfights between the Madonna, played by Lady Diana Manners and her stand-in, the elegant Princess Matchabelli. Manners, the wife of an English diplomat, who had been hailed as the most beautiful woman in England, found Gest's sideshow undignified but consistent with his do-anything campaign to increase ticket sales.

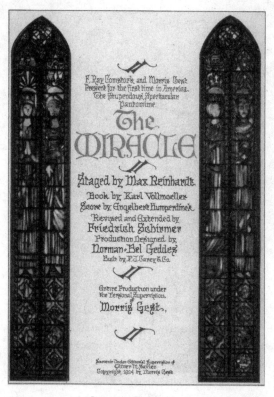

Program for *The Miracle*

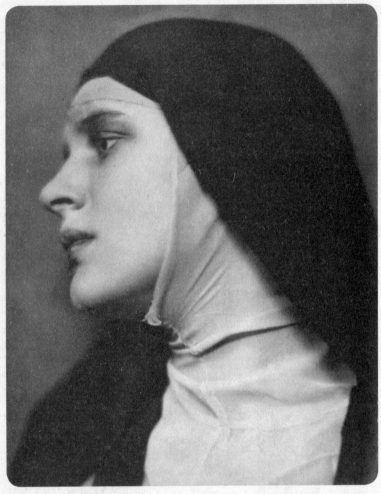

Rosamond as the Nun Megildis in *The Miracle*, 1923

The play finally opened on January 15, 1924, with Rosamond Pinchot as the Nun and Lady Diana Manners as the Madonna. The starring actresses were joined by a cast of Europe's most prominent stage actors, including Werner Krauss as the evil piper, Rudolf Shildkraut who played the blind peasant, Schuyler Ladd as his son, and Orville Caldwell as the handsome knight. Opening night nearly went off without a hitch except

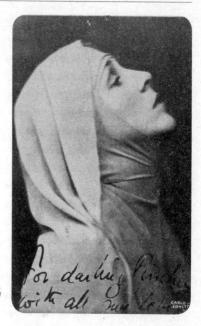

"For darling Pinchie with all my love." Diana Manners by
Carlo Leonetti

that backstage Rosamond had locked herself out of her dressing room
an hour before curtain. A locksmith was dispatched to avert liturgical
disaster and the audience never knew anything had happened. That au-
dience included Rosamond's parents, Amos and Gertrude; her uncle
and aunt, Governor Gifford Pinchot and Mrs. Cornelia Pinchot; and
a who's who of New York society: the Whitneys and the Vanderbilts; the
Duke and Duchess de Richelieu; the Duchess of Rutland, who was the
mother of Lady Diana Manners; Otto Kahn; Mrs. Charles Dana Gib-
son; Senator Simon Guggenheim; Mr. and Mrs. Phelps Stokes; R. M.
Sedgwick; Zoe Akins; the Posts of Washington and the Fields of Chi-
cago; Mr. and Mrs. William Randolph Hearst with Marion Davies; the
Brokaws; Frank Crowninshield; Miss Elisabeth Marbury; the Astors;
the Lippincotts; Conde Nast; Prince Matchabelli; the Ochs; the Bam-
bergers and Krocks; Mr. and Mrs. Jay Gould; and the Italian playwright
and tragedian Luigi Pirandello, who had just opened the National Art
Theatre of Rome with the support of Benito Mussolini.

The spectacle astounded audiences and critics alike. Alexander Woollcott, the prominent theater critic, described the transformation of the Century Theatre as "hocus pocus," and Reinhardt's ambition as the "most leaping" in American theater. "*The Miracle* is a wordless play," he wrote, "that is at once a play and a prayer and a pageant, and in its service the work of thousands of hands over many months in many lands, has culminated at last in the unbelievably transformed Century, itself touched by some magic new in the theatre. The result was such a spectacle as this country had never seen before."

John Corbin of the *New York Times* reported:

. . . One followed the Nun through a dance of elves in a wood, interrupted by an incursion of huntsmen; through a Prince's nuptial feast and mock bridal procession; through revels in an imperial palace and the phantasm of an insane Emperor and the bloody orgies of a reign of terror. Everywhere the scene was multitudinously animated, vitalized by the sweep of Reinhardt's imagination and his marvelous sense of detail. As for Miss Pinchot, the outstanding impression of her performance was the half animal grace and the physical vitality that first attracted Reinhardt's attention. That is the primary and indispensable qualification for that marathon of parts.

Running up and down the aisles of the Century Theatre for three hours every night, Rosamond playfully told a reporter that she recommended the part for weight reduction. "I, who seemed to have no superfluous flesh to lose, have lost seven pounds!" she exclaimed. On a more serious note, she also said that the play seemed to be having a strange effect on her:

I drifted dazedly thru the play, like a wraith in a dream. Had it not been that the part had been so thoroly [*sic*] drilled into me that it had become a part of my mind I probably would have been a farce. When it was all over and my friends gathered about me with congratulations I gazed at them stupidly, hardly recognizing them. I was reduced to a state of speechlessness. And next morning I was

surprised that the critics were so kind. Then of course I awoke to such a great sense of gratitude for the wonderful opportunity that had come to me.

At nineteen, Rosamond Pinchot became Manhattan's "it girl" and her name was everywhere. She was a part of the Reinhardt machine, a well-greased operation that relied on a stable of the master's chosen performers. She was frequently photographed with Max Reinhardt, who the press referred to as "Max, the Magician." She learned about fame and what it meant to be discovered. She learned about luck and fate and the power a man had to see what a marvelous creature she really was. What girl doesn't dream of being discovered? Being discovered meant going where she wanted to go. The papers reported that "There were no weary, grueling apprenticeships for her, no dismal days in tank towns, no trouping and no long bitter summers with stock companies." The headlines read: "Rosamond Pinchot Passes Some Actresses Who Have Spent Lives On Stage." Rosamond, they reported, had forsaken her debutante party to become an "Actress of Destiny." Perhaps she was destined for one big beautiful life and wouldn't have to dream up a career. Perhaps life was a quest for what was beautiful. One columnist noted that she "found in the theatre the fulfillment of her beauty quest." Certainly she was on a quest. She told a reporter for *The Princetonian,* "I have received so many condemning me for appearing in such an immoral play, after having been brought up as a respectable girl, but I find them very amusing, since of course you have to get accustomed to all sorts of situations in modern plays. At the start, my family also objected furiously, and practically forbade me to play the part as it stands, but I convinced them finally." When asked about her dreams for the future, she told Elita Miller Lenz, a reporter, "Well I dream of entering the drama seriously, to stay, and I am studying faithfully to that end, but I fear that perhaps after all this glory I may find myself announcing humbly next season, 'Madame, dinner is now served.'"

The Miracle closed in New York after 299 performances, after which Rosamond agreed to join the cast for a U.S. tour. In its first stop outside New York, she appeared at the Cleveland Public Auditorium for twenty-six performances in December of 1924 and January of 1925, but in a letter to

her father, she bemoaned the ugliness of Cleveland and wondered whether, at twenty years old, she could bear to travel through the hinterland and dozens of other bedraggled American cities. Through two years of grueling late-night rehearsals and performances, she had lost track of her friends, she missed her dachsund, Nicolette; her horse, Fleury; and Oscar, the parrot. She missed sleeping in a regular bed at night, but most of all she missed her family, particularly fishing with her father at her family's summer home, Grey Towers, in Milford, Pennsylvania.

A prominent crusader for progressive causes, Rosamond's father, Amos, knew when enough was enough. After two years, Amos had had his fill of haggling with Gest over his daughter's salary and working conditions. Rosamond was hardly downtrodden, but Amos Pinchot was not someone to tangle with. He'd graduated from Yale in 1897, gone on to New York Law School, and served in 1900 and 1901 as Manhattan's deputy district attorney; in 1912, he and his brother, Gifford, had helped Theodore Roosevelt establish the Bull Moose Progressive Party. In 1917, Amos had helped found the National Civil Liberties Bureau, the precursor to the American Civil Liberties Union. The writer Max Eastman attributed Amos's passion to an "inherited nobility," which earned him a sizable audience of readers in Manhattan. "If [Amos] wanted to make a statement on some public question," Eastman wrote, "he had only to call up the *New York Times* and they would give him a top headline and a double column."

Amos Pinchot was used to giving people headaches, and Morris Gest didn't need an Amos Pinchot headache or any headache for that matter. Amos wrote to his older sister, Nettie, in London about his battle with Rosamond's employers: "With the exception of Reinhardt, they are a very rotten lot, cold blooded exploiters, who care nothing for art, nothing for beauty and lack every quality of mercy. The only way to deal with those people is to kick them as soon as you get in the room, and very hard. Then they develop a very high regard for you or something equivalent thereto."

If there was one thing Amos Pinchot knew about the members of his spirited and active family, it was that they required abundant sleep and exercise, and what Amos meant by exercise wasn't running up and

down the aisles of the Cleveland Auditorium. That winter, unable to reach an agreement with Gest, Rosamond left the cast and boarded a train for New York, where she planned to get back to the life she missed.

But that spring, before she'd had a chance to catch her breath, she received a letter from Professor Reinhardt, who suggested that Rosamond come to Austria to perform in *The Miracle* and *A Midsummer Night's Dream* at the Salzburg Festival. Once again, Rudolf Kommer, the emissary, was dispatched to send the message:

> Schloss Leopoldskron
> Salzburg
> 20 April 1925

Dear Rosamond,

Now that everything is definitely settled, I feel justified in letting you know the Salzburg dates. The opening performance of the Festival will take place on the 13th of August. It will be *The Miracle,* with Diana and Rosamond. A week later or so Hoffmansthal's "The Worlds Theatre" will also be performed. At the same time there will be a Mozart festival (at the Salzburg Stadtheatre) under the direction of Richard Strauss. In short there will be a grand August in Salzburg. Your name has already been announced and the whole of Central Europe is expecting "Die fabelhafte junge Amerikanierin." It will be necessary for you to arrive in Salzburg around the first of August. Come as soon as you can. The duchy of Salzburg is full of mountains and lakes. I assume full responsibility for your entertainment. I pledge my reputation. You will never regret your visit. . . . I hear from New York that the new "Miracle" season is to open on the 24th of September in Cincinnati. I hope it will not be too Gestly. Here in Munich, where I arrived today from Berlin, your "Waltz Dream" song is haunting me. To counteract it I am singing your favorite: "Einmal Komint der Tag. . . ." Berlin and Vienna are full of new songs. I shall return to the States with a brand new repertory. Diana is somewhere in the south of France. I am proceeding to Salzburg in a day or two, where I shall spend my days waiting (in the coffee

houses) for news from you. Max, the magician sends you his herrlichste grusse. I am doing the same. Please remember me to your parents. Auf Wiesdersehn!

<div style="text-align: right;">

Yours ever,
Rudolf Kommer

</div>

If Kommer's dispatch sounded like a seduction, it was, particularly after the unpleasantness between Amos and Gest. Rosamond could pass up a winter in Cleveland, but how could she resist a summer in Salzburg at Reinhardt's castle near the Alps? If her meeting aboard the *Aquitania* had taught her anything, it was that half of success was getting the breaks, but half of that half was recognizing them. When she had been discovered, it was like a giant hand had reached down and plucked her out of a crowd. And here it was again.

In June, Rosamond boarded the fastest ship in the world, the Cunard Line's RMS *Mauritania*. She spent the summer rehearsing in Salzburg, perfecting her German, traveling about, and in August she performed as the Nun at the opening of the Salzburg Festival, then staged in one of the city's main public gathering places, Cathedral Square. In 1925, thanks to Reinhardt, Strauss, and von Hoffmansthal, a new festival hall was under construction and the Felsenreitschule, the archbishop's riding school, was being converted into one of the world's most unusual theaters to house the Salzburg Festival, a spectacular outdoor auditorium carved out of the towering cliffs in the middle of the city.

August in Austria was every bit as grand as Kommer had described. Rosamond rode her bicycle through the narrow streets of the Altstadt, the old city, introducing her dachshund, Nicolette, to stout, red-faced market women and admiring men. She toured Reinhardt's restored theaters in Berlin and posed in silhouette in front of the arches at the Felsenreitschule, again with little Nicolette; and thanks to a marketing scheme whipped up by Gest, she was caught by photographers in a smart white dress and heels, having been arrested by the Austrian police for riding her bicycle without headlights. She donned Tyrolean dirndls for picnics beside waterfalls in the Alps. She rolled through meadows of wildflowers and posed with fellow actors in an ecstatic human sand-

wich. The photographs tell the story, and Kommer's promise came true. She did not regret her trip to Austria.

That summer, at a state ceremony, Rosamond was presented with a gold-embossed plaque from the Austrian government thanking her for her performance as the Nun. Later, at a candlelight feast in the high-ceilinged banquet hall at the Schloss Leopoldskron, Reinhardt and Kommer presented her with a pair of colored lithographs. One lithograph depicted the Schloss and the little Leopoldskonner Weiher with fishing pavilions and Untersburg Mountain looming in the background, while the other showed the outdoor stadium carved out of the cliffs. In both scenes, a tamed and organized foreground gives way to a backdrop of forbidding mountain ranges and craggy peaks. Below the images, penned in a curvaceous German script, the titles read "Leopoldskron," and "Felsenreitschule."

That fall, *The Miracle* returned to the United States to resume its American tour in Cincinnati under new direction. While Reinhardt and his emissaries tried to keep the cast intact, Lady Diana Manners returned to London to resume married life and notoriety, while Rosamond returned to New York a celebrity.

New York was booming in 1925. In February, the *New Yorker* published its first issue with the dandy Eustace Tilley on its cover and a warning inside that it wasn't "edited for the old lady in Dubuque." In April, F. Scott Fitzgerald released *The Great Gatsby,* which initially sold relatively few copies to Jazz Age readers, perhaps because they were having too good a time dancing the Charleston to bother with books. In June, a man named Walter Percy Chrysler launched the Chrysler Corporation in order to provide the American consumer with a comfortable, well-engineered road car at an affordable price. And in October, Rosamond turned twenty-one years old. It wasn't a bad time to be young and beautiful and rich, particularly if your name was Rosamond Pinchot, and you had distinguished yourself as an unusual young woman, hardly the average debutante from a privileged American family. The Star Company reported, "This Rich Girl Is Happy: Her Father Lets Her Work, That's Why."

The press was right, Amos and Gertrude did encourage their daughter to work and to make herself useful. However, working, much less working as an actress, was still a novelty for a woman of Rosamond's

station. What readers wanted to know was what else she planned to do, particularly who she would marry, and who would have what it took to marry her:

> If this father and daughter had followed the ordinary course, she would have sat around, traveling from New York to Newport, and from America to Europe, waiting for a more or less inane young gentleman to come along and marry her and her fortune. Had that happened, Miss Rosamond Pinchot would have begun Mrs. John Smith or Mrs. John Snooks and she would have been obliterated as somebody's wife. Now when she marries, which, of course, she ought to do, for marriage and motherhood are the principal duties of women, the man she marries will be "Rosamond Pinchot's husband." That may not suit him but that is what he will be. Meanwhile, she can take a walk with her little dog, knowing that she is somebody, that she has done something, that in return for the kindness of nature and her ancestors, that gave her power, that she has done what she could do to be useful in the world.

Despite the press's concern for the future Mr. Rosamond Pinchot, Rosamond returned to the life she knew, one of beauty, wealth, and privilege and living with her mother at the corner of Eighty-first Street and Fifth Avenue. She could hardly complain. The galleries of the Metropolitan Museum were practically an extension of her living room and the meadows of Central Park were her de facto front yard. Every morning, entering the park off Fifth Avenue, she'd pass through the rolling greensward just south of the Metropolitan and make her way over to Central Park's stables, where she'd saddle up a horse she'd bought with money from *The Miracle,* a French hunter named Fleury, and spend hours galloping Olmsted's equestrian trails. At night, she'd accompany her father to dinner parties with the Morgans or the Whitneys. She'd spin over to opening night at the Belasco with her mother, or get tight with her friends at the Hotsy Totsy Club.

Landing her role in *The Miracle,* some said, had been a stroke of luck, but sometimes blessings followed luck. She counted among her bless-

ings an eclectic and sophisticated rat pack of friends and relatives who straddled café culture, Wall Street, and bohemia. Among them were her cousins Varick Frissell, a young Arctic explorer and adventure film-maker, and his sister Toni, a portrait photographer. One of her closest friends was Francesca Braggiotti, a willowy beauty from a colorful Florentine family who had begun a wildly successful school of modern dance for stodgy Bostonians in the Brookline firehouse and swept up a good-looking husband in the process, John Davis Lodge, the actor-son of Senator Henry Cabot Lodge. Rosamond ran from one engagement to the next, arm in arm with up-and-coming actors, lunching it up with busy young directors like George Cukor, who was gearing himself up to direct the first stage production of *Gatsby,* and enterprising playwrights like Zoe Akins, brilliant before her time.

With time on her hands, there were new friends to make, new lines to memorize, and exciting possibilities around every corner. Rosamond hosted a tea every Wednesday, cocktails or "stand up" dinners every other Friday, and on interim nights, she'd whisk herself back to late-night rehearsals or to Conde Nast's parties on his roof. She took acting classes at DeKanavas School of Russian acting, danced at Anna Graham's studio and at Mordkin's ballet school. She alternated date nights with her boyfriends Dwight Taylor and Sherman Jenney, but sometimes all three would stay up late together, drinking champagne and eating takeout cross-legged on the floor. They'd go to Carnegie Hall to watch Toscanini conduct the New York Philharmonic Orchestra, and the next day, instead of flowers, Dwight would send Rosamond a lovely apple tree in bloom. In the afternoon, he'd come over and they'd lie about on the rug and talk about magic until three in the morning. Friends and family would show up or not—it didn't matter, no one needed an invitation. During *The Miracle,* this was the life she missed, the life she longed for.

Between the moments of her busy life, Rosamond turned to "her book," her diary, penning brief impressions on friends, work, and performances from *Tristan and Isolde* to *Carmencita* to *The Emperor Jones* starring Paul Robeson. Gradually, she penned longer and more complex entries. On the frontispiece of her leather-bound journal of 1926, Rosamond inscribed the curious words of Joseph Conrad:

...If one looks at life in its true aspect then everything loses much of its unpleasant importance and the atmosphere becomes cleared of what are only unimportant mists that drift past in important shapes. When once the truth is grasped that one's own personality is only a ridiculous and aimless masquerade of something hopelessly unknown, the attainment of serenity is not so far off. Then there remains nothing but to surrender to one's impulses, the fidelity to passing emotions, which is perhaps a nearer approach to truth than any other philosophy of life.

Like almost every young woman, she longed for a young man, but given the men who surrounded her, the Reinhardts, the Gests, and the powerful Pinchots, that search was not likely to be easy. A man would have to come equipped with some remarkable qualifications, a story with substance and something to say for himself. As fall turned to winter, the phone rang ten times a day with offers of outings and engagements. Throngs of men phoned or sent flowers but none of the callers were particularly impressive.

But one night in midwinter, shortly after copying the passage by Conrad in the front of her diary, it happened. She met a young man with an extraordinary story that in some ways resembled hers. On Friday, January 29, 1926, Rosamond invited twenty friends to dine with her at her father's apartment at 1125 Park Avenue. She and her friends outfitted themselves in colorful costumes and swept off to the Beaux Arts Ball in the grand ballroom at the Astor, where three thousand invited guests dressed in seventeenth- and eighteenth-century costume were assembled in boxes and bosquets to witness "A Fete in the Garden of Versailles." Sometime that evening, between the foliage, the lead figures borrowed from the garden of Bagatelle, and the central fountain designed after "Les Grandes Eaux," Rosamond's friend Francesca Braggiotti introduced her to a fellow Bostonian, Bill Gaston, twenty-eight years old, six feet, one inch tall, who had come down by train, dressed in masquerade, to join the festivities. After the Dance of the Odalisques, the program read, Miss Rosamond Pinchot was to perform in a minuet arranged by Miss Julia Hoyt, Miss Clare Boothe Brokaw, and five other court dancers. An Italian comedy masque was

followed by a Crystal Dance, after which, Bill Gaston asked Rosamond to dance.

Behind the mask, Big Bill Gaston was remarkable. He had graduated from Harvard Law School in 1923, and everyone knew the Gastons because of Gaston Snow, the family law firm established in Boston in 1844. His grandfather had been the governor of Massachusetts just as Rosamond's uncle was the governor of Pennsylvania. His father bested Theodore Roosevelt in the boxing ring and her uncle Gifford had trounced Roosevelt as well. He was from one of the oldest New England families, and he'd been awarded the Navy Cross for valor in World War 1 during an aerial encounter in Belgium. He was a Son of the Cincinnati, an honor deeded through primogeniture to the first sons of the original soldiers of the American Revolution under George Washington. But aside from all that, what Rosamond noticed about Bill was that he was

Big Bill

magnetic, entertaining, and very, very good-looking. She wasn't the only woman who had noticed Big Bill Gaston. On the night she met him, he was married to Broadway's best-dressed actress, the sultry, sophisticated, and ambitious Kay Francis, and there were probably only three people on earth who knew it: Bill, Kay, and Kay's aunt.

Big Bill was married to Kay Francis, but not in any traditional sense of the word. Onstage, Kay Francis usually played a long-suffering wife or someone who had stumbled into trouble unknowingly. In real life, her story was quite the opposite. Like Rosamond, Kay kept a diary; but while Rosamond called her diary a "book," Kay kept an annotated desk calendar in which notes were spare and precise. When she wanted private matters to stay private, Kay switched to shorthand. Big Bill was usually referred to as "Billy G," but when the matter was not for public consumption, he was "B" or "BG." On October 19, 1925, as if waking with a hangover, she wrote in shorthand, "Married to Billy G., my God. I told Aunt G of BG and me—swearing her to secrecy."

Neither Kay nor Big Bill seemed to remember why they had married, nor did they think it was it was a good idea to tell anyone. On December 2, after a little more than a month of so-called marriage, Kay recalled, "My seduction of B! My God does he know how to kiss." But Kay's desk diaries refer to B. only sporadically over the next two years. Their marriage remained a mystery and a closely held secret until Big Bill's best friend, Bill Laurence, a *New York Times* science reporter, told Kay that her husband, who hadn't always been present but was always available, was making himself available to another woman, Rosamond Pinchot.

When Big Bill met Rosamond, he had put aside his Harvard law degree to try his hand at something he loved, writing plays. His first ironic drama, *Damn the Tears,* was in production. He had recruited Norman Bel Geddes for set design and his friend Reginald Barlow, a colorful actor and native of Boston, to star as his leading man. Rosamond soon learned that Big Bill had ideas, slightly strange ideas, about even stranger characters, but enough of an imagination and enough of what it took to get his plays out of the typewriter and onto the stage. There were men who bored her to tears, and then there were men like Big Bill who came equipped with a life, a story, and a plan. His was to buy an island off the

coast of Maine where he'd build a house with a stage, where he would cook and write and grow alyssum and potatoes by the sea.

Meeting him, Rosamond felt as if she was on a precipice, the way she felt when she'd met Reinhardt onboard the *Aquitania*. Bill Gaston was exciting. Like her father, he was an attorney and commanded an audience with his mastery of words. There was something about a man who, for half a moment, prolonged a glance, a glance you didn't quite know what to do with. There was something deeply familiar about him that women fell in love with, something in his bright blue eyes, sensitivity perhaps, loneliness perhaps. He was reserved at first until he was certain of the company, and then, she noticed, he could concoct an argument about as good as she had ever heard. When a man with a build like Bill Gaston held his power in reserve like that, waited before saying anything, there was something irresistible about him. Something that let you know there was more to him than most people could see, perhaps something that Rosamond had seen in the not so average run of life.

On February 18, 1926, Big Bill picked up Rosamond for their first date and took her to see Franz Werfel's *Goat Song* at the Guild Theatre on West Fifty-second; it starred the British actress Lynne Fontanne, who was renowned for lying about her age not just in public, but to anyone who would listen, including her husband. Alexander Woollcott, who defended the play, reported that Fontanne delivered one of the most beautiful colloquies of the modern theater, but the play itself was nothing short of a horror story not to mention an unusual pick for a first date:

> In a trans-Danube countryside of the eighteenth century, to the sorrowing lady of its greatest house, a monster has been born—perhaps a curse upon that uncomprehending rooftree, perhaps the seed of Pan strayed back for a little time into a world made uninhabitable for Pan. It is a creature so terrible, so unthinkable that they can neither kill nor look upon him. Then after three and twenty years, even as this darkened house is striving to be a little festive for the betrothal of the second-born, the monster escapes. His apparition falls like a spark in the chaff of the countryside's discontent. Gypsies, charcoal

burners, peasants, clowns, Jews, the nameless, the landless, the human flotsam of the little world, all are fused into rebellion. Primal chaos raises its head—so ugly to all those who are secure or righteous or smug, so beautiful to the despairing. . . . The revolution was a failure, utter, complete. But what has happened may happen again. For the Iphigenia of that renewing countryside walks the fields with the seed of the monster inside her. On that threat, on that promise, on that prophecy, the curtain falls.

Big Bill and Rosamond didn't wait for the curtain to fall. At intermission, he introduced Rosamond to Fontanne backstage, after which they agreed to forgo the second act. Exiting by way of the side door, they beat a path to nearby Town Hall where Bill's friend Paul Robeson was giving a concert of Negro spirituals. Not just any concert or any musician, Robeson had been singing to sold-out audiences around the country after deciding, like Bill, to abandon his other career, the law.

One date led to a second invitation, and so it was that Rosamond boarded a midnight train two weeks later to visit Bill and to attend his sister Hope Gaston's bridal shower in Boston. After the celebration, Rosamond reported in her diary: "much champagne and high Boston society." And while all was very gay, she wrote, "Bill G. quite tight." Later that day, they lunched at the Somerset Club where she noted, "He delightful and I feeling easily understood. . . . Felt myself rather affected."

After their date in Boston, Rosamond didn't see Big Bill for several months. It didn't really matter, people came and went and there were always enough men around to distract her from fixing her sights on any one in particular. She saw Big Bill twice in April that year, once for a cup of tea at her apartment that extended until well past midnight and once at the Algonquin, where her friend Zoe Akins was working with young George Cukor on a new play, *Pardon My Glove*. The play was scheduled to open at the Lyceum in Rochester, where Cukor had set up a theater company; it was set to be produced by the man Rosamond couldn't get away from, Morris Gest. Zoe had seen Rosamond in *The Miracle* and decided to have her read for the part of Mimi alongside Billie Burke, wife

of Flo Ziegfield, and who would later play Glinda, the Good Witch in
the *Wizard of Oz*. Several days after her date with Big Bill at the Algon-
quin, Zoe and George handed her the manuscript for *Pardon My Glove*.
Rosamond wrote, "They seemed to want me for the part of Mimi in the
play. It seemed like another *Aquitania*. Such a spring night!"

This time it was the hand of young George Cukor who reached
down and plucked her out of a crowd. Since the encounters with Morris
Gest, Rosamond had learned not to put too much faith in the press.
Still, news was news, and without the benefit of an agent, she admitted
to reporters that she suffered from stage fright and said that she made
a better "kennel man" than an actress. "Please don't say in big head-
lines that I am a genius or something like that. I know I am not. And
please don't put anything in the paper that sounds romantic." But the
press couldn't help itself, it was in love with Rosamond Pinchot. In a
love affair, right or wrong, glamorous or not, even the details sound
romantic. Sometimes, as in one column, "Lights on Socialites," the
press actually got the story straight:

> Her favorite color is red. Her apartment, a penthouse in the East
> Seventies, features large red flowers in white vases against white
> walls. She plays backgammon, doesn't care about bridge. Her favor-
> ite drink is a Haitian rum cocktail. She smokes a lot in public, rarely
> when alone. She has no superstition about black cats, often has one
> or two about the house. She likes to be alone a great deal, spends
> four or five hours daily by herself. Her idea of a good time is going
> places she's never been, alone.

In April, Big Bill was still working on his own semiautobiographical
play, *Damn the Tears,* an expressionistic odyssey of a Harvard attorney
from an old Boston family who turns into a baseball player, loses his
mind during practice, and ends up a shuffling lunatic on the streets of
Manhattan. While Big Bill was ironing the stranger kinks out of *Damn
the Tears,* scheduled to open in January 1927 at the Garrick Theatre, Ro-
samond was quietly damning her stage fright at rehearsals of *Glove*. On
April 24, 1926, she wrote:

Came home and slept before going to the Empire Theatre to read for Mimi. I was nervous and felt inferior at the reading. Still they seemed to like me. Damn the self-consciousness. After the rehearsal with Zoe Akins, Louis Walheim, Gilbert Miller and George Cukor and I went with Zoe and we sat in her apartment at the Algonquin. We read and talked. Then Bill Gaston came…later Walheim, Cukor and Miss Andrews. We talked late. I am home and lonely…still it is this human business. I can't seem to get it. Always the Cinderella feeling and loneliness.

In her diaries, Rosamond called her bouts of sadness and emotion "the Cinderella feeling." She described it as a "sinking sensation" that made unexplained appearances, then disappeared for days, weeks, or months. During the bouts, she felt listless, fearful, and suffered things more deeply. Amos, for one, thought his daughter felt things too deeply, advising her not to make too much of things. The Cinderella feeling was likely some form of depression. When it took hold, she longed for things to be different from the way they were, to go someplace, preferably alone, where she wouldn't feel as though people were watching her. But where she wanted to go and what she longed for, she didn't know.

While her success in *The Miracle* was an entrée to the land of theater people, it was also a passport to the world of aggressive businessmen who sold what the theater critic Alexander Woollcott called the "narcotic opulence of extravaganzas" to a frenzied public. The language they used was the slang of the cheap scam, the term they used was "show business," and the future was in the "motion picture industry." Producers like Gest and theater magnates like Shubert started out as ticket hawkers and real estate speculators and became an indispensable part of the Broadway machine, building theaters and recruiting ambitious young directors and actors to "deliver the goods," and "put one over" on an audience. Business was business. Rosamond Pinchot, a daughter of the old New York establishment, had become a Broadway star and she owed her success, or at least part of it, to the new Jewish theatrical establishment. Men like Morris Gest gave Rosamond and Amos a great big headache, but men like Morris Gest made Rosamond Pinchot a household name.

In the spring and summer of 1926, Rosamond often visited a woman named Mrs. Witt, a counselor who lived downtown. Mrs. Witt was likely a lay therapist and not a Freudian analyst, given the topics they discussed, such as what Rosamond was going to do with her life and her increasing ambivalence toward the stage. They discussed the subtle shifts in the Cinderella situation, Rosamond's eyes, her feelings of being watched, and her stage fright. Several times Mrs. Witt went to watch Rosamond dance at Mordkins and Anna Graham's studio and concluded that Rosamond's nervousness was justified. The aggressive theater crowd was to blame for her symptoms. She and Mrs. Witt discussed how she might find herself in a field that was more benevolent and conducive to her sensitive nature. "How marvelous it would be," the two women thought, "if goodness could be made interesting and attractive."

Rosamond and Mrs. Witt frequently discussed Rosamond's parents, Amos and Gertrude, who divorced in 1918 when Rosamond was thirteen. Rosamond idolized her father, calling him "Doly," while he called her "Sis" and referred to her as his best friend. Rosamond confided in Mrs. Witt, telling her that her father was the one person she knew who managed to make goodness both interesting and attractive. Gertrude, on the other hand, hadn't managed to make anything interesting or attractive. With her various ailments, she was sickly, cloying, and needy. According to Rosamond, Gertrude was just plain annoying.

Proximity was just part of the problem. Soon after Amos and Gertrude divorced, Amos temporarily moved into one of the many clubs he belonged to in the city, while Gertrude bought the four-story brick town house at 9 East Eighty-first Street. Rosamond and her brother, Gifford, known as Long Giff, went to live with their mother. When Amos married his second wife, Ruth, in 1919, Amos bought an apartment at 1125 Park Avenue, but he also owned properties all over Manhattan, including all four corners of Eighty-fifth Street and Park Avenue where he hired the architect Richard Morris Hunt to design a town house adjacent to one of the corners. At Gertrude's town house, just seven blocks away, Rosamond enjoyed all of the comforts any young woman could want, but neither parent's home felt like home. Home to her was Grey

Towers, her father's ancestral estate, high above the banks of Sawkill Creek, a tributary of the Delaware River, in rural Pike County, Pennsylvania.

If New York was like her mother, Grey Towers was like her father. If New York was the backdrop for Conrad's "aimless masquerade," Grey Towers was its antidote. In her diary, Rosamond frequently reported hearing the call of the whip-poor-will, a close relative of the owl and the only species that is known to hibernate by burrowing down in the duff of the forest floor or hiding away in the sides of cliffs. At Grey Towers, the Cinderella feeling rarely staged an appearance.

As a child Rosamond had a wild side; some called it exuberance, but others were alarmed by it. At four years old, she learned to ride, and at eight, she was entering equestrian competitions at Madison Square Garden. By the age of thirteen, she rode five jumpers in one class. Exploring Milford's forests and fields on horseback or on foot, she was frequently alone, but never complained of loneliness or being left alone. Quite the opposite, she preferred it. Dodging her uncle's foresters and her father's writers and politicians, she often wandered down from the château to walk her grandmother Mary's serpentine paths by herself, but other times, smiling and carrying on, she would entertain Uncle Gifford's young forestry students hard at work in the woods. In 1912, a year before Mary died, she wrote Amos, concerned about his eight-year-old daughter: "You are going to have your hands full with that bewitching little coquette of yours. I'm afraid she is going to be too fond of attention—especially from men—to whom she is irresistible, and probably will be. Her flirtations with the foresters are amusing now—but she will soon be getting too [fond] of their admiration."

There were no neighboring children to play with at Grey Towers, so typical childhood summers for Rosamond meant tinkering and dithering with her brother, Gifford. One summer when she was nine, an argument spun out of control. Over lunch, the two siblings engaged each other in a debate over the stained-glass windows in Milford's little church that quickly escalated into war. Rosamond insisted the windows

Gertrude Minturn Pinchot by S. D'Ora

Amos Pinchot

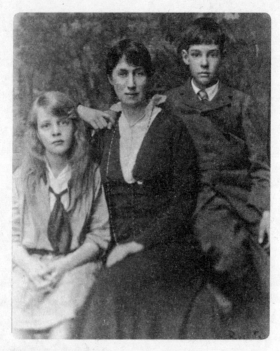

Rosamond, her mother, Getrude Minturn Pinchot, and her brother, Gifford Pinchot

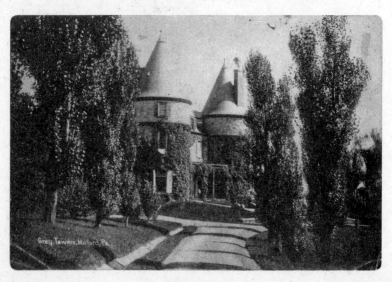

Grey Towers

were "BEAU-tiful," while Gifford said they were not. A relative looking after the children took Gifford's side in the matter; Rosamond, seeing no respite from the agony of her opinions, made hellacious noises as she seethed, hissed, and sputtered. Hurling evil looks over her shoulder like a little blond Medusa, she sped off into the woods, announcing that she wouldn't be back anytime soon. Some hours later she emerged, calm and dignified, only to be apprehended by the butler, who carried her directly to her room.

In June of 1926, after the final performance of *Pardon My Glove,* summer was at its peak and the woods around Milford were the best refuge that Rosamond could imagine. She drove out to Grey Towers feeling liberated. In her rearview mirror, the skyline of Manhattan faded over the Meadowlands. Cinderella was in abeyance. She didn't care what Cukor said; she knew she hadn't put on a stellar performance. It was one of the longest days of the year, so she made the best use of the summer sun, wandering through the remnants of a Civil War landscape above Grey Towers and remembering her childhood. Like the best of friends, her childhood landscape invited her into a conversation with herself:

All ugliness, all hurry, all heat seemed so far away. I feel happier than at any time in months. As I write this I am lying naked taking a sunbath in a little clearing in the woods. The year is at its height. The trees and the grass are fresh and unburned. The air smells of the warm ground. Oh if only I could express the delight of this summer day! I went over the hill back of the camp and came to the edge of the woods. There was a stone wall and a lot of old lilac trees. Once there must have been a house. Below the woods were very green…down the road is a beautiful spring full of water plants. Yesterday there was a medium sized bullfrog in it and I teased him by tickling his eyes with a blade of grass. It was hot so I took off all my clothes. What a marvelous feeling! I ran around the meadow like a horse, jumping over azaleas and watching my shadow. It was risky but I didn't care. I started off to the woods. The wind and sun were warm

and I ran along. There was a chance of meeting someone but that didn't make any difference.

Grown up now, she still preferred having the woods to herself. She'd wander for a while, then, beneath a perfect parting of the canopy where the sun was warm and bright, she'd strip off her clothes and prance about the forests in the nude. Sometimes she'd sprawl out beside a rock to daydream or curl up in the leaves like a nesting bird or lie down atop the cool duff to take a nap. Then, rested and warm, she'd rise, as if from a dream, to a world that seemed brand-new. She was refreshed by the glow of the sun. "Sleep," she wrote, "is the secret of happiness." And sleep in the woods beat back the blues in twenty minutes, cut down on the volatility, and stemmed the Cinderella longing. A clearing in the woods was a beauty session.

With the encouragement of Mrs. Witt, in the summer of 1926, Rosamond decided to take a hiatus from New York and fashioned a plan to go west. Characteristically, her mother was unsupportive and her father was supportive; but her parents knew she didn't need their support. Rosamond knew exactly what she was going to do. Gertrude thought her daughter's decisions were frequently made in haste, but hasty or not, Rosamond had navigated Vienna, Berlin, Salzburg, Syracuse, and Cleveland, so California seemed like a reasonable destination for an unescorted twenty-one-year-old.

Before she left New York for San Francisco by train, Rosamond played an odd little game with herself. She had squirreled away $10,000, like a ruthless bank teller, but she took only $263 with no way of getting more. She told people that she was going to California to work and take in the scenery but what she didn't tell them was that she planned to force herself to survive without her family, her name, or her bank account. She wrote in her diary, "I have no idea how long I will be gone or what I am going to do." What she did was change her name to Rosamond Peters, a "gentlewoman in reduced circumstances."

Rosamond Peters arrived by train in San Francisco on July 27, 1926, and checked into the YWCA. The next day, she scanned the papers for an apartment and a job. Several days after arriving she wrote:

Saturday July 31, 1926

At last I have done some real work. This afternoon after coming home from downtown, I got desperate and decided that it was time that I took advantage of my opportunities there and really do something besides pose as a gentle-woman in reduced circumstances. So I put on the pink cotton dress that I had bought for $2.98 in Rochester, an old pair of shoes and my shabby blue coat. Then I fixed my hair in points the way all the girls do here, and I put on my hideous little straw hat over my eye. When I was dressed I felt very sure that no one would be surprised or interested in anything I might do. I looked awful, particularly when I slumped over in the approved fashion. Once dressed I went out and took the Fillmore streetcar. I had seen an advertisement of the California Canneries so I went in and asked for a job. Crowds of women were everywhere. I asked for the head floor lady and finally found her among a crowd of women that were cutting fruit at a long table. I expected to be told there was nothing; one is always told that it seems. But this time it was different. She was such a nice woman, Mrs. Mabri. She asked me if I had had experience and I of course said I had. Then she asked me if I wanted to can that night. I answered yes....

Rosamond found undercover work as a peeler with Armenians on the peach line. She rented a cheerful yellow room with green-blue trim in a boardinghouse on Jackson Street with two interior decorators. She took shorthand and typing because she thought it would help her become more efficient. It was time she bought a car, so she loosened up the purse strings and bought an ancient Buick. On the weekends, she toured California, with its gleaming freshness and fecund countryside of oranges, tangerines, and dates. During breaks on the packing line, the Armenians wanted to find her a husband. Her fine rolled stockings attracted attention. Before her coworkers noticed one more thing that didn't add up, she quit, scanned the papers again, jumped in the Buick, and signed up as a photographer's assistant for $14 a week in Los Angeles. She didn't know anyone in Los Angeles and didn't want to. She wrote that she was "fleeing from the horrors of George Cukor's Rochester stock company." A Rolleiflex became her constant companion and she spent her weekends

spinning through the blues and golds of California, through canyons of dry, crackling live oaks, between the vast coastal range and miles and miles of ocean. Landscape reconnaissance was lonely, but at last, she could hear herself think. California's cities were white and clean and fresh. "I loved the abundance of California," she wrote, but "there was not much that was beautiful where people had been."

She wrote little during her trip west, but the press filled in the gaps. Reporters, curious about her mysterious wanderings from one end of California to the other, soon discovered her swimming in the Bay and loafing with the locals in the Imperial Valley. Times Wide World Photos tracked her to the University of California at Berkeley where they reported that she'd enrolled as a special student of English and psychology. It wasn't entirely true, she was only taking a class or two, but she was still every bit the celebrity, and an enigmatic one at that. When she'd registered at Berkeley, word got out she was on campus, and, according to news accounts, more than one hundred students enrolled in her English class just to see her. The teacher announced that he was glad for the increased enrollment, but several days later, her appearance caused pandemonium and the class was canceled.

For the better part of six months, Rosamond cruised California in her Buick, dressing in overalls and dodging the press. Her friend George Cukor telegrammed from Rochester in August that he hoped she was happy in her new role as the "Girl of the Golden West." He wrote, "You are sorely missed in this little city of homes, but let us dream true . . . and remember noblesse oblige." What Cukor meant was that she could vagabond about and catch her breath, but in time, she'd remember where she came from. If you were a Pinchot, you plunged into the forest to get the blues out of your system, but then you emerged to do the people's work. James Wallace Pinchot, Rosamond's grandfather, spent a year on horseback in the southern woods to recover from entrepreneurial overexuberance as a purveyor of dry goods in New York. His doctors referred to his treatment as the "naturalist's cure." But when Rosamond went west, the only prescription she had was her own. Her diagnosis was the Cinderella complex, so she went undercover and made believe there was no way back.

After *The Miracle,* she couldn't go back. Not to bit parts or to play stock in Cukor's little cities of homes. In 1926, few people had heard of George Cukor, but everyone knew Rosamond Pinchot and that, for a while at least, she'd fled. The actor's cure had taken her to a spectacular landscape of exotic fruits and vibrant people with their maps and their cars. They had all moved on from somewhere and she wasn't the only one changing her name and pretending to be someone they weren't. Everything about the place was transient, shifting. California had what topographers call ample prospect and encouraged a liveliness in a person, so finding no refuge, her world opened up instead.

She wrote that she was on a great adventure. In November 1926, she went to hear the British social reformer and mystic Annie Besant speak in San Francisco. Besant was a lightning rod, a contemporary of Gifford's, Amos's, and Cornelia's, and shared elements of their progressive thinking. She had married and divorced a minister of the Church of England, become an atheist, and written a tract advocating birth control for which she was charged with selling "obscene literature" but never prosecuted. Besant had allied herself with the theosophy movement, become a scholar of mysticism and Eastern spirituality, translated the *Bhagavad-Gita,* and written books on yoga, but the subject that night was reincarnation and the existence of the soul:

An interesting, yet somehow ridiculous evening. I went to hear Annie Besant speak on reincarnation. To me her arguments were foolish and unconvincing. It always seems absurd when anyone speaks with authority on the future existence of the soul. There cannot be any definite data on which to base it. She spoke of the gradual progression of human beings from the lowest stage as represented by the savage or criminal to the highest as represented by the successful man, the leader. She made no effort to explain why man should have to start in sin and horror. Plants do not. She spoke of reincarnation as the only hopeful philosophy. But what is the use of living for the next incarnation if you are never able to recognize it or personally enjoy it. I would far rather feel that I became just a part of the world like a dead leaf, than return here to fight this battle again.

While discussions of reincarnation and the afterlife were all the rage at the time, Rosamond was unconvinced, though she had to admit to a certain curiosity perhaps because of Uncle Gifford's interest in the occult. While commissioned to design the nation's first experimental forest for George Vanderbilt at Biltmore, Gifford, then in his twenties, met and fell in love with a young Chicago woman named Laura Houghteling who had succumbed to tuberculosis. After Laura's death, Uncle Gifford pined for his love for twenty years, carrying on conversations with Laura as if she were still in the room, even consulting with her before giving speeches on the floor of the United States Senate. Gifford kept George Perkins Marsh's *Man and Nature* by his bedside, but his library included treatises on the afterlife and spirits. Rosamond and her mother practiced yoga, but their yoga practice was by no means a spiritual endeavor. When Rosamond stood on her head, she'd prop herself up in the middle of the lawn and think about Uncle Gifford's obsession with insects, how people looked so unattractive upside down and whether if she fell asleep, she'd fall or if, like a cow, she could train herself to sleep standing up, only upside down.

While "Rosamond Peters" was exploring California, peeling peaches, dodging the press, questioning reincarnation, and doubting the existence of the soul, Morris Gest was sharpening his pencil. *The Miracle* was crisscrossing the United States and Gest wasn't tied to any particular Nun when the play reached the coast. He knew that Rosamond was floating around in various states of anonymity because he kept tabs on her in the press. Everyone did, but Morris Gest had a vital reason to; he had lost his blueblood cachet when Rosamond left the cast in a huff, and that wasn't good for anyone. She'd disappeared into the woodwork, the woods, or somewhere, and who knew what she was doing. Morris Gest was determined to find out.

One night, while still living in San Francisco, Rosamond returned to her green and yellow room after work. Wandering down the hall that night, she struck up a conversation with her neighbor Miss Buchanan, an Australian nurse. The conversation turned to women's hopes and dreams when the nurse said, "There is one thing I am looking forward to, the time when *The Miracle* comes out here." Rosamond's heart leapt. "I have the book of *The Miracle* here," said Miss Buchanan as she looked among

some papers and brought out the souvenir book of the play. Rosamond tried to stay calm. The nurse handed her the book and together they looked at the photographs of Lady Diana Manners as the Madonna, and Rosamond as the Nun, lying at her feet. Rosamond was dying to tell Miss Buchanan that it was she who had played the Nun. Rosamond wrote, "I wanted to kiss the paper, to cry, but I did nothing." There was Reinhardt, the cathedral, the evil piper, even Gest, and all the rest that she knew so well. In a little boardinghouse three thousand miles from home, the nurse reminded her of *The Miracle,* the play she went west to forget. It felt so strange, she wrote, as though it was all part of another lifetime.

That fall, Morris Gest sent Rosamond a "peace offering," a pale gold shawl to drape over her blond locks to make her look as pious as a nun. Gest "helped" the San Francisco paper scoop the latest installment of their public estrangement:

CANNOT STAY OUT OF PLAY, WOULD HAVE NONE OF THE NUN
But Now Pretty Heiress Will Try Role Again To Please Gest.

Rosamond was reported to have made up with Gest, explaining, "You see I feel like I owe him a debt of gratitude. He's a marvelous man and I was entirely wrong when we quarreled in New York two years ago."

The article went on to disclose the reason:

Miss Pinchot referred to the day she spurned Gest's $1000 a week salary and broke the contract which would have taken her on the American tour with *The Miracle.* Youthful, vivacious, she became bored with the famous title role and wanted adventure—so, characteristically she walked out on the producer.

The press could say what it wanted, but the deal breaker wasn't the salary; the deal breaker was Morris Gest.

Through the first few months of 1927, Rosamond stayed on to play the Nun in Los Angeles, also playing the role of Hippolyta in Reinhardt's

A Midsummer Night's Dream. After what had been a longer than antici-
pated actor's cure, she returned to Europe that summer for another en-
gagement of *The Miracle* in Salzburg and Dortmund, Prussia, where she
twisted her ankle during the performance and completed her marathon
of parts to a standing ovation. She also played *A Midsummer Night's Dream*
at the Salzburg Festival, this time in the role of Helena. Finally, she re-
turned to New York that fall, ready to resume the life she had had when
she'd dropped *The Miracle* to go west. It was as if finally she'd come out of
the forest, serene, and knowing that the world had its places that soothed
her and made her a better person, a calmer person, confident but more
kind.

Nineteen twenty-seven was a year of firsts. In March, the world held its
breath between Charles Lindbergh's takeoff in New York and his suc-
cessful landing in Paris. In April, for the first time ever, television was
displayed before a live studio audience at the Bell Telephone Building in
New York City. That fall, in October, Rosamond turned twenty-three
years old, and in December, the Ford Motor Company retooled its as-
sembly line and rolled out the first Model A, the successor to its popular
Model T.

While Rosamond was in California and Europe, she kept in fleeting
contact with Big Bill, but it had been almost two years since they'd first
met at the Beaux Arts Ball. Since she'd been away, Big Bill had had
quite a time of it. In January 1927, the critics torpedoed his play *Damn
the Tears,* calling it *Damn the Sneers* and "young Gaston's first gasping ef-
fort." But that damning evidently did not go far enough. They also
called his play a "conglomerate and heterogeneous mess." Poor Bill
went into something of a tailspin when Burton Davis of the *Telegraph*
wrote that he was utterly bewildered by the story of the peculiar and
brilliant young law student who came out of a family wrangle writing
poetry and unable to adapt himself to life. While Davis appreciated the
stagecraft, particularly the strange, leaning structures of Norman Bel
Geddes, whom he described as the good fairy of all unusual drama, he
still couldn't fathom the play: "As a piece of literature," he wrote, "I

have a suspicion that Mr. Gaston's work might be worth reading. As a piece of stagecraft it drove about one third of its friendly first night audience, by twos and fours and half dozens, out into the ugly sanities of thirty-fifth street."

Big Bill didn't pay much attention to the papers after that. The critics would say whatever they wanted to say and he couldn't do a damn thing about it. He knew how the publicity machine worked. If you didn't have a Gest, a Shuman, or a Belasco on your side, you might as well forget it. He'd still keep writing his plays and maybe next time he'd get the breaks like Rosamond had. Perhaps next time someone would understand him and what he was trying to say—if there was a next time.

When Rosamond returned from Salzburg that fall, she was only back for three months before the newspapers had something more pleasant to report. No one knew exactly how long plans had been in the works or how two public figures had managed to escape the eye of the camera or the ear of the press. On January 26, 1928, Rosamond, twenty-three years old, married Big Bill Gaston, thirty, in a secret ceremony in the parsonage of the First Baptist Church in West Chester, Pennsylvania. There were no eyewitnesses, but the coverage was juicy nonetheless:

> The social world of Philadelphia, New York and Boston would have been keenly interested in the little group that disembarked at West Philadelphia station on the 3 o'clock train from New York but not even a porter paid them any attention. . . . Miss Rosamond Pinchot, niece of former Governor Gifford Pinchot, who went from stage stardom to a job in a California canning factory and back to stage acclaim in the space of a few years, used Philadelphia as a jumping off place yesterday on her way to be married—a wedding she tried to keep a deep dark secret, but without success. Accompanied by her father and mother, Amos Pinchot and Mrs. Minturn Pinchot, who are divorced, but who allowed themselves to be reunited for the afternoon, she hastened out to West Chester from whence she departed an hour or so later as the bride of William Gaston, 2nd, lawyer by profession, playwright by choice, and a member of one of

Massachusetts oldest and most socially elect families by right of birth.

It was the sporting Rosamond, the Rosamond who wore no rings or jewelry, who wed Big Bill on January 26 in her light blue traveling suit. She dispensed with all the white dress business and dressed as a modern bride. She didn't tell others why she'd married Big Bill; she knew what she was doing. He was the best-looking man she'd ever laid eyes on. He had his plays, his boats and his gardens, and the things he cared about. He knew so much about the world and came from a long line of people who had opinions, the way she did, people who dissected the angles of right and wrong, but then they laughed about it, knowing they could be entirely wrong about what was right. As for the formalities, neither was hell-bent on extravagance. As for the "ceremony," they were in and out in less than an hour. One article noted that Rosamond "married without any particular fuss, she detests ceremonies."

Big Bill's mother, the impressive May Lockwood Gaston, came down from Boston to serve as a witness before the couple departed for Canada on their honeymoon. Apparently she wasn't in the mood for a particular fuss, either. Her husband, "The Colonel" William Gaston, had died of cancer unexpectedly in July at their columned manse in Barre, Massachusetts, known as Killingley Farm. Unhappily, Big Bill and his father had never made peace before he died. The Colonel thought he'd given his first son everything he needed for a good start in life. Big Bill had received the law degree at Harvard, the family's alma mater, and become assistant district attorney in Boston; but then he'd blown it when he dropped the law to write plays. Big Bill had hardly been the pillar of rectitude in an old Boston family. The Colonel's father, William Gaston, had set the standard and done right by the alma mater; he'd been the mayor of Boston, twice. He'd been elected to both houses of the legislature. In 1875, he'd served as the twenty-ninth governor of Massachusetts. He'd been the one to embed the owl and the logo on the Gaston family crest, which read "Fama

Semper Vivit," Fame Lives Forever. Bill's becoming a playwright and a man-about-town wasn't exactly the type of fame the governor or the Colonel had in mind.

Like the governor, the Colonel was a man's man. He had been a wrestler and a runner and played baseball for the Crimson. He'd been Harvard's champion middle-weight boxer, besting the redoubtable Ramon Guiteras in three ten-minute rounds and, to top it all off, had taken on his classmate Theodore Roosevelt and trounced him on the same day. The Colonel was a lawyer and a banker and a member of the Board of Overseers at Harvard, the Massachusetts Horticultural Society, and Trinity Church. In 1887, he had been responsible for the financial reorganization of Boston's elevated railway and at the same time established what was at the time the highest wage scale for transit employees in the history of the United States. Following World War I, he was appointed by the U.S. government to arbitrate labor disputes in Hartford, Connecticut, and Bath, Maine, and had served on the staff of Governor William Eustis Russell. It seemed that the Colonel's only defeats in life had been political, when he'd run for governor three times and for senator in 1922 against Henry Cabot Lodge and lost by a mere 7,350 votes.

No, the Colonel didn't want to see the Gaston family crest adorning the pages of Big Bill's curriculum vitae, even if he'd had one. The colonel had gotten wind of the fact that Big Bill was running around with the actress Kay Francis, but, like most people, he didn't know they had secretly married and divorced. His son's first attempt at Broadway hadn't just been an embarrassment, some said it had been a not-so-veiled commentary on him and his legendary relationship with the bottle. The last straw was when the Colonel learned that Big Bill had become a part owner of a speakeasy at 21 West Fifty-second Street. At that point, the Colonel had had about enough and made damn sure Big Bill felt it where it hurt. Big Bill wouldn't see much of his father's $7 million after he died. Big Bill was, for all practical purposes, disinherited. The vast wealth, most of it in stock, and the estates in North Haven, Maine, Barre, and Boston went to his brother, John, and two sisters, Hope and

Ruth. If fame lives forever in the Gaston family, Big Bill wasn't going to keep it alive by practicing the law, and he couldn't count on inheriting the fabulous wealth his siblings had. He'd find another way to keep the fame, if not the spirit, alive.

It seems as though Big Bill had already gotten something of a head start at fame, if not infamy, when he'd married Kay Francis and set up house in his Harvard dorm room. It is said that you never really know whom you are marrying. According to Big Bill, he and Kay had never really lived together because the dorm room didn't count. From the way Bill described it, they had not really been married either. The Pinchots had socialized with Kay Francis, liked her, so when they heard about Kay and Bill's marriage in the papers the day after Rosamond was married, they were surprised. But they could understand how Kay, a self-made woman who was used to having things her way, would also want to have her way with a dashing young law student at Harvard, even if it meant setting up house in a dorm room.

Big Bill at Harvard, 1919

Big Bill and Kay Francis made sure the ending of their relationship was about as ambiguous as the beginning. Just a month before Rosamond and Bill were married, Kay noted again in shorthand, "Bill said he might marry me again, only it would be the same thing all over *again*. Also that he hoped to sleep with me sometime again." Three nights before Rosamond and Bill married, Kay and Big Bill met at her home, went out to dinner and she recalled, "Talk of him marrying RP." Kay Francis knew that Billy G. was having one very good time with RP, but the talk of marriage was only talk and it wasn't a bad idea to keep the door open. Big Bill wasn't good husband material but he made a damn good date.

In the morning of their marriage, Bill and Rosamond were optimistic. He'd married the woman who'd been called the "Loveliest Woman in America" by the celebrated British poet, actress, and adventuress Viola Tree. Rosamond had married the most compelling man she'd ever met. They had a future together. Cinderella was in remission and Big Bill made her laugh. The papers reported that he planned to continue his law practice, although he was actually working on his plays; they reported that she would keep her career as a stage actress, although she quietly longed for a new direction, like volunteering for charity and political work. If she was to go back into the theater, she thought, it would be in production, if at all. She and Bill had a full life. They shared books, the theater, and music. They teased each other and penned little nicknames. He was Devil McNasty and she was the Biche. The sidewalks were hot with the sounds of Bessie Smith in Harlem singing "Mean Old Bedbug Blues," and the Gershwins at Town Hall playing "Strike Up the Band." Nineteen twenty-eight was Broadway's busiest year to date with at least fifty musical productions, and Wall Street was surging because everyone was buying stock.

Bill and Rosamond were in the news, playing host at elaborate dinner parties for the notable and the notorious. Rosamond chaired charity events with the Hamiltons and the Harrimans and the Hearsts and the Krocks. Bill and she had a marvelous apartment on East Fifty-seventh Street, with a location their friend Dorothy Parker described,

like so many others, as being "way over by the river, so far east I'm thinking of planting tea." They employed two gracious Japanese cooks, the Watanabis, who prepared fine meals, and dispensed with the annoyances of city life. They lived on the roof in the summer, the Biche in her bathing suit and McNasty with his feet propped on the parapet and a crystal tumbler of his favorite vodka. They'd carry on with their flirtations deep into the night, and as the traffic died down, they'd take their murmurings into the bedroom where they, too, quieted down and shared the sensual results of all that sparring. The next morning, they went their separate ways as any couple would. Rosamond buzzed over to Grey Towers. During the day, Bill went off to some office or other, pur-

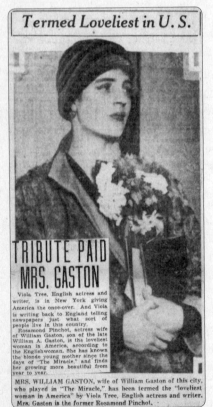

Termed Loveliest in U. S.

TRIBUTE PAID MRS. GASTON

Viola Tree, English actress and writer, is in New York giving America the once-over. And Viola is writing back to England telling newspapers just what sort of people live in this country. Rosamond Pinchot, actress wife of William Gaston, son of the late William A. Gaston, is the loveliest woman in America, according to the Englishwoman. She has known the blonde young mother since the days of "The Miracle," and finds her growing more beautiful from year to year.

MRS. WILLIAM GASTON, wife of William Gaston of this city, who played in "The Miracle," has been termed the "loveliest woman in America" by Viola Tree, English actress and writer. Mrs. Gaston is the former Rosamond Pinchot.

Newspaper clipping, source unknown

suing part-time projects in banking and the law. But in that first summer, Bill spent most of his time at Crotch Island, Maine, where he had begun to bring his plan to life. The house on Crotch Island would be the escape of his dreams, in the landscape he loved, near North Haven, where he'd grown up in the summers. With the help of his local architect and laborers from the surrounding islands, he began building a cabin of spruce from the island. But this was no ordinary log cabin. Half the first floor would function as a stage, where curtains could be drawn at night. The house looked west over the steel blue waters of Penobscot Bay, toward the mainland, the blue hills of Camden, and Mount Megunticook.

But there was a lot more to their lives than their private happiness. Like many prominent New Yorkers, Rosamond gave money, time, and her used coats to help the less fortunate. She focused her efforts on the New York Association for the Blind; the Salvation Army; Faith House, which trained young girls who were unmarried mothers; and the Halton Fund, which benefited single working girls who had no medical treatment. Like many an Upper East Side woman of privilege, Rosamond was everywhere and involved in everything. She hadn't followed the prescribed order when she chose *The Miracle* over a debutante party or revoked the stage for the peach line, but now she was back where she belonged, married and about to give birth.

William Alexander Gaston was born at Miss Lippincott's Sanitarium on January 5, 1929. In photographs, Little Billy is surrounded by doting Gastons and Pinchots, beaming from the benefits of coddling. In the photos, it appears that Big Bill was an enthusiastic father to his firstborn son. Meanwhile, Rosamond, the proud young mother, never looked happier than she did holding the little boy she called "Mow." He was a lively, good-looking infant, but then this was a very good-looking couple, an unstoppable couple that, from the looks of things, would give everything they had to give to their firstborn son.

After Little Billy was born, Big Bill and Rosamond resumed their busy lives. He went back to work on the island house that spring; Rosamond bounded back and forth between Milford and New York while still managing to squeeze in a trip to Corsica in July. As usual, the public

Rosamond and Little Billy, 1930

was curious about her travels and where she was off to next. On the docks of lower Manhattan, she answered reporters, "Rockland, Maine!" where she would "rejoin her husband and her young son." But she reminded them that she intended to keep up her career and planned to take a test for the talkies soon. On August 3, 1929, just a few days after returning on the *Conti Grande,* she appeared in a colorful advertisement in the *Literary Digest* for an elegant convertible roadster, in which she was identified as "among the distinguished women who drive the New Century Hupmobile." The advertisement read:

She adores horses, motor cars, and motor boats . . . Peel of London makes her riding boots and Nardi her habits . . . Her favorite luncheon place is the Voisin where she always has a certain corner table . . . they know her in Vienna, Prague, Salzburg, New York, and

points west as the Nun in *The Miracle*. And all over Europe as a member of Max Reinhardt's Repertory company . . . she shuttles between New York and an island off the coast of Maine by train, car and speedboat . . . Her personal car is Hupmobile. She drives it herself. One admiring Westchester motor cop has said . . . And how!

In the six years since she had met Max Reinhardt onboard the *Aquitania,* Rosamond Pinchot, the young woman who had once envisioned a career in the outdoors, became Rosamond Pinchot Gaston, actress, wife, and mother. She was also a woman of the future, a woman with unrepentant mobility. That's what her audiences wanted to know, that Rosamond Pinchot was unstoppable, not just in her new Century Hupmobile, but in her life. It was all so hopeful, how she'd burst from childhood through youth and onto the stage of adulthood with an identity that Reinhardt had ascribed to a kind of deliverance. Providence, he called it, and those who knew her were certain there'd be a fine second act.

THE LANDSCAPE OF MEMORY

I suspect that most Americans are lost. I believe we each belong to a patch of ground close to where we started, where we breathed in our first scent of roses or hint of mint, but we usually end up miles, if not continents, away. I've been curious why people live where they do, so, wanting to get to the bottom of things, I've conducted an unscientific survey to uncover the reasons: Do you feel like you belong here? If not, where do you belong? Do you ever feel lost where you live or uneasy? Do you long to go back to where you were born? If you could, would you go back there? And if not, where would you go?

Most people's lives are determined by other people. Mine has been determined by landscape. My faith lies in geography. Where I was born, where I have been, and the nature of those places, has shaped and colored my life. In those places I met this person, not that; I navigated this trail, not that. I decided to become friendly with places. I oriented myself by topography and the cardinal points. When I didn't know whom I was with, at least I knew where I was and that's when it didn't really matter where I went.

In the fall of 1991, I moved to Seattle and became interested in the use of memory as a design tool. I grew up in the East, so the West was disorienting, and like many people who pick up and go somewhere else, I was under the spell of the past. I missed the four seasons and the cities with parks that couldn't be sold to a developer. I longed for old estates where blue-haired ladies sat behind rickety desks with their tickets and their straw donation baskets just waiting to tell me a story. Something in

my eyes told them I was like them, daydreaming of the exquisite: the ellipse garden at Dumbarton Oaks, the Monets at the Hillstead Museum, the Court of the Lions at the Alhambra—places they'd visited on great big buses, got out, walked around and mingled with ghosts.

It wasn't that the West didn't have old buildings or a brief, interesting history; it just seemed to me that while people knew how they'd come west, they couldn't tell me why—it didn't seem that they appreciated the West or even knew it. One time, I unleashed my unscientific survey and learned that a person lived where he did because that's where his car died, so he stayed. Thankfully the car died in a spectacular location, so he said that Providence had led him there. If the place had been a hellish cow town, he likely would have blamed the car. Wanting to believe our hearts are moved to live where we do, and that where we live is a matter of choice not circumstance, I longed for a different answer: that someone shed a tear over the view of snow-tipped mountains from downtown Seattle or found his or her true self fishing for steelhead on the Deschutes. One spring night, he or she noticed the sweet scent of the prairie and whispered, "I'm home now." Instead, I found the West to be a corridor, a flight path to somewhere else.

In the fall of 1991, while teaching landscape architecture at the University of Washington in Seattle, I gave my students an exercise in remembering. Between student loans, jobs, and classes, they barely had time to consider where they belonged, so I made my first assignment friendly and titled it the "Landscape of Memory." I asked them to return to a place they remembered in childhood and to depict, in their choice of media, the landscape that meant the most to them. The project was part design, part sensitivity training with a dose of activism. I believed that half the battle was to discourage fledgling landscape architects from falling prey to developers who were all too eager to rid a site of what landscape philosophers call the "spirit of place." The spirit sometimes inhabited the forgotten corners of a site, like an old wild meadow of native grasses, a dank, mossy seep, or the perfect snake habitat in a crumbling wall. Architects are trained to anticipate the worst, so I feared that my students would cave in to the arguments I'd caved in to in my first job when the client wanted to eliminate a tiny pond at the entrance to his site and erect a quasi–Roman bath he called an entrance statement. He asked me, "Can't we just build a water feature and get rid of the one that's real but really messy?"

As it turned out, I was surprised and pleased by my students' multimedia presentations. Navigating their journeys into the past, each discovered that a beautiful story waited for them. The place they selected held the keys to who they were and who they would become. Invariably, the place had several features—a shelter or enclosure, a body

of water, and a friend who accompanied them on the journey. As the students told their stories, it became apparent that their memories were clear, but each expressed varying degrees of grief that their childhood landscape had vanished. I'll never forget one student whose memory of landscape wasn't like the rest but was every bit as relevant to the loss of landscape memory as to the loss of the landscape itself. He and his companion had grown up playing beneath an overpass where a drainage pipe fed a mud puddle.

It takes one afternoon with a backhoe to dismantle the spirit of place. It takes a generation to lose a sense of belonging. My loss, like most, was tied to a series of ruptures that tore the fabric of family. While I was touring the country restoring places and teaching students to deepen their connection to the landscape, I had lost my own. I didn't feel an allegiance to this place or that. I wanted to rescue them all from anonymity, dishevelment, and destruction.

One photograph can jar the memory from the comfort of forgetting. Like the one taken on a spring evening in 1931, when Governor Gifford Pinchot and his wife, Cornelia, sat down together on a comfortable sofa in the living room at Grey Towers with their two-year-old great-nephew, Little Billy Gaston, son of Rosamond and Big Bill, to read him a book. Behind them stood a Tang Dynasty sculpture of a rearing camel, and, in front, a huge dog nuzzled at the governor to get his attention. Dressed in corduroys, a slightly rumpled jacket, and a paisley tie, the governor brought his reading to the sofa that evening and was just taking off his glasses, when he looked up with a kindly gaze into the lens of a camera. Paying no attention to the photographer, Cornelia and Little Billy huddled together reading from an oversized volume of Grimm's Fairy Tales.

Of all the photographs I'd found of my father's well-documented childhood, that one fascinated me the most. I scoured everything in it—the lamps, the books, the jugs, and the rearing camel—thinking something lurked in the scene. I thought I would discover a sign of what was to come or evidence of something that had been missed, but I couldn't find anything. It was a photograph of a child of privilege with his famous family in a French castle above the Delaware River, surrounded by a beautiful hemlock forest with crashing waterfalls, walking paths, fields and flowers, and animals to play with. The whole story seemed idyllic. Much later, what struck me about the photograph wasn't what was in it, but who wasn't.

When the photograph was taken, Governor Gifford Pinchot had just been elected to a second term and there were few signs of hope in a deepening depression. In 1931, the construction of the Empire State Building, designed to look like a pencil, was completed

Governor Gifford Pinchot, Cornelia Pinchot, and Little Billy

with steel from Pennsylvania steel mills. With a staggering height of 1,250 feet, it became the world's tallest building. Construction of the George Washington Bridge, then known as the Hudson River Bridge, connecting New Jersey and New York, was under way. With a span of 3,400 feet, it was double that of the previous record holder for length. But despite these great civic works and the jobs they created, almost a million people were unemployed in Pennsylvania alone, and the governor himself decided to donate one quarter of his annual salary to relief efforts. Released prisoners voluntarily returned to prison to avoid life outside the penitentiary; many Pennsylvanians were living on roots and grasses, and one woman was fined $17.90 for killing a woodpecker to feed her children.

In 2004, almost thirteen years after teaching students to remember their childhood landscapes, I began the journey back to discover my own. I remembered what the Zen poet Gary Snyder wrote in The Practice of the Wild: *how each of us has a map inscribed in the brain where the elders once sat by the fireside and told us stories of the tribe, the land, the fish, the water, and the birds. In my peripatetic existence, I'd learned a lot about the natural world, but not from the elders who told stories by the*

fireside. I had lived in more than a dozen cities in the East and a handful in the West, not knowing I was searching for a place I had been taken to when I was four years old, behind Grey Towers, where my ancestors spent their summers and where Gifford, Amos, and Rosamond taught my father to swim and fish as a child.

LITTLE BILLY'S FIRST SUMMER, 1929

In June 1929, when Little Billy was just six months old, Rosamond decided it was time to take him for a spin. She sat him down beside her on the passenger seat of her bright green car she called "the Grasshopper" and headed east through the Holland Tunnel and over the grassy marshlands of northern New Jersey. She passed through rural hamlets, fields, farms, and openings before reaching the mixed deciduous forest that cloaked the Kittatinny Ridge. Crossing the Delaware River, she noticed how the landscape shifted, and in that crossing, a certain wildness took hold. She thought it was on account of the vegetation or the topography, but whatever it was, she imagined Little Billy would appreciate a dose of wildness in his first summer of life on earth.

Little Billy

At Grey Towers, Little Billy was the center of attention. In the summer of 1929, his great-uncle Gifford was no longer the chief of the United States Forest Service. Between his first and second terms as governor of Pennsylvania, he and Aunt Cornelia and their son, Gifford, had just set sail on a nine-month scientific expedition aboard their schooner, the *Mary Pinchot,* to explore the South Pacific, which meant that Grey Towers was quieter than usual that year. Still, the Pinchots' "summer castle" was a very busy place, teeming with politicians, artists, writers, bankers, and businessmen who flew in and out to speak with Little Billy's grandfather, Amos. Even in the quiet times, the grounds were frequented by family, including aunts, uncles, cousins, and governesses who fussed and fiddled over Little Billy. When she came out from the city, his mother, Rosamond, added to his crowd of admirers by bringing her theatrical friends with her. They hovered around inhaling the scenery and fawned over its adorable new addition. And to the little addition's amusement, a parrot named Oscar flew into the front foyer of the château every night and slept sprawled out on the floor. When Little Billy's grandfather Amos wasn't sparring with his political opponents or entertaining the literary and business lights of the day, he carried his grandson down through the forest and pointed to the wily brown trout in the dark pools of Sawkill Creek. Uncle Gifford's foresters still surveilled the grounds, checking on the diameter of trees, and in his absence, recited the botanical names of insects, correctly pronounced and spelled so that Little Billy got the right start—the Pinchot start, an education in the natural world.

Grey Towers was a sight to behold. Designed by the premier architect of the day, Richard Morris Hunt, the estate sat high on a hill between the Delaware River, Sawkill Creek, and the Pocono Mountains, just outside the small town of Milford, in Pike County, in the northeastern corner of Pennsylvania. Amid the fields, forests, and rivers of Grey Towers sat several old farmsteads with families who had been there since before the Civil War. With thousands of acres of remarkable scenery and opportunities for fishing, riding, and swimming, it provided the perfect bucolic retreat. Located just an hour and a half drive from New York City and three hours from Philadelphia, the estate also served as a great backup babysitter for the loveliest son of the loveliest ingenue on the go.

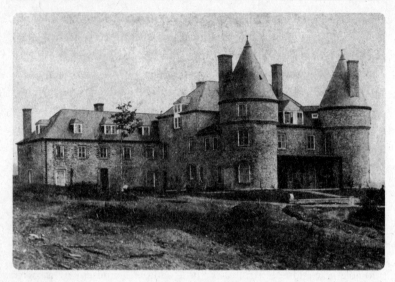

Grey Towers, circa 1883

Constructed in 1886, the château and its allied structures took advantage of commanding views to the east, over the Delaware River to the Kittatinny Ridge, and over parts of New York, New Jersey, and Pennsylvania. In the days of Little Billy's great-grandparents, James and Mary Pinchot, it offered a bird's-eye view of little Milford below. The grounds included a carriage house, an ice house, a stable, gardeners' cottages, and the Forester's Cottage, a summer schoolhouse built by James Pinchot and endowed as a classroom for the Yale School of Forestry in 1900. There was a handsome new swimming pool and a tennis court and the remnants of the School of Forestry's summer camp off in the woods where, up until 1926, fifty Yale students resided in tents each summer, planting their seedlings and measuring the duff. But what most visitors raved about was Aunt Cornelia's Long Garden, which featured a half-moat, a water rill, perennial beds, and various pools. The garden was punctuated by two small classical garden structures, a playroom for her son, Gifford, known as the Bait Box, which terminated the rill, and an office for her husband, Gifford, located beside the central garden axis, known as the Letter Box.

Cornelia Pinchot, Billy's great-aunt, was the self-appointed chief of garden design. Constantly approving changes to the grounds and performing little bits of magic in this corner and that, Cornelia never sat still. When she wasn't the chief of celebrations or running for political office, the grounds drew most of her attention. At the height of the Great Depression, she had a large amphitheater constructed, putting the unemployed of Pennsylvania to work to undo what she called "a huge towered Camelot set on the side of a treeless stony hill, with the usual French dislike of shade, inherited from a Gallic ancestor." When times were flush, she hired noted landscape architects and designers Chester Aldrich, Ellen Biddle Shipman, Rose Standish Nichols, and Elliot Kauff to design the grounds. When the Depression hit, Cornelia weeded and maintained the gardens for the most part by herself, keeping copious notes on her blue-eared Manchurian pheasants and their Grow-All pheasant food, on her three-banded Italian honey bees that came in three-pound packages, her Mount Hood blue columbine and her daffodils, iris, and lilies from the Carolinas.

Cornelia Bryce Pinchot, courtesy of
Grey Towers, USDA Forest Service

There was no more glorious place to be a child than in the garden of the remarkable Cornelia Bryce Pinchot. Often during Little Billy's childhood, Aunt Cornelia offered to take him at Grey Towers because "Tiny" needed a fresh-air escape from Manhattan, and Rosamond needed that vacation to Corsica and no one needed the headache of what might happen to a small child with his father at a construction site fifteen miles off the coast of Maine. So, perched in the turret room of the château like a little owl, Little Billy could watch Cornelia meet with Bottomley, the architect, who'd stand as upright as a board on the terrace below the bust of Lafayette, or with Stroyan, the big strong yard man Cornelia called a "high-grade man," who came with lots of other men to dig things up. She'd point and they'd talk and she'd point again and suddenly the other men who'd been leaning on their shovels would spring to life like little soldiers. Stroyan barked at his men like a drill sergeant and they'd start digging. A new tree was wheeled in from the woods and voilà, magic, the tree looked like it had been there forever.

There were two landscapes at Grey Towers. The first was Cornelia's comfortable domesticated landscape of pool, terrace, and hand-troweled edge that wrapped itself around the château and civilized the surroundings. Hers was the landscape that everyone saw, where politicians and visitors strolled the rill consulting with each other and pondering public things. When the situation called for privacy, they wandered down to the sunken, frothing moat where voices were drowned out to the croaking of bullfrogs. Cornelia had the moat built when a visitor to Grey Towers, remarking on the loveliness of the château, noted that it was reminiscent of a castle but lacked one thing, a moat.

The other landscape at Grey Towers had little to do with Cornelia's order or domesticity. One might say it was the Walden of Amos, Gifford, and Rosamond that had fortunately escaped the ancestors' saw. Behind the Forester's Cottage lay the forest. Deep in the forest and down moss-covered banks lay a beaded necklace of deep pools, waterfalls, and a swift watery chasm where Sawkill Creek narrowed to virtually nothing. This landscape wasn't a secret, but it was natural, and the Pinchots preferred to keep it that way.

In the summers, Governor Gifford and Aunt Cornelia lived in the château, while Amos lived in the Forester's Cottage. The Forester's Cottage was hardly a cottage. It featured three floors, ten bedrooms, and spacious common rooms perfect for family activities. Rosamond and her brother, Gifford, grew up in the summers in the Forester's Cottage with their father, Amos, and mother, Gertrude Minturn. That is, until their divorce in 1918, when Amos married Ruth Pickering, a reporter from Elmira, New York, with whom he had started a relationship while still married to Gertrude. With his new wife, Ruth, Amos had two little blond daughters, Mary and Tony, who kept the Forester's Cottage buzzing.

With the demands of Amos's second family for space, Rosamond and Little Billy were moved to the château where there were usually two overqualified but enthusiastic babysitters at the ready. Governor Gifford and Aunt Cornelia spent many summer nights reading to Little Billy Gaston on the generous couch at Grey Towers, teaching him about the sound of crickets and the light of fireflies, taking him for walks at twilight in the flower garden and tucking him into bed at night in one of the remarkable tower rooms with a turret.

Perched in one of the turret rooms, Little Billy was often alone, but his location had marked advantages. He could look out over his great-grandfather James Pinchot's landscape of open meadows and big trees and Aunt Cornelia's colorful additions to the property, and he was within earshot of the moat with its battalion of bullfrogs. He could peer through the leaves of the General Sherman Tree, a sugar maple, planted by William Tecumseh Sherman himself in 1888 as a gift to Little Billy's great-grandparents, James and Mary Pinchot, and into the walled garden with its urns and roses. He could even spy on the adults as they carried on about politics beneath the trellis covered with vines at Cornelia's fancy new dining table, a stone water table inspired by her trip to the South Seas.

Of course, Cornelia's architect Bottomley would rather have seen a long, coffinlike water table like the Rennaissance-era one at the Villa Lante in Bagnaia, a garden that told the tale of humanity's turbulent descent since the Golden Age, but Cornelia had in mind an egg-shaped basin below an odd-shaped trellis that didn't tell the story of anything.

In a compromise, it featured a cheery blue bottom the color of the South Seas and like the table at Lante, a ledge wide enough for a place setting. Meals were more than just meals at the water table. Meals were a form of entertainment, where plates heavy with food sailed back and forth across the water on wooden barges, docking, it was hoped, on the other side.

Little Billy's mother didn't really care to sit around under the vines with all those politicians who she said were generally boring and unattractive. Rosamond called the place "Cornelia's Stonehenge," but Little Billy heard Cornelia call it by another name; she called it her "Finger Bowl." When Aunt Cornelia filled the pool with a school of Japanese goldfish, Little Billy screamed to Rosamond in delight, "Mummy, I see a funny fish with a funny face and go-fedders in back!" It didn't matter what anyone called the Finger Bowl. When his whole family gathered under the vines, there was nothing more exciting in the whole wide world.

The Finger Bowl, Grey Towers,
Courtesy of the USDA Forest Service

One Sunday, Cornelia rose early to put the cooks to work. Billy heard her whispering and sneaking about, sending people with lists and detailed instructions to gather equipment and supplies. She told him that there wasn't to be any horsing around and that he was not to go into the kitchen. Billy knew something was up. From his turret room, he watched delivery trucks coming and going, and by noon the house started smelling pretty darned sweet and familiar, of vanilla and yeast, flower and sugar. By afternoon, Little Billy was giddy with excitement. As it was turning dark, Aunt Cornelia tiptoed over the Mosaic Terrace and summoned everyone from everywhere. Just in time, Little Billy shot down the stairs to watch her light her baked Alaska with its towering meringue top in the shape of a volcano, floating on its own little wooden barge. With a tender shove, Cornelia sent the barge sailing across the clear blue waters of the Finger Bowl. As the barge threatened to capsize, Cornelia made a last-minute intervention, inserting dry ice in the mouth of the crater so that it hissed and sputtered, coming to rest at the stone ledge. Everyone began singing. It wasn't anyone's birthday, and no one really knew what was being celebrated. But Little Billy didn't care, he just squealed his approval.

Cornelia had had a remarkable childhood herself. She was born in 1881 in Newport, Rhode Island, to Lloyd Stephens Bryce, a wealthy journalist and politician, and Edith Cooper, the granddaughter of Peter Cooper, founder of the Cooper Union, a free school of engineering and the arts for exceptionally talented youth in New York City. Endowed with an adventurous spirit, she dispensed with debutante balls to take her own cross-country journey, as one observer noted, with neither pearls nor maids. After declaring that the "butterfly existence" prescribed by her parents was not for her, she said that she "marked down, pursued and captured one of the few really big men I have ever known—one who never turned his back but marched breast forward—and [will live] happily and gloriously ever after." That breast-forward man was Gifford Pinchot.

On August 15, 1914, Cornelia Elizabeth Bryce married Gifford Pinchot. She was thirty-three and he was forty-nine. Gifford married late, but he hadn't exactly been avoiding women. After the tragic loss

of Laura Houghteling and any number of subsequent flirtations, including one with the landscape architect-to-be Beatrix Jones née Farrand, the magnetic and enterprising Gifford set his sights on a woman Theodore Roosevelt, who attended their wedding, characterized as having "the best political mind of any woman of his acquaintance." Cornelia not only supported Gifford's political career, she had her own as well. She was an outspoken supporter of women's rights, educational opportunities, and protection for women and children in the workplace. She sought office in the U.S. House of Representatives three times and ran for governor but lost each election. She also encouraged women to drive and participate in politics, particularly when it came to voting for her husband.

As cautious and methodical at dating as he was at forestry and government service, Governor Gifford made sure he knew who he was marrying when he brought Cornelia down to Sawkill Creek to see if she was enough of an adventuress. She evidently passed the test and their son, Gifford, learned to fish on the Sawkill where James had taught Governor Gifford to fish. Amos, the governor's brother, taught his son, Gifford, to fish the same creek. However, fishing wasn't limited to the Giffords. Thanks to her father, Amos, Rosamond was as good at reading the water as any of them. Sometimes she'd thrill all the boys, her father and the governor included, by reaching down into the river's potholes to pull up a trout. That was when Little Billy realized he wasn't like most boys and his mother wasn't like most mothers. She'd wander the woods, fishing and swimming, and sometimes she took him to see a little green ship that never moved, but survived in the middle of the pool below the falls. His mother called it the "Good Ship Rhododendron." She told him stories about that ship and that was when he realized that he was the luckiest boy of all.

In June, the fields and forests of Pennsylvania warm to the point where its wildflowers fear nothing but the young and the young at heart. Given the conditions, the summer of 1931 looked to be a banner year for snipping. One night, Rosamond scooped up little Billy and took him out to the perennial border where together they snipped one of Cornelia's lilies. That night, she pinned it carefully to the top of the

page in her red leather diary. As June wore on, the hot summer sun baked the fields. One day was just as lovely as the next. The wind blew through the trees, the river ran low, the sun shone down on Cornelia's perennials, her fleet of gardeners stirred the vegetable beds, and Rosamond decided to take Little Billy for a walk. One of her favorite destinations was the reservoir, where she liked to collect fresh watercress for lunch. That day, Billy wore a pair of little green trunks and crept gingerly through the prickly underbrush and patches of blue myrtle in bloom. At the bottom of the hill, where the trees thinned out, they came across the old graveyard where the first- and second-generation of Pinchots lay. Stopping briefly to look at a towering stone obelisk carved with the name Cyrille Pinchot, Billy turned to ask his mother, "Was he a big man? He had a very big stone."

Cyrille Pinchot was not just a big man, he was the kind of man Aunt Cornelia would have said was a "breast-forward" man like Gifford or a "top-grade" man like Stroyan. Cyrille Constantine Desire Pinchot and his wife, Maria, hailed from the French bourgeoisie. With his father, Constantine, Cyrille was forced to flee France under the Bourbons in 1816 when the family supported Napoleon's ill-fated last gasp at Waterloo. Gathering a troop of soldiers, Cyrille was said to have arrived one day late and missed the battle. Fearing retribution, Constantine, Maria, and Cyrille escaped to England but not without first commandeering a gunboat to attempt a daring rescue of the emperor off the barren, windswept Isle of St. Helena in the southern Atlantic. Failing that, they made their way to America, where they established a successful dry-goods mercantile in New York City before moving to Milford, which already had an established colony of French immigrants.

In 1819, Constantine bought a store and a house at Milford's main intersection and four hundred acres of farmland. Business thrived and he became the largest landowner in Pike County. Cyrille continued to amass not just land but forested lands from which he could harvest timber, rafting it down the Delaware River to ports such as Philadelphia, New Hope, and Trenton. His father died in 1826, and by 1860, Cyrille

Constantine Desire Pinchot had ravaged large swaths of his father's forest, leaving the landscape around Milford in shambles.

In 1832, Cyrille and his wife, Eliza Cross, gave birth to a son, James, who inherited the family's zest for business while caring deeply for the arts, civic improvement, natural beauty, and in no small measure, the forest. James grew up fascinated by systems of French and German forestry in which trees were thought of as a crop. By implication, he understood that if trees could be sustained generation after generation, so could wealth. With his sociable nature, good looks, intelligence, and penchant for hard work, James reestablished the family's dry-goods business in New York under the name Pinchot and Warren, which became renowned for its remarkable wallpaper. James quickly made a name for himself but worked so hard that in 1855 his father tried to convince him to return to Milford for a year to raise chickens. He rejected the idea, but then James was diagnosed in 1859 with strange hemorrhages in the lungs and was directed by his doctors to take a good sturdy horseback ride through the south to recover. Another of his restorative techniques was said to be dancing at New York's gilded-age cotillions, where he met Mary Jane Eno, the beautiful, bold, and opinionated first daughter of Amos Richards Eno.

Like James Pinchot, Amos Eno was one of New York's most successful dry-goods purveyors. However, Eno didn't stop at wallpaper. He turned his success into a real estate empire. In 1855, Eno paid $170,000 for an assemblage of land around a peculiar triangle at the intersection of Fifth Avenue and Broadway and Twenty-third streets, where he developed the Flatiron Building. In 1859, he built the Fifth Avenue Hotel, then known as Eno's Folly. His daughter Mary Jane grew up watching her forebears perform acts of remarkable public service, not only contributing money and objects to the Metropolitan Museum of Art, but gifting the Eno's hometown, Simsbury, Connecticut, with a church, a library, and a way station for the town's less fortunate. Included in any young woman's cultured upbringing was a love of gardens and nature, so Mary spent countless summer hours at her childhood home in Simsbury rearranging and straightening the beds and realigning the broad paths of her family's estate.

When James Pinchot and Mary Jane Eno married in 1864, Mary envisioned a fine future for her husband. Soon enough, the two became major philanthropists in New York City, supporting the arts with a particular interest in the work of landscape painters. Their first son, Gifford, was born in August 1865, named after the landscape painter Sanford Gifford, followed by a daughter, Antoinette, and a second son, Amos, born on a trip to Paris in 1872, named for his maternal grandfather Amos Eno. James and Mary exemplified lives of purpose, so naturally they developed a distinct plan for each of their children. Gifford was raised "to do something important." Amos was assigned to tend to the family estate. Antoinette, known as Nettie, went to England to escape the long arm of her parents, marrying a British diplomat instead of becoming one herself.

Among his charitable endeavors, James hatched a scheme to dignify the dusty little crossroads in downtown Milford. Accepting the none-too-glamorous commission was his good friend Richard Morris Hunt, whom he met while chairing the committee to locate and design a base for the Statue of Liberty. The two men discovered a shared passion for all things French and Hunt soon recognized that Pinchot wasn't feigning French, he was the real thing, or at least his father was. Hunt wasn't feigning French, either; he had studied at the Ecole des Beaux Arts in Paris, won the Prix de Rome, and worked to restore the buildings around the Tuileries. With impeccable taste, talent, timing, and no reservations about spending other people's money, Richard Morris Hunt was a man with no small mission.

James Pinchot's plan for an improved Milford was just one part of his personal vision. He and Mary also wished to build a house that would recall his ancestors' origins in the Picardy village of Breteuil Sur Noye, a medieval villlage the Pinchots left in a hurry before boarding their gunboat to retrieve the emperor at St. Helena. Located on the Noye River, Breteuil was a study in water, featuring waterfalls, mills, millraces, moats, rills, and great wheels. At Breteuil, generations of Frenchmen harvested grain and turned that grain into flour. While hatching plans for an American summer place, James Pinchot remembered his watery past in Picardy and Mary recalled her childhood summers spent rearranging the broad paths at her family's estate in Simsbury, Connecticut.

Normally prone to grandeur, Hunt held back and brought the scale of a small French country estate to his design for Grey Towers. The journey began at an elegantly proportioned gatehouse sited off a quiet country road just minutes from Milford. There, a long, sinuous carriage road snaked between allées of poplars, mounds of turf, and an occasional hillock. Playing the proper games of site planning, Hunt first teased the visitor with a glimpse of the manse. He threaded the road around a clump of imported trees, sending the eye off its mark and into the forest. Denying the view, then giving it back, Hunt mimicked the journey of blood to the heart, a surge of openness followed by constriction. Before the final ascent, a huge walled garden was visible to the south. To the north, three monumental sixty-foot round towers anchored the château, all of grayish bluestone quarried from the land. Steeply pitched roofs crowned the building and its towers, the slate from Lafayette, New Jersey. The first impression was one of solidity. The French influence, indisputable. The visitor had left America and arrived at a small French château, but not just any medieval château. Those who knew their castles knew that Grey Towers was meant to evoke La Grange, the château of Lafayette. Upon completion of its forty-four rooms and twenty-three fireplaces, Catherine Hunt, the architect's wife, toured the house and said that it "had a character about it quite unlike anything else in America." And it was quite unlike anything in Richard Morris Hunt's residential portfolio. While Pinchot spent $44,000 on construction, he spent nothing on Hunt's design. Out of affection for James and Mary Pinchot, Hunt never charged his friend a single penny.

After completion of the château, a lifetime of landscape challenges remained at Grey Towers. Thanks to James Pinchot's timbering ancestors, the site resembled a moonscape. Frederick Law Olmsted, also a friend of James Pinchot's, was unavailable at the time, so, at forty-four years old, James decided on an early retirement and embarked on a massive reforestation program for his devastated land. The land had once been covered in a dense mix of oak, ash, hickory, hemlock, and white and yellow pine. So James planted hundreds of native trees, but also introduced his taste for the picturesque by importing specimen trees, shrubs, and vines. Meanwhile, Mary Pinchot, who refused to keep secret her taste for Simsbury over the Milford moonscape, pitched in to

design a circuit of walking paths through the property. It was on those paths that the next generation of Pinchots, including Rosamond and Little Billy, would form their memories of the natural world.

Several years after James Pinchot died in 1908, Amos and Gifford divided up the property, with the château going to Gifford, the Forester's Cottage going to Amos, and a line being drawn down the middle of the walled garden. But neither brother paid too much attention to the line. The brothers were each other's most important allies. Power had descended to Gifford, but he shared his successes, and sometimes his failures, with Amos, "[He was] the man to whom I most naturally turned first. . . . He could not, of course, appear as my formal representative. Nevertheless, his advice and his help were invaluable. . . . He was indispensable, and was especially useful in getting the facts to the public."

Gifford's parents placed such hope in their firstborn son that Mary could barely hide her displeasure when Theodore Roosevelt failed to give Gifford appropriate credit for his work in conservation. No gentle amount of arm-twisting would get her point across, so she wrote TR that her son was the "soul and fount" of forestry. Indeed, Gifford had established forestry as a legitimate profession and served as the spokesperson for much of Roosevelt's environmental legacy. Without too much ado, Roosevelt agreed with her assessment when he wrote in his autobiography, "Gifford Pinchot is the man to whom the nation owes most for what has been accomplished as regards to the preservation of the natural resources of our country."

Amos Pinchot had a more difficult time of things than his older brother. As a child, his parents criticized Amos for everything from his dawdling to his penmanship. Surviving in the shadow of Gifford, he became a member of TR's inner circle and, with his brother, a founder of the progressive wing of the Republican Party that later became the Progressive Party. To Gifford and Cornelia's dismay, Amos eventually became a fierce critic of the Rough Rider; and Roosevelt, in turn, warned Amos that he was his own worst enemy. Amos, he announced, had an inability to get on with others and to unite for a common cause. As the center of the Progressive Party's "radical nucleus," Amos argued for the common man, for social and economic justice and civil liberties. "What

I am trying, in a humble way, to help do," he wrote, "is to prevent violence, disorder and misery by getting people to see the justice of the average man's demand for a better economic position in this country, and the utter futility of denying or ignoring this demand." Not everyone agreed with Amos Pinchot, however. Theodore Roosevelt cut to the chase, writing Amos: "Sir: When I spoke about the Progressive Party as having a lunatic fringe, I specifically had you in mind."

During late summer storms in the Poconos, boulders thundered down the floor of the Sawkill, scouring everything in their path. When the afternoon turned quiet, Rosamond and Little Billy sprawled out on the front porch of the Forester's Cottage protected from the rain. They could hear the sound of bells every quarter hour tolling from the church with the beautiful stained-glass windows in downtown Milford. The tones reminded Rosamond of lying in bed on summer nights in childhood trying to sleep, hearing the whip-poor-will behind the house and counting the hours until sunrise. Along with the wood thrush, the whip-poor-will was Rosamond's favorite bird. As a child, she'd sit on the floor of the forest, holding her breath and watching as the bird emerged from holes in the canyon wall at dusk. She observed how it hid itself to lay its eggs. In folklore, she knew, the whip-poor-will appeared at the moment between life and death.

Little Billy had a busy summer in his first year on earth, and in August, it was about to get even busier. As if Grey Towers wasn't enough of an immersion in the natural world, when Rosamond came back from Corsica, she loaded him up for another spin, this time up the Maine coast where his father was in the last throes of work on the Crotch Island house.

Logistically speaking, construction on an island fifteen miles out to sea made the construction of Grey Towers a generation earlier look about as easy, as the French would say, as folding a serviette or tying a cravat. There wasn't one easy thing about building a house off the Maine coast in the 1920s. Between the wharf, the boathouse, the icehouse, and the satellite guesthouses, Big Bill had set himself up with a

nearly impossible task. Just getting there was an obstacle. Once there, there was the problem of the fog and the boats and the tides, not to mention the equipment and the help. Still, Maine was synonymous with "away," and away was how Big Bill liked it.

Big Bill first landed on Crotch Island in June of 1926, shortly after learning he'd been left out of the Colonel's will. At twenty-eight years old, he called it quits, for the most part, with his siblings. He swore off cucumber sandwiches, toast points, and the well-packed clay courts over on North Haven, making only the required appearances at "Gaston Cottage," where the rusticating relatives kept one eye on their bank accounts and the other on the Fox Island Thoroughfare. The Thoroughfare, the tidal channel between elegant North Haven and the working-class warrens of Vinalhaven, was about the only thing Big Bill missed, for its long safe harbor, its sleek, low-to-the-water Herreshoffs, and its tippy fleet of North Haven dinghies bobbing gently at anchor. He'd learned to sail in its choppy inlets. Sail—by God, he'd been a legend, not just at sailing but at boxing and tennis; but then he'd staged a secession from his siblings,

Colonel William Gaston at Gaston Cottage, North Haven, 1919

bought Crotch Island, and christened his boat the *Crotch Island Crab*. Next door to the Welds and down the road from the Pingrees, the Gastons, the unconscionably rich tribe he'd once thought was his, looked down over Iron Point, down over their sprawling deck, down over their extra-dry gin and tonics, down to the water where Big Bill plied the Thoroughfare just getting where he had to go. They smirked at the name painted on the stern. It was so embarrassing. Proof that he was a mess.

In his first summer on earth, Little Billy was too young to know he was being transported from the Pinchots' French feudal castle to the Bostonian Gastons' interisland family feud, nor did Rosamond know the depth of the discord between Big Bill and his siblings. Five nautical miles away from each other, it was easy to keep matters at bay. To her, the bad-mouthing and drinking all seemed harmless and colorful. With the exception of Uncle Gifford and Aunt Cornelia, her family wasn't exactly a pack of teetotalers, either. Big Bill used to tell her there were inlets and tides and hull-stripping rocks between him and North Haven, and maybe now he could finally have a little peace. He stayed in touch with his

Big Bill, North Haven, Maine, 1912

mother and his sister Hope, but that was about it. On Crotch Island he would cook, sail, make friends with Vinalhaven's quarriers and fishermen, those who worked for a living. In exile or excommunication or whatever anyone wanted to call it, he would plant potatoes with young Billy. And to keep his colorful imagination from going down the drain the way the rest of the family had, he would continue to write his plays.

When Rosamond and Little Billy arrived that August, they rounded the point at Crotch Island and were greeted by a seven-foot-tall painted wooden sculpture of a stern, balloonish character in top hat and tails. *The Man* was Rosamond's wedding present to Big Bill and in it, she probably saw a likeness to her husband, or at least to the mysterious family she had married into. As she came up the path with Billy, she couldn't believe what she saw. The house was largely complete and Big Bill sat like a swami reading a book, surrounded by alyssum and peonies. He'd planted vast flower gardens at the front of the house, and in the lower fields—between Crotch Island's drumlins of granite, where the topsoil was as deep and rich as one could imagine—he'd planted his

Rosamond and Bill, Crotch Island, 1930

potatoes, his beans, and his corn. He had outfitted the corners of the cabin with cigar-store Indians and hung its walls with naïve oils of small harbors and sailing ships. A French lithograph of Pandora hung in the bedroom. Great candelabra and Italian putti floated from the roof beams. He'd found a miniature replica of a steamship and onto the mantel it went, christened the SS *Crotchetta*. Female figureheads adorned the walls. A ship's stern was fashioned as a balcony. And flowers, oh, how Bill loved flowers. Indoors and out, the flowers were everywhere. Big Bill's architect, a local named Coombs, understood Big Bill's vision of rusticity, so he kept the bark on the cabin's logs. Big Bill got his bark and the bugs that came with the bark. But what Big Bill really wanted was his stage. Half the great hall was designed as a living room, and the other half accommodated the dining room. The two areas, set off by a stair, doubled as a stage and a seating area for his audience.

Big Bill celebrated the arrival of his family that August as if it was the opening night of his first successful play. He introduced Rosamond and Little Billy to his boatman, Reddy Phillips, who really was as red as a lobster and ran the *Crab* through the rocky jaws of Crotch. She met his new friend, Les Dyer, a fishermen from Vinalhaven who sold Big Bill fresh flounder off the back of his boat. Big Bill was growing wild mushrooms under the house, and the Watanabis concocted one of their fabulous creations that night, with seaweed from the rocks and mysterious bivalves no one had ever seen before. His modern kitchen looked out over the back cove where the full moon rose in August. In the lee between Crotch and adjacent Crane Island, Big Bill had begun work on a cottage for Little Billy, with bunks, a little desk, and a bright red hand pump for fresh water. On his own cove, facing west, where the sea lapped up beneath his own tiny dock, Little Billy would one day be able to look over to neighboring Crane Island, where the rocks turned as pink as roses in the setting sun. In future summers, Big Bill and Rosamond planned to invite their theater friends to stay in small satellite guesthouses. But this summer, they didn't need anything or anyone else. The island and Little Billy and fresh flowers and a potato patch and the tides and the stars, and honestly, what more could one need? Life was complete.

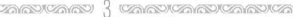

A CHRONOLOGY OF CHAOS

On my first day of kindergarten in September of 1963, my father aimed his sleek Moroccan limousine, the Delahaye, through the low stone walls at 53 Bayard Lane in Princeton and scanned the school yard for an audience. As he pulled up to the stairs to drop me off, an assembly of mothers and teachers whispered and pointed at our car's Arabic license plates. I rolled down the privacy window separating front and back compartments, said good-bye to my father, slithered off the red leather seats, and crept quickly up the stairs hoping that no one had seen me. The king of Morocco's limousine wasn't the kind of car you'd see pull up every day at Miss Mason's School and I wasn't the kind of child you'd see, either, dressed like a ragamuffin in my homemade smock.

All I wanted was to be deposited on the steps like Beth Johnson or Alice Britt by what my mother said were "normal mothers" and certainly not by my father. My mother didn't drive my father's precious foreign cars, so he drove me to school, which I don't think he minded, because Miss Mason's entrance drive was like a runway at a beauty pageant. Princeton perfect mothers were all lined up in their Ford Country Squires, the family car du jour, complete with fake wood paneling. They sported floral shifts, dark orderly hair, and sunglasses like Jacqueline Kennedy. Somehow I knew that those mothers were different from mine. They spent their mornings at the hairdresser and their Bain de Soleil afternoons primping and applying unguents at the club. They kept a firm grip on the social order, who was who and what was what.

Meanwhile, all those normal mothers wanted was to get to the bottom of just one thing: Who was that man behind the wheel of that fancy car? Was he a movie star?

They never got their answers, at least not the ones they were looking for, because our family didn't leave tracks. No one knew quite what the story was. Some talk of fancy lineage, some Moroccan connection, it didn't add up. We didn't appear at the ritual gathering places of suburbia where people snooped and put the pieces together, like country clubs, dance lessons, or church. Our mystery quotient was only enhanced by our disappearing acts, which, after school, were swift and certain. It was a long way home. We lived twenty miles outside Princeton in Ringoes, New Jersey, a one-building town outside the township and the borough and the gossip radar range.

The drive from Princeton to Ringoes, like any drive from here to there, was made interesting by a series of spaces and landmarks. Driving back and forth to school, I'd play spy from the front seat of the king's car as we passed beneath tunnels of elms and sycamores as splendid as boulevards in the suburbs of Paris. We'd cross over little brooks surging with spring runoff, along sinuous white fences of horse farms, and around houses so close to the road that on dark winter mornings we could shine our headlights on what the owners were eating for breakfast. On the way home from school, I'd announce to my father that the drive was boring. I'd stretch out in the backseat with the top down and I'd gaze up at the thick canopy of trees, followed by an opening to the sky, followed again by canopy, followed by sky.

While the drive was discouraging to any form of adult social life, my parents were unclassifiable bohemians, Ivy League, but certainly not suited to galas, golf, or a gin fizz by the pool. They lacked the wardrobe and the patience, so the distance from Princeton suited them just fine. In fact, the town of Ringoes, part of rural Hunterdon County in the Sourland Mountains of western New Jersey, was closer to the artist's colony of New Hope, Pennsylvania, and the muddy currents of the Delaware River than it was to Princeton. But like Princeton, Ringoes had history and once claimed a far more industrious past. Still there was a world of difference between the trim streets of Princeton and where we lived. Looking back, twenty miles was the greatest gift a parent could give a child. Outside the grip and maw of well-tended lawns, I got to thinking about the landscape.

My mother was no "normal" mother and my father assured me that our house, an old mill, was no "normal" house. One day in 1964, my mother was poring over the New York Times *when she found a Sotheby's advertisement for eight acres and a picturesque old mill. My father fell hopelessly in love. The mill building had gone*

through a conversion as a summer getaway by a childless couple named the Mc-Crackens, who removed the mill wheel, completed an addition, and then divorced in what seemed to be a hurry. My father and mother were thrilled at discovering the mill, but they were equally excited at what came with it—a house full of early American furniture. They weren't the shopping types, so tables, chairs, and bureaus became an attractive selling point. Soon, my father was giddy that he owned the oldest structure around, but I was too young to know what that meant to him, that the mill was awash in history and history was ripe for cherry-picking. He'd tell me that in 1730, when the mill was built, Louis XV, the Sun King, was the king of France, George Washington was just two years old, and Thomas Jefferson wasn't even born yet. The mill, put in context, made you scratch your head in wonder.

My father loved old mills, but I never knew why until I was forty-five years old. After he died, I discovered the connection between his love of mills, growing up in a mill, Milford, and the region of mills in Picardy where the Pinchots lived in France. When I was young, we'd go for long drives in the Delahaye, and my father would keep one eye peeled for his favorite buildings. The mills and moats he discovered on our drives were never quite as impressive as our Moat or our Old Mill. He said that

The Old Mill

our mill had a proud past. In the early 1730s, Ringoes, New Jersey, attracted En-glish and Scotch Presbyterian farmers who beat the land into submission, then sent their grain to seven flour mills and fifty-seven gristmills to be used for stock feed. By 1965, the prosperous Presbyterians had long since vanished and the mills had shut down. The little town of Ringoes had become just another far-flung rural outpost between New York City and Philadelphia grooming its open fields for developers. Narrow dirt roads and sweet-smelling brooks still meandered through farms, fields, and orchards, but what most distinguished Ringoes, in my opinion, was a sporadi-cally manned general store with a noteworthy candy selection.

Like most mills, ours was a sensible structure, built on a fieldstone foundation with a second story of wood painted barn red. The Old Mill sat at the low end of eight rugged acres of ash, maple, and sassafras, and so many rocks that even the Scotch Presbyterian farmers gave up clearing much of the land. Mill Creek once ran its natural course feeding the millrace, but in the 1950s, the creek was diverted under a bridge and sent off the property. Above the Old Mill was an open field for softball and a mature chestnut orchard where my mother sent us with thick canvas gloves to retrieve the key ingredient for her turkey stuffing. I never thought trees could be dan-gerous, but harvesting a chestnut was like approaching a sea urchin in a tree. As a child I was fixated on the unlikely journey of the sea urchin, how it had escaped its watery climes and found a home among the terrestrial family of nuts.

The McCrackens' conversion of the original mill was a simple affair. It included a rustic country kitchen on the ground floor, a spacious light-filled living room on the second, and a large bedroom in the eaves on the third floor. The 1950s addition was built at an obtuse angle to the original mill and doubled the size of the living space by including a stone-floored room, a garage at ground level and two bedrooms above. I lived in the bedroom over the garage, and attached to my bedroom was a vine-covered porch from which I kept watch over the comings and goings in the driveway. In my bedroom was a closet and in that closet was a rickety ladder and a string that led to a 40-watt lightbulb in the attic. Spanning the joists in the attic was a long wooden board that led to a dusty old trunk. And in that trunk, forty stuffed animals led extremely complicated lives, and like my mother with her soap operas, I was always trying to figure them out.

Living in an industrial mill building from the 1700s made perfect sense to my fa-ther, who liked anything with gears, wheels, and moving parts. In the early days, he spent most of his time fixing things. According to my mother, the mill wasn't your

*all-American dream house. Like driving King Mohammed V's parade car, it re-
quired certain unusual qualifications: an unfailing imagination, a toolbox one might
take onboard a ship, and either an extremely practical spouse or a full-time mechanic.
Along with fixing things, my father named things like a self-appointed geographer or
Adam in the Bible. His names weren't systematic, but I went along with them be-
cause I felt sorry for places that had been abandoned to geographic anonymity. There
was the Moat, the Dungeon and Giant Rock, the Fort, the Tree House, the Wall,
and the Chestnut Orchard. As if to remind us of the greater history, he named the
places of our lesser history. Named or unnamed, those places became my closest com-
panions in childhood.*

*The Moat once housed the mill wheel but now skirted the length of the original
mill like a sunken aquatic theme park. After the wheel was removed and the river
diverted, the poor struggling Moat became a mold incubator. About the length and
width of a train car, she filled up with enough stagnant rainwater and underground
seepage to support a colony of birds, frogs, and fish. The Moat probably could have
been classified as a Superfund site, but there was something endearing and tragic
about her. The Moat had once known a purpose, but denied her purpose, she de-
scended into a murky wet hell realm that invited one to recall everything that was
creepy about the world: the strange stagnation that takes over a pond when it loses the
flushing action of floods or the pallor of a forest when it loses its nutrition from fire. I
thought waterborne gremlins inhabited the Moat, and gremlins needed company, so I'd
line up my pink-haired troll collection, a subset of the stuffed animal ark, in the ivy on
the Moat's parapet wall. I was anxious as a child and felt sympathy for the Moat,
because like me, she seemed restless and her conditions fluctuated for no apparent
reason. I'd look down after the ice melted in the spring, and the water was green; but
the next year it was orange or yellow, and no one knew why. "Something to do with
mold," my father said, or "something upstream," he'd snap. "Don't fall in there." No
one ever fell in, but a deer did and my father hatched various schemes to rescue it.
After a week of throwing grass and legumes at the hungry deer, a band of handsome
young men from the fire department showed up to airlift the deer out of the Moat. It
was the first rescue mission I'd ever been on. If I'd been a little bit older and a bit more
clever about men, I might have found a way into the Moat myself.*

*There was only one way into the Dungeon, which was through a heavy trapdoor
in the kitchen floor. The Dungeon was my father's name for a small stone subterra-
nean room, permanently wet, adjacent to the Moat. My father only waded into the*

Dungeon when something had gone terribly wrong. He said that escaped slaves had hidden in the Dungeon on their way up north. When he got angry he'd say he'd send us to the Dungeon, but never did because the Dungeon was home to the pump, which delivered water from the well but also pumped errant seepage back into the Moat, thus keeping the Moat's memory of water from flooding the kitchen. The rattling clanging pump sat in a murky pond of fluctuating ooze that, according to my calculations, had been fermenting like yogurt since well before the Civil War. When he waded into the Dungeon, my father explained, he was just like the old millers centuries before who'd gone down there to adjust the great gears of the milling operation that transformed the force of Mill Creek into the energy that ground grain.

I spent hours down at the creek, perched like a bird on top of a glacial erratic my father called Giant Rock. I reached the top by shimmying up a silver maple that grew close to its base. From a scary height, I peered down at the creek that once fed the Moat, watching scarlet crawdads stirring things up in emerald pools of moss. I counted bright red maple leaves swirling and flirting with the current, imagining they were open palms waving at me until they disappeared under the bridge and out of sight. When I was young, I didn't think about where the river was going, about how most everything in life fits some glorious or inglorious pattern, ending up somewhere, and sometimes pretty close to where it started. I certainly didn't think about the connection between landscape and family, that the river at the Old Mill and the Sawkill at Milford were both tributaries to the Delaware and that I'd grown up like my father had, spending countless hours in a little mill inspired by a big mill far away.

While I was jumping off the wall on my pogo stick or riding my unicycle, my mother was bemoaning her lightless kitchen, my brother was uncovering omissions in the Information Please Almanac, *my sister was claiming that something that belonged to me belonged to her, and my father was tinkering with bolts under the king's car. In my memory, he spent most of his time in the garage or mowing the lawn or in a corner of the upper field where it smelled like something had died and where, one summer, he tended a patch of sunflowers. He never went to work but I didn't think that was strange because no one in my family ever went to work. Since we lived in the country with no one around, I didn't notice the tidal pattern of my father's comings and goings.*

When he wasn't fixing things, my father was taking photographs with his Rolleiflex. In 1965, he took three photographs of me at the Old Mill in a particularly cute stage. In January, he posed me under a lone pine tree. In February, I was surrounded by my stuffed animal ark that looked like FAO Schwartz had capsized at the mill,

and in April, he arranged me in a scene by the Moat. After that, he started to disappear. He came back from time to time, but I decided I wouldn't bother him anymore while he was working under his cars. One time, the sharp snout of the Peugeot's hood was propped up and I looked down at him through the engine compartment and called him "Daddy." He snapped and told me never to call him that ever again. I was to call him Papa, he said. Places had names and people had names. After that, I kept the names straight.

In the summer of 1967 he took a trip to France and another to Morocco. By the summer of 1968, when I'd learned to call him Papa, he'd finished fixing everything, and that's when he vanished.

I remember sitting by the Moat with my trolls when my mother said he'd left for his girlfriend Therese in the south of France. She'd found the letters between them sitting in plain view. She said we'd been marooned in the Old Mill. Mother wasn't a club person or a joiner, but every day on our way back from school we'd pull into the liquor store where she was paying her dues at the not-so-secret society of pain relief.

Around the time my father left, all my thoughts about what was creepy in the world came together in a vision, not by my mossy, mildewy moat, but in my bedroom over the garage. In the middle of the night, I saw a tall figure dressed in white coming down the hall. I thought it might have been my father dressed as a ghost and that he'd come back to surprise me. I lay completely still and hoped it wouldn't come any closer. I pulled the blankets over my head, lay as flat as possible, and held my breath until I fell back to sleep. I never saw it again or told anyone about what I'd seen, but my greatest fear was always of that figure in white.

My father probably missed the Old Mill from France, where his girlfriend lived, or Morocco, where he kept a pied-à-terre. He sent postcards from exotic places like Andorra, where there were big fluffy sheep, and Gibraltar with its apes and men in fuzzy hats guarding the Straits between the Rock and Tangier. Someday, he wrote, we'd go back to see these places. He signed the postcards love, so I knew he loved me. For a while I thought he was just off fixing something and that he might come back but he never did, except occasionally on Sundays when he'd drive up to the Old Mill in one of his cars, symbols of everything that drove my mother insane. He'd take us out to dark empty restaurants with belly dancers, or we'd cross the Delaware River at New Hope, where there were bumper-sticker purveyors and candle stores. We'd walk around not saying much because mother didn't want us to. She was mad as hell, so she hid the postcards or lost them in her newspaper collection and hired the meanest, most

expensive New York attorneys she could find, with a handsome senior partner who told her to sell my father the Old Mill for $18,000 so we could rent a house that didn't require a full-time mechanic. This was just the beginning of the bad legal advice she received for which she paid top dollar. Nineteen sixty-nine was the last year she would ever own a house. She rented progressively smaller houses and apartments the rest of her life.

After my father left, I started straightening things in the landscape. But a nine-year-old who was bent on straightening didn't have much to do in Princeton, New Jersey, in the late 1960s. There were tie-dyed antiwar protesters besmirching the public parks and there was a poor, bedraggled, black neighborhood on Witherspoon Street abandoned to its crumbling infrastructure, withered street trees, and buckled sidewalks, but other than that there wasn't much in the way of dishevelment. Live-in gardeners tended the velvety lawns, nipped back the rhodies, and kept the elms in postcard condition so that there wasn't a leaf out of place on streets like Hodge Road and Bayard Lane. The proud old Princeton streets with their Norman-inspired palaces on sprawling properties looked just like they had for the past eighty years, if not better.

The landscape in Princeton was so orderly that I was on the lookout for signs of dissent. When I spotted a sunken fencepost or a lawn gone wild, I became embarrassed and felt sympathy for the person living there, thinking they suffered or someone had left or there had been a fight. But part of me breathed a secret sigh of relief, thinking someone had simply escaped the tyranny of keeping things up, had dropped the gin and tonic on the lawn one night in a spasm of suburban ennui or smashed it against the curb in a paroxysm of stultifying boredom, spouted something about Madison Avenue and commuter trains and the goddamned grass and finally, grudgingly admitted that life had gotten the best of them, at least for the time being. A slovenly front lawn was a public admission that not everything is perfect about the world and one might as well admit it.

By fifth grade, I had developed a preternatural understanding of how things fell apart. I was too small to go around fixing things like sunken fences or broken pavement, so one day I undertook a project that was quite manageable. I went into the backyard of our rented house and started planting concentric circles of zinnias and marigolds. But it didn't stop there. I discovered the tall wall of paints and varnishes at the hardware store and instead of going to a friend's house to play, I'd go talk to the big men in aprons about my next home-improvement project. After school, I read pamphlets on flowers and bulbs and I set up a little work area in the basement where

I sanded tables and stripped garden furniture and repainted it. I'd taken a wood-working class in first grade, where I'd learned to glue and clamp things together but I wasn't just gluing and clamping: I was halting the downward slide toward dishevelment. I wanted to reverse the chronology of chaos.

BIBI: 1968–1986

I was nine years old in the summer of 1968 when my mother came home from a meeting with her samurai Park Avenue attorneys armed with *The Good Housekeeping Guide to Camping.* That day in New York, she told her attorneys that my father was on the warpath. They smiled their Park Avenue smiles and agreed that my father was a dangerous man. They said it was a good idea for my mother to get out of Dodge. They'd take care of things.

Mother was adventurous and had a flair for the dramatic. With her love of history, she decided we would head west, following the route of Lewis and Clark. We weren't about to hang around coiffed, insipid Princeton with its country clubs and normal mothers. Princeton was provincial, she said, and when pressed, my mother put the whole East Coast in that category. We'd just pack up the car and drive across the country—no pearls, no maids, no big deal.

She chose a good time to beat it. The summer of 1968 was one long season of trauma, bookended by the assassinations of Martin Luther King in April, Bobby Kennedy in June, and the Chicago riots in August. Mother was always forming brief fixations on American heroes, and perhaps because hers had been one of the first classes that admitted women at Harvard Law School, her heroes were usually men. Not small men, but men of vision—chief justices and presidents, Gandhi, Dr. Martin Luther King, Thomas Jefferson, Lewis and Clark. Ironing my clothes before school, she'd turn on the *Today Show.* My hero was Barbara Walters, but my mother went all out for Hugh Downs. Barbara Walters actually looked like my mother, and for some reason I knew Barbara had one hell of a time getting to where she had gotten. A lot of people thought my mother could have gone there, too, or someplace even

better. Her professors at Harvard Law School seemed to think the Su-
preme Court.

When Dr. King died, my mother went into a tailspin, chanting Ne-
gro spirituals and knowing, as did many Americans, that the nation's
brightest light had been snuffed out. About the same time, she tired of
Thomas Jefferson when the stories of his dumbwaiter and his connubial
slave began to remind her of all men in general and one in particular.
When she announced we were going out west, she launched her Lewis,
Clark, and Sacagawea period, deciding that we'd be like a latter-day
Corps of Discovery in a warm, dry station wagon. The story of Lewis
and Clark had everything—adventure, landscape, drama, tragedy, love,
bravery, and at last there was Sacagawea, the guide. Jefferson had, of
course, commissioned the Corps of Discovery, but Lewis and Clark dis-
covered that a woman was essential to the mission. Sacagawea wasn't
sitting around Princeton in a chaise longue working on her base tan.

It was the practical time to go. We were on vacation waiting around
for attorneys who were on vacation waiting around for judges who were
on vacation, so in the meantime, we'd scout out the Oregon coast where
my mother dreamed of opening a bookstore. After a week studying the
guide to camping, Mother made a list, then piled my brother, sister, and
me into the Ford Fairlane her mother had bought her and we headed
over to Sears, where a battalion of buttoned-up clerks greeted us in the
camping aisle. We trooped in and out of huge canvas geometries pitched
on the linoleum floor, fingered the plaid-lined sleeping bags, and sniffed
the ice chests; and before we left, Mother ordered up one of everything
with the brand name "Coleman."

It took us ten days to cross the country and might not have taken as
long if my brother, my sister, and I hadn't argued every day about who
would sit in the front seat. On the second day, my mother established a
rotation system that allowed us time to stop everywhere. We stopped at
the Grange Barbeque in Sioux City where we ate burned meats with real
live cowboys, and the Corn Palace in South Dakota where I bought a
necklace of corn strung on deer gut, which at the time I thought was
disgusting, and Mt. Rushmore, America's most bizarre built landscape,
and the Black Hills where the scenery became scary and contorted.

After a day of mysterious overheating in the Oregon desert, we reached the Columbia River where Mother was finally able to remove the bucket of ice she'd positioned by the accelerator to cool her feet, and her beer, from the heat of the engine. That afternoon the air became heavy with the scent of leaves and moss, so we rolled up our windows. Heading west on Interstate 84, Johnny Cash was on the radio and Mother was in a very good mood. I thought we had finally reached the place she wanted to go, the opening to the Pacific. But no, she said, we had reached a place she'd read about in her books on Lewis and Clark and the *Mobil Travel Guide,* the Columbia River Gorge. By midsummer's half-light, I gazed out the window at a long green tunnel of space, snaking pools of platinum, tall trees, waterfalls, and the biggest moat I'd ever seen.

I learned a lot about my mother that summer. Radcliffe and Harvard Law hadn't taught her a thing about cars or camping, but she'd learned the wisdom of neutrality and the skillful means of dodging certain subjects, or when that didn't work, staging a fit. As far as subjects were concerned, my father and his family would be ruled out of order, and the only exception to the rule was my father's brother, James Gaston. Her voice became wistful when she spoke of him. He was a hero who had rescued us from my horrible father. He was a marvelous dancer, she said. I had no idea what she was talking about, so we drove on.

About an hour east of Portland, we came to a natural land bridge, the Bridge of the Gods, and as I looked up through slapping windshield wipers, I saw a sign that read GIFFORD PINCHOT NATIONAL FOREST. The name "Gifford Pinchot" stirred something, so I got up my nerve and asked my mother who Gifford Pinchot was. For the first time, without hysterics or threatening to stop the car, she answered a question about my father's family. "Gifford Pinchot was related to your father," she said. "He was a man like Meriwether Lewis who'd done good things for our country. He was the first chief of the United States Forest Service and set aside most of the public land in the western United States." I was old enough to know that if Gifford Pinchot was related to my father and he had done good things, he was also related to me. I lodged the name in my brain for safekeeping and wondered if I'd ever hear another word about Gifford Pinchot, and if someday I could say he was my relative, too. We drove on

through the wet night, and I felt as though I'd discovered a special rain-drop sparkling like a prism on the windshield through which I could see another world. There was someone to be proud of in the constellation of my family. Someday I'd escape the tyrannical boredom of places like Princeton and I'd straighten the landscape and I'd do something good for our country like Gifford Pinchot. But for now, driving the slippery roads of Oregon, I decided not to ask any more questions. It wasn't good to get my mother upset while she was driving.

Like Sacagawea, Mother pushed deep into the forest that night and cajoled the whining Corps of Discovery into setting up the big blue canvas tent by a beautiful river. The next morning we continued west along the Historic Columbia River Highway toward Portland. Just before the basalt cliffs of the Columbia River Gorge flatten out into the broad plains of the Willamette, we came to a series of waterfalls, each one lovelier than the last: Horsetail, Oneonta, Multnomah, Latourell, Bridal Veil. These were the last truly audacious natural landmarks the first Corps had reached on April 9, 1806, before reaching the Oregon coast. Lewis and Clark reported the route: "We passed several beautifull [*sic*] cascades which fell from great hight [*sic*] over stupendious [*sic*] rocks. The hills have now become great mountains high on each side are rocky steep covered generally with fir and white cedar. . . . the most remarkable of these cascades falls about 300 feet perpendicular over a solid rock."

I told my mother that Multnomah Falls was the most amazing place I had ever seen, and I didn't know why we needed to get back in the car and keep driving. For me, Multnomah Falls was the end of the Oregon Trail because its bowl-like formation made me feel safe. According to the handsome U.S. Forest Service ranger in his green suit, there were enough stories about that waterfall to think about for the rest of your life. No one ever agreed that the Oregon Trail begins or ends anywhere, but my mother had her argument down: the last stop was the Pacific. Perhaps she was braver than I. She longed for vastness, for the late sun in the western sky, for the marine air to penetrate her bones the way it had when she'd lived with my father in Morocco. Where the great maw of the Mediterranean opens to the Atlantic, she'd had her three children. She'd written guidebooks and articles with my father on the landscape

and the people. But now he was back in Morocco and she was in the dewy muck of Oregon pounding Sears tent stakes into the ground. She didn't know who she'd married. She didn't care anymore. The attorneys were taking care of things.

My mother wasn't a shopper, but she collected postcards, and I collected state banners on sticks, and books on wildflowers, so naturally we went into the tourist trap at the base of the falls. There she found a postcard with the legend of a young Indian squaw, the daughter of the chief of the Multnomah, who married a young Clatsop brave. Shortly after marrying, the squaw dressed in white and, abiding by the will of the tribe's medicine man, leaped off the top of the falls, sacrificing herself to halt the spread of the plague and save the tribe. The legend was a little bit intense for me, so I bought a book on western wildflowers. There I discovered the bright red cardinal flower, the delicate shooting star, and Oregon's state flower, the prickly, muscular Oregon grape that doesn't look like a flower at all.

Mother drove us back to Oregon in the summers of 1969 and 1971. Thanks to the *Mobil Travel Guide,* each time we devised a different route through America's national parks and forests. By the next summer, the backseat started to challenge the front seat rotation policy, and since nothing in the backseat could be worked out without a restraining order, the latter-day Corps of Discovery spent the summer of 1972 back in miserable Princeton. By that time, I was thirteen years old and my interest in straightening, planting, ladders, and paints had evolved into a full-time job painting the exterior of Princeton Day School where I was in the eighth grade.

I never did see ninth grade at Princeton Day School. That fall, my father felt the attorneys nipping at his heels, so we didn't see much of him; but we learned that he wouldn't be paying for his children's education at the expertly painted private school. After throwing a perfectly understandable fit and wailing to her ground force of attorneys, who, for some reason, weren't able to wring tuition out of my father but were able to pay themselves, my mother announced we were moving to the suburbs outside Washington, D.C., where there were perfectly good public schools.

Through the 1970s, my brother, my sister, and I saw my father every so often according to court order and elaborate negotiations facilitated by the attorneys. We'd tiptoe out the front door and over the lawn to pile into his two-seater Peugeot or the king's car and, in my mother's version of things, breathe in all his glamour. We were actually dodging discussions about attorneys and hearing tales of his eggless, butterless life, his weightlifting at Gold's Gym and his runs around the reservoir in Central Park. It wasn't really clear where he lived but he always had the day mapped out. Sometimes he'd take us to the "talkies" to see Charlie Chaplin in *Modern Times* or *City Lights,* the only films he said were worth watching. Other times, he'd take us to big houses with butlers and silver bells above Georgetown to meet people who he said knew his mother. But I was mostly quiet and didn't ask any questions. That might give him the legal advantage.

In the fall of 1977, I had just turned eighteen years old and been accepted to college when it occurred to me that there was something fairly unusual about my parents' divorce. Neither of them would speak to each other and my mother sobbed continuously, saying she couldn't afford to rent a shack, much less a house or an apartment. She'd emerged with nothing and my father had lost his most valuable asset, what he said were some buildings in New York. Still, no one was allowed to mention my father or see him. No one knew who was paying the legal bills, either. My mother thought that her lawyers were doing their work out of the goodness of their hearts.

I enrolled at Newcomb College in New Orleans in 1977. When he died in 1970, Big Bill had left a college fund for each of his grandchildren, which came in handy. I was old enough to be financially independent, but young enough not to know what to do with the money. Two years later, I came up with a creative solution and at nineteen, packed myself off to Italy, defying my mother's mother, who thought that the only place to absorb culture was in her homeland, France, and that Michelangelo, with his rippling displays of musculature, was a vulgarian. Unlike my brother and sister, I wasn't all that fond of my mother's mother, not since the summer of 1977 when she took my brother and me on the grand tour of Europe and discovered, while in Lucerne,

that instead of taking my afternoon nap at the hotel room, I'd disappeared up Mt. Pilatus on a gondola ride with a man named Hans. In Italy I ran wild, telling her I preferred Italians to Frenchmen because the Italians made gaga eyes at me while the French did zero. She had the last word. I had terribly good taste, she told me, in everything but my father.

Michelangelo wasn't one of my mother's heroes, either, but on the eve of my departure for Italy in the fall of 1979, she gave me a handwritten note with the words of Bernard Berenson, nicknamed Bibi, a Harvard scholar and Italian Renaissance art collector, who, I discovered later, was born Bernhard Valvrojenski, oddly enough, a cousin of Morris Gest:

> Now I am in the decline of my eighth decade and live so much more in the people, the books, the works of art, the landscape than in my own skin, that of self, except as this wee homunculus of a perceiving subject, little is left over. A complete life may be one ending in so full an identification with the not-self that there is no self left to die.

While I was enrolled at the School of Political Science at the University of Florence, I kept the quote by my bedside, reading it over and over and trying to understand what Berenson meant but also what my mother meant by giving it to me. Looking out at the hills of Fiesole and Berenson's villa, I Tatti, I dreadfully missed my college boyfriend, the man my father called "Allen the Red." But I reasoned that if I was to become a "wee homunculus," I would need to study and travel and forfeit things like marriage, pregnancy, and other distractions where women lost their way. I'd become an explorer, a nomad, and focus on the paintings of Andrea Del Sarto, the politics of Italy's Brigatti Rossi and I'd master the "passato remoto" that no one ever mastered. My mother had entered a difficult, perimenopausal, Sylvia Plath period and my father didn't know where I was—but I didn't know where he was, either, so I decided not to cogitate on my nonparents. Instead, I'd become smart and write papers on the psychodynamics between Henry Kissinger and Richard Nixon, I'd memorize the capitals of foreign countries. I'd learn about topography, forests, and gardens. I'd begin my life with a full identification with the not-self. So full, I'd disappear.

I graduated from college in the spring of 1981 with a degree in political science and a love of photography. I moved back to Washington where from time to time I'd see my father, who thought I showed signs of talent so he bought me a rudimentary darkroom. I was working at an architecture firm, taking photographs of Andy Warhol and immigrant parades as a stringer for the Prince George's *County Sentinel* on the weekends. I found an Italian boyfriend who bought me red roses and who talked about his heroes, Mies van der Rohe, Walter Gropius, Frank Lloyd Wright, and Thomas Jefferson. He'd call me Berenice after Berenice Abbott, the photographer. I was twenty-two and he was thirty-two and I had fallen in love, but mostly with the things we talked about, things like form and the quality of light hitting trees. I became mesmerized by Eugene Atget's photographs of the parks around Paris and I began to be haunted by landscapes, so I spent hours taking photographs on the Mall and walking by myself in the upper reaches of Georgetown where, between 1923 and 1933, Beatrix Farrand designed one of America's most complex gardens for the ambassador Robert Woods Bliss and his wife, Mildred—Dumbarton Oaks.

Things were going along just fine until one moonless night my rose-toting architect called me to say that he had the opportunity to go back to his ex-girlfriend, who had suddenly become free. While the two of them went tooling off to a romantic weekend on the eastern shore, I found myself with a turbaned taxi driver speeding through the rainy streets of Washington, D.C., to spend the night with my mother. I was devastated, and she knew that kind of shock firsthand. Are you sure he wasn't gay? she'd ask. Maybe he was depressed. Maybe he will come back. After I assured her he wasn't and he wouldn't, she told me that it was a good thing to love a man. It was better than feeling sorry for him like she had for my father.

It wasn't the first time I'd been left, but it was the first time I wrestled with how someone could tell me that he loved me, then vanish from my life without a credible explanation. For months I walked around like a corpse, but then something strange happened. I saw the rose-toting Italian wherever I went, or at least I thought I did. Launching my Cartier-Bresson period, I started shooting shadowy pedestrians and capturing

mysterious moments on the back sides of government buildings. My father didn't want to see his darkroom dollars going to waste, so he asked me how I planned to make a living on shadows.

Soon enough, I got a real job as a lab assistant at the Museum of Natural History at the Smithsonian Institution. Each morning I sailed down Washington's towpath on my bicycle to work, and sometimes I would pass my father in his Jeep or the Peugeot crossing the Key Bridge. He was living the life of a mole in a subterranean cave off MacArthur Boulevard, while ostensibly working at an outfit in Arlington that dealt in ships' diesel engines, and seeing a woman who worked for the Moroccan embassy. When we passed each other on the bridge, we'd simply wave. My mother lived just a few blocks away, barely surviving as a paralegal for the nastiest pack of lawyers in town. In the evenings she'd sedate herself with wine and the *Washington Post* and tell us that if any of us saw my father, she'd kill herself. So my sister cut my father off completely, calling him a Nazi; my brother saw him on the sly from time to time, as did I. But I was learning that what people said and what they did were two different things. My mother didn't kill herself, but my brother and sister felt it their duty to tell my mother I'd seen my father whether I'd seen him or not.

When we saw each other, my father and I both had our own agendas. Sometimes I'd meet him at Clyde's, a marble and wood-paneled restaurant in Georgetown, to ask him for money. He wanted information from my mother's attorneys, he said, about where all the money had gone that was supposed to go to my mother and to us. He'd order up his dry martini, two olives and a twist, and whip out a stack of legal papers; if I didn't sign his affidavit, he wouldn't help me in what he called "the financial department."

I enrolled at the University of Virginia's Department of Landscape Architecture—Charlottesville in the summer of 1983. At twenty-four years old, I had an intimate relationship with Thomas Jefferson, thanks to my mother; a portfolio of shadows and light, thanks to my father; and thanks to Beatrix Farrand, a career plan that sounded a lot better than dodging parents, siblings, and ex-boyfriends in northwest Washington, D.C. That fall, at Virginia, I met a young woman named Silvia Erskine.

After studio, we began running together, and between classes we talked about love, boyfriends, Italy, and professors we thought were handsome. I had never met someone whom I felt I'd known all my life. Silvia was tall, poised, and good-tempered. She dressed simply and in good taste, wore little or no jewelry, and kept her hair in a bob. Her mother grew up in Florence, Italy, and her father was a famous editor and a native of Memphis. Silvia had grown up just off the Merritt Parkway, in Westport, Connecticut, in a dignified world where books and history and gardens mattered and where, on visits, I'd sit down to dinner with the likes of Robert Penn Warren, Ralph Ellison, and Cormac McCarthy. On break from the university, I'd drive north from Virginia, spin around the family vortex on Washington's beltway, and head for Connecticut. I'd run into car trouble along the way, and once I broke down on the Merritt Parkway. Its gentle alignment coils through the deciduous forest of southeast Connecticut like a serpent, making for one of the prettiest drives in New England and one of the most historic. But the Merritt, Silvia's father, Albert, told me, was the best and worst of roads. It would be better, he said, to break down on the Indianapolis Speedway.

After several gallant winter rescue missions, Albert Erskine grew a bit tired of my car troubles, and I became embarrassed. His writers came and went with their manuscripts, and I came and went with my car stories. On an icy winter day, I broke down again, this time in New Canaan, and called the Erskines from a pay phone at exit 37. I stood shivering by the side of the road and looking around at the landscape of wintry trees when memories of my grandfather came flooding back. Before my father left, we spent Christmases at Big Bill's old stone house in New Canaan on the Silvermine River. Big Bill gave my mother kangaroo rugs and purses from Australia. His fourth wife, Teddy, kept the name Getty squeezed between Teddy and Gaston, the Getty from her previous marriage to J. Paul. I recalled her Christmas presents, ribboned packages wrapped in red velvet from New Canaan's fancy department store. She had made Christmas magical for me as a child. In 1970, my mother drove us to New Canaan for the last time. I was eleven years old when I kissed Big Bill's red, swollen face good-bye. A few days later he died. As the story went, he died the way he lived, making last-ditch passes at the nurses.

Between 1983 and 1986, the family drama around Washington, D.C., was unpleasant enough that I didn't have a home to go back to. So I hightailed it for Connecticut where Silvia and her parents didn't know if I had a family or not. Through the years at graduate school and holidays spent with the Erskines, as inseparable as Silvia and I became, she still knew virtually nothing of my life.

One day in May 1986, all that began to change. The day we graduated from the University of Virginia, my father showed up in his usual fashion, unannounced, driving a white Thunderbird with his Moroccan bag, a clutch of bananas, the *New York Times,* and a Rolleiflex on the front seat. This time he showed up with my brother. I remember being happy to see them but distinctly disappointed by the Thunderbird, a low-slung domestic car that he admired for its sweeping lines and reliable engine but that I thought looked like a porpoise.

I remembered everything my father ever told me. He frequently mentioned the names of people he said were his relatives, names like Eno and Sedgwick. They seemed always to be lurking around the bend with what he called their "vast wealth." Sure enough, there were Gastons rusticating in the horsy hills of Charlottesville, but he told me he wasn't going to go see them. The ties to the Gastons had been severed long ago, over money, he said, so there wouldn't be much to talk about unless one wanted to talk about the weather, or the $7 million the Colonel left. Or how his father got left out of the will, which left him out also.

I'm not sure whether my father thought of himself as the black sheep son of a black sheep father but he always seemed to know where the white sheep had gone. When I'd visit him in his Washington cave, I'd notice articles about an illustrious relative, or people once married to the relatives he'd met once or twice, articles clipped from the Style section of the *Post,* about people like Tony and Ben Bradlee and Ben's new wife, Sally Quinn. He'd clip book reviews on people long since dead and who were somehow related to him, like Mary Pinchot Meyer and Edie Sedgwick. He'd clip the lengthy obituaries of the friends of Rosamond and Big Bill's, like Kay Halle and Lady Diana Manners and the Barrymores and the *New York Times* science reporter, Bill Laurence. He'd clip the articles like teenagers clipped stories of their idols, but he'd rarely contact those names from the past

because they were either dead or not particularly interested in him. Like ghosts, they were lingering about, somewhat benevolently at this point. They inhabited their world while he inhabited his, but he knew where they were just in case, if he was ever in the neighborhood. He'd never call first, he'd just show up. Displacement was one rugged terrain and his clippings were like survey markers to all that had gone by, to all that was lost.

I never asked about who all those people were because I'd never let myself believe that they were my relatives. I treated his clippings unkindly, by rolling my eyeballs, like he lived in a fairy tale. So I didn't read the articles or make sense of who these people were. Perhaps I was still wanting the king's car to become a station wagon with fake wood paneling. I wanted my father to go to work in the morning and show up in the evening, and I didn't want to call him Papa.

A few days after graduation, Silvia asked me to dinner at the Caseys, her fiancé David Radulski's landlords, who lived close to the architecture school. Everyone was packing up and leaving for the summer, but I was in no hurry to leave because I didn't have anywhere to go, so I accepted the dinner invitation. That night, Silvia and David picked me up and we drove over to an old country house in a gracious neighborhood in Charlottesville. As we entered, Silvia introduced me to our hostess, Rosamond Casey, who went by "Ros," and her husband, John Casey, a novelist and professor of English at the university, and several other dinner guests. As the party moved about the house, several old prints caught my eye on the wall of the entrance hall, so I lingered over them and made out the name Rosamond Pinchot, and beneath it, Mrs. William Gaston. The advertisement identified Rosamond as a driver of the "New Century Hupmobile." I knew the name Rosamond, and the name Pinchot, but I had never put the two names together nor had I put them together with my father's name. I knew there were about six William Gastons, but I didn't know how this William Gaston was connected to the woman in the picture who appeared to be some kind of celebrated driver. According to what was written, she'd had a corner table at a restaurant called the Voisin and sped off in motorboats to an island off the coast of Maine. I was confused and disoriented. What was this advertisement doing in a house in Charlottesville?

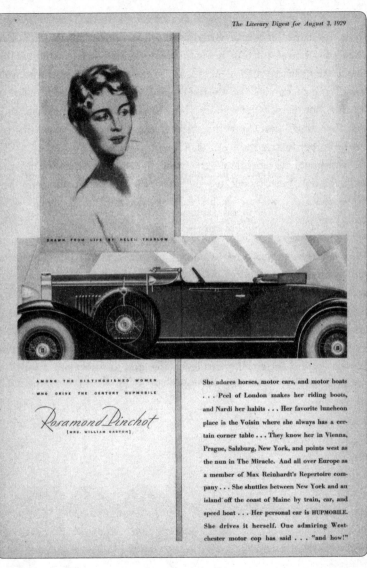

Ad for the Hupmobile, 1929

After a few minutes I joined the guests at the dinner table. Still dizzy from the names, I noticed Rosamond's husband, John, looking at me. "She looks like a Pinchot," he said. I was embarrassed and told the table that I might be a Pinchot but I wasn't really sure. The Pinchots were some kind of relatives of my father but I didn't know them or know much about them. After a short while, Rosamond and John established that the woman in the advertisement was my grandmother and that my grandmother Rosamond was this Rosamond's aunt.

My father never mentioned the name Rosamond Casey when he came to graduation, perhaps because she wasn't a Gaston who ran around the horsy country with vast wealth. Rosamond was just a few years older than I was, an artist, and his cousin Tony Pinchot Bradlee's daughter, so he might not have kept tabs on her. If he had known that he had a cousin who had been named for Rosamond, his mother, he certainly never let on. In the web of family confusion and information blackouts, it was very possible I'd missed things, but I certainly hadn't missed the fact that I had a cousin who'd lived down the street for the past three years. A cousin who shared the name Rosamond with my grandmother and who had pictures of my grandmother on her wall taken the year my father was born, a year no one could forget for its joys and sorrows, 1929.

CYCLE TWO

A SYNONYM FOR LOVE

I once told a boyfriend, a Canadian, that longing isn't love, it's longing. Cantanker-ous and surly on his good days, he longed for someone who had vanished. I considered myself an expert on matters of the heart, so I gave him my opinion: a living, breath-ing definition of love requires the beloved to be present. We may still love someone who has died, but that is different. Loving someone who is alive but isn't around seems to me like a waste of time and sets up a chain reaction. I longed for him, he longed for her, and she longed for someone who, for all I knew, might have been the man in the moon.

Longing has all the intensity of love, but it is dark whereas love is light. Longing isn't fluid; it is static and impenetrable. It isn't buoyant; it's leaden—and ready to pour its way into cracks of emptiness like barium or lava. When the loss of someone is staggering, when someone has completely vanished, longing becomes a replacement for love.

The energy of love needs to go somewhere, so many things offer themselves up as surrogates. Rosamond longed for Bill to be a decent, gentle husband. My father longed for his French cars, the Salmson, the Delahaye, and various rare Peugeots. He longed for Maine in August when half an hour before dark, the light dropped down from the west and bounced over the coves before it landed on the beach at Crane Island, where it turned everything a flaming shade of red like roses he'd seen in the

desert. He longed for the old green punt, which had served him well, and his 45-horsepower white outboard, Old Faithful, *once beloved and true; it had somehow failed him at the worst possible moment, so, like a lover scorned, he'd first lose faith, then lose interest and lean his little failure up against the boathouse to rust. Soon after he married my mother, he longed for women in faraway places. That set off an epic chain of longing. Or maybe the chain began before my father's disappearances, before Big Bill's disappearances, even before Rosamond's untimely death. Perhaps the longing began with Rosamond's father, Amos, maybe with his father, or his mother. The chain of longing may go farther back than any of us know.*

My father was the first man in my life to stage a vanishing act. The rest, I suppose, have been a variation on the first. Friends said I chose men who would vanish. There one minute, gone the next. I'd long for a while, then, as my longing subsided, I'd experience sightings like I'd seen a ghost: driving next to me in traffic, walking along the street, or grazing in the vegetable aisle at Whole Foods.

Perhaps longing is a precursor to rebounding. Some women are all business when it comes to a rebound, attacking the situation like an algebra problem or a spot on the rug. Some take trips, employing the geographic cure. Among nature's synclines and anticlines, longing stands little chance of holding on. One might take a stubborn case to Maine, where it washes away with the tides at full moon. Try exposing it to a stiff nor'easter. I've found the best place to take my longing is where the landscape longs for itself, where glaciers and forests are vanishing, where the extinction of wetlands and songbirds puts human longing in perspective, where the landscape is so grand and fascinating, there isn't time enough to dwell.

Perhaps the best cure for heartbreak is some combination of forgetting and remembering. The easy part is to forget the scoundrel, how handsome he was in his raccoon coat. The hard part is remembering ourselves, that before the life we know, there was a life we had, and the pieces are scattered all over the place. Step by step, we move forward, remembering who we were, discarding the old, cultivating the new until one day we wobble forward on tender hoof into a grassy clearing with an overlook, a prospect where the view goes on forever.

Rosamond

ROSAMOND: 1929-1934

On the good days, usually Saturday afternoons in the fall when the light and the air in Manhattan are tied for first place, Rosamond and Big Bill would steal away into the corner of some old, dusty bar in the theater district, throw back a double round of old-fashioneds, and, five minutes before curtain, run across the street to a matinee. She said on those days, the good days, that being with Big Bill was truly living. He was the only man for her. On the bad days, she wanted to rip his eyes out.

On the good days, it didn't matter what he said or did; she believed in herself and her ability to bring good things to their marriage. She looked in the hall mirror at 444 East Fifty-second where they lived with Little Billy and liked what she saw: the golden locks that framed her soft, round features, her full lips, her long-legged athletic physique and

the way she held herself, regally and with poise. She forgave herself those things she didn't like, her potato nose and her thick calves because, what the hell, she was a lot better looking than most women. Men noticed her, so she knew she must be something special.

On the good days, the inner and the outer reached a kind of synchrony. The melancholy subsided, passion showed on her face, and hope made an end run around the unknown, around the million little insecurities a woman keeps hidden from the world but mostly from herself. She not only knew just how much she had figured out about life by her mid-twenties, but she knew that even if Big Bill couldn't take care of her financially, the way most women expected, she could take care of herself. She hadn't married for money; she'd married because she loved him and they understood each other. If worse came to worst, all she had to do was lean on the doors of fate, and Providence would open up to greet her. There'd be love, there'd be work, and there'd be money. When one is young and beautiful, life unfolds that way.

On the good days, she would look over at Big Bill on their walks through the Ramble in Central Park and like what she saw. She locked arms with him at parties in New York and traveled with him back and forth to Crotch Island where they'd till and harvest and throw seaweed on the vegetable plots for mulch. They'd nibble herbaceously like rabbits al fresco, squatting and gazing at each other between rows of lettuce and spinach. He was there, so she thought she'd never know the Cinderella loneliness again or the eyes that followed her. She had a husband, and the days on balance were mostly good days.

At twenty-five years old, Rosamond had a nose for business and on one of the confident days, she purchased two pieces of real estate on the southeast corner of East Seventy-fifth Street and Second Avenue with her earnings from *The Miracle*. It was the same year that Little Billy was born. Not many people were confident about anything in the late fall of 1929, but Rosamond had a suspicion that if he was lucky, someday Little Billy might come into some real money from her investment. She had faith in the future for his sake, faith that tomorrow would show up even more handsomely than today. She had learned about smart investing from her grandmother, Mary Eno, whose father, Amos Eno, made his

money back in no time by collecting rental income on his holdings. Real estate, particularly Manhattan real estate, was never a folly.

January 24, 1931, was another of the good days, when the *New York Times* reported that Mr. and Mrs. William Gaston and Clare Boothe Brokaw threw open their neighboring apartments at 444 East Fifty-second Street for an after-theater supper attended by some of New York's most highly sought after dinner companions. The fifty guests that night included the Hamiltons and the Nasts and the Hearsts and the Krocks, the Warburgs, the Lamonts, Walter Lippman and Mrs. Douglas Fairbanks. Clare's publishing people mixed seamlessly with the Gastons' friends from the theater world.

But despite the sumptuous meal, the perfectly appointed table settings, and the three indisputably glamorous hosts, people weren't gossiping or gay; conversations covered dreary, depressing topics such as Manhattan's bread lines, personal financial ruin, and what, if anything, the government intended to do about it. Herbert Hoover was predicting that prosperity was just around the corner while promoting public-private partnerships and volunteerism to stem the misery of the poor and the unemployed. The do-nothing party season could be laid at the foot of the do-nothing president. Even Manhattan's gilded party crowd felt the pinch. Clare Boothe Brokaw knew things just weren't right, even for her.

It was a trying time for a woman on the prowl. While many women's dreams of grandeur were going down the drain with their husbands' fortunes, Clare Booth Brokaw, the ambitious socialite, writer, and managing editor at *Vanity Fair* magazine, had done just about everything a woman should do not to become one of them. She had received her divorce from her millionaire husband, George Brokaw, in 1929, so with a nicely paid position at the magazine plus the settlement, she was in good shape. Under no circumstances was Clare Boothe Brokaw about to let the worst days of the Great Depression become the worst days for Clare Boothe Brokaw. She was one of the women who attacked life with a sledgehammer. She didn't sit around longing for a man who had vanished; she'd zapped her ex like a spot on the rug. So, on the night of the dinner party to die for, Clare kept one eye on the canapés and the other on the men in the room.

Many knew that Clare hadn't married for love when, at age twenty, she married George Brokaw, the son of multimillionaire Isaac Vale Brokaw, a clothing magnate whose French gothic château dominated the northeast corner of Fifth Avenue and Seventy-ninth Street across from Central Park. Admitting that she wanted to jump out the window of the Plaza Hotel the night she married her husband, Clare Boothe hadn't married George, she'd married the name, address, and bank account of one of New York's most eligible bachelors, a man almost twice her age. The Brokaw Mansion, located at the epicenter of Millionaire's Row, was about as good as it gets for a woman determined to stage a ground assault on Manhattan and described as being about as feminine as a meat axe.

The design of the Isaac Vale Brokaw Mansion at 1 East Seventy-ninth Street was based on the French Château Chenonceau, a spectacular castle dating to the early 1500s. Chenonceau bravely straddled the Loire River and became known as the "château of six women" because, over the course of four centuries it was under the control of six powerful women including Catherine de Medici and Diane DePoitiers, who constructed four fabulous triangles of flowers, tapis vert, and other acts of extreme Frenchness adjacent to the château. Constructed in 1890, the Brokaw Mansion was unusual for a house of the period, and highly unusual for Millionaire's Row, not because it had huge, airy, well-lit rooms, four stories, an attic, a basement, and a sub-basement but because it had its own moat that wrapped around its foundation—that is, until a horse fell in and Isaac Vale Brokaw enclosed it with a stone wall. Soon after she moved in, Clare wanted to demolish not just the stone wall but the entire Brokaw Mansion. According to her editor, Donald Freman, her husband George prevailed and kept the wall by deferring to his mother, who still lived at 1 East Seventy-ninth Street. Meanwhile, Clare persevered, making needed improvements to the interior of the castle like a woman possessed. Second only to a moat or portcullis, the wall wasn't a bad feature for a woman who mucked around in the world of men whose love was about as murky as pond ooze.

Most women experience at least a brief pang of longing when they learn that an ex has moved on and married someone else. To substantiate her dictum that "no good deed goes unpunished," on January 10,

1931, just a few weeks before putting the finishing touches on the menu for her celebrated dinner party with the Gastons, Clare learned that her ex-husband, George, had married Frances Seymour, a young, glamorous Massachusetts socialite. Although it appears that she never really loved her alcoholic bore of a husband, Clare took the news like a woman scorned. She wrote in her diary how she wished the couple the worst and hoped they would never experience a happy moment together. But after her private rant, Clare probably composed herself, and with her self-professed "rage for fame," composed a mental list of eligible men. Clare being Clare, and Bill being Bill, it wouldn't have been a surprise to see Big Bill's name on that list.

At first, Rosamond couldn't quite put her finger on what it was about Clare she distrusted; after all, they were neighbors, not quite friends, but friendly. Perhaps it was Clare's unquenchable thirst for men or her sense of competition. According to Clare, she, too, had met Max Reinhardt in April 1923, crossing the Atlantic on the SS *Majestic,* just six months before Rosamond met him on the *Aquitania.* Clare claimed that Reinhardt had asked her to play the Madonna, and she claimed she would have, had the part not mysteriously gone to Lady Diana Manners.

Rosamond couldn't compete when it came to Clare's killer instinct for men, but she knew she needed a backup-man plan for the times when Bill couldn't overcome his bouts of grouchiness or forgo his frequent disappearing acts. In mid-April of 1931, Rosamond chaired a benefit for the Halton Fund featuring a "Carnival of Imagination and a Pageant of Romance." Entertaining New York's A-list at the Plaza Ballroom, she dreamed up a theme for the pageant, "The History of Love and Romance," in which guests were directed to appear in costume as heroes and heroines of love, from Greek mythology to the present. But no pageant was complete without a contest, so the contest chair posed the guests a question, "What is love?" At the height of the evening, a contest winner would be announced.

That night while the who's who of New York paraded around in their masks and the latest Paris fashions, Rosamond masqueraded as the Spirit of Love and wore a blue traveling suit similar to the one she had worn the day she married Big Bill. She called her outfit the "costume of

a modern bride," only this time, instead of ten minutes of protocol performed before the justice of the peace, she staged an elaborate mock wedding ceremony complete with dutifully costumed attendants played by New York's wealthiest and most powerful women. If there were whispers coming from the corners of the ballroom of the Plaza Hotel that night, they concerned the fact that the role of Rosamond's fiancé wasn't played by Big Bill. The old grouch was nowhere to be found. Her fiancé was played by John Davis Lodge, the handsome actor and grandson of Henry Cabot Lodge who had trounced Bill's father, the Colonel, in the race for senator of Massachusetts. The younger Lodge, like Big Bill, had graduated from Harvard, received a law degree, then served in the navy and married Rosamond's lithe and lovely dancing friend, Francesca Braggiotti. With a world-class ego and lineage to boot, Lodge dressed up as the Spirit of Youth and met Rosamond, the Spirit of Love, at the Carnival of Imagination's Altar of Love. Onstage, Lodge looked triumphant.

Although Rosamond couldn't explain the absence of her husband, still the resplendent panorama of romance proceeded with a parade of gods and goddesses, including Jupiter and Juno, Apollo and Venus, Osiris and Isis, Helen of Troy, and Ulysses plus miscellaneous historical figures such as Gandhi, who made his cameo appearance as the love of government. One and all agreed that the pageant was a spectacular success and cheered the night's contest winner, a Mrs. Juliana R. Force, who defined love as a "great happiness and much serving."

In what seemed to be an unending season of denial, no one from Herbert Hoover to Big Bill Gaston seemed to want to tell the truth about anything. More than one quarter of the nation's money supply was hidden under mattresses, and people throughout the country were hoarding food and supplies in expectation of the worst. Big Bill established his regular schedule of vanishing and hiding things like where he was going, what he was doing, and with whom. About the time Rosamond and Bill realized that she was pregnant again, Rosamond's marriage to Big Bill wasn't just struggling, it had pitched itself on the rocks.

December 14, 1931, just eleven months after the Carnival of Love, Rosamond was having one of her worst days. In the middle of the night

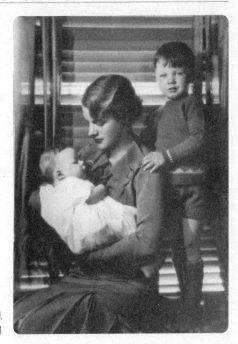

Baby James, Rosamond,
and Little Billy, circa 1931

before her second son, James, was born at York House in Manhattan, she was bedded down when the phone rang. She couldn't imagine who would be calling her at that hour, but unable to sleep, she picked up the phone to hear the voice of a woman who asked for Big Bill several times but refused to identify herself and then hung up. Rosamond was furious. Big Bill wasn't even around to answer the phone when his other women were calling.

She too managed to survive by denying there was anything wrong, believing that the good days were just around the bend. Three weeks after the birth of James, on the day after Little Billy's third birthday, she was at home at 444 and distraught but didn't tell anyone. Instead, she wrote and wrote deep into the night. She thought about how the days passed comfortably and the apartment was so lovely as the sun poured in the windows. She mused on the pleasant little roof with its beautiful views of the East River and the dear little Watanabis with their good

food. It was all so consoling, but after about seven in the evening, when
Big Bill got back from the speakeasy, things got ugly:

> By this time, 11 o'clock, I'm sunk every night it seems. It's so dreary living
> next to a person and hardly speaking to them because you know there
> is nothing but nastiness between you. When we are alone, we haven't a
> word to say. So we sit in silence. Bill left another of his handkerchiefs
> with lipstick around today. Why the hell must he do that? I feel cornered
> sometimes. Desperate in any direction. I can see nothing but loneliness
> and heartbreak at least for a while.

Women's flirtations, like those of their so-called friend Clare Boothe
Brokaw, were only a part of the problem. Big Bill left a steady stream of
clues about the women who were more than just casual acquaintances.
At his speakeasy, nights past midnight were common, but there were
nights he never came home at all. When Rosamond asked him where he
had been, he told her it was none of her business. He didn't need anyone
to ask where he was going or tell him what to do or to notice he wasn't
doing anything or to make him stop whatever he was doing, which was
what the Gaston family had always done, famously.

There are funny drinkers and sloppy drinkers, and there are mean
drinkers. And then there are mean drinkers who have someone else
waiting in the wings. Big Bill was one of those. He was the kind of
drinker who grew more and more silent but turned up the heat with
every word. Bill made comments and barbs that brought out the worst
in Rosamond, brought out her defensiveness, her sense of indignation
that Bill owed her more than his vanishing acts and his nicknames. He
compared her to his other broads. Their sweetness, even their nick-
names, Biche and Devil McNasty, had vanished. On the bad days, she
realized that what she had was a skeleton of love.

She'd say she wanted a divorce and he'd say he'd take the boys and
they'd rant and rave and she even bit him once in the middle of the
night, but he didn't really pay it any mind. There was nothing she could
do to stop him from doing what he did. Instead of walking away, Rosa-
mond engaged him like a boxer in the ring. Coming from a family of

boxers, Big Bill knew just how to keep her off balance, to give her just enough to keep her wanting something he never intended to give. He'd always have one foot out the door. When he was out, that's when her love turned to longing, which really wasn't love at all. But when he was in, they'd fuss and fight and in the middle of the mayhem, he could turn sweet and tender, proclaim a cease-fire, become the underdog, get up, prepare a tray with fruit salad and little toasts and bring them back to the bedroom like a peace offering. For half an hour everything seemed normal. They'd hold each other for a few fierce moments and with a tear rolling down her face, they'd make love, a love that never really resolved anything because the next night the whole damned performance would repeat.

Friends of Rosamond's knew about Big Bill's drinking, but in the years leading up to the repeal of Prohibition in 1933, Bill and his friends were drinking more than ever. Still, friends didn't know about his meanness. To them, he appeared charming. Rosamond knew the other side. He'd say things, things she couldn't forget, after which she said she felt "a bit cracked somewhere." On the night of May 26, 1932, Bill

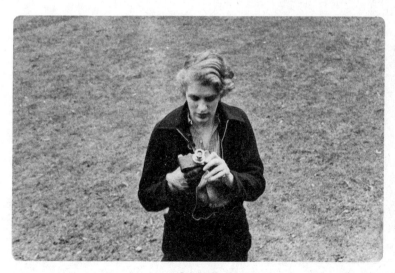

Rosamond

told her that everyone found her dull and that she was the "world's worst bitch." She could usually control herself, but that night she hurled a flowerpot and a telephone at him and fought back with her own litany of insults. That was the night she told him what her doctor had told her that day, that she was pregnant again, and that if she was smart, given the state of her marriage, she'd do what she needed to do to end the pregnancy. And she was smart, so she began to take the "medicines" the doctor prescribed, but they weren't enough. At Mordkins dance class, she jumped up and down doing everything to try and get rid of the thing she feared had started. Meanwhile, Bill didn't have much interest in the situation. Rosamond wrote, "I am just another of his girls having an operation."

On the same day Rosamond was photographing society women and their babies for Eleanor Roosevelt's magazine *Babies—Just Babies,* she took twenty grams of quinine and trotted her mare ten times up and down the hill above Grey Towers. The next day, and still nothing, she went to see the doctor again. "He still has hopes these many pills may dislodge the poor tiny life that is so unwanted. Nothing could make me have this baby. Then why can't I just force it out? No I guess something drastic must take place next week."

On June 3, Bill stopped by the apartment in New York and strode around saying nothing. "Not once has he referred to my having to have this beastly operation," she wrote:

> Not once has he expressed the slightest concern or interest. How typical of him! I long so for some man. Not to be made love to but just to be close and friendly with. I used to feel that way toward Bill. We had such fun and so many jokes. Now there's this emptiness. No one in the world to kiss, no one to give all the tenderness I have to give.

Rosamond checked in to Doctor's Hospital on East End Avenue at Eighty-seventh Street, where, on the morning of June 9, she was given a hypodermic that made her feel slightly drunk. Still, she remembered the details. A black rubber cap was put over her face that made her want to scream and push it off when slowly the marvelous "nothing matters"

feeling came over her and she slipped away. When she came to, she wrote, "My first feeling was of disappointment because I hadn't seen and known more."

Flowers came from Bill and he offered to come to the hospital, but she said no. The flowers reminded her that he found it easier to send flowers than to be kind and helpful. After spending five days of prescribed bed rest in the hospital, which gave Rosamond plenty of time to think, she made her decision. She'd move out from the apartment at 444 the following Wednesday and go to Reno for a divorce.

Moving day. I up early. Yesterday a letter came from Bill enclosed in a tin box that held poor old Felix the plush cat who we used to have such fun over in our early days. On Felix's arm was the wedding ring, pathetic. Yet I was glad. The letter was strange. Bill suggested I come back to him so that he could get an aviation job with Roosevelt. He said we'd start again on a new basis but made no pretense of offering anything concrete. It was a sort of business letter. So this morning I went around to 444 very weary and we got to talking about dividing up the furniture. He grumpy. Then we talked about his letter. I said I couldn't start again having lost faith in him. He feels his career blasted by this marriage. Poor fellow he wept so. Then I made a great mistake. I told him I was or rather am in love with someone else. That was bad business. His face got hard. But after all why not end all this once and for all. I'm afraid that as a husband he'll always be a failure. And how darling I used to think him, how wonderful. Now as I write I find myself longing for him and a little bit of the old feeling comes back just enough to make my chest feel strange. Oh Bill dear—poor Bill. He's probably in bed with some girl.

On the day she left Big Bill, Rosamond went to Lord and Taylor and bought herself a white net evening dress for $29. Like their marriage, their separation was picked up quickly by the press. The *Sunday Mirror* announced, "He Wed Two Stars but Couldn't Stand the Eclipse." Big Bill, they said, had "hitched his wagon to a star" one too many times. The article proposed a question to its readers: "Can a husband stand to have a wife outshine him? William Gaston found

he couldn't be Mr. Kay Francis or Mr. Rosamond Pinchot." Nobody
came away happy with that article. Except maybe one person, Clare
Boothe Brokaw.

No sooner did the articles appear than Clare hatched the perfect
plan to rent Big Bill's Crotch Island love nest for the summer. Clare
knew a romantic base camp when she saw one, so that summer she
made her way fifteen miles out to sea where she swam, wrote, listened to
sonatas on a rusty Victrola, and entertained her latest conquests under
the swaying spruce. Her guests included the conservative political
observer Mark Sullivan, a recycled beau named Kerry Skerritt, and
William Harlan Hale, a devilishly attractive writer who, for some rea-
son, took it upon himself to help Clare dye her hair in the bathtub with
chemicals by candlelight, and in the process, came perilously close to
setting the island ablaze. Clare kept a close tally of Crotch Island no-
shows, among them, the presidential adviser and financier Bernard
Baruch, and the vice president of William Morrow, Thayer Thompson,
about whom she complained, "Thayer says 'I adore you' as other men
clear their throats." Meanwhile, Clare's editor, Donald Freeman, also a
no-show, was just plain annoyed at the whole island escapade. Suspect-
ing Clare was distracted, Freeman cabled Clare in nearby Vinalhaven, "I
suppose you are in the throes of illicit love otherwise I would have had
a letter from you detailing your bucolic existence." Clare's bucolic exis-
tence on Crotch Island wasn't all that bucolic because Big Bill kept barg-
ing in, ostensibly to check on the boats and, according to her side of the
story, to make his advances. Big Bill was good for an occasional snog in
the bracken ferns or the seaweed but his highest and best use was fur-
nishing Clare with the keys to the house on Crotch Island. Clare knew
Big Bill made an acceptable landlord but an unpredictable lover, just like
Kay Francis knew he'd made a lousy husband but a great date. "The
depths of him are like the depths of me," Clare wrote in her diary,
"shifting sands, and we each need an anchor, and we could not anchor
ourselves to each other."

After their separation, Rosamond still saw Bill with his broads at
their elegant Manhattan venues. She arranged the schedule for the boys
to see their father, but there was hardly a doubt in her mind that she'd

done the right thing by leaving him. She was free from Big Bill's midtown Sodom and Gomorrah. She was liberated from Clare's colorful antics. She could look in the mirror again and like what she saw. Big Bill wasn't husband material and someday she'd make the trip to Reno to finalize things, but now she'd break her daily interactions and pull herself back together. She'd try to forget the longing or the love or whatever she felt for Big Bill.

First things came first, so first she went shopping and bought herself a new wardrobe to supplement the white net dress. Next, she marched down Park Avenue to East Sixty-second Street where the woman she called her best friend, Bessie Marbury, a mercurial publicist and literary agent, had organized New York's first social club for women, the Colony Club. Aunt Cornelia and Rosamond's mother, Gertrude, and everyone who was anyone was a member, so Rosamond, interested mostly in the indoor swimming pool, a speedy elevator, and a kennel to attend to little Nicolette, signed up for a series of treatments to have her body pulled and rolled like an oat by a great big machine that looked like a medieval torture device. "Each morning I go to the Colony Club and take the roller," she wrote. "Mother bought a course but can't take it. It's a funny business, one stands and heavy springs are run up and down over the behind. There is pain attached to it but I feel very virtuous."

Time, distraction, and the roller brought forth a refurbished Rosamond who seemed open to the possibilities of a new love, but for the time being, she would settle for a full calendar and a new round of beaux bearing gifts. Just like in the *Miracle* days, photographers caught her bounding up and down the avenues, grazing at the vegetable place downtown, and taking Little Billy to his favorite sledding hill in Central Park:

The hill on 79th Street is very steep, and I always thought it very dangerous. I made Billy begin by going only a short way up. He annoyed me by his skill in handling the sled. Pretty soon he was going right to the top coming down all the bumps with the big boys. I sat on a rock and watched half scared and half very proud. He's a nervy little cuss and such a darling.

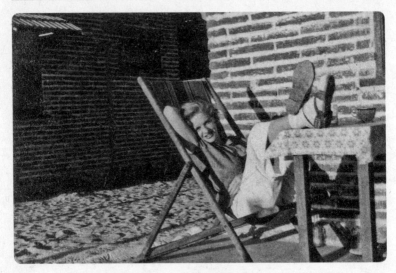

Rosamond

One day she noticed that the light and air had changed. "Each day is so happy," she wrote. "Summer, youth, health, friends, children and a little love too. Just now I went out and looked at the cool sweet night. The dipper very clear. Oh the delight of this time! I feel life again very worth living."

In the opening days of her rebound, the new round of beaux simply reminded her of who she longed for. The recruits included the dynamic forester, Bob Marshall, man enough, but who, while on their walks together in Harrisburg, talked too much, inundating Rosamond with tales of Eskimo women and his prediction that socialism would soon sweep America. There were others, like the governor's handsome young speechwriter, Fred Roddell, who was refreshingly sweet and fun. On weekends in Milford, Fred and Rosamond would disappear for hours and not even the governor knew where they went. Prohibition was enforced at the château, so the two would slip off to the Forester's Cottage where Amos and Ruth served alcohol, or they'd buzz back and forth to Harrisburg in his car, "Hell Bent." But Fred looked so young, she thought. He didn't have the presence of Big Bill, the big beautiful

bear of a man she'd married, who, no one needed to remind her, was still her husband.

One afternoon at Grey Towers, Fred leaned over midsentence and handed her a four-leaf clover. When Rosamond sat down at her desk that night, she pinned Fred's treasure in the margins with a note and an arrow, "FR found in front lawn of Grey Towers. Perhaps some luck!" It was a lucky day for Rosamond, a lucky day for Fred Roddell, and a luckier day for another "FR." On Friday, July 1, 1932, Franklin Delano Roosevelt was nominated by the Democrats to become the next president of the United States. Rosamond, Amos, and the other adults were sprawled out on the floor of the Forester's Cottage listening to the radio until 12:30 A.M. when the last of the returns came in. At three years old, Little Billy didn't know what all the fuss was about and why his mother kept singing "Happy Days Are Here Again." The adults screamed the name of state after state but finally settled down when everyone cheered "Roosevelt!" The nation's luck had turned. At last there was a man to

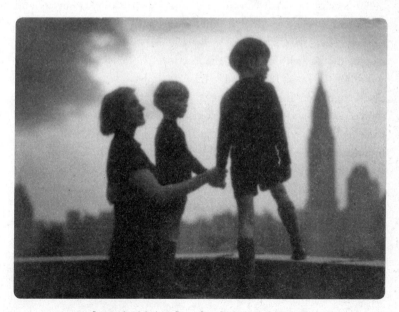

Rosamond and the boys, Empire State Building in the background

lead the country out of the worst streak of bad luck it had ever known. While the Pinchots didn't march in political lockstep, in the election of 1932 they voted unanimously. Gifford put his only hope in FDR, exasperating the Republican Party. Rosamond was worried that Roosevelt would win the nomination but not the election. Amos suspected Roosevelt's New Deal was one more way in which the rich would consolidate its hold on power. He supported Roosevelt for the time being. Were it his choice, he'd be singing "Brother, Can You Spare a Dime?"

As the nation slipped even deeper into the Depression, Rosamond pieced her life back together with the help of remarkable friends. Although they were separated, Big Bill seemed to be in a competition with Rosamond for their friends, so there were his friends and her friends and the friends they fought over. In Bill's camp was the banker Bobby Lehman and his friend Bill Laurence; he took the Barrymores and his theater crowd, and, of course, his revolving bevy of beauties. But he didn't have much in the way of family. And there were people in Rosamond's camp; her many theater connections, and people who were fond of her because they had known her family—such as the Roosevelts, and the Vanderbilts, Conde Nast, the Hamiltons, the Hearsts and the Krocks. Then, there were people they fought over, like Bessie Marbury, who held court with her lover, the interior design fashionista, Elsie De Wolfe. Big Bill took Rosamond to meet Marbury at her house on Sutton Place soon after they were married and Marbury ended up far more fond of Rosamond than Bill. Of course, Marbury was partial to women, anyway, but that didn't matter, Big Bill could still be jealous. It drove him crazy when their friends doubted him and doted on Rosamond.

Charmers like Bill wanted charming women like Rosamond, until they realized they'd lost the charm competition. The Great Depression was riddled with surprises, not the least of which was a person's net worth. Contrary to what most thought, and possibly contrary to what Big Bill thought when he married her, Rosamond didn't have a financial net to catch her if she fell. She did have her friends and mentors, however, and as Rosamond refashioned her life, mentors were every bit as valuable as money.

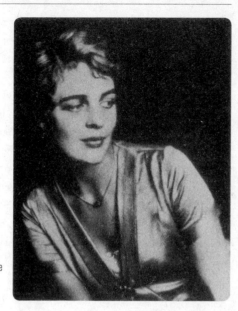

Rosamond, courtesy of the Billy Rose
Theater Collection, New York Public
Library

Cornelia and Gifford had a lot to lose from having their niece in a
controversial profession like acting, considered inappropriate for a soci-
ety woman. But by Cornelia's political calculus, the Pinchots had even
more to lose if they didn't help extract Rosamond from the clutches of
the man they called "Beelzebub." And as fortune would have it, 1932
was an election year. While the Roosevelts knew the Gastons, the Roose-
velts also knew the Pinchots, and that fall, Eleanor needed an actress, a
woman like Rosamond, to stir things up a bit.

In September, several months before the election, Rosamond re-
ceived a call from Eleanor Roosevelt and Mrs. Henry Morgenthau, ask-
ing her to come down to Democratic headquarters. Rosamond trembled
to think what they might want her to do.

I went up to the office where poor wan Mrs. Roosevelt and clever Mrs.
Morgenthau ply their arts. Mrs. M. had her plan all ready. She wants me
to direct a Speakers Institute. To get well-known authorities on the

salient issues of the platform and campaign to talk to voters in a 2 day
session. I'm to get the speakers and stir up the audience. Hard work
probably but fun.

During this period, Rosamond attended Eleanor Roosevelt's class in
economics at Columbia University. Eleanor noticed that Rosamond
wasn't the type of woman who fell into paroxysms of joy over macro-
economic theory. Having been through the travails of infidelity herself
when Franklin took up with her social secretary, Lucy Mercer, Eleanor
had just the answer. Rosamond didn't need economics, she needed to
train women stump speakers for the Democrats and to coach them in
political oratory. Rosamond admitted that she was no professional ora-
tor herself, but she could tell a good speaker when she heard one. She
told reporters:

> Conviction, not complexion, is what counts in a woman campaign
> speaker. Beauty is no requirement but personality is. A woman
> speaker must not be the vampire type or too obviously charming.
> She must not seem to trade on her looks. A sense of humor and the
> ability to leaven her oratorical loaf with a little lightness and wit are
> invaluable. But the most important of all is the belief in her candi-
> date and the ability to instill confidence in others.

That fall, Rosamond found herself happily consumed with work that
was deeply familiar, having been subjected to endless hours of droning
rhetoric beside the Finger Bowl. Still the press wanted to know about
her marriage, so the *World Telegram* came right out and asked her, to
which she responded: "My husband and I have separated but we're on
friendly terms as my lunching with him shows. Divorce isn't my object
at all. Right now my chief interest is to see Franklin D. Roosevelt
elected!"

The children were well stashed in a new apartment on East Seventy-
ninth, and Little Billy was in school downtown. She had her friends and
her riding in the park, but once in a while, in the great in-betweenness

of things, the Cinderella loneliness would creep back in and the longing would find something to cling to. It was then that seeing Big Bill was the worst possible thing she could do. After all, there are some things, like longing, that all the distraction and mentors in the world can't cure.

There was the slim chance that her husband in his raccoon coat would come around, straighten up, see who she was, and stop it once and for all with the broads. In the torrid whirl of A-list parties, not everyone noticed who showed up with whom, but heads swiveled like twists of lemon when Rosamond and Big Bill awkwardly showed up in the same hors d'oeuvre line introducing each other to each other's dates. "Please meet my husband, Bill Gaston," Rosamond would say to a new swain, while Bill would say to one of his women, "Please meet Rosamond, my wife."

Rosamond never knew the extent of Bill's philandering, but others did. Tallulah Bankhead told Rosamond, "I told him to keep off. That I was a Southerner but didn't have any colored blood." But there was Loraine McAdoo who hadn't told Bill to keep off; she encouraged him. Rosamond discovered he'd even slept with the actress he'd introduced her to backstage on their first date, Lynn Fontanne. Then there was old-what's-her-name, the dame who woke her up the night before James was born. She didn't know about Clare Boothe Brokaw for certain, but she suspected there was more to that story than met the eye. Clare kept calling her for lunch, though they weren't exactly friends. Clare was more Bill's friend, not Rosamond's. Their relationship fit the pattern of Big Bill's "friendships" that defied definition.

Despite his infidelities, Rosamond was in a position to help Big Bill get the aviation job in the Roosevelt administration. If Bill had a job, she thought, it would help everyone. At least it wouldn't hurt. It was she who had been given the breaks in life, the little miracles and the big ones. Big Bill hadn't, what with his family who made fun of his writing and his plays and who derided him for the *Crotch Island Crab*. She felt sorry for Big Bill and knew that if she helped him, perhaps she wouldn't have to say good-bye to him, not now, not ever.

Saturday November 5, 1932

In the afternoon to Headquarters. Got tickets and waited to see Mrs. Roosevelt. Felt shy about talking to her. Still I remember my promise to Bill and that old promise made when we were married about five years ago in West Chester. All those promises have been broken but still I want to help him when I can. Am so sorry for him. Mrs. Roosevelt was sweet. I told her quickly that I wanted to be sure that if Bill's name should come up she'd say nothing against him. She said she wouldn't. I left and realized that by talking to Mrs. Roosevelt I had probably done me more good than Bill. Funny. Afternoon shopping for children's room. The apartment about done now and very nice. At 7:30 Bill came. He looked a little worn almost puffy. Same coldness same constraint and yet that old pleasure in seeing him. We went to the Garden. Garden not as big as I expected. We sat in Mr. Bornicky's box. Genial little Senator Burns, Mr. and Mrs. Bick. Anna Dall came and Bill went to sit in another box. Very thrilling evening. All the democratic tickets appeared. Finally Wagner came. Big cheering. Then at last Roosevelt leaning on Eleanor's arm smiling nodding. The crowd stood up and yelled and waving flags. There was a rippling sea of flags. Roosevelt's face is soft in the jowls, handsome above. Perhaps the softness is due to his enforced physical inactivity. While the crowd still clapped Smith came in. Good staging. Renewed cheers. The two leading democrats stood together making huge dramatic gestures of welcome for the crowd and photographers. Funny. Two good speeches. Roosevelt's first. Then Smith, spicier, more dramatic, less scholarly. The audience laughed at the great actor and great politician. Bill and I made our way out of the Garden. It was like old times after a prize fight. I felt lonely when I got home. If only—but what's the use now? He phoned me after an hour. We talked and I'm still so fond of him.

Between the election of Franklin Delano Roosevelt and his inauguration, Eleanor Roosevelt sent Rosamond a mysterious note. Because the Pinchots knew the Roosevelts and the Roosevelts knew the Gastons, Eleanor Roosevelt probably knew that the Pinchots had gone so far as to have Big Bill shadowed and, without telling Rosamond, reported him to a committee of the New York Bar. Eleanor wrote Rosamond:

49 EAST 65TH STREET
NEW YORK. N. Y.

At Warm Springs, Ga.
November 25, 1932.

Dear Rosamond:

Many thanks for your telegram which has
only just reached me, having been lost in
Franklin's pile of mail.

You were a dear to telegraph as you did
and both of us appreciated it very much.

I also want to tell you that I realize how
much good work you did. I heard on all
sides what a success the school was and
many other things which you accomplished.

One other thing which you did and which
only I perhaps will ever know ~~that~~ filled
me with a deep admiration for you, my dear.
It was a fine thing and if you can go through
the hard things of life and come out without
bitterness, and with the power of doing the
kind of thing you did, in the end it makes
one grow and be of more use to all one's
friends.

Much love to you and I hope to see you before
long.

Affectionately,

Eleanor Roosevelt

Rosamond had been useful to her friends, and for better or worse, she had put Big Bill in that category. Eleanor knew about infidelity, so she probably approved of what Rosamond had done to help Big Bill, despite everything he had done to her. After all, there are hard things in life, and it is harder still to come out without bitterness. If Eleanor had a synonym for love, it might have been transcendence or much serving. Longing was no synonym for love.

On New Year's Eve, the night when longing receives a kind of amnesty and nostalgia hits hardest, Rosamond wrote, "Have a longing for him tonight. Don't exactly long for Bill but the thought of him brings a weepy feeling to my throat. The pity of this! I love him in an angry way. Bill, you have been very false, and still, I know that in your own way you love me. Human love what a farce it can be!"

Every New Year's Eve, Amos Pinchot's family celebrations in the Forester's Cottage included an odd ritual, the Resolution Game. Each family member chose something that another family member needed

to resolve to change. Ruth was to pay more attention to things domestic and Amos was directed to be more sunny-minded, while brother Giff was to stick to one line and go to bed earlier. Rosamond was advised to act more on thought and less on emotion and to be more cheerful. The Resolution Game was a curious way to kick off the New Year, but the Amos Pinchots were a family of fearless observers, and the fearless part of being a fearless observer was taking the liberty of pointing things out. Even Little Billy adopted the strategy when at three years old he admonished an overweight visitor at Grey Towers, screeching across the entrance hall, "What makes you so fat?" Horrified, Aunt Cornelia told Rosamond that it was important that the Pinchots teach young Billy how to behave since he wasn't about to learn it from Beelzebub.

While Rosamond was learning to accept that the husband she had was not the one she hoped for, she enjoyed a group of loyal female friends. Her oldest friend, Francesca Braggiotti, was running off to Hollywood to become Greta Garbo's voice-over in Italian. Francesca's younger sister, Gloria, made a good confidante as well, so they walked the reservoir together talking about Gloria's role as a Spartan woman in *Lysistrata* and comparing notes on men. There was Toni Frissell, a fashion photographer for *Vogue* and *Harper's,* whom Rosamond thought of as a sister. But one needed an elder more than a sister during a rebound. While Eleanor Roosevelt and Bessie Marbury gave Rosamond good advice, Rosamond subscribed to the Pinchot worldview, which meant that neither the message nor the messenger should escape scrutiny. Flaws were human, but they were still flaws. Rosamond couldn't help but notice Eleanor's "awful yellow teeth." Bessie was brilliant but, according to Rosamond, monstrously fat and at times insufferable.

There was a third woman with whom Rosamond shared an unusual rapport, the coy, bitchy, and unflappable beauty maven Elizabeth Arden. A legendary battle-ax in business, Arden was always on the lookout for a deal, so she arranged for Rosamond to give her riding lessons in exchange for hiring the youthful ingenue as a celebrity greeter at beauty headquarters. Rosamond's highest and best use, Arden thought, was to represent the shining face of glamour for the growing masses of the in-

secure. Rosamond would wheel and deal in unguents and potions, charm the customers into makeovers, and rope them into pointless additional services. Looking to exploit Rosamond's celebrity cachet, Arden organized a trip to Philadelphia:

> Of all the places to be writing. I'm sitting in the dressing room in back of Wannamaker's auditorium in Philadelphia. And I can hear Liz Arden's agitated voice trying to explain to the callow Pennsylvania models how to walk devastatingly—a wheezy little orchestra plays. It's hot and somewhere a machine that sounds like an icebox pounds steadily. It will be a long session I can see. It's 8:30 in the evening. On my person is about $40,000 worth of jewelry. Yes, I'm a precious creature tonight. Henry Sell, who does the advertising for Maubuisson, got them to lend me a diamond bracelet an inch and a half wide and a diamond clip three inches long—there's a huge yellow diamond in the middle of the clip. It's all very amazing to Rosamond who has never owned a real jewel until this winter. Mother's emeralds and diamonds made me feel pretty dressed up. But all this, well, I have just a glimpse of what a tart feels about jewels.

Arden reminded Rosamond that no matter the hardship, a single woman in the Depression needed to keep her beauty quotient from slipping even one demi-iota. Liz, a notorious tightwad in the payroll department, didn't pay Rosamond what she was worth, but being a fast study, Rosamond learned to think like the master herself. At Liz's expense, Rosamond took full advantage of benefits at beauty headquarters by signing herself up for soothing and luxurious "Ardena baths," massages, makeovers, and other perks that brought things back to even-steven with old Liz. When Bessie Marbury, who had something to say about practically everything, got wind of the fact that Rosamond was commanding a paltry $150 a week, she told Rosamond to put the screws to their friend Arden. No more cut-rate deals for the face of feminine beauty. Rosamond, she crowed, you must charge Arden $500 a week, minimum. Period, no negotiation!

One night Rosamond was invited up to Arden's roof after serving on a committee at Rockefeller Center that decided on movies for the

Roxy. Perennially late, she first got lost in the "chromium and corners" of the spanking new Rockefeller Center and then sped through the bright lights of Midtown to meet up with Liz, who was putting the finishing touches on her vast apartment, which Rosamond found cool and modern.

> The rug in the salon is the palest cream. Elizabeth and the great photographer Stieglitz were choosing a Georgia O'Keeffe painting for the main room. Stieglitz is a querulous, opinionated old man with tufts of grey hair growing out of his ears. He talked much about how he hated commercialism. Yet I bet he struck a hard bargain with Elizabeth. Mrs. Chase of *Vogue* was there, also that dreadful woman Dorothy Flightman of *Town and Country*—snobbish, insecure, English of the worst sort. Mrs. Chase writhed with lumbago. We all went into the bar. It was a small room. The walls are glass and on them painted the most delightful and extravagant cavalry of officers mounted on mad horses. The horses have pink or green tails and manes. They rear and prance. The bar is black and chromium. It's all terribly grand and rich. I had to laugh at one thing Liz said, sitting in one of the exquisite and expensive chairs, dressed in velvet and pearls. She started talking about the Depression and said, "I don't know what's going to happen to us. I expect we'll all have to go down the drain together."

Even the wealthiest feared demise during the Great Depression, but if a woman could survive the lean years, if she could shell out for her subscription to the roller at the Colony Club and keep her beauty quotient from slipping, then she hadn't just survived, she had triumphed. Arden was a testament to survival, having evacuated like a refugee from rural nowhere in Canada and landed in New York with a few dollars in her pocket; opening a salon, she married her business partner, and basically told him to forget it when he suggested he deserved a few paltry shares in her company. Liz was a walking empire of ingenuity, a siren of survival, a roving pink tornado for the newly evolving beauty industry, and the more havoc she could wreak with a woman's fears, the more it fed her bottom line.

That summer of 1932, Rosamond was returning from dropping the boys off with Big Bill's mother in North Haven, Maine, when Liz Arden and Bessie Marbury invited her to go on a picnic at Marbury's Lakeside Farm in Mt. Vernon, Maine. At Bessie's urging, Liz had bought the 750-acre spread, Maine Chance, right next door to hers, and there was speculation that the two dynamic women shared more than just common interests in business and the arts. Their relationship was not just close but candid. Bessie Marbury thought it her job to encourage Arden not to hoard and worship money but to spend it, so Liz joined the Friends of the Philharmonic and the Opera Guild, and Marbury gave her advice on interior decoration, suggesting she hang her walls not with miscellaneous pink horses but with masterworks by the doyenne of pinkness, Georgia O'Keeffe.

The two Elizabeths were accustomed to giving unsolicited advice on every earthly subject, not only to each other but to others. During the lakeside picnic, which resembled a quasi-Grecian orgy, the two older goddesses double-teamed the younger goddess, treating her to a complimentary al fresco body wax and career counseling session. The latter, naturally, met with mixed feelings:

> I can't help wondering how a woman who has so many bitchy qualities could have reached the peak Liz Arden has. Really in some ways she's pretty bad. On horses, for instance she knows it all, is bad tempered and kittenish. She has no idea of how to treat servants. Is either terribly intimate or unbearably rude. She rides like what she is, a foolish middle age woman who has taken up the sport because she thinks it's the right thing to do. I wanted to swim and sunbake but had to plug along the roads with Liz. Finally got back in time to get a little sun. She spent the time being photographed with Great Dane dogs. . . . Afternoon, escaped and lay in the sun for a while. Liz came and put hot grease on my legs pulled it out and all the hairs, my furry fetlock growth came with it. Watched the old girl work and noticed how expert she is in her own field. One last swim in the beautiful tepid lake. Then a high tea on Arden's porch. Bessie Marbury held forth. She keeps urging careers on me saying that my personality should be made into something. Then hurried packing a cold supper and said goodbye to dear Old Bessie.

She probably won't live long. Her fat is monstrous but her spirit is clear.... I went off leaving her to her interests, her Guernsey cattle, her manuscripts and her preparation for the annual Democratic Party.

While Elizabeth Arden was a force to be reckoned with, Rosamond had great admiration and affection for Bessie Marbury, writing that despite their age difference of fifty years, Bessie was her best friend. Bessie had once represented Oscar Wilde and George Bernard Shaw, and, never saying never, she served as the producer of Cole Porter's first musical. Grossly overweight and frequently ill, Bessie's various conditions had her frequently take to her Sutton Place bed where she received guests in a purple robe while crocheting and dispensing advice like a wheezing lesbian oracle. "Do this," she spat, "don't do that, be that, forgiveness is a virtue, be kind to your husband." Rosamond loved Marbury more than she loved her own mother, frequently arriving at the red front door of Bessie's home carrying "weird plants" to make Marbury laugh. In her diary, Rosamond frequently assigned nicknames and she nicknamed her mentor Bessie "The Toad." "I like toads," she wrote.

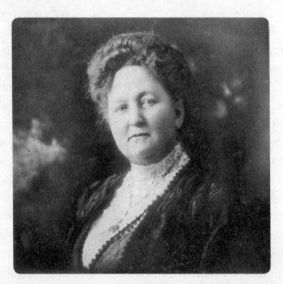

Bessie Marbury

Marbury was openly lesbian and a strong advocate of traditional marriage if one could but find a full-fledged man. Marbury wrote, "a caress is better than a career," but admitted that during her marriageable years, there was virtually no man she found interesting enough to marry:

> To be quite honest, I firmly believe that every woman should marry if this is humanly possible for her. Her one indisputable field of usefulness is in the bearing and raising of children. This is the end for which God intended her. I wish that before any girl decides against matrimony on general principles, she would consult me before it is too late because this is a subject upon which my advice would be of benefit, as I know what I have missed.
>
> If a woman through her own conceit registers against marriage in favor of some problematical career she will find, provided she lives long enough, that all through life she is at best only a misfit. She may live creditably and even accomplish infinite good, her influence may be of great service to the world, she may help and heal, she may spread sunshine, she may exude happiness; nevertheless she has missed the normal expression of all these things clamoring within her for utterance. Her natural territory is her home, even if it is a tiny flat. She should realize that the mothers of great men have contributed much to their making. If on the other hand the bearing of children has legitimately been denied her, then she can prove herself a real help to her husband, and if she is more richly endowed in vision and in capacity than he, she can encourage and mother him and be the silent influence making a good man better or a bad man less evil.

Over the years, Rosamond went to Bessie's bedside to listen to her lively incantations on everything from poetry to personal life, but at seventy-six, Bessie's health was slipping, and finally, on the January 22, 1933, Rosamond called Bessie to learn that her best friend had died quietly at home. On a cold sunny day, January 24, Bessie's closest friends gathered to say good-bye at Sutton Place. Once again, Rosamond wore what she wore the day she married Big Bill. That day she

donned her so-called traveling suit and her old gray hat. At night she sat down to her diary:

> Together they made my wedding dress and veil. Not very romantic costume. Went down to the little house with the red door. There were already a lot of people there. Flowers banked the dining room. There was a heart of white violets with red roses bursting from it, and there was a cross of lilies. The front of the coffin was open. I looked at white dear Bessie, or at least a part of her. I said goodbye. The little rooms upstairs were darkened. Liz Arden came in showing her grief very much, weeping. Mrs. Roosevelt came looking yellow and plain....A few of Bessie's family and Miss Morgan and Mrs. Vanderbilt. Mrs. Vanderbilt is quite sweet. She's old but still slim and quite gay. Her hair is white. Miss Morgan shook hands with me. It hurt. She has a grip like a cowboy. There was a short service in the house. A Catholic priest went through what I suppose must have been a chant. It sounded ugly and foolish. He dragged out "Blessed is thy name and blessed fruit of thy wooooomb Jeesuuus." A small group of catholics stood in one corner and replied. They and the priest seemed to be in an indecent hurry. We stood and thought our own thoughts. The little black Pomeranian that Bessie gave to Alice came in. He showed a deplorable lack of taste. He sniffed around at the feet of the mourners. Someone tried to pick him up but he snapped at them. The priest with a violent gesture threw holy water at Bessie's face. Her little fat hands were crossed and held a rosary. That was the last I saw of her.

After the private funeral at what society writers called Bessie Marbury's "Amazon Enclave" of New York's most powerful and liberated women, Eleanor asked Rosamond to join her in her car to attend the mass at St. Patrick's Cathedral where two thousand people had gathered to celebrate the life and mourn the death of Bessie Marbury. On the way, they were escorted by New York City's finest. Rosamond recalled the spectacle:

> ...the train of cars was stopped. Some boys in the street spotted Mrs. R. and lean[ed] in the window of the car for autographs. She gave one with rather poor grace, writing on a newspaper. Then we drove to the

cathedral. There was a crowd and police dividing off the avenue. As we went up the steps, cameras snapped. We walked down the aisle in twos, solemnly. The coffin was carried ahead. Al Smith with bowed head led the pallbearers. The Mayor was behind and countless others. There were people of all kinds, many of them absolutely obscure, many famous. There were writers, businessmen, actresses, producers, society women, politicians. No one had friends from as many walks of life.

That afternoon, Rosamond sat in the same pew with some of America's most prominent women, women who had also attended the Sutton Place gathering and who knew Bessie Marbury like a sister. At home that night, Rosamond wrote:

Now that she is gone, there is an empty place. How many happy interesting hours we spent together…she seemed to have an endless fund of anecdotes. She'd tell about JP Morgan, what an old tyrant he was—how he couldn't get anyone but worms to go on his yacht. She'd tell about Isadora Duncan and her two illegitimate children. She'd tell about her own youth on Long Island. She started earning her living selling eggs and writing articles for a local paper. I remember that she told me that her father used to read her classics instead of Peter Rabbit stories when she was a tiny child. Perhaps that accounts for her use of language. I was always surprised by her words. Not that she talked in a literary way. She just used extraordinarily fresh, exact expressions.… Goodbye dear friend. Life in New York will always be a little bit empty without you. I will never forget.

Eleanor, Liz, and Bessie all struggled with how a woman, particularly a woman who had been more or less dismantled through marriage, could be a fine influence in the world and on men. On the day after Marbury died, Rosamond was asked to write an obituary for the *New York Journal*. She hesitated for fear it might be in bad taste to appear to be cashing in on her friend's death. But she decided that she could say yes because Bessie had urged her to write for the newspapers, even proposing that the *New York Journal* feature a regular column of Rosamond's

thoughts. Mary Dougherty, the *Journal* editor, thought that Rosamond would be a hit. "You must have very definite opinions," she said. Rosamond countered in her journal, "I having definite opinions! I who never knew what I thought about anything!"

During the winter and spring of 1933, Rosamond wrestled with what to do next. She knew that a bad day for her was nothing compared to the day-to-day existence of millions of Americans standing on food lines or off in the hinterlands eating roots, berries, and woodpeckers. While Cornelia was usually at the table, Rosamond felt surrounded by men like her father; Uncle Gifford; his young handsome speechwriter, Fred Roddell—men who huddled under the vines at the Finger Bowl debating the perils of economic tinkering:

> During all the talk, I felt quite without ideas—a complete and miserable fool. Yet I realized that it was talk and people like this who would finally find the answer to the terrible economic and social problem that confronts the world. None of [them] had any real plan—Inflation? Limitation of working hours with a minimum wage law? The more vigorous trimming of the great incomes? An almost 100% inheritance tax? Government ownership? My mind couldn't grasp it all and yet there was Fred three years younger than I with enough understanding to be actually writing Uncle's messages to the legislature. What's the answer to that. I guess it's that I'm a woman and he's a man. I just can't get terribly interested in the big impersonal things. Though I know I should. My interests are vague and uncreative.

There were days of vagueness, days the press never captured, and days of spontaneous kindness and creativity when Rosamond struggled up a snow-covered slope on horseback to deliver food and supplies to a little old woman who lived about as far away as one could imagine from Fifth Avenue, Eleanor, and the two Elizabeths. The little old woman was named Mrs. Craft, and she lived alone on a run-down homestead in the middle of a meadow five miles above Grey Towers. In the 1930s, the poorest of the poor didn't just inhabit the cities, they were living in the woods on land owned by the wealthy such as the Pinchots; and like many Penn-

sylvanians, they were struggling to survive. The Craft farm consisted of a pre–Civil War frame house surrounded by trees with a barn and a small lake. There hadn't been any paint on the place for years and Mrs. Craft, Rosamond thought, looked like a witch in a German fairy tale with her gaunt features, bent figure, and strange cap.

Occasionally Amos and Rosamond would set off to visit Mrs. Craft together, but Rosamond would also make the long, rugged trek alone on her horse, Zeena, followed by Arco, her dog. When she was in the city, Rosamond would stop at Macy's on Thirty-forth Street to send Mrs. Craft a box of food, but she would also go to Kytes general store in Milford for a case of oranges to strap to her saddle or she would tuck fresh fruit or frozen raspberries into her saddlebags. When she arrived, Mrs. Craft would thank her for the delicacies and light a fire with a few dried roots and twigs she'd stored in her shed. The two women from different worlds would talk about their lives, the death of old Mr. Craft, about the Civil War, and about the woods. Rosamond didn't want Mrs. Craft to waste her twigs and roots on her, but Mrs. Craft insisted. There were days of crystal clarity, and days others remembered, of her generosity and her kindness.

That summer, Rosamond wrote wistfully, as if stranded between past and future, about the woods she once loved:

> I wonder how many girls have loved the Falls as I do. Probably not many. In the old days, girls didn't wander around in the woods as I do and have always done. I know every inch of the stream. What a delight it is on a hot summer day. What clean damp smells. There are lots of little falls. In some places the water has worn strange round holes. Once I almost broke my leg when I stepped into one by mistake. Once I put my hand down and felt the slippery body of a trout. The hole was small but somehow the trout escaped. Now whenever I go to that place I put my hand down but there is never another fish.

Just after the New Year, 1933, Amos was as excited as a little boy telling his best friend "Sis" that there was something remarkable up at the Craft farm that he wanted her to see, a rare phenomenon of nature, a deer as white as snow. Every day, he said, the deer appeared at the old

Craft place and stood under a tree where Mrs. Craft fed it from the palm of her hand. Mrs. Craft called the deer "Silver Star." Rosamond couldn't imagine such good luck befalling a little old woman in her stocking cap high up in the middle of nowhere, so, more than curious, Amos and Rosamond fired up the Buick, the sturdy woods car, to go see Mrs. Craft and, they hoped, the white deer. When they arrived, Mrs. Craft welcomed them in a most friendly way, but as soon as Amos asked about the white deer, Mrs. Craft's face fell. "Silver Star was shot last month," she said. She wept as she described how a group of men had come and killed her beautiful tame friend, cutting off its head and feet. The body, she said, was gone. It didn't make any sense, how even if you had nothing, the gifts that drop in as reparations, strange remunerations from Providence, even those might disappear. Perhaps we don't pick the good days or the bad days, perhaps they pick us; or perhaps they spread themselves out, thinly and without warning, against a backdrop of longing and hope.

During these years, Rosamond landed an enviable beat when she was assigned a byline by the Universal Press to cover Eleanor Roosevelt during her first days in the White House. Having written only baby articles and shot photographs for Eleanor's magazine and captions for *Vogue,* Rosamond was offered a paltry sum of $150, but she had learned to think like Liz and fume like Bessie, so she wrote in her diary, "I felt cheated, expected much more. Well, may clear $50 and it will be good experience."

The first leg of Eleanor and Franklin's move to the White House was a distinctly down-market affair, a send-off by train, surrounded by city and state dignitaries in Jersey City, New Jersey. The Universal Press announced that Rosamond Pinchot would be in "constant news and social contact" with the First Lady during the opening days of the Roosevelt administration. Trying to make sense of what to do when she reached the station, Rosamond first settled into the train car with the newspaper boys who thankfully poured her a drink. Mrs. Roosevelt moved slowly and merrily through the car, and when she saw Rosamond, she asked her back to sit in her stateroom. The two women sat and chatted cordially and when Rosamond got up to leave, Mrs. Roosevelt leaned over to kiss her. Rosamond was sure that Eleanor, an ardent dry, had smelled

liquor on her breath. A good slug of scotch might well have loosened up the reportage, but Rosamond was sure it wasn't the news and social contact the Universal Press had in mind.

In the sweep of her life thus far, Rosamond told her diary that March 4, 1933, Franklin Roosevelt's inauguration day, was one of the best days. She was swept up in the rush of adrenaline and the crush of humanity, busy forgetting and remembering who she was. Forgetting about Big Bill, she remembered that she belonged to a great family. She loved its quirky high-strung individuals, like Uncle Gifford and Aunt Cornelia, who both stopped at nothing to do what was right, and who piled themselves into the Studebaker that day and, with flags flying, navigated the congested streets of Washington to the sounds of cheers and drums. Together they rolled through one of the world's great political spectacles, a tribute to power and compromise between those who had agreed to disagree peacefully. From the Studebaker, Rosamond watched men selling neckties with Franklin Roosevelt's face crudely painted on. She observed the many famous faces in the stands and she couldn't help but notice, "Politicians don't look very well out of doors in the daytime. It doesn't become them." Rolling on and on down Pennsylvania Avenue, she and Cornelia laughed and waved when a paradegoer mistook Uncle Gifford for Santa Claus.

It was the moments she noticed that made it one of the best days. Meanwhile, the afternoon turned frightfully cold. By 5:00 P.M., Gifford had observed the swearing in of the senators at the Capitol and, having fulfilled his obligations of empire, he and Cornelia joined Rosamond on the White House lawn where Rosamond described more of the little things: "Crocuses very yellow and small were blooming in the flower bed. In the White House it was warm. The delight of it! I was surprised to find the place very nice. It wasn't cold; it was lovely and dignified."

Rosamond, Cornelia, and Gifford arrived at the White House before the other guests. Recognizing a prime snooping opportunity, what she characterized as a family specialty, the Pinchot delegation ranged around the upper floors while the crowd was kept downstairs. They snooped through the round room with its greenish blue walls and crystal lights. Just as they were checking out the corners and casing the bookshelves,

Mrs. Roosevelt rushed in, which put a prompt end to ranging and snoopage. Rosamond turned her attention back to her assignment, which was to observe Eleanor at close social range. While Cornelia and Gifford perused the canapés, Rosamond took notes about the First Lady's attire, which, unfortunately, contradicted the glowing reports of competing news agencies. While what she wrote was never published or publishable, Rosamond told her diary that Eleanor's blue velvet dress with her blue felt hat was a "rather odd costume"; but it was Eleanor's strained attempt at fashion symmetry that caught her attention. It wasn't as though the First Lady had to look completely up to date or à la mode—after all, she needed to appear the dignified wife of the dignified president—but what was she thinking when she pinned two bunches of orchids to her dress in two places? Honestly, where on earth was the fashion sense?

After Franklin Delano Roosevelt had been installed in office for a few months, Rosamond made several more personal visits to see Eleanor at the White House. Each visit was warm and intimate and ended with a kiss. Perhaps the kiss was a simple felicitation, perhaps an awkward and compelling moment of magnetism between two women, one whose beauty was brilliant and the other whose brilliance was beautiful. In either case, the kiss, to Rosamond, was worth noting in her diary, as was Eleanor's appearance: "By a door stood the President leaning on the arm of his son Jimmy and next to them Mrs. Roosevelt in a clumsy white dress. Her face looked yellow against the white but she was so sweet. I said good evening to the President. He always calls me Rosamond." After the president called Rosamond by her first name and Rosamond returned his pleasantries, Eleanor took Rosamond aside. Together they sat down on a bench where Eleanor kissed her and asked her to come back to the White House the next day for lunch.

After a rip-roaring night on the town and sighting Louisiana's kingfish, Huey P. Long, in a purple nightgown sashaying through the halls of her Washington hotel, Rosamond rose early the next morning and made her way over to Arden's for resuscitation. "They put me in a sweat bath," she wrote, "and all the champagne I'd drunk the night before oozed out.

At least I imagined it did, which made it just as good. Then the face was massaged and painted, then the hair curled. That all made me feel queenly again. Ready to go to the White House for lunch. The French delegation headed by Herriot were just leaving and the hotel lobby was full of little men who gave me flattering, lecherous looks. Rush, rush to get to the White House in time."

Rosamond arrived at the White House in a ramshackle taxi, where "Negro" butlers opened the front door to let her in. Ike Hoover, the presidential greeter, first ushered her into various halls and anterooms before leaving her to her own devices in a room with a group of men half her height. "They were all little yellow Phillipino [*sic*] men, a delegation," she wrote. "I pleaded dirty hands and a flunky was assigned to take me upstairs to wash." Rosamond noted the large luxurious bathroom where little cakes of pink soap had already been used. Surprised by the state of the state soap, and wanting to avoid the other guests, she waited patiently back in the hall for the signal from Hoover that the president and Mrs. Roosevelt were ready to greet her. As if at the theater, she heard a vague shuffling and whispering behind a door as the president, the First Lady, and their entourage prepared for their entrance. The door finally opened and Franklin Delano Roosevelt walked awkwardly toward her, leaning on the arm of his bodyguard. He smiled, then took Rosamond's hand. "Hello, Rosamond, how goes the writing?" he asked. Mrs. Roosevelt followed him, wearing a light blue dress that was surprisingly au courant; but something else caught Rosamond's eye: Eleanor, forever the fashion wreck, had sweet peas pinned to her dress that were shocking shades of "discordant purple," she wrote, and worse still, she wore a big, ugly gold watch Rosamond thought looked like it belonged to a German governess. Her unpowdered, unrouged face, however, wore its usual kind smile.

After salutations, the president made some "slightly feeble quips" and Rosamond noticed "one of the President's few unattractive characteristics." There was something strange in the way he threw his head around that bothered her, but she still admired how he handled himself. "His manners are so genial," she wrote. "He seems unbothered by the vast, almost unheard of responsibilities that rest on his shoulders. I felt sorry for

him." Rosamond watched as the president was led off by his bodyguard and left the room in his "jerky, paralyzed way." Eleanor Roosevelt then moved in to direct Rosamond on a personal tour of the White House.

The First Lady took Rosamond's arm and together they went upstairs, where Eleanor showed off the White House bedrooms with their high ceilings and their fine proportions. "This was Lincoln's room," Eleanor told her. "And this is where Franklin held the talks with Herriot and MacDonald." Rosamond observed the famous picture collection that hung on the walls and remarked on how many battle pictures there were. The First Lady then took her into Franklin's bedroom with its plain black iron bedstead. Presidents and their wives never shared the same bedroom, and here was the proof. Around Franklin's bed was a ring of chairs where he talked to his advisers in the morning while eating his breakfast.

The tour led from one elegant room to another until the two women finally settled into one of the comfortable White House sitting rooms, where Eleanor reached for her needles and yarn. She was working on what Rosamond observed to be a flimsy white sweater. Eleanor's voice, Rosamond thought, was soft and lovely, and as she relaxed with her knitting, Rosamond fell into a kind of trance. She gazed out at the green loveliness visible through the windows. "It was all pleasant and emotionally stirring."

While Eleanor knitted and chatted, Rosamond mused on the downside of prettiness and the upside of ugliness:

I thought of the life of the nation, the millions thinking about this one family. I thought of what Bessie Marbury once told me of Roosevelt's love for some girl and how Mrs. Roosevelt had been fine, had accepted it. I thought if she had not he would never have been President at all. For certainly he owes much to her. She's a fine dear person and life has given her a richness that makes one forget her ugliness. Her ugliness may have been an asset. The vain silly side that is so noticeable in all of us pretty women is completely absent in her. I don't suppose that she ever had a flirtation. Certainly she never had a love affair. At least that pain was spared her. And she has accomplished so much.

Suddenly, the presidential greeter Ike Hoover reappeared to advise Mrs. Roosevelt that Premier Richard Bennett of Canada wished to have a word with her. Hoover led Rosamond and Eleanor down the stairs, followed by Major, a yellow and black police dog that spied Premier Bennett and suddenly flew at him, biting him in the thigh. Bennett was taken aback but tried to calm the situation. "It's all right," he said, "he didn't draw blood." Trying to calm the situation in her own way, Rosamond turned to Eleanor and noted that Major appeared to be an ideal dog for the White House.

While Premier Bennett limped away waving good-bye and clutching his leg, Rosamond and Eleanor Roosevelt convened at the front door of the White House. The two women bid adieu the way women do, sometimes, without words. Rosamond's struggle with Big Bill was a struggle so personal that it could barely be spoken of, even in private. Eleanor's debacle with Franklin was information that Bessie told Rosamond to keep to herself. Confiding the truth indirectly and through intermediaries, knitting a gossamer web of intricate, sometimes unspoken connection, women cradled each other by their presence, through the bad days, the days when the gods weren't doling out reparations. Separated by age and experience, Rosamond and Eleanor were joined in a greater than normal grief and the desire to put that grief behind them. Rosamond wrote of her last visit to Eleanor at the White House: "The light fell on her grayish face and large yellow teeth. I felt a real affection in her presence. A great woman."

The summer of 1933 saw temperatures of 110 degrees in Milford. There was barely a hint of relief under the trees or near the river, which had all but evaporated. In part because of the heat, Rosamond thought Milford seemed subtly different that year. The countryside around Grey Towers was infinitely beautiful, but at twenty-eight, Rosamond felt lost idly sitting around. "Is that age setting in?" she wrote.

Perhaps I'll lose that old delight in nature. I have no center here in Milford anymore. Father's house isn't home and I'm a guest in this house

too. Cornelia is very sweet to me but if I'm around too much she may
change. I must try to make myself scarce. Uncle is too busy with his job
and his callers to notice. At least I hope so. Maybe I am just tired but
anyway I feel depressed.

At almost twenty-nine she felt old. At 110 degrees she felt hot. At
145 pounds, she was having Aunt Cornelia's doctor inject a strange
gland solution into her endocrine system so she wouldn't feel fat. She
also felt bored, so one night Rosamond reached for her diary and cre-
ated a list of her family members and ranked them in order of her fa-
vorites. Her father was at the top, naturally, followed by her brother,
Gif, and Aunt Cornelia. Uncle Gifford would have made it to the top
had he not been such a straight arrow and a prude, so he held up the
middle. Her stepmother, Ruth, and her blossoming young stepsister,
Mary, ranked dead last.

Rosamond couldn't have been more annoyed by the new regime at
Milford. Mary looked so very sweet in her little blue skirt that fit closely
over her slim hips, she wrote, "Being an ardent reader of movie maga-
zines, she's hot for love and romance already at 12." Mary, it seemed was
stealing the spotlight and Rosamond thought she was the competition.

That summer, Rosamond contemplated whether she needed Grey
Towers the way she once had. She told her diary that she found herself
with the "on tops" of Manhattan. Hers was a life of friends and engage-
ments that would have made other women flagellate themselves in fits
of envy. Returning to New York after a Milford weekend, she'd find
notes, flowers, and invitations piled up in the foyer, but she'd reject most
of the offers. Her antennae weren't just raised, they were raised for the
type of man she could feel passionate about, a man who could erase the
memory of Big Bill. She wasn't likely to find such a man droning on and
on beside the Finger Bowl. "I don't think I could stand public life," she
wrote one afternoon in Milford. "It involves too much tiresome conver-
sation about nothing and too much sitting around. There were twenty
people at lunch today and among them there weren't four amusing at-
tractive people."

The on tops included acquaintances such as Elsa Maxwell. Rosa-

mond wrote, "that toadish adventuress, instructed me to come to her party as Ethel Barrymore. That involved a great effort." George Gershwin, another on top, required a different kind of effort, namely, patience. He would talk all night about himself and his newfound love of painting, and everyone piled in the car to go see Gershwin's portrait, of himself. Gershwin at the keys or at the canvas, who could ask for anything more? One night Rosamond dressed hectically for dinner at George Kaufman's. Later she wrote:

> All the men at the party were Jews. Every woman except I had married Jews. There was Ellen Berlin, Irving's famous Catholic bride—and Margaret Swope and the Sam Goldwyns and the Bill Paleys. I drank three cocktails to buck me up—sat on an elegant yellow damask couch with a man named Bennett Cerf. He was Jewish too and very attractive to me. Nearsighted to an amazing degree, we exchanged specs. I felt cool and self-confident. Know I was making a hit with Cerf. Sat next to him at dinner, too.

Bennett and Rosamond were ambivalent on tops, so naturally they hit it off. A few nights after dinner at the Kaufmans, Cerf held a party for Bill Faulkner and when Faulkner didn't show, that meant more champagne for those who did. Cerf was scheming up a new enterprise with his partner, Donald Klopfer, an outfit named Random House, claiming that they would "publish anything under the sun that came along—if we liked it well enough." Five years later, their vision of randomness was coming to fruition. Bennett, like many of Rosamond's theatrical crowd, became a frequent visitor to Grey Towers, skillfully navigating the Scylla and Charybdis of the Pinchots' political and social archipelago, which, true to the times, didn't include many Jews. While Bennett and Uncle Gifford discussed publishing his next tome on forestry, Rosamond wrote that Bennett also fit in well with Amos on the tennis court and carried on marvelously with Aunt Cornelia under the vines, discussing everything from politics to children's books. Cerf kept Rosamond apprised of his book deals. "Today was the day he was to fly down south to see Eugene O'Neill about publishing his future works,"

Rosamond noted in her diary. "I hope he gets them." Cerf wasn't just good at business; Rosamond found him simply good fun. "There's something good about him," she said. Bennett took her places where Big Bill might have taken her, and, it seemed, he didn't just bring himself to Grey Towers, he brought out literary offerings from the city. On May 29, 1933, she wrote:

> Read Bennett's book about the children on a pirate ship. Feel I must finish it. But I'm not as fond of it as I should be perhaps. This is the second time in less than a year a young enamored man has given me his favorite book and I've had to fake enthusiasm. Fred gave me "The Breed of Basil." That was much worse. In fact it was romantic drivel. This is very literary delicate writing, Wouldn't it be funny if Bennett didn't really like it at all, if he'd given it to me just to make an impression. I feel as if he must like something stronger and perhaps a little more vicious than this. But then Beatrice [Kaufman] describes him as a gentle soul.

Rosamond wasn't accustomed to the gentle souls like Bennett and Fred. Still, they had a redeeming intellect that kept her mesmerized. "The secret to my success," she wrote, "is to show interest in the lives of other people." That wasn't difficult with Cerf, except when he decided to kiss her. She described Bennett as having a girlish way of kissing. Bennett, she wrote, "isn't man enough for me. . . . Too bad I had to find that out." Bennett, she thought, looked like "a bear in a bathing suit."

Probably unknown to Cerf, Rosamond ventured out on one dead-end date with his partner, Donald Klopfer. Bennett wasn't man enough for her, but Klopfer disenchanted in a different way. She wrote:

> He's big and tanned and Jewish. But after a while I found that he has about as much personality as a Pekinese. In fact he bored me almost to death. He's not a bit gay and humorous like Bennett. He's a snob too. He even mentions things like "Socially prominent people," the "400" and other horrors. We saw a perfectly lovely movie called "Red Top." It was French, about a little boy. Donald didn't get it at all. I kept wishing I was with Bennett. We went to the casino and ate and danced a little. He

was a bum dancer too. Poor creature—his inferiority complex about being a Jew has ruined him.

One night, Rosamond was all dressed up and ready to go out with Bennett when the phone rang. Zoe Akins was on the line and wasted no time telling Rosamond that she wanted her to play the lead in a new play she'd written based on Somerset Maugham's story, "The Human Element." Rosamond reminded Zoe that she had wanted her to play every lead in every play she had ever written since they'd met seven years before. Rosamond knew Zoe was just being Zoe, so that night, Rosamond and Bennett changed their dinner plans and sped off to the Waldorf to discuss the play.

That night, Zoe liked Bennett and Rosamond agreed that Bennett was likable; but Zoe didn't want to talk about men or her new play. What she really wanted to talk to Rosamond about was coming to Hollywood that winter. Her home in Pasadena, Green Fountains, was surrounded by five enormous eucalyptus trees, she said, and Rosamond could take screen tests and investigate a film career. Akins was already an insider at MGM with an office in a bungalow at the back of the lot. Everyone, it seemed, was headed west, as the film studios were expanding. The action was now on the coast, not on Broadway. Rosamond knew what Zoe was saying was true. Her friend Francesca had headed out to do her Italian voice-overs for Garbo, and Francesca's husband, John Lodge, was feverishly making a name for himself at RKO, sidling up to Cukor for a part in *Little Women* with Katharine Hepburn. Rosamond wondered if she would be next. She told her diary that the years and the sorrows and the two children and the happiness and the loves had helped her to remember who she was. Perhaps it was time to go back to what she'd been. "I've been telling people for the past year or so that I was all through with the theatre," she wrote. "Now I'm not so sure."

The familiar faces didn't know that she felt rootless or lost; they didn't need to. They didn't know what had happened since *The Miracle*. They didn't know she'd decided that it was better to stay with what she knew, acting, than to try something new. They didn't know how Father was suffering from arthritis and financial problems and how he had his

new family, which made her feel left out, or how Mother was as needy and cloying and sickly as ever. They didn't know about Big Bill and his broads or how he had told her all she cared about was her career and that even if she'd wanted one, he wouldn't grant her a divorce. Big Bill hadn't run off with anyone in particular, he'd run off with many women; so that wasn't like running off to be with someone else—it was more like running off with himself. He couldn't do much better than Rosamond Pinchot. Anyway, she didn't believe in divorce, and neither was in any rush to end it. No one knew that; they didn't need to. She only told people what they needed to know. The rest she kept for her diary.

In January 1934, at Zoe's invitation, Rosamond boarded the Cunard Line's SS *Franconia II* bound for California via the Panama Canal, leaving the boys with her mother. Onboard, she avoided the predictable onslaught of vacuous suitors, spending most of her time with the popular author, artist, and history professor Hendrik Willem van Loon, who, though more than twice her age, was three times as interesting as anyone else onboard. Van Loon's critics accused him of writing about history "as if he enjoyed it," variously improving on fact, and every so often inserting himself into the narrative. Rosamond was riveted by van Loon the way she had been by Bessie Marbury, describing van Loon as a mountain of flesh, but delighting in his sketching the landscape and lecturing on venereal disease in detail at the dinner table. After discussing the formation of islands and describing the deep holes in the Pacific, he interjected several dirty jokes, then spun off into a discussion of history that sounded strangely familiar. While lounging like a whale at the bow of the *Franconia,* van Loon bellowed, "Balboa happened to settle in Panama, probably the most vital military stronghold in the world. He is almost unknown. But Columbus quite by accident happened to land on the West Indian islands and his fame is vast. So you see it's all chance." Van Loon concluded, "Everything is getting the breaks."

When Rosamond arrived on the docks at San Pedro on January 24, Zoe met her in her grand car and whisked her back to Green Fountains

for a luncheon in her honor with Cukor, Billie Burke, and a number of "antique ladies" she called Rochesterites. It was good to be back in California, Rosamond wrote:

> Memories kept coming back, oil wells, the smell of petroleum, orange groves, the open air markets with food piled in horn of plenty profusion. The mountains where I'd written all night on Annie Besant, owl drug stores. I remembered how I'd first come here eight years ago fleeing from the horrors of George Cukor's stock company. I took a room and got a job at $14 a week in a photographer's shop. No one knew my name. I knew no one. It was fun living that way and completely carefree. I knew obscure people. Now I know the ones on top.

She remembered California, but not this California.

> I've never seen a house so completely in tune with the cravings of its owner. This is Zoe. It's luxurious and slightly formal. Zoe showed me around and I admired it until I was exhausted. My room is the most ornate in the house. Its almost baroque. There's a throne-like bed that has the most delicious mattress. The walls are pale blue, the doors richly painted. There are rich cherry colored velvet curtains. And what a bathroom!

That afternoon, a festive lunch was set for ten near the pool, followed by a late-afternoon trip to the city and the studios. "It was such a funny feeling to drive into Los Angeles," Rosamond wrote. "I kept thinking 'this is the place that I dreamed of.' Seven years have passed so probably the cells in my body are all new and they're a little bit vague about where the old cells visited." That afternoon, she drove over to Culver City, where, through the gates, Rosamond made out three words in red lights, "Metro Goldwyn Mayer." She found Zoe huddled in her swell bungalow working late with Irving Thalberg, Norma Shearer, and Robert Montgomery on *Riptide*. Soon enough, she felt the excitement of being on the lot, surrounded by stories of the stars and their lucky breaks. Rosamond wrote:

Norma Shearer is married to Irving Thalberg who is one of the very biggest shots of MGM. Consequently she gets most of the good parts whether she's fitted for them or not. She's a pretty, rather determined young woman with a nice smile. But no one could be less fitted to play Marie Antoinette or Iris March than she. After all she has no distinction at all.

After sitting down to tea with Zoe and Shearer in a little movable dressing room, she noticed Robert Montgomery, " a very winsome young man, but actorish."

Just when the day seemed like it was ready to end, Zoe extended one more invitation, to dinner with their old friend Jobyna Howland and a group of "hot, loud mouthed vulgar people." Rosamond wrote of dinner, "I never heard such language as filthy or clothes so rich. No one spoke about anything. George Cukor was even glad to get home and go quietly to bed."

She hadn't been in California for twenty-four hours before she realized people in Hollywood never sat down to orderly dinners or meaningful conversation. Meals, she discovered, were "yelling dinners," where there wasn't a modicum of modesty or kindness. Conversations were screamfests and no one sat around waiting for anything. If you wanted something, you made it happen.

Like it or not, Cukor made things happen. He directed Rosamond's screen tests at MGM, using the same cameraman as Garbo used. Cukor's exuberance was contagious; that is, when he wasn't poking fun at Rosamond in his ruthless, sniping way. George was George, but he was also in a position to help her. Shortly after she arrived on the lot, Cukor was the one to tell her that David O. Selznick had noticed her, after which she wrote, "I've got a face, a real face." But like Big Bill, Cukor would then undermine her.

Before long, David O. Selznick had not just noticed Rosamond, he was obsessed with her. With a dose of newfound self-confidence, Cukor announced that Rosamond "was behaving like a star already," but, he said, she needed to improve her "pathetic little wardrobe," and if he were Rosamond, he'd be sure to dress up every time she appeared on

the lot. "You look dreadful," he said, "you are much too fat. You must look sleek!"

For the next few weeks, Rosamond chewed but didn't swallow her food and on March 2, David O. Selznick summoned her into his office, a great Spanish drawing room at MGM. As she entered, she saw Selznick's shiny brown shoes propped up on his desk. His eyes were invisible behind his glasses. "We've decided to take you on," he announced. "Oh, have you?" Rosamond replied in her calmest voice, thinking Selznick sounded as if he were engaging a servant. After some awkward small talk, Rosamond was dismissed and sent into a tiny office to talk salary with "a slick young Jew" named Thorn, who immediately told her that he was the only truthful person on the lot. Rosamond pushed for a dollar figure; he pushed back, not wanting to name one, and she pushed harder still, at which time he told her $300 a week with "gradual raises for untold years thereafter."

"Laugh at them," said Cukor. But Rosamond knew there were millions of girls who dreamed of any offer at all. She dreaded the thought of becoming a puffed-up fool, one of the shouting people of Hollywood, but if she could land an important role, she'd be set for life. Father could come to California and recuperate in the sun from his aches and pains and bad financial decisions. She could have a house by the beach for the boys. They could ride in the mountains and go camping in the forest. Perhaps she could even help buoy the Pinchots' sinking fortunes.

The night after receiving word from Selznick about her contract, Rosamond cruised back to Pasadena through Beverly Hills when she decided to stop and call Big Bill from the lobby of the Beverly Wilshire Hotel. The clerk connected the call within two minutes, and as soon as Big Bill picked up, Rosamond knew that she was speaking with the Devil McNasty Bill who was in one of his jealous moods. She didn't share the news of her contract but asked him how he would feel if she brought the boys to California. "All you want is publicity and a career," he shouted. "Listen, you can't have your cake and eat it, too." Rosamond demanded an answer and shouted at him, when all of a sudden the phone went dead. Big Bill had hung up. She put down the receiver and burst into tears. How could he be so nasty, she thought,

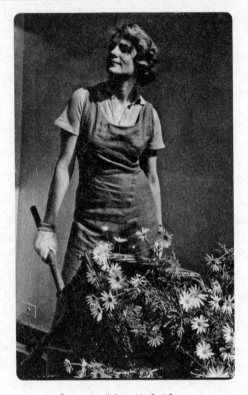

Rosamond in Hollywood by Cecil Beaton

when he could be so sweet? All the time he knew that she loved him, that she'd never really loved anyone else. She didn't want to take the boys away for good. She'd send them back for their time with him. She vowed to herself to fight him this time even if it meant getting a divorce.

Rosamond returned to New York in early March of 1934 when she received final word from MGM's Thorn about salary. The Hearst papers covered the deal, reporting "Contract Sealed," but the studio was looking for a film, so she wasn't due back on the coast until October. She had six months to smooth things out with Big Bill, improve her pathetic little wardrobe, hit the roller at the Colony Club, and lose a few pounds so she'd look sleek. In California, she would start a new life, grow a fresh

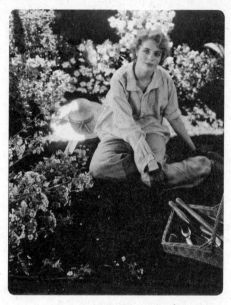

Rosamond in Hollywood by Cecil Beaton

arm like a starfish. She'd remember who she was and stop longing for things to be different. She'd bring the boys out to Hollywood, and someday Father would come, too. If it was a geographic cure, then fine, she'd eat her dates and fresh fruit and feel completely and utterly new again. That was, after all, the point of a rebound, wasn't it?

THE KING OF JEEPS

I was seven years old when my father and mother gave me a set of wholly impractical gifts. During one of his excursions to Gibraltar, my father sent me a string of pearls in a blue velvet box. At about the same time, my mother gave me a silver Hand of Fatima from Morocco, a talisman of protection she probably should have kept for herself. She never told me the story of Fatima, perhaps because I was too young, or perhaps because she didn't consider herself lucky. At sixteen, her father died and she was certain that God had abandoned her. After that, she wouldn't allow herself the luxury of magic or religion. Declaring herself an atheist, she decided to find her own way to make things right.

Thus the silver hand fell to me with no explanation. Many years later, when I was forty-five years old, I was cleaning out a drawer and found the Hand of Fatima floating around in a little gold box and decided it was time to deploy it for protection. Learning the story of Fatima, I discovered why so many women across North Africa wear the hand, keep it by their bedsides, affix it to the front doors of their houses. And I began to understand why my mother had given it to me.

The hand is thought to predate both Christianity and Judaism. It appears in Jewish culture as the Hand of Miriam, and in Islam as the Hand of Fatima. Fatima was the daughter of the prophet Muhammad and was married to Muhammad's nephew, Ali. She was known as a miracle worker, and according to legend, when she prayed in the desert, it started to rain. One day, Fatima was roasting

Young Bill Gaston

halvah in the garden when she raised her head to see her husband bringing a beautiful new slave girl into their home. As she watched the two of them pass, she became distracted and started stirring the boiling halvah with her hand. So upset was she, she couldn't feel the pain of her burning hand.

The Hand of Fatima symbolizes a woman's patience and faithfulness, but it is also used as a talisman against evil, so that, depending on the circumstances, women don't waste time in patience and faith. Western therapists might say the hand symbolizes a woman's sometimes lifesaving ability to dissociate from her own pain, but whatever interpretation is chosen, one version of the legend of Fatima contains a moment of redemption. As her husband and his concubine lay down on the matrimonial bed, Fatima crept into the room above them and peered down through a crack in the floorboard. She saw what she dreaded, shed a tear that landed on the shoulder of her husband, and realizing it was hers, he pried himself from the slave girl and renounced her in honor of Fatima.

My father kept a pied-à-terre on Rue Balzac in Tangier for nearly thirty years. It was while in Morocco that he started carrying a straw bag with short little handles that was part briefcase, part toolbox, part market basket. Inside the bag, the contents stayed the same: a copy of the newspaper the Dépêche Marocaine *he'd fold around a nest of bananas, a can of Spanish sardines packed in olive oil, a socket wrench, a few spare parts dirtying the works, a can opener in case of emergency, and*

the Rolleiflex like the one his mother had. The Rolleiflex was his constant companion in a peripatetic life of appreciating various forms of beauty. It was to beauty that he pledged allegiance, more than to, say, marriage or blood relations. He carried his camera thinking that a photograph can freeze time and halt dishevelment. Women vanished, got fat, and lost their glow; places that had once been pristine fell to wrack and ruin. Even kids, kids who were once so damn cute, grew up and asked for money.

He knew that it wasn't accepted practice for foreigners to photograph rural Moroccans; nevertheless, my father took thousands of photographs during his years with my mother in Tangier. He was the first to tell me that Moroccan women lift their left hand, the hand Fatima burned in her vat of halvah, to ward off the influence of the evil eye that is said to be lodged in the lens of a camera.

While the Hand of Fatima may protect a woman from evil, nothing halts dishevelment. Rosamond wrote that her greatest fear was that of growing old and losing her elasticity. Like most women, she quietly considered herself an ugly duckling. But it wasn't just men who noticed when women were losing their magic. Rosamond had just turned thirty when Liz Arden told her that she was allowing her "little beauty to slip." Rosamond told her diary, "The hell I am!" Long before Cukor assailed her "pathetic little wardrobe," she spent entire days working on "clothes," deciding what fit and what went with what. She was always prepared to be interviewed or examined, prodded, photographed, and posed by the great fashion photographers of the day. Makeup people smoothed gobs of Vaseline on her face, and she wondered why on earth a woman would want to live after she was no longer much to look at. Sometimes Rosamond longed to dive headfirst into a plate of mashed potatoes or stuff her cheeks with petits fours but instead she went days eating nothing but buttermilk and lettuce.

After receiving Rosamond's diaries, I thought long and hard about definitions of beauty. In the landscape, there are no ugly ducklings, only places that could use a bit of straightening and a dose or two of magic. By removing a crumbling stone wall, adding an eye-level hedge, or contributing a fresh new focal point, the eye is rewarded with some previously unknown loveliness. A landscape contractor once told me that early English gardeners moonlighted as magicians. By day, gardeners turned a lackluster spread into a serenely beautiful setting, and by night, they'd wipe off the dirt and perform their sleight of hand. The basis for most magic tricks is the art of misdirection, in which the magician draws the eye to one location while he performs his

sly manipulation in another. Since Cleopatra first batted an eyelash, women have mastered the art of misdirection. Magic and makeup disguise the truth, but true beauty has nothing to hide. True beauty can allow itself to slip and still be truly beautiful.

YOUNG BILL: 1938-1969

The years between 1938 and 1942 were rocky ones in the annals of Gaston father-son relations. Big Bill found more important things to do than spend time picking up after the emotional turmoil of his children. In January of 1938, Big Bill had headquartered himself in a rustic château in Cascade, Colorado, where he went to ski and romance western maidens at the foot of Pike's Peak. That winter, he returned east and at Cornelia Pinchot's urging, re-enrolled the boys at the Green Vale School in Old Brookville, Long Island, where Little Billy was a straight A student. The Pinchot family was relieved to see that Big Bill was showing signs of maturity when he hired Ida Hanninen, Rosamond's cook, and Miss Tuck, Little Billy's beloved nursemaid. But the following summer, Big Bill dismissed Miss Tuck, claiming that she was not glamorous enough for Crotch Island. Big Bill wrote Cornelia Pinchot, "I think she is going to get on my nerves in time. She's got quite a grim visage, if you've noticed, to look at steadily for three months, three meals a day, with no relief. Then she's taken to wearing shorts and her legs are no landmark of beauty. These latter remarks are facetious, of course—still, I've known smaller things to upset a nobler household."

At nine years old, Little Bill thought Big Bill, with his robust frame, wanted to kill him. Little Bill would spend most of his time in his attic bedroom where he felt safe. It was there he devised his first escape route. There were two windows in his room, and if he jumped on a chair and climbed out one of them, he could lean out over the roof to a tree, slide to the ground, and run away. Big Bill didn't seem to have a problem with his younger son, James, who had learned to manage his father. But when the boys fought, it was an entirely different matter. Big Bill knew

how to put the screws to his oldest son. The younger almost invariably came out on top.

For four long years, the two Bill Gastons eyed each other like cats, counting the days until the younger, at thirteen, could be shipped off to the Kent School in Connecticut. Seemingly indifferent to the boys' loss, six months after Rosamond died, Big Bill married a redheaded Texan, Lucille Hutchings, and simultaneously began an affair with the children's writer Margaret Wise Brown, author of *Goodnight Moon,* nicknamed Goldie. In the summers, Little Billy became a gopher for Goldie, running errands while Big Bill would "visit" her at her cottage on Long Cove, a quick boat ride away from Crotch Island.

By the time Little Bill finally shipped off to Kent, his grades had slipped from As to Cs. At Kent he made very close friends, but he harbored no fantasies about going home. By court order, Rosamond's estate paid for a room in the house to which Big Bill had moved in New Canaan, but young Bill wasn't welcome there and it was just as well. In the fall of 1948, Little Bill was admitted to Harvard and at nineteen years old he learned that since Rosamond's death Big Bill had siphoned $200 a month from her estate. While a monthly administrator's fee had been approved by the court, Little Bill knew it was an optional fee. So, with that, he'd cornered his first big rat. The dispute led to a flood of warring letters between father and son. Big Bill wrote:

> I gather that you thought you had trapped me in a great secret and conspiracy. . . . I can no longer contribute anything toward your further education and support. You must do it with your own funds. All the law obligates me to do is to take care of you and provide you with a home. That is here, if you want it, which I'm sure you don't. It does not compel me to send you to college, if I haven't the money for it, which I haven't. I have spent many thousands on you, have had no return at all, as you admit, and hereby sign off, except as to my legal requirements. You are much richer than I. When you come of age, you ought to have about $100,000. This is twice the biggest amount I ever had in my hands at one time. Very few boys have it. In a sense you may be lucky

that your mother died when she did, because were she alive today, you wouldn't have that same amount probably for years and years. It gives you your complete freedom at a very youthful age and I know you are counting on it. At the same time, don't forget, (as I haven't) that you have done nothing to earn it—just an accident of birth.

At eighteen, Little Bill began to receive disbursements from Rosamond's estate that put him in the top 5 percent of what Harvard students spent in a year, but Big Bill still controlled the rate of disbursements until he turned twenty-one. He still used his father's return address but it was just an address to which he rarely returned. If things hadn't been so heated between him and the old man, Little Bill might have gone back every once in a while to spend time with his colorful Texan stepmother, Lucille, of whom he was fond. Young Bill still had Milford, where he occasionally went back to visit his aunt Cornelia and his stepgrandmother, Ruth, but other than that, there wasn't a place he called

Big Bill, Jim, Little Bill, Tom, and governess Maggie Philbrook, 1948

home. Except his cars, of course, and Big Bill had his opinions on those, calling them the only thing Little Bill cared about and his "symbol of values."

Perhaps, as his father said, it was an accident of birth that Bill the younger had inherited his money thanks to his mother's death, but it was no accident that Bill the younger went on a vehicular buying spree with Rosamond's money. Young, dashing Bill Gaston, a fifth-generation Harvard man, was known in the Yard for his fleet, including the delectable French Salmson and the Model A and other cars stashed here and there, toys he'd tinker with along Cambridge's "Fender Alley" instead of attending biology class. Biology class had only one redeeming characteristic, the biology of a size 8, self-assured, chestnut-haired beauty named Frances Loud whom he had discovered amid a swarm of buzzing Radcliffe co-eds.

Frances looked damn good in a bathing suit, so at first their courtship progressed swimmingly. In the summer of 1948, after capsizing his

Young Bill at Harvard

dinghy together in Boston's Back Bay, Little Bill confided to Frances that he longed for her so deeply he wouldn't survive the three-month summer break from college without her. Bill wrote her that he was terribly depressed and considered ending it all, like some members of his family, but Frances didn't take Bill's long, sorrowful letters seriously. She thought he was just exaggerating, horsing around as he was known to do, and she couldn't believe that he would manipulate her that way or that someone who appeared to have everything could possibly say that he only had her. While he longed for her, Frances was too young and too thrilled at the prospect of being in love to know that longing isn't love, it's longing.

Young Bill had no plans to follow the Gaston family tradition by attending Harvard Law. After receiving his BA in modern European history in 1951, being conservative by nature and aware that when it came to luck in life he'd been given the mixed end of a very mixed bag, he decided to outwit an enthusiastic draft board by signing up for a three-year tour instead of getting drafted for two. In May 1952, he qualified for the Army Language School at Monterey, California, and undertook a rigorous yearlong stint by the sea studying Turkish. On her visits to Monterey, Bill showed Frances around the base and took her for long drives up and down the coast where Rosamond had once driven her old Buick, singing to herself and taking pictures. Frances and he were so hopeful. She called him her Dear Rake and he called her Floud. She was feisty and self-confident; they'd survived their separations. She didn't understand all the business about ending it all, but she felt sorry for him and his extenuating circumstances.

With his gift for languages, young Bill had aspirations toward becoming a member of U.S. Army Intelligence. In 1953, he was transferred to Fort Bragg, and in what could hardly have been called a hardship post, he was assigned to cover base parties and photograph the Miss America Beauty Contest from the snazzy Ritz Carlton on the boardwalk in Atlantic City. While working the pageant, he wrote to Frances, who he thought could have been a contender herself, that he secretly rooted for the dark horse, Miss Kansas. He thought she had suffered unfairly at the hands and legs of Miss California, who bested

Kansas in the swimsuit competition. When Miss Kansas came up with a lackluster performance in the talent stint, Bill broke down and reported that she had a voice that sounded like a day-old sparrow. It was tragic, he said, but boy, Kansas looked good.

When his father heard about young Bill's military assignment, tensions began to diminish. Big Bill sounded practically envious of his son when he declared in a letter,

> Your life doesn't sound like the army at all. It sounds more like a
> country club, with terraced and flowered lawns, tennis, swimming,
> yachting, the best food and weekends to the mountains with
> beautiful sirens. You know, in all the time you've been in the Army,
> I haven't seen you in uniform once. When you become a Turkish
> expert there are only three things I know about you can do: rugs,
> candy paste and a harem. Not so bad at that.

In the summer of 1954, after serving three years in the army and receiving his honorable discharge, young Bill convinced Frances to join him in a mission. It was more his plan than hers, but still it was a plan, and she was indispensable.

Recovering from a grueling first year at Harvard Law, Frances was staying with relatives on the French Riviera when young Bill buttoned up the fleet near Boston, flew to Paris, bought an Austin London taxicab, and surprised her with a ring in Nice. On December 7, 1954, they married on the Promenade des Anglais in a civil ceremony just blocks away from where Frances lived with her kindly French uncle, Henri Willem, her mother's brother who lived on the historic harbor and traipsed around the Promenade dressed in a Moroccan djalaba, slippers, and a fez. The ceremony was brief and unpretentious. Like Rosamond, Frances dressed in a blue traveling suit. Like Rosamond and Big Bill, they were in and out in half an hour. Young Bill gave her a classic diamond-ruby-diamond that made things official.

After spending six months tooling around the south of France and tending to the underbelly of the London cab, young Bill and Frances headed north through the Rhône on a little detour before turning west

toward the Straits of Gibraltar. To her surprise, the man Frances had married, who supposedly knew everything about engines, somehow forgot to put oil in the car. They were waylaid for several weeks at the Hotel de Paris in the city of Rhône awaiting pinion gears and gaskets. But no worry, they'd cross the Straits and leave expensive troubles like that behind.

At the Spanish port of Algeciras, they boarded a ferry for Tangier where they applied for their *carnets de residence*. The plan, as explained to the authorities, was to start a family, write a guidebook to northern Morocco, and perhaps start a little export business in oranges, jeep parts, gypsum, and, they didn't mention, maybe even a bit of uranium. Whether or not their ventures made money, they'd still have much of Rosamond's $100,000, an island off the coast of Maine, and half an interest in Rosamond's buildings in New York. If Bill was careful, which he was, and lucky, which he wasn't, the sum could last a lifetime in Tangier.

In 1955, Tangier was a shady Shangri-la of beat poets and businessmen, a small town perched like a bird on the mighty haunches of North Africa, a Mediterranean mirage of gleaming white boxes leaning up against her hills like neatly stacked sugar cubes. She was a cross between early San Francisco shining on her headlands and the Boulevard St. Germain in Paris. Thanks to her international free trade zone and Wild West atmosphere, the city was also something of a Klondike, which meant that according to his calculations, Bill could spend pennies a day and live like King Mohammed V.

The plan seemed simple enough but was an outrage to Frances's mother. She thought her brilliant daughter's marriage to a Gaston, any Gaston, would be the mistake of a lifetime. The more Frances's mother heard about the Gaston family, the more she thought the whole enterprise would end the way the Gaston marriages ended, in disaster. What daughter of hers, who had grown up on a steady diet of opera and Ezio Pinza at the Met and attended the elegant Dalton School in Manhattan, would give up a Radcliffe education, a law degree at Harvard, and the promise of a brilliant future? And give it up to do what? To move to Tangier, Morocco, with a man who paraded around like royalty in a foreign limousine with red leather seats in a place where they didn't even

Jeanne Willem Loud, Frances's mother, and Frances Clothilde
Loud, Vinalhaven, Maine, circa 1951

have washing machines? But Frances thought Bill and his plans for the guidebook were a lot more fun than law school, and he wasn't going to sit around and wait while she took a swan dive into the cesspool of the legal profession. She was miserable at law school anyway, loved him, wanted children perhaps more than she wanted him, so it didn't take much to talk her into the mission.

He had the goods. The good looks of a movie star—the angular jaw and blue eyes of Paul Newman, and the self-confidence of James Dean. He had the money, more money than she'd ever seen. He knew history, the kind of history that mattered in the big scheme of things, that the Visigoths had delivered a stunning defeat to the Romans at Adrianople, and that Rome had been sacked twice, first by the Goths in 410, then by the Vandals in 455 so by the time 474 rolled around, Rome was in shambles. He knew who had been where and what towns the Greeks had

plundered in what battle for what fort and it was all going to be relevant to the *Guidebook to Northern Morocco*. He spoke languages, four of them— five if you counted English—and he knew his way around engines, sort of, which he and Frances laughed about and agreed was probably far more useful than all their degrees and almost-degrees from Harvard and Radcliffe put together. Like his father, he was a rebel, which had its appeal, the second in five generations of Gastons who had basically said "screw it" to the legal profession. Big Bill had slogged through the mandatory education at Harvard Law, grudgingly, out of demi-respect to the lineage, and, being a sport, he'd accepted a post as assistant DA in Boston but never practiced after that. Bill the younger took it a step further and kissed the legal lineage good-bye without ever having said hello. He wasn't a joiner, he said, so he didn't pay his dues to the Society of the Cincinnati, the sanctum sanctorum of military heritage in the United States. Nor had he signed on to the whole wretched ritual that surrounded the family crest, Fama Semper Vivit, the vainglorious challenge to the progeny to do something, anything, to get oneself noticed, even if it meant emblazoning a ridiculous owl on a lapel and balancing the checkbook, anything one could do to make sure that "Fame Lives Forever." All that nonsense. He'd scraped by with a history degree, and that was about enough. The languages he knew—Arabic, Turkish, French, and Spanish—were thanks to the Army Language School at Monterey. Nothing to do with Harvard, Kent, or the Gaston family and its owl.

Virtually no one except the border officials, not even Frances, knew Bill had already traipsed through North Africa before. He had a curiosity about that part of the world, so in 1949, while nineteen and a sophomore at Harvard, he'd boarded a slightly converted Dutch cargo ship for Rotterdam in mid-July and traveled by train through Brussels and Paris before finally boarding another ship in Marseille bound for the coast of Algeria, where he found himself wandering the streets for eight days with his Rolleiflex. He'd been practicing his escape routes since he lived with his father, practicing so many years he couldn't remember. There were many times Bill, like his father, had simply

disappeared, like the time he played hooky from Kent School for a weekend in 1947 and wound up in Cuba. That weekend, ambling along the back streets of Havana, he just happened to wander into a smoky nightclub where Rosamond's brother, his uncle, "Long Giff," performed as a professional Cubana dancer. That weekend, in what young Bill said was the strangest coincidence of his life, he'd discovered a kind of Providence far from home. Rosamond's brother shared her joie de vivre, loving landscape more than people, so perhaps young Bill's escape had taken him exactly where he needed to go. Long Giff was just plain fun, volunteering to teach young Bill the things a man needed to know, about women, about dancing, about how to artfully escape the tragic endings both of them knew so well.

In the spring of 1955, Bill and Frances were full of hope for the future when they found a whitewashed villa, Villa Renny, high up on the Old Mountain in Tangier on Rue Jamaa El Mokra. The Old Mountain was a picturesque part of town, away from the bustle of the old port, where a sizable community of expats lounged around looking out at the view, longing for Tangier in her earlier days. When he wasn't directing the gardeners Abdeslam and Mohktar on tending the roses or clipping the mint, Bill was darting in and out of a sea of djalabas taking pictures with his Rolleiflex. He'd float through hilltop villages and vast open spaces in a Jeep or a Land Rover, take field notes on features of the Rif Mountains for the guidebook, and then return to a little desk in a garage he'd rented just off the Grand Socco, the proud main square of Tangier. The French had envisioned the Socco as a small version of a place in Marseille or Toulouse, but the land at the edge of the Casbah was pitched at an unmanageable angle toward the Bay of Tangier, so the Socco ended up a rather pathetic, tilting, disagreeable space for café culture, but a remarkable setting for grand traffic jams requiring the constant desnarling presence of a well-dressed gendarme. At the center of things ancient, French, and somewhat tragic, where young Bill found life both meaningful if not ripe for discovery, he opened a little storefront business at Rue Delahaye No. 1. The year was 1957. He called his enterprise "The King of Jeeps."

Perhaps it was the peak of his life. When he wasn't off in the Rif or composing letters to the editor of the *Dépêche Marocaine,* Morocco's largest daily newspaper, criticizing the authorities for neglecting the scenic potential of Tangier, Bill did a brisk business in used parts for Jeeps, Land Rovers, and desert vehicles. The King of Jeeps was, for all practical purposes, a garage, but to him it was a little home away from home. In the back, he kept his fleet, including the 1930 Salmson S4 coupe, the sleek black convertible Peugeot 203 with a roaring lion hood ornament, the World War II army Jeep, and his prize, King Mohammed V's limousine, a jet black French Delahaye, custom built as a parade car in 1950, which he'd bought in a moment of sheer inspiration, or folly, or both, from a well-dressed Tangerine named Mohammed el Akra. In the storefront office, he kept Rosamond's old Corona and his Michelin maps of the desert, spare film for the Rolleiflex, and, of course, a carbon copy of the *Guidebook* in progress.

When the import-export business in oranges and Jeep parts was slow and when he wasn't adding up his accounts like a French bureaucrat, he'd turn his attention to the manuscript, which was his kind of work because it offered a vision of hope for the wayfarer stranded in harsh surroundings. Morocco was one treacherous landscape no thanks to its rutted roads and lack of signage, and his guidebook would take the terror out of getting lost. Whether in the casbahs and souks, in the Phoenician-Carthaginian confusion of ancient Lixus, or the gardens of once-lovely Larache where flowers were planted on land that had once been a moat, Bill Gaston and his guidebook would get you there and get you out in one piece.

About eighty kilometers north of Fès, just past the crossroads at Ain Aicha, the road climbed toward the great plain of Ketama, winding and twisting its way into Morocco's most rugged chain of mountains, the Rif. Before reaching the top of the world, the road hugged the cliffs and narrowed to a single lane where it looked as though it were squeezed out of a tube to form the ragged makeshift roadbed, every inch fought over by passing vehicles. "Few of the roads in northern Morocco," Bill wrote in the preface to the *Guidebook,* "will bring joy to the motorist's heart." The

roads, he wrote, "winding over cedar topped mountains and through rock-bound canyons, are year round prey to the ravages of the seasons."

His favorite place to take photographs was in the forest around Ketama, high in the Rif, where there was very little asphalt to speak of, simply a rough dirt road. It was a good road and straight, except for a gentle bend where the Moroccans had made way for a majestic Atlas cedar, a species that made this area of the Rif ecologically notable. Young Bill had seen trees as noble and notable as this one in the hemlock forest around Milford and the camps in old growth built by the Civilian Conservation Corps. But the Atlas cedar didn't belong to the Rif at all. It was native farther south in the mountains near Azrou. He deigned to notice the things that didn't belong where they landed. The Atlas cedar, therefore, was more than a mere curiosity. He called it a "vagary," something that required one to think long and hard about what belonged where, how it got there, and how it survived, like the Portuguese forts along the coast that the Moroccans said were Spanish. With his Moroccan bag and his meal in a can and his Rolleiflex, Bill never knew what to expect or what might bring joy to a motorist's heart. Perhaps the bend in the road, high in the Rif, might become important, as important as remembering what he recalled of Milford, her moat, and the Good Ship Rhododendron that struggled each day at the base of the falls. Four thousand miles away, he discovered a single tree, like a replacement landscape or a foster mother with her welcome of greenness and promise of cover.

On a Wednesday, market day, in the fall of 1955 in Ketama, the town given the same name as the wide rolling plain, young Bill Gaston pulled over and stooped down to the dusty ground at twilight and pointed his Rolleiflex at a classic Moroccan street scene of white-robed townspeople moving in a cloud of dust through the town's serrated arch. The following year, the photograph won him the coveted first prize from the *Dépêche Marocaine* of Tangier. He proudly stood on a podium with Frances and various Tangerine dignitaries to collect his prize, but a few days later the locals decided that a Westerner had no business exposing poorly dressed rural Moroccans to the evil eye of a camera, so his title was unceremoniously yanked. But he'd managed to make off with the prize, an impres-

sive faux silver cup that read "Premier Prix" on a little round stand that declared his photograph the winner.

If there'd been a part of himself waiting to be found somewhere in the world, he'd found it high up in the Rif with the startlingly blue-eyed Berbers. Few foreigners ventured to places like Chauen and Ketama in the 1950s because there wasn't much in the way of accommodation and no real reason to go. For the sake of those who found one, Bill approached each town like a choreographer. Like a cross between Rommel of the desert and Reinhardt of the stage, he'd study the portals, arches, and gates to ancient villages. "One should never," young Bill Gaston wrote, "for the first time, approach Chauen from the north, for this is to enter the loveliest town in northern Morocco by the back door."

Morocco was still a traditional society in the mid-1950s, but that didn't stop Bill from posing Frances in the middle of the desert in a bathing suit on the hood of his British cab. They were accomplices in this romantic field trip, so by early morning light in Tangier, they'd rise and rev up the World War II army Jeep and take off into the Rif. Sometimes she'd play the jiggling stenographer in the front seat, in which case their notes would be neat and well organized. Sometimes he'd go by himself because she looked uncomfortable in military garb surrounded by djalabad tribesmen. She'd stay home washing clothes in the sink, ironing, and wailing to Portuguese fado or bounding around the Villa Renny to "Roamin' in the Gloamin'" with Harry Lauder, whose broadcast from Gibraltar was aptly named "Scots on the Rocks."

In the 1950s, Richard St. Barbe Baker, a British-born Canadian forester from Saskatoon pronounced that the phenomena of soil erosion and deforestation required nothing less than a spiritual devotion to restoration and began a society named "The Men of the Trees." Baker wrote a gothic, emotive tome entitled *Among the Trees,* featuring an introduction by the broadcaster Lowell Thomas, who wrote that "men who plant trees love others besides himself." Like Gifford Pinchot, before becoming a forester, Baker had considered the clergy, but in 1955, he opted instead for a nine-thousand-mile journey to promote reforestation in the Sahara. At

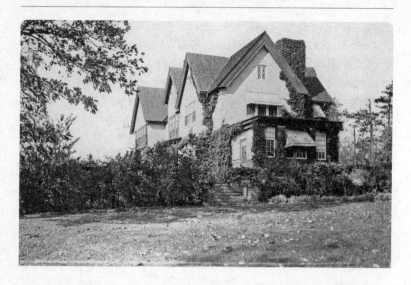

Frances C. L. Gaston and a London cab near Tazenakht, in the Moroccan Sahara, 1955

one stop, he set up camp at the fashionable Ville de France Hotel in Tangier to deliver a lecture. The Men of the Trees had attracted the attention of men like Franklin Delano Roosevelt and George Bernard Shaw, so young Bill Gaston, the self-appointed king of desert vehicles, hoped he could help:

Dear Mr. Baker,

During your recent stay in Tangier I followed with great interest several articles in the local French paper in which were described your fight against the advancing Sahara. The vastness of your scheme and its vital importance to the future of man proved inspirational to me, for it is not often that men embark on such altruistic endeavors, particularly in Tangier. I have read also of the establishment of the Sahara Reclamation Company through which you plan to effectuate conservation measures.

To put it briefly, I wonder if there exists the possibility of my fitting into your organization. I have not had any formal training in

forestry or land reclamation, my only experience along with a great enthusiasm having been gained at the knee of my great uncle, Gifford Pinchot in the United States. I can only imagine how enthusiastic he would be if he were living and knew of your present project.

My training has been in journalism and though this may be a bit removed from your plans it may be that your organization will require a publicist, though frankly I would prefer to be out in the desert planting trees . . .

Young Bill never landed a job for the noble caravanserai of Richard St. Barbe Baker. Like a mirage, the forester in the desert vanished, replaced by a mission closer to home. In October 1957, a new generation of Gastons—mine—was launched with the birth of my brother, named, what else, but William Gaston, nicknamed, what else, Billy. Between editing and typing chapters of the guidebook and her own articles for *Colliers Encyclopedia,* my mother gave birth to the towheaded infant at the Clinic California at the bottom of the Old Mountain.

On July 3, 1959, I was born under the whir of ceiling fans in a small whitewashed room at the same Clinic California. Because there was no reigning name for a girl in the Gaston family, my mother and father assigned the name Patricia because of my long, "patrician" fingers. But Patricia was hard to pronounce for two-year-old Billy, who also couldn't say "baby," so everyone called me Bibi. My mother told the story of my birth so many times and with such insistence that it seemed to grow tentacles that looped and threaded their way through every interstice of my earthly existence. According to her, I was delivered by a Spanish cleaning lady at the clinic because everyone had gone home, including my father and the handsome French doctor who was supposed to deliver me. The two, she said, had run off down the hill to a cocktail party and couldn't be reached. We had been ruthlessly abandoned. My father said that story was hogwash but offered no competing explanation, so the story stuck. On my birth certificate, my mother wrote two addresses, The Villa Renny, Djemaa El Mokra, Tangier, and the Fidelity Title and Trust Company, New Canaan, Connecticut. By 1959, apparently, the Valley Road House, Big Bill's primary residence, was no longer a return address.

Bibi at the Alhambra, 1962

Bibi in Tangier, 1963

In March of 1962, my mother was depressed about the state of civil unrest in the streets of Tangier. Between daily riots and increasing violence, it was a good time to beat it back to the States. "Gaston, *vous avez bien fait,*" said people who understood the value of a French franc versus a Moroccan dirham, "you are smart to get out while you can." At about the same time, my mother had given up trying to cajole a washing machine out of my father but had a third child, Isabelle, in what my mother said was a very painful delivery. Meanwhile, her mother visited Tangier to assist with the laundry, the housekeeping, and the newborn, noticing as well that my father was around less and less; and bottles of wine made their appearance in places where people didn't commonly keep them.

The idyll was over.

My mother wanted to educate her children in America, so in the spring of 1963, she and my father hauled their belongings off to the bidonville in Tangier's poor neighborhoods and put the bleached white walls of Villa Renny up for sale. A Scot bought the villa, dismissed poor Mohktar, and hired a high-class flower gardener who made changes to the garden layout. My father wasn't entirely ready to abandon the import-export business, so he took a dirt-cheap pied-à-terre next to a goat meadow on Rue Balzac. My mother would return to the United States while my father would slowly close up shop in North Africa on the vagary of Moroccan time, which meant later, or perhaps never.

My father shipped the Delahaye aboard a British ship bound for New York, just in time for a remarkable celebration that fall when the president of the United States was scheduled to land in a helicopter on the lawn at Grey Towers. Not one to miss an occasion, on the morning of September 24, 1963, my father rolled the king of Morocco's limousine out of her safe, dark lair near Princeton, shined his car to within an inch of her life, and made adjustments under the hood. She arrived ninety-five miles and three hours later in little Milford where flags and banners were hung in celebration. The papers warned of scalpers hawking overpriced food and "Brobdingnagian" traffic jams complete with ten to fifteen thousand flag-waving visitors. A rare 1917 handblown glass goblet was bought as a gift from the people of Pike County to be presented to President John F. Kennedy, who was sure to put Milford on the map.

Around midday, I climbed out of the king's car like a foreign digni-
tary, albeit a young one, and my father lifted my brother, Billy, high onto
his shoulders to listen to the president speak on the legacy of Governor
Gifford Pinchot. "Every great work is in the shadow of a man," the
president began, "and I don't think many Americans can point to such a
distinguished record as Gifford Pinchot." The celebration that day was
to honor not only Gifford, but Gifford's son, Dr. Gif, and the entire Pin-
chot family for its donation of the château to the U.S. government.

This was my father's first trip back to Grey Towers since 1960 when
Aunt Cornelia died. In fact, he'd hardly been back since 1946 when, at sev-
enteen, he'd been the youngest pallbearer at the governor's funeral. Corne-
lia and Gifford had once meant the world to him, but now practically
everyone he had ever loved in his family was dead and the château he'd
grown up in was being given to the U.S. government. "Of the thousands
of cultural resources administered by the Forest Service," began the
Historic Structures Report for Grey Towers, "none holds more pro-
found significance for the Forest Service itself than Grey Towers, the

Bill, Isabelle, and Bibi Gaston at the Bait Box, Grey Towers, 1963

home of its founder Gifford Pinchot." But on that fall day, once-manicured lawns had turned to fields, the pools and fountains had been turned off, and the vision of James W. Pinchot and Richard Morris Hunt resembled a scene out of *Rebecca*. Since the governor had died, the old place had sunk into dishevelment.

In his speech of 1963, staged in Cornelia's Depression-era amphitheater, President Kennedy publicly announced how the government intended to straighten out the situation. The Pinchot family would slice off 101.77 acres of land and deed it to the U.S. Forest Service. At the same time, preliminary plans for the Pinchot Institute for Conservation Studies would be drawn up with headquarters in the château. "This institute," the president announced, "which is only the latest manifestation of a most impressive legacy, I think, can serve as a welcome reminder of how much we still have to do in our time. I hope that . . . what Gifford Pinchot and Theodore Roosevelt and Franklin Roosevelt and Amos Pinchot and others did in the first fifty years of this century, will serve as a stimulus to all of us in the last fifty years to make this country we love more beautiful."

President Kennedy completed his tour of the house and grounds and posed outside Grey Towers' massive wooden front door for photographs with Ruth and her two children, Rosamond's two half-sisters, Tony Bradlee and Mary Pinchot Meyer. None of the photographers and practically none of the family knew just how close the relationships were—that Mary, then forty-three years old and married to a man in the CIA, was having an affair with President Kennedy at the time.

My father would not have known about the affair; nevertheless, the scene at the front door of the château must have seemed odd. There was barely a trace of what once had been. Rosamond had once stood on those very steps with Amos and Gifford and the Roosevelts. Perhaps the problems began when Amos took a sabbatical from his marriage, leaving uptown Gertrude for upstate Ruth. Someone had told young Bill how the scene between his grandparents played out, how infidelity was called a "breach of promise" at the time, and a scene was staged to spare the new wife. The police were called to view photographs of Amos with another woman in a hotel room to make it appear that he'd been caught red-handed. No one emerged completely unscathed, but the marital rupture

was complete, so Ruth could march into 1125 Park Avenue as if she hadn't been a party to infidelity.

My father felt what Rosamond had felt, that Amos's first family was all but forgotten. Perhaps it was Amos's undoing that was Rosamond's undoing and explained why he felt displaced. Or maybe Amos's problems began when James Pinchot designated Gifford the heir apparent and Amos was assigned to balance the family checkbook. He'd also been displaced. Or perhaps the Pinchots had been so high-minded that they forgot about one another. But that wasn't true, either; Amos and Gifford had been good to Billy after his mother died. Maybe it was his father's fault, the man the Pinchots called Beelzebub, the Devil. Maybe it was Ruth's doing; after all, she was intimidated by the very memory of Rosamond and how Amos loved her so.

No one mentioned Rosamond anymore. One almost wondered if Rosamond had been a dream. Someone said something of Bill's mother that sounded like a dream: "She had a presence of poetry—a whisper of myth come alive again." Perhaps it was John Barrymore who had said it or his wife, Blanche Oehlrichs, who used the pen name Michael Strange. He couldn't say for sure.

What mattered and what was being celebrated, was that the "Amoses," as Amos's second family was called, would become the government's new neighbors, inhabiting the Forester's Cottage adjacent to the château. The Forester's Cottage was smaller and more manageable. Meanwhile, the "Giffords," who once lodged in the château, had succumbed to the crippling monster of maintenance, so they were leaving. But on that fall day, everyone's moving on with their lives hadn't settled his.

Despite the diaspora of the good old days, my father made his regular pilgrimages to Grey Towers. When he really thought long and hard about the way things had turned out, it was probably better he hadn't owned any of it. He could come and go as he pleased and never lift a hammer or drive a nail or write a check. Instead he honed the art of pilgrimage, living lightly on the land having survived his lessons in loss.

He could do the trip in his sleep. From the Old Mill he'd wind his way through the rural farms and fields of the Sourlands, through the Water Gap, over the Delaware River. He'd usually pass up the Milford

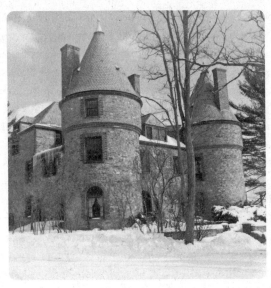

Grey Towers

Cemetery with the signs that talked about Governor Gifford Pinchot, and where few knew it, but where Rosamond was buried in the little mausoleum. When he finally reached Grey Towers, he'd navigate the forlorn entrance drive, park, get out, and head through a copse of aging black locusts Cornelia had planted. He'd cross the deteriorating lawns and head over to the Forester's Cottage, where he'd fix himself a drink like they did in the good old days. He'd take a seat in one of Ruth's rattan chairs on the front porch and chat amicably with whoever was around. There'd be a kind of simultaneous and symmetrical forgetting and forgiving as he'd nod at the children, though he couldn't remember their names. He'd spent endless summers torturing his governesses and playing with his puppies on those deteriorating floorboards under all that ivy which hung beneath Rosamond's tower room. But now there was really nothing to say, so he'd make a few polite efforts at small talk, bid adieu, and do what he came to do. He'd go where there had never been enough time to go and do what he'd never gotten enough of in what he called the good old days.

He thought there would be a resolution through repetition. Year after year he came back for the same thing, something that never changed. It was the thing that the whole family sought at Grey Towers, but it hadn't shown up on the government's maps because that would have ruined the place. He didn't keep coming back for a cultural moment or a historic one. He returned to a moment in the landscape where, by stepping through a curtain of green, he'd puncture the solid wall of everything that seemed so terribly important and descend into the canyon of the Sawkill. He was opinionated about these things, and if pressed, he would have dispensed with the houses and the gardens and the cultivated fields. He'd keep the history and the accomplishments that had distinguished the old place, but it was that pine-needle path through the forest that he would take, and in turn would take him, to what was really going on at Grey Towers. Rosamond had taken that same path. The path had taken all of them there, he and James and Governor Gifford and his grandfather Amos. All the Pinchots knew that the land was splendid, of good exposure and views, but the one thing that made Grey Towers worth remembering and the thing that kept them all coming back was the Falls.

So on that glorious fall day in 1963, after the president said his final good-byes to the Pinchots and thanked them again for the château, he was whisked off the steps to begin a multistate tour to promote the nation's environmental heritage. After the helicopter lifted off, my father led us through the grounds, then down to Sawkill Creek where he'd once played with his mother and learned to fish with Amos and Gifford. Together we found our way to the narrow channel at the base of the Falls where he took me on his back and then in his arms. We kicked and slid through the green chasm of the Sawkill where there was no forgetting Rosamond.

Just two months later, on November 22, 1963, President John F. Kennedy was shot dead in Dallas. Almost one year later, on October 12, 1964, Rosamond's half-sister Mary was also assassinated, at close range, along the C and O towpath in Georgetown, Washington, D.C. A black man, Raymond Crump, was accused and tried but never convicted. People said the CIA was responsible, but her murder was never solved.

In the year after my father's return from Morocco, the Pinchot family was compared to the ill-fated Greek house of Atreus.

From 1963 through 1965 my father traveled frequently back and forth from the States to Tangier, Rabat, and Casablanca on his orange-juice and Jeep ventures. Airmail letters and postcards flew back and forth between Morocco and the Old Mill, where my mother had developed a distinctly unglamorous existence, a cardinal sin in the Gaston lexicon. Overwhelmed in the musty Old Mill with three children, she battled loneliness but succumbed to the one thing my father said was a deal breaker: fat. She'd ballooned to a size 16, which my father warned her was untenable for a man who "grew up in the shadow of three splendid, perfectly proportioned cylinders at Grey Towers." The Gastons carried the fat gene, which my father had been lucky to avoid, while the Pinchots were long, lanky, and athletic ectomorphs. Fat was criminal, so my mother went to see a doctor, but, like many women, she couldn't slim down. She'd had her children and sunk into a state of deep despair. My father started spending more and more time away from home, eventually taking a Moroccan lover. My mother found postcards from foreign countries in the Old Mill, and several days before her birthday in May 1965, my father wrote my mother from Rabat, Morocco, admitting to an affair:

<div style="text-align: right">Hotel de la Paix</div>

Dear Sweet Fran,

I suppose this morning I can count myself lucky to be alive, and that I did not take the way out which is customary in my family. I think it is best you know something of the terrible crisis I am going through. Frequently I feel like I am on the precipice, with the bones of my mother and her father beckoning from the gloomy abyss below. Yet I have not succumbed for I sense there is sunlight and day above, and these attract me more than the morbid. I feel I shall emerge and be reunited with those few who do love me despite what I have done. . . . My dear, this experience has been so incredibly painful for me that, whatever be my relations with you in the future, such an event can never take place again in my life. I

have learned a lesson, perhaps late in life for this sort of thing, but I have learned it. I have lagged behind in many things as you know. Needless to say I am equally distressed that you, as innocent bystander in this turmoil, should suffer. But perhaps you too will learn something from it, something about the man you had the misfortune to marry. Perhaps you can fathom what demon inside him caused him to fling himself into a situation which could from the beginning, only destroy him or, at least, come close to it.

My mother had heard it all, or something like it, before when he'd spoken of ending it back in 1948 and 1949 in his letters to her during their sophomore and junior year. Here was his grief again, only this time she could add infidelity to the story. This time, she decided to stop feeling sorry for him.

In the summer of 1965, my father hatched a plan, and once again, it wasn't her plan, it was his, and for all she knew, he was saving the best for someone else. We were going to build a shack of driftwood on Crane Island, Maine. To a child, the enterprise sounded like fun, but to my mother, the plan, coupled with my father's disappearing acts, was the beginning of the end.

No one in his right mind would place a dwelling so close to the sea. And maybe he wasn't in his right mind after he returned from Morocco and went to work on the little building he called "Shack." In 1965, Shack was just a folly, a self-deprecating statement of where my father stood, a stone's throw but a world away from his father's island, Crotch, where, through the 1960s, Big Bill still held court in his great hall with his candelabra, flying putti, and famous guests. Shack was more than a world away from his brother, James, who always managed to come out on top, with the largest island in the Gaston archipelago, Hurricane Island, which he rented to Outward Bound for its first wilderness camp, mainly, people said, to avoid taxes.

Half Pinchot and half Gaston, Shack was purposeful, but with a feminine loveliness that defied her salty origins. Like my father, she made good use of what nature had deeded. Shack was not opposed to the sea; in fact, each year she became more a part of it. With her warped

and mottled irregularity, her steely gray eyelids, and a delicate roll to her roof, Shack resembled a rail car that had run off its tracks just inches from the sea. My father hooked up a red hand pump to a hose that led to a fetid swamp that, in the wet years, siphoned enough liquid he called water into a small steel sink in Shack's galley kitchen to wash the dishes or boil the lobsters. But that was Shack's only utility so to speak. "No heat, no electricity, no bathroom, and complete luxury," my father would say. Shack wasn't tied down to a footing or a rock. Exposed and vulnerable, she accepted her destiny and braced herself against the winds and the storms that would ravage her each year. During the winter, tides swept through the cracks and fissures of her floorboards, leaving deposits of sand, ground barnacles, twigs, and strands of desiccated seaweed. Like a gentle friend, the sea would perform a kind of scrubbing action on my father's little driftwood creation, wreaking no havoc, but leaving notice of its annual visit.

Courtesy of the sea, Shack stared out through two wide-eyed windows my father fashioned from a double-holer. Somewhere someone was missing the seat to an old wooden outhouse, that, from the looks of things, had seen many a derriere. It was magic, really, how he'd make something out of nothing. I thought of Shack as a brief moment in an archipelago of sadness when creativity transformed his grief.

In 1969, my mother initiated divorce proceedings, engaging two law firms in New York State and one in New Jersey, whose first task was to prove my father lived in New York so that they could attach themselves to Rosamond's buildings at Seventy-fifth Street and Third Avenue. Playing games of cat and mouse, the attorneys proved unsuccessful, but in time, he was outwitted; in letters to Big Bill from Tangier, my father claimed to be a fugitive from the American legal system. He wrote to friends saying that my mother had fallen victim to the worst sin imaginable, "accumulation of gross poundage." He wrote letters to his girlfriend, Therese, in Paris claiming his love for her and inducing her to come to Crane Island where she could drink from a swamp and experience an American summer vacation à la Emerson and Thoreau. And in a series of letters to Lady Diana Manners in

London, the Madonna in *The Miracle,* he desperately sought to fill in gaps of information about his mother. He was forty-four years old and Manners was seventy-seven when the two exchanged a series of letters in which my father admitted knowing virtually nothing about his mother. His mother's diaries and scrapbooks, he told the Madonna, had long since disappeared.

PARADISE

I received my master's degree from the University of Virginia in the spring of 1986 knowing more about the geometries of Andre Le Notre's moat surrounding the French château Vaux Le Vicomte than Thomas Jefferson's perfect little oval fishpond at Monticello or the temperate rain forests in the Pacific Northwest. European classicism was an elegant place in which to steep for a few years, but not a place to linger. I never aspired to become a garden designer for the rich and famous, but after analyzing the axis at Versailles and the proportions of the Villa Lante, I soon realized that the arrows in a classical designer's quiver are best deployed in the garden design of palaces and vast pleasure grounds of the new gilded age. In the years that followed, I paid my dues in Greenwich and Palm Beach, places with enough geometry and intrigue to match that of Vaux in the midseventeenth century. Next door to properties I worked on, the owner wasn't around to enjoy his twelve-car garage and his acres of flowering parterres and vanishing perspectives. He'd been sent up the river as had Vaux's owner, Nicolas Fouquet, France's minister of finance, for misappropriation of funds. In Palm Beach, we read about the neighbor's plight in the paper. It turned out the misappropriator didn't actually miss the manse or the grounds while he was locked up because he had never used his backyard to begin with. The landscape was all for show, a vast spread, a pattern really, which one didn't inhabit but viewed from on high.

Gardens used to serve a loftier purpose. At Villa Lante, I once watched a scruffy old Italian gardener deploy a coat hanger to unclog a line of Renaissance-era fountain jets at the base of a mossy sculpture of a lounging river god. The sight of the man, and the god, reminded me that gardens once served as allegorical Disneylands. Statues of mythic figures were not just sited to punctuate a garden axis, but to engage an owner in a quest of imagination and hope. Great gardens had a mission. When they stir us, gardens unlock the mysteries of mind and emotions, fate and destiny. They answer the question: How might we celebrate the place we live in, these leafy corridors between heaven and earth? May I suggest an island of lemon trees or a room of moss?

I'd chosen landscape architecture because I wanted to rescue places. When I began to feel more like a spy than an architect, I decided to redesign my career. My romp across America first took me to work on the great American masterpiece, Central Park, and then to the forests of the Pacific Northwest and eventually back and forth between projects that had enduring value and those that did not. Along the way, I found myself in desecrated places where man and nature hadn't gotten along. They'd ended things badly and I was sent in to rescue the patient.

Fifteen years after resuscitating the landscape at Seventy-ninth Street and Fifth Avenue in Central Park, I learned that Rosamond, Gertrude, and my father had lived almost directly across the street. If my life and my upbringing had been, in my mother's word, "normal," or if I'd heard the elders tell their stories by the fireside, I might have known I was working to restore what was once my family's front yard. If I had known my connection to New York City, I might not have gone on my ten-year romp. I wasn't upset and it wasn't a waste. During those years, I kept stumbling into places where Rosamond and my father had been and ones strikingly similar. Looking back now, perhaps I was always on a path to the diaries.

While uncovering the story of my father and Rosamond, I would frequently share my story with strangers. As I described what I was doing in Morocco or Hollywood or Florida or Maine, they got a wild-eyed look and said that I was doing exactly what they had always wanted to do, so they made grand statements: I was a salmon, swimming back and back to complete the unfinished stories of my ancestors. I was putting a pattern to chaos. I was putting weary souls to rest. It was all projection, really; those were the things they wanted to do, the things we all want to do.

BIBI: 1986-2000

In 1986, my father spent a fifth dry-docked summer in a dusty boatyard next to the ferry terminal in Rockland, Maine, putting the last coat of varnish on a 1948 Nova Scotian cabin cruiser. Burmese for "Victory," the *Aung* was a close replica of his father's boat *The Harpie*. I had just landed a three-month position evaluating scenery for the State of Maine, a job that sounded much more fun than it was, when I wandered over to the coast and spotted him making last-minute adjustments in the engine compartment before launching the boat he thought of as "Miss America of the Sea."

The maiden voyage got off to a muddy start. At the last minute, I had invited a friend to come aboard before the launch, but a certain miscalculation woke us up in the middle of the night when I fell out of my bunk onto the floorboards. In darkness, we lifted the hatch and there, spread out in all its starry, watery glory, lay the rocky coast of Maine, only it was pitched at a forty-five-degree angle. The tide had gone out. Instead of spending the night aboard the ship with the crew, my father was snugly installed at the Wayfarer East, one of the species of seedy, slumping hotels on the Maine coast that he swore by because the price of a good night's sleep was less than a weekend's worth of Pabst Blue Ribbon beer.

The *Aung* wasn't his first wooden boat by any means, but he said it was the first boat in a long time that was worthy of anchoring off Crotch Island. With a beam of nine feet, *Aung* was not much wider than a passenger car, but her stern deck was so long she could hold a dance floor full of people. *Aung* cut a fine inaugural figure leaving Rockland Harbor in the summer of 1986. My father wanted to show off his newly refurbished boat, so he planned to head north to Camden Harbor, where, like the beauty pageant at Miss Mason's School on my first day of kindergarten, he hoped for an audience. As part of my new government job for the State of Maine, I had rated Camden Harbor one of the most scenic on the coast. The scenery was enhanced by a long, narrow channel stacked three

deep with some of the most shapely, valuable sailboats in the world. My father knew everything about his new diesel engine, but he hadn't had much of a chance to test drive *Aung*'s manual steering, so as we spun into Camden's picture-perfect lanes of boat traffic, he became visibly agitated. *Aung* was twice as long as any boat he'd captained, so as he tried to slow her, she reared out of control and slid indelicately into the side of a small sailboat heading in the other direction. The sideswipe wasn't serious, and the other party waved gaily as if it had been a most common error on our part. We recovered and were making a fast turn at the top of the harbor when I cringed, turned green, and ducked my head in horror. We were playing bumper boats in scenic Camden Harbor. Harbor gawkers glared and put their hands to their mouths as we careered into million-dollar Hinckleys and nailed the rub rails of J-class racing boats. Once we rounded the top of the harbor, my father brought *Aung* out of her death spiral and we hightailed it out of Camden. We rounded Curtis Island light and headed east into Penobscot Bay toward Vinalhaven, where I felt sure we'd be a bit more welcome. But as it turned out, my father had made quite a name for himself with the boatyard boys when *Aung* had spent

The captain and crew of the *Aung*

time in dry dock, and according to his side of the story, the good ol' boys had cheated the pants off him. According to their side, he hadn't paid his bill, so they didn't exactly cheer at *Aung*'s long, sleek lines when we pulled up to the dock. In fact, one of the boatyard boys greeted us by dropping his pants and mooning the boat.

I'd suffered enough excitement for one day, but we finally rounded the cove of Crotch Island where the captain popped a Pabst, and the crew poured a round of Chivas on the rocks for herself. We sat down to relax where Big Bill had once planted his flower gardens, and without unpacking or doing anything practical, we took in what we had come for, what he called "the setting," and to do what we always did, argue about the view. He waxed poetic about the good ship *Aung,* about beauty in general, the evaluation of which he thought of as his best suit. I advised him that since I had seen him last, I'd acquired scenic exper-tise, what with my basement job analyzing maps. As always, he was curi-ous how I planned to make a living, this time off scenery.

Since he wasn't impressed by my answer, I changed the topic to re-port on something I thought he would be more interested in: the pictures of Rosamond I'd seen on the wall of his cousin's house in Charlottesville that spring, just days after he'd come to my graduation.

He rose to the bait like an angry, feisty fish. "Listen," he said, "we don't need to talk about her. Ever. She was a whore." I was terrified by his response, but I understood. There wasn't any need to talk about her, not now, not ever. So we went back to talking about his beauty subjects, the setting, the noble lines of *Aung,* the sweet fluffy buffleheads bob-bing in the cove. And of course, our favorite topic, a debate over the fate of a solitary spruce that split the view of Penobscot Bay like a knife.

Moments later, he changed the subject, to his brother, the subject that, to him, never got enough airtime: how his brother had betrayed him and betrayed the whole family. I never understood the context of what had happened, only the way he described it, how his brother had poured acid in the wound. I let him repeat his story for his own good. There were no nice words to describe how his brother took sides with my mother during my parents' divorce and came away with the property at Seventy-fifth and Third Avenue while my mother was in a divorcing

woman's coma. She'd signed away the family's most valuable asset. Now listen to this, he said. Are you listening? he asked. The buildings would someday be worth hundreds of millions, he said. None of that, not one dime, will go to you. Not to your mother, either, he said. My mother got nothing out of it, a big fat zero.

It was true. My mother was left practically indigent after her divorce. She never spoke to my father again but she always maintained good relations with James Gaston, saying he had rescued her. He was the good brother, she said, and our hero. None of it made any sense to me. She was supported by her mother all her life and lived the last twenty years in a one-room San Francisco studio, without a working refrigerator or a washing machine. I could have asked my father why he left us with no money, and why he'd done things like call a moving company to have all our furniture moved out of the Old Mill when we'd left for Oregon one summer. But there was no point; it always came down to the same thing: he was ruined after the divorce. He couldn't help us or help anyone. The properties were the family's future and his brother now had everything that once was his. My mother was so brilliant with her Radcliffe education, he said, but trusting attorneys led to her demise. He would never ever call James Gaston his brother, not as long as he lived. Nothing could prepare a man for that kind of betrayal. And one thing you should know, he said, you can't take betrayal to court!

My father's voice bobbed, weaved, then drowned out. I could have pressed him for the details of the legals and financials, but instead, I listened to the waves tapping at Big Bill's dismantled dock. Betrayal was something I'd never experienced, but imagined, at its worst, was like the beat of a drum that never stopped, a firm warning that there is no refuge in human relations. Big Bill knew the betrayal of his siblings, and my father knew his brother's betrayal. His brother hadn't just poured acid in any wound. I didn't know it at the time, but this was the first wound, the deepest wound, the Rosamond wound.

There was nothing I could say or do, so my thoughts drifted back to what my father had said about Rosamond. I had always had two pieces of information—that she was beautiful and that she had killed herself. But here was a third piece and far more perplexing. What did he mean

when he said she was a whore? Was my father furious at having lost something irreplaceable, or did he mean that Rosamond had been with other men? I was too afraid to ask him. Too afraid to expose myself to the pain that never went away.

My pain hadn't gone away either, how he'd rated me like scenery during a trip back to Tangier in the summer of 1981. In a receiving line of dignitaries talking camels and rugs, I overheard him introduce my sister as the pretty one. I lost my voice for three days while my brother and sister said nothing, colluding in silence. He did to me what had been done to him, making one child feel good at the cost of another. It was the first time I realized betrayal could spread like a disease. But there was no point in bringing that up either. Discussing the scenery was more useful. So I told him how a cove view rated higher on the scenic scorecard if it contained moving water versus flat. Rocky outcrops, lighthouses, reversing falls and old boatyards were more beautiful than flat-roofed industrial buildings and used car lots.

That fall, after the scenic work ended, I went to work for a firm that that ripped up the scenic Maine coast to make way for subdivisions with names like Stonegate and Buck's Crossing. I was doing things that my education had not prepared me for, like ordering backhoes to turn virgin forests into mulch and flattening fern-strewn ledges to make way for neoclassical entrance statements. They were unforgivable acts really, crushing and trampling the divine to make way for mediocrity.

One day the next spring, after receiving a ten-cent raise, I sat straight up in my drafting chair, put down my electric eraser, and placed a cold call to a grand old master of landscape architecture in Greenwich, Connecticut, Mr. A. E. Bye. I never expected Bye himself to pick up the phone but he did, and I must have sounded like an inmate on death row. I whispered my story into the receiver and with the voice of a hoot owl, he said he didn't hire just anyone, that if I expected to do subdivisions, he didn't do subdivisions, but I should come down to speak with him, anyway. When I arrived on the estate of his client, Leonard Lauder, Mr. Bye could see that I was a casualty of war. I had tortured spruce and injured lichens and maimed mosses in the name of landscape architecture, and in turn my actions had tortured me. We were staring down at a

tree pit when Bye told me we'd stop all that, that I needed to work with him. Not for him, with him. I would do penance, be forgiven and shown the way home. We would go into the forest. Learn its moods.

That summer, I met a man in Maine and we fell in love. We spent my birthday with eight friends in the crumbling house on Crotch Island. All weekend, the men set off firecrackers on the broken-down dock and the women fought off bats and spiders with a tennis racket. When we convened beneath the putti and candelabra at night, the group was curious about the island's history and I admitted knowing little about it. I'd heard tales of Big Bill's "boats, booze, and broads," but the story didn't go any further than that. Crotch Island had become a sad shadow of its once glorious self. There had been days, good old days, when the place was a showcase for bacchanals and artistry, plays and curtains and cooks and boatmen, gardens and an outhouse competition with charcoal drawings festooning the walls depicting the chronological development of the toilet. But by the late seventies, Crotch Island had sunk into a state of dishevelment, a state I knew all too well. With its dock dismantled, the boathouse sinking into the sand, and spruce logs rotted beyond repair, Crotch was just a few years away from the end.

In the fall of 1987, I left for Connecticut to join Bye. Then in his seventies and an avowed bachelor, Bye spent his days ridding the world of noisome exotics and his nights cooking up plans for new projects. There was more than enough in the native landscape to amuse and inspire, so one didn't need all those sickly hybrids. Nature, he thought, revealed herself to the willing and the observant. We were hired to design a soft reprieve from the muscularity of city life where our clients were often the captains of industry: George Soros, Robert Benton, Leonard Lauder, Bob and Sandy Pittman—people, Bye explained to me, who were often bored by their own success. He said it was his mission to introduce them to the emotional qualities of their property, something they didn't have time to think about until he wandered into their lives to enlighten them.

On a site visit, Bye and I would arrive in his little red Honda. He looked around, waved his arms in the air, and uttered a few words like *delicacy* or *humor,* and having summarized the emotional qualities of

the land, he'd get back in his car and take a nap while I measured up the property. Waking from his nap, he'd collect the clients and, holding their rapt attention, say just two or three words—*elegant, melancholic, elegiac*—then walk away. It was landscape haiku and we'd stand around afterward scratching our heads.

One weekend toward the end of our time together, I invited Mr. Bye to photograph Crotch Island with his Leica, and we got to talking about personal things; I asked him why, in seventy-odd years, he had never married. He smiled like an old elf and told me that he had all his work and his fame to contend with, plus, he added, he was too sensitive for love. He had more important things to do. Landscape offered a canvas of meaning on which we could work out a compromise with the destruction that is everywhere. If we could get it right in the landscape, we could get it right with our emotions; and if we could get it right with our emotions, the world might never end.

In the winter of 1987, I penned a manifesto to my uncle Tom, Big Bill's third son by his third wife, Lucille. Something needed to be done about Crotch Island, I said, or the house might as well be torched. In the same letter, I offered up my friends as labor, with a plan to restore it. After deliberations with his wife, Noni, who wasn't enthusiastic about pouring money into the crumbling Gaston infrastructure, and his daughter, Kate, who was too young and had no interest in the place at the time, Tom agreed, and a major effort got under way to tear down half the house and rebuild it. I still knew nothing about what had made everyone abandon the family's only built legacy to the squirrels and the bark beetles and the storms and the tides. Most places eventually fall to pieces, but I found it a bit peculiar that every significant landscape in my family had deteriorated: Milford, the Old Mill, and Crotch Island.

In the winter of 1989, a year after work on the island house was largely complete, Mr. Bye was admitted to the hospital and closed his office. Cut adrift, I took a position at Central Park in New York, a park I knew a lot about, thanks to a small, jumpy Chicago urbanist, who tried to convince my graduate-school class of semislumbering landscape architects

that Central Park marked one of the great antiurban gestures in American civic life. That thought woke us up.

As seen by the falcon or conjured by a landscape architect, Central Park appears like a great green rectangle that rejects the imposition of Manhattan's glorious grid. In January of 1990, I was assigned to restore a landscape at the edge of the rectangle, along Fifth Avenue between Seventy-ninth and Eightieth streets. The most recent expansion of the Metropolitan Museum left a landscape of complete dishevelment—broken pavement, compacted dirt, and dead and dying trees. Tim Marshall, deputy director of Capitol Projects, took me to Seventy-ninth Street and Fifth Avenue on a snowy Saturday in January to explain my assignment: I was to first investigate the site's history and then bring it back from the dead.

Much had changed since the days when Olmsted and Vaux put pencil to paper, particularly on the city side of Central Park's perimeter wall. In February of 1965, the Isaac Vail Brokaw Mansion, Clare Boothe Brokaw's staging area for her victorious assault on Manhattan, had been razed in a stealth demolition that was reported in the *New York Times* as the "Rape of the Brokaw Mansion." The demolition so incensed New York that Mayor Wagner created the first Landmarks Preservation Commission. On the park side, what was once a sprawling meadow below the Met had shrunk to a sliver of green, eaten up by successive additions that wrapped the original diminutive museum like a set of Russian dolls. The original 1880s brick structure by Vaux and Mould was devoured by Richard Morris Hunt's addition and facade completed in 1926, which in turn was devoured by the Rockefeller Wing of 1982 and the Kravis Wing of 1990. Olmsted's vision of a green Fifth Avenue had been abandoned. When I arrived on the scene in 1990, the latest addition, the Kravis Wing of European Sculpture and Decorative Arts, had just been completed by the architectural firm of Roche and Dinkeloo. Henry Kravis, the Wall Street investment banker, then funded a spectacular $1.4 million restoration of the park's landscape on the south side of the museum.

In Rosamond's day, the parkgoer passed through a vast open meadow, around rough outcrops of Manhattan's diamond-hard schist, and past a newly planted sycamore at the base of Greywacke Arch. Sited

at the center of the vast rectangle was the Croton Reservoir, Manhattan's water supply, now the site of the Great Lawn. The perimeter landscape along Fifth Avenue had originally been designated a deer park in the Greensward plan, a welcome bit of enchantment where the park meets the city grid. Across East Drive, in one of Manhattan's magic moments, the Obelisk was erected, a gift from the Egyptian government for America's work on the Suez Canal. On February 22, 1881, thirty-two horses arrived near Greywacke Arch, having dragged the granite obelisk ninety-nine feet a day from lower Manhattan. On a slope overlooking the Metropolitan with views to the street corner at Seventy-ninth Street and Fifth Avenue, ten thousand jubilant New Yorkers greeted William Maxwell Evarts, then U.S. secretary of state, who asked his fellow citizens an urgent question:

> . . . This obelisk may ask us, "Can you expect to flourish forever? Can you expect wealth to accumulate and man not decay? Can you think that the soft folds of luxury are to wrap themselves closer and closer around this nation and the pith and vigor of its manhood know no decay? Can it creep over you and yet the nation know no decrepitude?" These are questions that may be answered in the time of the obelisk but not in ours.

Every site tells a story. After the first foot of loam, our excavation yielded shards of everything: old terra-cotta pipes, glass bottles, foundations of paths, walls, and cobblestone from the original landscape of the 1860s. One day during construction in the fall of 1991, my father was casing the neighborhood and somehow tracked me down at the corner of Seventy-ninth and Fifth. He always knew more about my whereabouts than I knew about his, and he had a habit of showing up in places unannounced. Perhaps the Upper East Side was like a charnel ground, and that day, in the late-middle years of his eggless, butterless, weight-lifting life, he was probably doing what he had always done, performing a kind of surveillance on the old neighborhood, where he had once been the treasured child of the loveliest woman in America. As if there'd be a resolution through repetition. Only this time, he was looking for me.

Perhaps he had just come over from the tenements where he had taken me and my siblings several times in the 1960s when I was about nine, where derelict old walk-ups teemed with indigent tenants who leaned out over fire escapes at East Seventy-fifth and Third Avenue. It seemed to me that the tenants weren't very happy and there was all sorts of trouble. When I was nine, I didn't know that Rosamond had bought her Third Avenue walk-ups with the money she made in *The Miracle,* or that when she died, she left them to both of her children.

So that day in 1991, my father didn't find me at the corner of Seventy-ninth and Fifth. He wandered into the corner playground just as crews began installing a huge bronze statue of three art deco bears and a set of ornamental gates inscribed with the profiles of monkeys and owls. Between the time I left for lunch and the time I came back, the crews put their finishing touches on the gates of owls. My father appeared, asked about me, then vanished.

"He didn't look like your father," the site engineer, Doug Blonsky, said as he described the man who had been at my project who said that he was my father. I knew what he meant. Despite the lineage and those low-cholesterol East Side good looks, he had never looked like fathers who set off for the office each morning in a suit carrying a briefcase. At sixty-two, his business was selling ships' engines, but he spent most of his time combing Manhattan's law libraries in jeans, sneakers, and a T-shirt, thinking about the past and everything that was lost. How could he forget that he was the heir to what might have been a kind of American quasi-royalty? His grandfather Amos and great-grandfather James and even Rosamond had once had a firm stake in Manhattan, not only in its real estate but its history. They'd played for the right team, fought for the common good; they'd placed others above themselves, and played a role in making it a better place. They hadn't been frustrated playwrights like Big Bill. The Minturns had conjured Central Park, for God's sake. Gertrude was the granddaughter of Anne Marie Wendell, married to Robert Bowne Minturn, known as a great gentleman and "merchant prince" of Manhattan. Some historians believed that his great-great-grandparents had hatched the first plan to build Manhattan's first "central park." The Pinchots had helped erect the Statue of Liberty.

They hadn't grabbed and hoarded their spoils. They stood for justice and the rights of the common man. Amos helped in the defense of Sacco and Vanzetti and fought for labor laws to protect the rights of women and children in factories. Rosamond and Amos and Gifford gave their assistance and money to the poor; they hadn't betrayed their own brother. No wonder he was casing the joint; this had been his own backyard.

The perimeter wall binds the park like a ribbon of stone. Though it is a small feature in the scheme of a great metropolis, I have always thought of the wall as the greatest accomplishment of the park and its creators. As the dividing line, the wall protected the soft folds of Olmsted's Greensward, clearly delineating the edge of the park. The other, the city, could not interfere with its mission to provide for the common relief as the green lungs of Manhattan.

In the years after I restored landscapes in Central Park, my mind kept coming back to the perimeter wall and how my father and I had missed each other that day. If I had known Rosamond's story, I might have embarked on parallel excavations and learned that she had been born on October 26, 1904, in a picturesque brownstone at 2 Gramercy Park, just one day before the first underground subway line opened in Manhattan. Horns blasted off the piers on the Hudson River and great festivities were under way, but her father, Amos, was suffering from a severe bout of melancholia. Gertrude and the doctors decided to keep silent because he was a very public man. I might have learned that Rosamond was depressed at the time of her son James's birth; in fact, she wrote that she had brought a child upside down into a "world of sorrow." I might have considered how my mother had been depressed at the time of the birth of her third child, how her marriage in 1962 was over, and she'd been drinking. I might have seen how patterns of trouble repeat.

In the spring of 1991, I left Central Park Conservancy to join a boyfriend in Philadelphia. But as it turned out, I didn't waste a lot of time there. After three months of living together, I discovered the letters of a recycled ex-girlfriend in my so-called boyfriend's desk and notes to new ones as well. I really couldn't blame him for all the confusion;

he had about as much trouble telling me the truth as I had trouble hearing it.

To the tune of two untruths, in late September of 1991, I left New York for Seattle, this time with a thirst for mountains and scenery. I crossed the continent, no pearls, no maids, no big deal. I told everyone I was done with Mr. Philadelphia, but like Rosamond, what I said and what I did were two different things.

In Seattle, a young woman dressed from head to toe in Soho black asked me, "You come from the East, so, just what makes you think you can design in the West?" I responded that a good design training could take someone anywhere. It was an East Coast response, so I never heard back. Several weeks later a landscape architect contacted me about a position with the U.S. Forest Service on the Hood River Ranger District in Oregon. Hood River, he said, was like a college town without the college. One could buy a windsurfing board and a tractor on Main Street. The town has just under five thousand people and only one traffic light. The scenery didn't require evaluation, it was all spectacular.

I arrived one snowy night in January at the base of Mt. Hood, and for three months I never saw the sun. I would have turned around and gone home if I'd had a home to go to. Three months later, the clouds lifted, and I could hardly believe I was in America. I rented a little house in a ponderosa pine forest at the foot of a volcano with views of two glaciers and the Columbia River. I was surrounded by rhododendrons, century-old pear orchards, and freezing rivers. That summer, I read about wildflowers and the West and oriented myself. I learned that Mt. Hood's splendid tip wasn't just snow, it was layer upon layer of ancient ice. The pink cast wasn't light, it was alpenglow. The long spines of bonsaied vegetation weren't desperate trees clinging to life; they had a romantic name: krumholtz stringers. I thought of myself as exiled in paradise, learning the language of the most beautiful place on earth.

One day in the summer of 1993, my father appeared out of nowhere with his Moroccan bag, his bananas, and his Rolleiflex. He called first, which was odd, from a jet phone flying over Mt. Hood on his way to a meeting about diesel engines near Seattle. "Are you down there?" I

heard him say. "Yes, where are you?" "In the neighborhood, several miles away," he said. Several hours later I met him at Oneonta Gorge, a mossy chasm along a snakelike stretch of road that was constructed in the teens, the Old Columbia River Highway. I was with Laura Starr, my friend and the chief of design for Central Park, who had heard about my father's dropping in to see me at Seventy-ninth and Fifth and had a name for him, "Père Bibi." Laura took photographs of the two of us along the highway that day. That night, he stayed in a dingy western-ranch-style motel at the edge of town. The next day he and I drove through the orchards of the Hood River Valley up to Timberline Lodge, where we wandered past the dusty dioramas of Indian memorabilia and the stories of men whose backbreaking labor built the place prior to the Works Progress Administration. We ate an awkward white-napkin lunch beside the huge rustic fireplace. On the way back down the valley, I drove while my father looked out at the broad muscular flanks of Mt. Adams and the nimble, feminine tip of Mt. Hood. That afternoon he was quiet, saying only, "This place is Paradise."

I thought about how beauty was his synonym for love and how we had both made an unspoken agreement to love beauty when people had failed us. It might have seemed like a ridiculous pact to a daughter who had received nothing most daughters receive, like attention or support, but he and I hadn't agreed to a standard father-daughter relationship; we had both agreed to be in awe of beauty, and that agreement made me feel a bond as strong as love. He approved of the Columbia River Gorge, what I was doing there, and though he didn't say it, that made me feel like he loved me. He had seen in landscape what I had seen.

I knew very little about Gifford Pinchot when I took a position on the rural Hood River district, headquartered in a low-slung industrial building nestled in the orchards below Mt. Hood. I had told only two people that Great-Uncle Gifford was some kind of vague relative, because I wanted to fit in to the sea of green rigs and pickle suits, what Pinchot himself called "the outfit." Anyway, I really wasn't altogether sure of how many "greats" went before Uncle Gifford because no one in my family had told me how we were related. I feared that if someone knew I was related to Gifford Pinchot, I'd be tagged aristocratic, a spy, a

slumming dilettante. They'd ask me why I thought I could design in the West. But what no one knew, what they didn't need to know and probably didn't care about, was that I needed to work for a living—I always had—so I counted my days, quietly acclimating myself to predawn office hours, coffee-black, and what seemed like the military.

My year as a Forest Service employee in a hard-bitten timber-felling ranger district passed quickly. I restored campgrounds and trails and tourist destinations. I was asked to design a new deck at the top of Oregon's largest tourist attraction and her highest cascade, Multnomah Falls, for the Columbia River Gorge National Scenic Area, and it was there, while restoring trails, walls, and compacted slopes, that the memories of childhood summers came back to me.

I hadn't spoken to my mother for about six months so one day I called her from a pay phone at the base of the falls. "Guess where I am?" I said. "Maine, Mongolia, where?" "Another M word, Multnomah Falls, Oregon," I told her. She cooed at how I'd moved from here to there by myself and landed a job. She reminded me of our summers out west, how she'd wanted to open a bookstore on the Oregon coast. We spoke for a few minutes about camping and she told me that the reason that I felt like I'd been to the Falls before was because I had, when I was eight years old and I'd just started keeping a diary. I collected books on wildflowers and banners, she said. Indian paintbrush were my favorite. And there was a bird, she said, an amphibious bird that dove through the falls and lived in the cliffs.

"Yes, the water ouzel," I said. I'd learned about the bird while restoring areas near Multnomah Creek.

"You mean where the Indian maiden jumped to her death?" she asked.

"Oh, Mother, the legend of Multnomah is just one of those tired old Indian legends you hear throughout the West." There wasn't any proof that the beautiful daughter of the Multnomah had dressed in white and, thanks to a prescription from the tribe's medicine man, leaped to her death to calm the Great Spirit and rescue her people from the plague. She didn't need proof, my mother said.

I was too busy dropping a deck in by helicopter at the top of Mult-

nomah Falls, reconstructing campgrounds with prison crews, and re-
covering from Mr. Philadelphia to remember the camping trip in 1968
and the Gifford Pinchot raindrop. There was no time to make sense of
why this place touched me so deeply, how similar the waterfalls of the
Columbia River Gorge were to that of the Delaware and Milford. Or
that, of the million places that needed straightening, I'd been asked to
straighten this one.

The following spring, I fell in love with someone whose history fit
mine like a lock and key. He looked like Gifford Pinchot. He was charm-
ing like Big Bill. He had three children he'd abandoned like my father.
Within five minutes of meeting the Irishman on a project site on April
15, 1993, he told me that we needed each other. I thought he meant he
needed the project. It wasn't long before I realized he needed me to get
out of his marriage. We took long lunches together, hiking the slopes of
Mt. Hood to share waterfalls and rare plants. He read me poetry and
passages from the Gospels about the lilies of the field. He took off his
wedding ring and hung it on the dash when he first told me he loved me.
He built my projects and together we discovered the elation of making
things beautiful and ridding properties of disharmony. We spent hours
on a rock by the side of the Hood River rediscovering laughter and sto-
ries. But he would never talk about the past, so I wouldn't, either; we
colluded in the silent grief common to families of alcoholics and sui-
cides. Discussing the past was a waste of time; something you couldn't
do a damn thing about.

In time, the Irishman divorced and we lived together as I built my
business and he juggled his children and work. I took on increasingly
complicated projects, repatriating Native American burial grounds
along the Union Pacific railroad tracks, restoring desecrated gravel min-
ing sites ripped clean of their topsoil, designing trails and overlooks,
and beautifying trailer parks and picnic areas. I designed benches in mead-
ows of wildflowers and was chased by angry, gun-wielding landowners
who lectured me on "the truth about the government." I pressed on,
despite the politics, building and beautifying, eventually winning the
U.S. Department of Transportation's top design award for restoring the
Columbia River Highway.

In the years before leaving Oregon, I had two recurring dreams. One was of a deer struggling to break free, moving fast but going nowhere, the other haunted me by day and woke me up at night. I dreamed of the white figure who had come into my bedroom as a child at the Old Mill.

About the time the daydreams started, I decided to move back east, and the Irishman announced he was coming with me. We chose to start our East Coast lives in Florida where there was a booming economy and where we bought a modest bright-pink stucco, Spanish-style bungalow several blocks from the beach in a historic neighborhood. We had started over, but within a year, I was disheartened by Florida, which seemed decadent, wasteful, and overdeveloped, a haven for felons and deadbeat dads disappearing into floating neighborhoods of houseboats. Women lounged around in their tan lines waiting for their favorite electrician while their husbands were at work. The night brought bird-sized bugs to porch lights, and morning brought snakes in the pool; summer brought stinging sea lice, and fall, hurricanes named after women. There was no respite in a sea of cars, no waterfalls, no mossy trails, no fields of grass except those infested with red ants. The Irishman saw nothing wrong with Florida that my attitude and a category-five hurricane couldn't fix. After a while, I became terrified each morning when he'd leave for work, fearing he'd get hurt, leave me with the bugs and the sea lice by myself and never come back.

While in Florida, I received a call from an architect at the Cooper Union in New York. The *New York Times* was holding a competition to bury a time capsule somewhere in Manhattan, and Cooper's team decided to bury it in a garden labyrinth at the Cathedral of St. John the Divine. I went to work researching the history and meaning of labyrinths, a compelling assignment for someone who had spent half her life trying to find her way home. The labyrinth, I learned, is traditionally composed of twelve rings that lead to a center rosette. The path made twenty-eight loops, seven on the left side toward the center, then seven on the right side toward the center, followed by seven on the left side

toward the outside, and, finally, seven on the right side toward the outside, terminating in a short straight path to the rosette.

I took a risk by calling my uncle, James Gaston, and his wife, Gail, for a place to stay in Manhattan. If my father had known I had entered enemy territory, he probably would have disowned me. I had last seen my uncle in 1986, when my mother took me to Seventy-fifth Street and Third Avenue on a social visit to meet his new wife, Gail. At the time, I didn't know that where we had gone was to Rosamond's properties, the ones that had once belonged to the brothers and my father always said put an end to the relationship with his brother.

While I was planning the labyrinth James Gaston and his wife put me up in one of Rosamond's old apartments, though at the time, I still knew virtually nothing about her. I simply thought I was staying with my relatives at some apartments they owned. On the last night of the capsule competition, I finished early but didn't go back to Seventy-fifth Street. I wandered over to Seventy-ninth and Fifth Avenue, to my old project site in Central Park.

I simply sat there, on a bench, in the cold, until the streetlights came on. On the easterly edge of Central Park, where the transverse road dives deep into Manhattan schist, across from where the Brokaw Mansion once stood with its moat, where the built fabric of street and wall collides with the soft drape of elm, I didn't know what to do next. For some reason, I kept landing back at that street corner, casing the neighborhood, somewhat like my father. On a bench opposite the playground at Seventy-ninth and Fifth, where owls and squirrels graced the gates to a little playground, I remembered my father and how we had missed each other during construction. I felt guilty for not telling him I was staying with his enemy, his brother. I had wandered and searched, and each turn of the path had been tied to the love of a man. I had come and gone from New York many times, brought back to that street corner for reasons unknown, in a tidal pattern of moods and emotions: restless, enigmatic, mysterious.

CYCLE THREE

OUR TOWN

I spent most of my twenties and thirties filling out change-of-address cards. I don't think I inconvenienced anyone by all my moving about except perhaps the phone company and the post office. By the time I reached my forties, my parents had died and the men I loved had a habit of vanishing, so one day I sidled up to the cash register at the Museum of the American Indian and bought a bright red pastel drawing of a teepee. A year or so later, I haggled over a one-hundred-year-old Moroccan rug in the Casbah in Marrakech, thinking about how Bedouin women lie down night after night on a rug in the desert. I learned that the patterns of star and arrow are as complex and purposeful as the algorithms of a mathematician, like a microcosm of the world in wool. Now, when weariness and the weight of an atomized family takes hold, I lie down on my rug and tell myself that I am just one in the billions of wanderers. Lying there, looking up, I imagine a dome of sky and stars doing what they have done forever, what Thornton Wilder called "their old, old crisscross journey in the sky." On my rug in a house in a small town in a state on this earth I call home, I learn over and over to become friends with my closest companion, restlessness, or as the Buddhists say, I settle down with myself.

In the last months of her life, Rosamond met Thornton Wilder while she worked on the first production of Our Town. *While her diaries from 1937 and 1938 have never been found, I know that she would have been interested in Wilder, the man, not because he was fast becoming a celebrity playwright but because he was curious and philosophical by nature.*

In the 1920s, before he became a playwright, Thornton Wilder spent part of a summer with a pickax digging up the streets of ancient Rome while a student at the American Academy. He later said that he would never see Times Square in the same way again. Someday, he thought, archaeologists would come and say, aha, this looks like the site of what once was a city. After teaching for many years, Wilder turned his attention to plays that asked us to consider the meaning of our lives. Americans don't live surrounded by the archaeological treasures of Athens, or the bas-reliefs of Rome. We worship what is new, our geology is in flux, our contemporary affliction is rootlessness, many of us live and die alone. Wilder grappled with life-and-death themes knowing that Americans live on the surface of things and are generally averse to contemplation; still, each one of us lives in close proximity to a layered, often painful, past.

Our Town's Stage Manager narrates as days come and go. He introduces us to a New Hampshire town, Grover's Corners, where people live and die and fall in love and walk off in twos. Mothers tell their children they have good features, the wind blows, the clock ticks, the terrain is a thousand billion years old. Young Emily Webb marries George Gibbs, her high school sweetheart, and she dies in childbirth. She is given the choice to come back for just one day to see what her life had been. She accepts and chooses a day before she was married in a white country frock. She comes back at twelve years old, when she was too young to understand just how full and beautiful her life had been. Upon Emily's return to the graveyard, the character of the choirmaster, a suicide, Simon Stinson, reminisces bitterly about life, reminding Emily of what she has just seen, that to live life means living in "a cloud of ignorance," and wasting it as if one had a million years.

In the days and weeks after Rosamond died, the press and the public blamed everyone and everything. Rosamond took her life on the morning between the opening nights of Our Town in Princeton and Boston because, the speculation was, she was depressed over her life, she hadn't won a role in Our Town, love had eluded her, and the message of the play pushed a fragile creature into fantastical notions of death. The Philadelphia Ledger said she had "caught the mood of the last act of Our Town," and that the "plot of a new play in which death is depicted as more beautiful than life may have inspired Rosamond Pinchot to commit suicide," and that she had "heard life spoken of as simply a strange interlude before death." One news report speculated that the note contained Emily's famous soliloquy in which she bids good-bye to Grover's Corners, her mother and father, clocks ticking, and asks the question, "Do any human beings ever realize life while they live it?"

I cannot claim to know why Rosamond did what she did. Perhaps she'd had enough. Or perhaps there was a much more visceral reason we will never know, a reason that would not have surfaced publicly at the time, that, for example, she may have been ill or pregnant. What I do know now was that on her best days, Rosamond lived the life that Bernard Berenson described, a life of the not-self, a life of the people, the books, the works of art, and the landscape. It was the life to which my mother hoped I might aspire. On those days, while giving spontaneous gifts of time and thought, Rosamond might have felt as Berenson had, that there was no self left to die.

In her twelve thousand days on earth, she'd taken a good dose of the world, breathing the salty air, weeping at the sound of the church bells in Milford. By the stream, she bounded from rock to rock like a wildcat. Through her good days and her bad days, through the disintegration of her parents' marriage and the disorienting years of her own, a home eluded her and she had lost her connection to the place that mattered most, to Milford. From all visual appearances, she seemed graceful and cheerful but few knew how deeply she longed for the love of the one person who would never love her back and the place that allowed her to be who she really was.

If she could return now to her life, I wonder if she would choose a day before her marriage or whether she'd come back at a later time, for one more afternoon of tennis with Amos, or a day of laughter and nicknames with Big Bill tending peonies and potatoes on Crotch Island, or for a day with her granddaughter to see what she'd missed. We'd meet in our raggedy overalls trying to look chic at Bendel's lipstick counter, with our hair going every which way and calling for our gland injections. We'd find George Cukor and Dave Selznick at the Voisin, at her certain corner table. We'd order buttermilk and lettuce and a chocolate milkshake for Dave. Cukor would arrive yelling and telling us we were too fat. We needed to look "Sleek!"

For her sake and mine, I am glad that day will never come. Just imagine, one day to know someone, one day to know Rosamond. And yet, we meet someone every day of our lives and will never know them or see them again. Given the choice, I hope Rosamond would choose just an average day, like the day she described in her diary:

My car has been painted a green so bright that people stop in the street to look at it. Truck drivers in coy voices yell, "Can I be your chauffeur?" I love green, it reminds me of nice places, summer shade. This day it poured. I went in search of Harris tweed downtown. Loved

to see old New York, hear the Metropolitan chimes. They remind me of being a child in Grammercy [*sic*] Park.

In the last year of her extant diaries, 1934, Rosamond wrote of a young man, Henry Murray, whom she met aboard a ship but would not allow herself to love because he was married. During their brief flirtations, Henry suggested that they saw life differently. He was a "thread" person, while Rosamond was a "bead" person. He told her that she saw the disparate, fleeting events in life but didn't see that they were connected and how they might add up to a necklace. To others, perhaps it appeared that Rosamond was a bead person, scattered and unfocused. But there was a Rosamond that people rarely saw or knew—the Rosamond of her diaries that I felt I knew—the Rosamond of her diaries who found herself a home:

I love the country; and at our home in Pennsylvania where I could walk and ride and swim, I was intensely happy. There is a beautiful waterfall on our place. I always keep a photograph of it beside my dressing table at the theatre; and when I am blue or discouraged, I look at that picture.

The Falls of the Sawkill

Somehow the thought of that waterfall, going on and on without interruption, helps me. In the first place, it will always be there; a bit of loveliness to which I can go back. But even aside from that, it gives me a sense of the steady flow of life itself; the big unbroken current, in contrast with which turbulent streams of our individual lives seem so trivial.

ROSAMOND: 1934-1938

After her screen test for a film titled *Rebound,* Rosamond left Hollywood for New York thinking she had something to offer the world. Rolling east by train, she remembered how the producer-director Alfred de Liagre told her that her eyes were like two spoonfuls of the Mediterranean, and MGM's David O. Selznick yelled, "You have a thousand times more than Kay Francis." Selznick was one to know. Kay wasn't just the woman Rosamond called her "predecessor," she was the darling of the Warner Brothers lot and at the time, one of the highest-paid women in America. So Rosamond knew that when she returned to Hollywood next time, she could feel confident that she had a thousand times more of something—she wasn't sure what—but more important, she had a signed contract. She'd forget the things that appalled her about Hollywood: the yelling parties and the latest wisecracking zinger from Cukor, this time on Valentine's Day, when he told her that she looked far better in her screen test than she did in real life. She could settle into Los Angeles, pursue her acting, save money, buy a little house by the beach, take her sunbaths beside the sprawling coast oaks, and starve herself of everything but waxy brown Medjool dates.

On the first day of the five-day journey, she wrote slowly in her bunk, swaying to the rhythm of the long sleek liner as it crossed the New Mexico desert. The train reached Tucson before breakfast, where she got off and ran through the streets for exercise and bought a bright red bandanna at a Sears Roebuck store, then climbed back onboard for the trip to El Paso, where, again, she got off and ran through the streets and markets strung with bright bulbs swinging wildly in the dust and

dirt. The warm night was filled with people who looked dark and wicked, men standing guard over their fruit stands and women presiding over peanut brittle piled high in Toltec pyramids. The train rolled on through Texas, as flat as a billiard table and far less green, where, Rosamond wrote, "miserable treeless towns stood scorching in the sun." She noticed how pathetically thin the cattle were and how their ribs stood out through their shaggy skins. The train reached San Antonio by three, where she saw a sign that read ZIMMER, VIOLIN LESSONS. If there had been time, she would have gone in to visit the "poor music-loving German marooned in a hideous Texas town." The train stopped in Houston, then ground to a daylong halt in New Orleans where she wandered off groggy and tired.

Before eight in the morning, she found her way to the St. Charles Hotel, threw on some old white tennis shoes, and roamed the streets of the Vieux Carré. The old French Quarter called itself French but was, architecturally speaking, Spanish. "As I walked along, I caught glimpses of myself in shop windows. What an unattractive girl, tall, rather fat in the waist and behind—bespectacled and messy. How the hell could any movie company want to hire her?" She crossed Canal St. to Royal, tooled through the antique shops and narrow streets, over to the levee and then back to the Vieux Carré where the generous Spanish arcades of the dark gray Pontalba Building with its odd mansard roof nudge up beside the St. Louis Cathedral. She lingered for a while in the cool shadows of the New Orleans morning and wondered about the Pontalba family as if they were the Pinchots: "Were they planters or merchants or soldiers? Were they handsome or ugly? One thing is sure, they were people of great energy." Inside the peaceful cathedral, she mused about how cleverly the Catholics built their dark places of worship. "Always when I go into a church I think of *The Miracle* and I kneel as I did then. Near the altar, candles flickered in green and blue and red glasses, I went up and lit one for Bill. He is always the first person that I think of. I lit a candle for Zoe and later one for each of the little boys—oh and one for father." When rested, she continued back out into the bright streets, admiring the iron balustrades and verandas.

The designs are so lovely. Grandfather Pinchot came to New Orleans long ago and bought a lot of that ironwork for the houses in Milford. I recognized the same oak leaf and corn pattern on several buildings. Rather feebly following in Grandfather's steps, I went to a wrecking company thinking that I might buy some ironwork too. But it was very hot and the iron seemed to be in small scraps and anyway I'm not going to be able to build anything for a long time if ever. So I didn't buy a thing. As I left, I reflected on how inferior I am to old JW Pinchot. The further I get from Hollywood, the less alluring a screen career seems. Still I have no other career and very little money.

Before the train left New Orleans, Rosamond found a lunch counter and feasted on Pompano paupiette and a brightly colored planter's punch. She felt sentimental about leaving the city full of graceful little houses, deep-set French windows, and James Pinchot's oak leaf and acorn balustrades that probably drove his architect insane. From her berth, she watched anxiously as the last of the little old houses disappeared from sight.

After hearing so much about quaint New Orleans, I expected to be disappointed but the Vieux Carre is really like a French town. There are the same slanting roofs, the same lovely facades and even the same old hags creeping through the streets mumbling. There is even the same smell, half wine, half mustiness of damp courtyards. The place seemed to be crumbling but gallant. It's a ghostly place, sad and full of gay memories of romantic people. Perhaps it was the planter's punch.

When she arrived back in New York, Rosamond stayed with Amos at 1125 Park Avenue where her sisters couldn't wait to hear her news. So she told them exactly what they wanted to hear. Her ten-year-old half-sister, Tony, overheard her big sister, the movie star, talking on the phone to her suitors and singing a popular tune, "Love in Bloom":

"Can it be the trees that fill the breeze with rare and magic perfume?
Oh, no, it's not the trees, it's love in bloom."

Twenty years older, Rosamond didn't pay much attention to her younger sisters. Amos warned Mary and Tony not to bother Rosamond, that she was a very busy person, but Tony was so excited she could hardly stand it. Rosamond told her sisters she'd seen Johnny Weissmuller on the set of *Tarzan* and she'd gone right up to Robert Montgomery and pretended to idolize him to his face. The magic oozed in the City of Dreams and her gang had migrated to the coast to chase the future. The future wasn't on Broadway—the papers were right—it was in Hollywood, where she was at the center of the action. It was all true, she assured her sisters, what they read about in their movie magazines. She'd landed at the perfect moment when producers and directors had discovered there was money to be made on unconventional types of girls like her. She told her sisters what she told her diary:

> Katherine [*sic*] Hepburn proved that to be pretty isn't essential.
> Certainly I'm not pretty from the usual point of view. I don't believe
> I have sex appeal for a single one of those executives either. But I'm
> what they call different, so they are willing to gamble $3600
> more on me.

She didn't tell her sisters that Selznick had shouted, "Forget your modesty" and like a tyrant ordered her to rifle through MGM's wardrobe department, through the tall women's costumes of Garbo and Crawford to find an outfit that worked! What he and Cukor thought was modesty were waves of stage fright and ambivalence. She wasn't itching with ambition like Kay Francis, driven like Hepburn, or raging for fame like Clare Boothe Brokaw. Sometimes she knew her being an actress was absurd. She was too tall and everyone knew it. She wrote, "[I'm] a big gangling girl without any real reason (except money) for wanting to go into pictures." She knew she'd be happier behind the scenes, in technical production, possibly as an assistant director. But she didn't tell people that. Hollywood assumed she wanted to be a star because she looked like one, posing and primping on the lot. So she told Hollywood what she told her sisters, what they wanted to hear. Neither of them needed to know that she had been so

terrified during her screen tests that half an hour before cameras rolled, she'd pulled up to the lunch counter at the Owl Drugstore to down a slug of whiskey.

Her adventures on the coast were fresh and exciting, but life in New York hadn't changed one bit. Her mother, Gertrude, demanded she visit and as usual made Rosamond feel indebted to her because she watched the boys while Rosamond was gone. Seeing the boys was the bright spot although they'd grown. She wondered whether Little James would finally speak, and was it possible she'd transferred her bad feelings about Big Bill to Little Billy? His meekness always surprised her. Nothing had changed, but she felt strangely disoriented, not like a mother at all. She liked the role, she wrote, but her body still felt quite her own. She looked forward to seeing her father, Amos, but dreaded having to negotiate with Big Bill. Nothing would have changed in that department, either. He was still padding around the same old East Side parties, behaving like a surly animal toward her while charming the pants off some new dame.

Rosamond soon learned that Big Bill wasn't just up to his old tricks, he'd thought up some new ones. He was now spreading rumors that she was having an affair with Bobby Lehman, his old friend and boss at Lehman Brothers. But there was nothing she could do to stop him. She didn't like the sound of divorce; after all, he might still come around. Once she heard from MGM, she'd get back on a train with the boys, and if Bill tried to stop her, then, at last, she'd divorce him. On March 28, 1934, she wrote in her diary, "Cut him out of your life. You're really too good for him. He hasn't a generous or sympathetic emotion about him. He's just attractive. Damn it that's it."

Before long, she wrote Zoe with the news:

We agreed on October 1 because MGM said they had no play ready now. So I'm going to get at least six weeks of stock this spring and summer. Nasty idea! The whole situation amazes me. Every morning I wake up with a funny feeling. What has happened? Ah yes, I'm going into pictures. Strange how you and I and George Cukor should turn up together in California after all these years. I'll love being near you, that's one thing. And I guess it will be terribly good for me to

get completely away from Bill for a winter. He has really behaved so
badly, now he accuses me of sleeping with his boss! And yet I'm so
lacking in self-respect that I can't get over him. It was lovely to
get back to the little boys. Billy is a charming child, very humorous.

On top of the rumors, she'd come back to a new round of Big Bill's
not-so-loving nicknames, like "sugarcoated bitch," and "witchie la
biche." When he saw the headlines in the Hearst papers, "Contract
Sealed," Bill couldn't wait to sink his claws in and rip her to pieces, tell-
ing her again that all she wanted was fame and publicity. Her photo-
graph in the papers was awful, he said, and she agreed it wasn't the best.
The camera added girth, so that spring Rosamond went to see Cornelia's
personal physician, Dr. Berman, in New York, to have a metabolism test
to discover why she got fat so easily.

The spring was filled with parties, rehearsals, and gland injections
administered by Doc Berman. She had time on her hands and time to
spend with the children. So, on a cold and rainy spring weekend, Rosa-
mond took five-and-a-half-year-old Little Billy to Coney Island, where
she spent the first full day she'd ever spent with him. She mused at the
number of questions he asked and she answered, how motherhood forced
one to be self-sacrificing, and how Billy was a darling, gallant little boy
who had lots of energy to be cheerful and friendly—but she grew bored
waiting for him to chew his chicken. At night she said the Lord's Prayer
with him, and she wrestled with whether to teach Little Billy to pray. He
wouldn't turn off the light at night, explaining, "I never close my eyes."
He asked her questions about God and told her he'd put her in a tiny halo.
Rosamond described God as the spirit of good but she had a hard time
describing spirit. She worried about Little Billy turning into a version of
Big Bill. It was a mother's, even a part-time mother's, worst fear. "Inheri-
tance is a strange thing," she wrote. "Billy even loves flowers, just as Bill
does. He's always picking them and bringing them in."

That spring, Bill quit his job with Bobby Lehman. The man who
said that he "bet on people" didn't think Bill was a good bet anymore.
He told Rosamond that Big Bill was in a "bad state of mind," and "too
sensitive." At a party at Lehman's weekend cabin, Bobby confided in
Rosamond that he was leaving his wife and placing his bets on another

woman. She confided in him that she felt responsible for at least part of Big Bill's bad mood. Without her knowing, she told Lehman, Amos had brought a complaint before the bar. "If it wasn't for my family Bill could practice law in New York," she said. Lehman assured Rosamond that Big Bill's disposition was his own problem.

Rosamond described that spring in New York as the era of "cellophane and publicity." She heard a man on the radio describing "the age of cellophane," but she added the part about publicity. "Everything is wrapped in cellophane now, even books. And everything is preyed upon by the hound of publicity," she wrote. "I half hate publicity and at the same time realize its power. I run from it and that makes the hound chase even faster." Hardly a day passed without hyped-up press reports about Rosamond Pinchot in showbiz lingo. She called them stupid blurbs. "I curl up inside with disgust and then I remember it's better to be mentioned in any way than not at all." The press was in pursuit while Rosamond wrote that she was sick of herself, ". . . Sick of the futile life I lead, sick of the untidiness of it and the waste."

It wasn't just the age of cellophane, it was the age of air travel. Cukor and Selznick dashed between New York and Los Angeles, the first studio

George Cukor and Rosamond

jet set. They'd touch down in Gotham, ring up Rosamond, and they'd all dash off to parties together where they were surrounded by what Rosamond described as "richly costumed society people," men dressed "like Henry the Eighth," and women with "frozen faces." As always, Cukor and Selznick brought their yelling and sarcasm with them. At dinner with Cukor and Dorothy Parker in April 1934, Rosamond found it hard to decide who was more obnoxious. Splitting hairs, they were both clever, and while George was funnier, he and Dot were equally imaginative. Both so voluble, however, they exhausted each other and succeeded at completely shutting each other up. Cukor left the party spent and speechless. Rosamond hated the evening. "Life seems meaningless," she wrote.

David O. Selznick's hot pursuit didn't make her feel any better. Despite the presence of his wife, Irene, he'd see Rosamond at a party, follow her around, corner her, and kiss her. One night in April she resisted, and David, her new boss, decided she'd better know the score: "You can be the worst flop ever and you can be a triumph," he threatened. Rosamond looked away. "Look at me!" he insisted. So she smiled, laughed, and played the game. When Rosamond wrote Zoe that David was propositioning her constantly, Zoe became angry, but Rosamond wasn't entirely sure if Zoe was angry at David or Rosamond. Rosamond wrote Zoe again in June:

> I'm keeping Dave off and being cold, first because I don't have goings on with married men, second because I like his wife Irene and third because her Pa is Louis B. Mayer! But I do like Dave. People always tell me I have perverted tastes.

In the middle of May, Rosamond spent several days at Milford. When time permitted, she wandered into the forest and stripped off all her clothes to take the sun. Spring played its tricks that the whip-poor-will knew all too well, so it stole away in the crevices. On May 16, Amos and Rosamond took the seven o'clock train from Milford to Philadelphia to lend their support to Gifford and Cornelia in Gifford's bid to become Pennsylvania's next senator. After learning of his defeat, Gifford met with reporters to help them cobble together a dignified election post-

mortem, then offered the traditional family salute. Rosamond comforted her proud, gray-faced uncle, as did Cornelia, but on their way home, she was consumed with futility. Uncle had lost, Father was in New York with his new family, and nothing seemed the same, comforting, or even familiar. In fact, she thought, nothing was the way it should be.

When she moved out of 444 East Fifty-second with Bill in 1933, Rosamond thought that given a little time her life would soon settle down and she'd find a home. She'd had sixteen addresses by the age of thirty-four, not including her encampments in Europe with *The Miracle* or her sojourn to California. Now, she felt her beloved Milford slipping away:

> Staying in Father's house when his family is there is no fun at all. In fact, I loathe it. There's always the feeling of resentment against Ruth and Mary. If it weren't for them, this house would have belonged to Gifford and me. What a lovely time we would have had in it. But now we're just outsiders...being so close to 30, I resent Mary's darling youth. What's more I foresee better times ahead when she'll delight in stealing my gentlemen. How easy that will be too. The prospect of getting old is most unpleasant. People will say "How she's gone off. What a huge monster of a woman." Ah yes. That's the penalty of having been lovely once.

What was lost in Milford was usually countered by some unexpected gain in New York. There was her upcoming movie contract, the bubbly late nights with her queue of gentlemen callers, and her beloved friends scattered about. Still, she didn't share her fears with anyone: how her days were crowded but the nights were filled with longing for Big Bill, his occasional tenderness and their laughter at the silliest things. For years she thought she'd find someone to replace Big Bill, someone to love again, if she wasn't, God forbid, one of those women who loved but once in life.

Their love for each other had washed out to sea like some old weather-beaten buoy. Usually she'd let the longing wash over her and the heaviness linger in her chest. But sometimes the longing got the best of her and he was the only one who furnished what was familiar: that lizard feeling of slow, languorous love, of loss. She didn't want to be

miserable, but she knew his mean presence like her own potato nose in the mirror, and his meanness made her feel alive. She and Bill were stuck at a crossroads, it seemed. So on the bad nights, instead of counting to ten or saying her Mississippis, she'd phone him up. Sometimes he'd answer and she'd hang up, but there were times when he answered and she'd ask him to come over. He'd growl, but he usually found his way through the night, up the elevator, and into her apartment. As soon as he arrived, she thought maybe she deserved all his nastiness; after all, she'd fussed the evening away preparing for his arrival, dusting her face with specks of glitter, knowing it was totally and utterly hopeless. All her primping made her feel pathetic, but when he arrived, slouching in as usual, his coat open with his belt slung low on his hips, she'd feel a sense of relief, a brief cessation from the longing. He was home. She'd watch him sit down on a little chintz chair, the one he was too big for, and she'd lie on the bed feeling dreamlike and sultry and they'd talk, but it just went round and round.

On a spring night, May 23, she called, he answered, he growled, she asked, and he slunk over as usual. That night, she gussied and slipped a white nightgown over her new leanness thanks to the gland injections, but he wasn't interested. Helen Hayes was speaking on the radio. They had once loved everything she had to say, but now Helen bored him. He shouted over her voice, mostly about nothing. He went out onto the roof. After a while Rosamond joined him on one of the wicker chairs. She watched how the moon fell on his profile, which made him appear exciting and handsome but then, with no warning, nothing said, he got up and walked away. She waited, thinking he would return, but he had no interest in her or the moon or anything else. He went into the living room to lie down on the couch. Eventually, when she went in to ask him to join her, she heard the elevator door and rushed from room to room. Then she ran out on the roof and, barefoot, she climbed onto the railing. Looking down to the dark street below, she saw him come out from under the apartment house awning and walk down the street toward First Avenue. With toes gripping the stone, she sobbed and sobbed under the clear moon and considered jumping off the parapet.

...I'm still thinking of it. How simple that would be. No more striving for the vague things that I'll never attain, no more misery. If it only weren't for Father. My suicide would kill him too. It would make his life intolerable. Tonight I reached another low in unhappiness.... Now I ought to be through. Tonight he behaved so hideously. Again he deeply hurt me. But still I look forward to getting back at him, to making him say that he loves me. I'd never do anything to hurt him. Never.

By the first week of June, that desperate night was just a memory. On June 4, 1934, Elsa Maxwell called a rehearsal of the June ball in which Rosamond was to pose in a "historical pageant of society beauties and naval officers." Rosamond arrived late, as usual, and the "so-called society beauties" turned up even later, too late to rehearse. Elsa Maxwell ran around looking distracted, so Rosamond "pulled out to do a bit of shopping." That night, before the ball, her date, George Gallawich, picked her up to take her to dinner at the Casino. "The one nice thing about dinner was the chicken livers," she wrote, but she wished George was less presentable and more amusing:

We wandered around, danced, saw the great comedian Jimmy Savo and went up to Mrs. Roosevelt's box. Sitting beside Mrs. Roosevelt was Mrs. Hearst. That's an example of what a girl can [be]! Mrs. Roosevelt, all teeth, kissed me. On the way home George insisted on doing the same in a different way.

Although Big Bill wasn't interested, other men were making regular "declarations of love." Rosamond wrote, "Nowadays I never believe anything men tell me." So she went about her business, making appearances, primping, and making diary entries of her odd little encounters with the "on tops." On Monday, it was tea at Cecil Beaton's. On Tuesday, it was off to the Vogue studio to sit for a photographer named Hueme:

The photo is for *Vanity Fair* so I guess it had to be "arty." Anyway they pinned my hair into mad tufts, up on my head. Draped me in black

velvet and stuck bunches of peonies under the straps of my brassiere.
Then he took me in affected positions.

On Wednesday, she spotttted Katharine Hepburn who shared the
same hairdresser with her at Ogilvies:

She remembered me and put out a wiry hand in greeting. Immediately
brought up the subject of Cukor, our mutual friend. She was very
friendly, not at all the snooty dame she used to be. The mouth was
scarlet and spread half across her face, huge but rather thin lipped.
Her cheekbones stood out sharply. Her eyes were blue, I think, and
not very noticeable. She spoke in that valuable and synthetic way
that is typical of actresses.

On Thursday, it was back to lunch at the Colony where Rudolf Kom-
mer introduced her to H. G. Wells. "He wasn't an impressive fellow,"
Rosamond wrote. "He had a voice as high as a woman's. Somehow he
reminded me of a Welsh Terrier." And on Friday, she went out to Mil-
ford where, upon arriving, "the air smelled so sweet, of spring and hem-
locks." But by Sunday, she dreaded returning to the city, "I feel a little
too sentimental and soft for hard boiled New York," she wrote.

By midsummer, Rosamond was squeezing all there was out of a day.
David O. Selznick, her married "boss," was still in hot pursuit. On June
14, Rosamond hosted a huge party at the River Club for David and
George to thank them for launching her career in Hollywood. That af-
ternoon, Rosamond walked down Lexington Avenue where the vegeta-
ble stands were full of midsummer's cherries and raspberries. She
stopped at a beauty parlor to have her hair turned up and nails painted,
then went off to a gland appointment at Doc Berman's where she was
pleased to learn that her weight was down to 144. In the evening, her
date, again the not so amusing but presentable George Gallawich, picked
her up in an open roadster. "The driving was lovely," she wrote. "There
was gold in the west. My hair flew wildly. I wore the new blue and polka
dotted dress and had absolutely nothing under it. The back was cut
down to my waist and there was a bustle and a puff in the front. On my

feet I wore flat heeled gold sandals." After dinner, she and her date ar-
rived at the River Club just in time for her guests to appear, Cukor, the
Selznicks, Conde Nast, the Whitneys, Liz Arden, the Paleys, and of
course, Bill Gaston, who slinked around the perimeter with some un-
known broad. It was a good warm night for a party and Rosamond, hav-
ing recovered from the night on the parapet, was tight and felt full of
self-confidence. As the evening got started, David took her by the arm
and pulled her out to the terrace above the river where they were joined
by Bill Paley. The three leaned against the rail in the dark, cocktails in
hand, and talked about nothing for a while when all of a sudden a couple
emerged from the bushes at the end of the terrace. "If ever I saw two
guilty looking people!" David shouted. Upon hearing Selznick's wise-
crack, Bill shouted and pointed at Rosamond, "Hey, that's my wife!"
Great confusion broke out with raucous laughter and good-spirited
sparring, and thankfully no one came to blows. The party wore on, and
Bill disappeared with his date back into the bushes. The remaining rev-
elers swam and conversations had quieted down when Selznick turned
to Rosamond and whispered, asking whether she was wearing a brass-
siere. Just as his wife, Irene, wandered off, David started his regular
round of chasing and kissing and this time begging to take Rosamond
home. The situation was getting out of hand, so Rosamond went to find
Irene in the basement with a group of men sprawled out on the floor
playing a drunken game of craps. David followed her and wasn't in
much better shape; in fact, his head nodded and he appeared to be col-
lapsing when suddenly he surprised everyone by peeling $20 bills out of
his pants pocket, making a delirious last-ditch effort to win the hand
before turning over and falling asleep on the floor. When he started to
snore, Irene decided she'd had about enough and said she wanted to go
home. But David was fast asleep, so Irene Selznick directed Rosamond
to kick her husband. Rosamond hesitated. After all, kicking her boss
wasn't the recommended means of getting ahead; but at that point, Ro-
samond was taking orders from the highest authority in the room. Rosa-
mond looked twice at Irene and then administered a swift-heeled blow
to the backside of her new boss. David looked up at Rosamond with his
heavy face and sagging lips as Irene announced, "We're going home,

honey." "No, we're not," David said slurring his words. "I'm staying." Irene then began to drag her husband off the floor and into the corner where they huddled and argued and kissed before he pulled out his wallet and handed Irene a wad of bills, telling her to go home. As Irene left the room, David leaned over to Rosamond and said, "I'm taking you home, darling." Rosamond turned and whispered to one of the craps players, asking if he would take her home. The two ran out of the room and up the stairs while behind them Rosamond could hear David in pursuit, she said, "like a great buffalo." David called her name. Rosamond didn't answer. As they left the building, he pursued her out into the street as the craps player hailed a cab and Rosamond slid into the seat next to him. David then opened the door, demanding the craps player get out. Rosamond thought David looked fat but there was something quite attractive about him. "No, Dave," she insisted, "go back and take Irene."

The next morning at 11 A.M., Selznick still hadn't given up. His secretary called to set up lunch with Rosamond, or cocktails, or whatever she wanted. She declined. Later he called again and Rosamond had her assistant, Clara, claim that she'd gone to the country.

Several weeks after the melee at the River Club, Rosamond was too busy to worry about her charging buffalo boss-to-be, David O. Selznick. Bennett Cerf was proposing marriage, but he was too busy, so not for five years. She was too busy, too, getting her miserable little wardrobe together to please Cukor. Clare Boothe Brokaw had also managed to convince Rosamond that she would be perfect for a part in a new play, about an unhappy marriage, entitled *Abide with Me,* about her former marriage to her millionaire alcoholic husband, George Brokaw. Several nights before the performance, Rosamond confessed to Zoe Akins that she still couldn't figure out what it was she so mistrusted about Clare except that Clare had cast her as an ugly, wicked bitch of a woman whose marriage was hideous. Rosamond wrote Zoe:

For some reason, I seem always to play the unhappy wife. This part I play calls for a bitch of the lowest order. That's such fun and comes very easily to my nature. God knows how I'd flounder in a comedy.

But I'm going to try it. Even if I don't ever become an actress, this experience has at least rid me of one of my nightmares, the dread of being on stage. Thank you dear Zoe for driving me into it. I've simply got to earn some money and perhaps the theatre is the way for me after all. If my trust fund has any more cuts made in it I may have to either be an actress or a kept lady. Which do you think is easiest?

If there was a role written as much for Rosamond as for Clare, it was that of Nan Marsden in Clare's *Abide with Me*. But according to the papers the wicked one was not the wife at all, but the husband:

"Abide With Me," Clare Boothe Brokaw's melodrama, which will have its premiere at the Beechwood Theatre in Scarborough on Tuesday evening, deals with the problem of a young and charming society woman married to a secret and sadistic drunkard. Rosamond Pinchot will portray the leading role, that of Nan Marsden whose marriage to the outwardly sanctimonious Henry Marsden is a continuous torture behind closed doors. Paul Guilfoyle will play opposite Miss Pinchot in the role of the dipsomaniac husband. . . . The character of Charlotte Field, the girl Henry Marsden marries after Nan divorces him and whose misery at the hands of Marsden arouses Nan to violence against him, will be played by Dorothy Hale.

Later in that summer of 1934 Rosamond starred in *Aren't We All*, a play about another miserably married woman. At the time, she confided in her diary that she wondered what it would have been like if she'd never met Reinhardt at all but had settled down in some calm, respectable marriage to a conventional young man. Not a Bill Gaston or a Bennett or a Selznick, but a Fred Roddell perhaps.

She wondered where, indeed, all the men she'd once loved had gone. Where had Reinhardt gone? There had been such a fondness between them. The press sometimes reported on them as if they'd been man and wife, sometimes speculating he loved her. In February 1933, the fire in the Reichstag sent the wealthier Jews fleeing Germany, and she suspected Reinhardt was among them. Hundreds had been killed in

Vienna and Linz in Austria's brief civil war. Reinhardt once told her how he had been chased through the streets of Vienna as a child. Now he was probably driven out of Berlin and she imagined that he couldn't return to Vienna, either. She wondered what had become of the Schloss Leopoldskron.

In New York that summer of 1934, Rosamond began to think that her husband, Bill Gaston, was a "distinctly evil fellow." He was still making mincemeat of her reputation and telling people that her bedroom was a gymnasium. She hadn't been a nun, but Big Bill was no monk. "Well, if he does any more of that," she wrote, "I'll let go and say what I know about him." Her friend Gloria Braggiotti knew something about Big Bill that he wouldn't like spread around about him. Everyone knew Bill liked his women, but not many people knew he also liked them black and from Harlem.

A month before she was due back in Hollywood, Rosamond consulted a publicity woman, Eleanor Lambert, to fine-tune her image. Over lunch, they talked hair and makeup. When Rosamond asked what she thought the public's impression of her was, Lambert said that in the eyes of the world she was "a very rich girl who had gotten all the breaks because she was so beautiful." The public, Rosamond told her, was in for quite a disappointment when they saw her up on the screen. "Always be dignified, always be a lady," advised Lambert.

The next day, the discussion continued at the Colony Club, this time with Grace Moore and Cole Porter over lunch. Porter complained, "Because I went to Yale people won't believe I can write movies." Rosamond agreed, "Society people think I am a Bohemian actress, and theatrical people think of me as a society girl. So I am an outcast." There was no winning. That afternoon, back in Milford, Rosamond napped and dreamed she was a houseguest of Greta Garbo. There was Garbo, tall and sleek, welcoming her to her home and being so very nice. Solitude was Garbo's way of coping. Rosamond had seen her lie down in the bottom of her car to avoid being spied as she left the studio. She had hidden herself, Rosamond thought, and they called her mysterious.

· · ·

After six not-so-exhilarating months in New York, Rosamond and the boys boarded a flight for Los Angeles. That October in Hollywood, David O. Selznick told her he was crazy for her, she dressed in rags just to annoy Cukor, and in November 1934, she received news that there were now six Pinchots, not seven, on the *Social Register.* She'd been dumped. The reason stated under her photograph in the *San Francisco Examiner* was "Divorce," but she hadn't divorced Big Bill. She wasn't a divorcing woman. The real reason she'd been excommunicated was reported in the *New York Times:*

> The *Social Register* for 1935, which is now being distributed to its subscribers throughout the city, contains some startling omissions from its pages, notably the exclusion of the names of those who have turned to the stage or screen. Also those who, from the viewpoint of the Social Register Association, have had too much adverse publicity are missing.... Mrs. William Gaston, the Rosamond Pinchot of stage fame, who is niece of Governor Pinchot of Pennsylvania and who was a star in the original production of *The Miracle*, is not listed in the 1935 *Social Register.*

No men of the stage had been dropped, but Rosamond was in good company. An Astor and a Roosevelt made the excluded list, as did a relative nobody named Mrs. Mildred Tilton Holmsen who had been dropped not only for her 1934 divorce but because she had "caused much more than usual comment in Reno because of her walking around in shorts." Still, the publicity people at MGM were all in a dither demanding Rosamond make a statement, which she did: "If this is the worst sacrifice that I'm asked to make for going into the movies, I think I've had a break. Now at least professionals will no longer be able to point scornfully at me as a social registerite dabbling in the arts." It was only later she felt a pang of sadness, knowing that both of her grandmothers had been listed in the first *Social Register* of 1886. She wrote,

> It's as if some tie with my own people had been cut. But the socialites aren't really my people any more so I shouldn't mind. There's never

been any scandal attached to my name though heaven knowing, [*sic*] there might well have been. Lots of other professionals are in the Social Register but I guess they haven't had such a hullabaloo about their business. Oh, hell, forget about it.

But George Cukor wasn't about to forget about it. The next morning at seven, he called Rosamond to say he'd decided to do "the big thing" and go on seeing her. But that didn't mean he wouldn't tease her. Or she him. That day, Rosamond dressed in her worst pair of raggedy overalls and went to his house for a lunch with Kate Hepburn and several of George's friends. When Hepburn arrived, George disappeared, and after a while, Rosamond bounded outside to see what was going on. Kate greeted Rosamond with an icy silence. George had told Hepburn to be her bitchiest self and to act horrified that one of her own, a crusty easterner, would be tossed off the register. Once Rosamond realized what was going on, everyone yelled and laughed, retiring to a huge Hungarian lunch. Afterward, while George sprawled out on the lawn making wisecracks and wrestling with his cat named "Miss Pinchot," Rosamond decided that no matter what people said about her, she liked Hepburn, a lot. Her face seemed so lean and intelligent.

A few days later, Rosamond was out of her mind with excitement when she learned that Max Reinhardt was in Hollywood. "How strange fate is," she wrote. It was as if a great wheel was turning and her far-flung friends of the past eight years were all together again, including Francesca Braggiotti and her husband, John Lodge, Zoe, Cukor and Vollmoeller, who had written the script for *The Miracle*. Now, at last, Max Reinhardt had also arrived. But not everyone was as excited about her reunion with Reinhardt as she was. When Selznick learned she planned to meet Reinhardt the next day, he launched a whopping tirade of criticism, ripping into both Rosamond and Reinhardt. Rosamond frequently noticed Selznick's weight but didn't say anything. This time, it was his turn: "You are too wide. Get that behind off!" he shouted. Selznick carried on about her "complexes" and her "character." Then he criticized Reinhardt. Later Rosamond wrote, "For David to be anything but humble about Reinhardt is absurd."

The next day, November 8, 1934, Rosamond made her way along Hollywood's lively avenues, up and up through California's canyons of sprawling coast oaks, to meet Max Reinhardt at the Hollywood Bowl. At America's largest natural amphitheater, nestled in a deep ravine above the city, she found Max, in his element, rehearsing a spectacle of typically massive scale, his interpretation of *A Midsummer Night's Dream:*

> He seemed so glad to see me. I was glowing with pleasure at seeing him. I'd dressed up in my nice black and white print with the green tie and wide green belt. My hair curled because I'd steamed it. My face was almost without makeup. I felt pretty, a nice feeling. He gave me a seat beside him and had the rehearsal go on but he didn't pay much attention nor did I. He asked me about everything, life, career, state of happiness and I told him. Then he watched the actors and gave a few directions. There was one lovely talented girl, Olivia de Havilland. After a while he looked at me and said in German, "Do you remember that day in the Century Theatre when I first told you that I loved you?" I nodded and remembered. Life is strange, very.

It felt like just a few short months since she had seen him, she wrote, when in fact, it had been six long years. Reinhardt looked heavier, and at about sixty, he had aged. His wife greeted Rosamond and described how they had fled Austria not knowing if they would ever return. "We have lived through a lot," she said. Rosamond thought about how Reinhardt had lost the thing he loved most, his home, and was now adjusting to life in exile. Providence would decide if again he would see his beloved Leopoldskron, its paneled library with the hidden stair, the mirrored banquet halls, the harlequin masks and actors from the Commedia Dell Arte frescoed on its walls, the rose parterres lapping up between the palace and the little lake Leopoldskroner Weiher, his mirror to the Alps.

Reinhardt still had his grand dreams, this time of a star-studded cast for the autumn run of *Dream* at the Bowl. It would be the perfect performance, needless to say, regardless of cost: Charlie Chaplin as Bottom, Garbo as Titania, Clark Gable as Demetrius, Gary Cooper as Lisander,

John Barrymore as Oberon, W. C. Fields as Thisbe, Walter Huston as Theseus, Joan Crawford as Hermia, Myrna Loy as Helena, and Fred Astaire as Puck. He admitted that he hadn't gotten a single one of them to commit but he had discovered a boy named Mickey Rooney to play Puck and convinced Olivia de Havilland to play the part of Hermia. That fall of 1934, Reinhardt drew two hundred thousand people to ten performances of *A Midsummer Night's Dream* at the Bowl. Max even had a deal in the works for a film version. "How sad it is that he is old now," Rosamond thought. "To have had a love affair with him would have been a delight and an education," she wrote.

Rosamond shared Thanksgiving with friends at a beautiful sprawling house she'd rented from MGM's famous Latin lover, the movie star Ramon Navarro, who was born José Ramón Gil Samaniego in Mexico and whose parents had escaped Mexico during the revolution. She invited many of the friends she'd rediscovered in exile. Everyone, it seemed, was from somewhere else. There was George Cukor, who grew up in Philadelphia, the son of Hungarian refugees, and Francesca Braggiotti, whose family had escaped Italy when their villa was turned into a hospital and, at thirteen years old, Francesca ministered to wounded troops. Francesca, of course, was accompanied by her husband, John Lodge, the actor who was fleeing the shadow of his grandfather, Henry Cabot Lodge. Joining them were George Oppenheimer, who had fled his East Coast upbringing and Brown education and landed as a screenwriter for MGM, and another colorful Austrian American film director known in Hollywood as the Jewish Fu Man Chu, Joseph Von Sternberg, who had added the Von to his name when he arrived and whose father had been in the Austro-Hungarian army before leading his family to a better life in New York City. Last but not least was the long-lost Reinhardt, who had narrowly escaped the führer, who was poised to take over the Schloss. On Thanksgiving day, while Von Sternberg sat in the corner advising Reinhardt on the casting of the film version of *Dream,* Rosamond instructed Little Billy on how to carve off pieces of a plump turkey, a species that somehow managed to escape becoming America's national bird, and that George, her butler, had mutilated beyond recognition. No one knew where George came from, but for

the moment, everything seemed just right with her crazy quilt of reassembled friends.

From October through December, Rosamond primped and exercised and watched her intake of fatty Medjool dates and took her sunbaths and held her glamour parties with the Barrymores and Gary Cooper and Gloria Swanson. When she thought no one was looking, she abandoned her hostess duties and vanished into the backyard to lie down under the jacaranda tree, staring up through its dark branches and pale blue blossoms. Like many Hollywood contract workers, she spent her nights saying things were fabulous and her days gnawing on her fingernails wondering whether the studio would find her a movie and if her contract would be renewed. She'd visit Selznick in his offices to discuss possible parts, including one he thought she'd be perfect for, Florence Nightingale. She waited and wondered until December 17, when she went to see David in his vast drawing room where he was sitting on the couch drinking a chocolate milkshake. "Nightingale is off," he bellowed. "Paramount beat us to it!" Rosamond suggested that if MGM had kept their plans a secret, it might have gone through. David yelled, "Yes, but you can't keep anything secret in Hollywood!" Sucking down a second milkshake, David picked up the phone, dialed the scenario department, and started yelling at the woman in charge, "Stories for Pinchot! Stories for Pinchot!" He got off and told Rosamond she would have to be patient. On her way out, he put his arm around her and pressed his face against hers. At least, she thought, he was trying to get her a lead.

A few days later Rosamond returned to ask David for a favor. This time, she took Little Billy with her, his first visit to the lot. While they waited, they went to see Cukor, who was delighted with the fine German accent Little Billy had learned from his nursemaid, Miss Tuck. When David's secretary called for Rosamond, Rosamond left Little Billy with Cukor, who kept making him repeat words in German, then took him over to see W. C. Fields on the set of *David Copperfield*. While Little Billy watched the child actor Freddie Bartholomew play young David Copperfield, Rosamond was once again being accosted by Selznick. She had gone in to ask David for a screen test for her friend Bob Chatfield-Taylor,

but as soon as she stepped into his office, David started kissing her and working himself into a frenzy. His face was unshaven, and she observed the large pores on his nose. He took off his glasses and blinked. There was something distinctly unseductive about him—in fact, she found David rather disgusting—but he was humorous, which made the whole situation ridiculous and this time more playful than threatening. David quieted down, stopped sputtering, and Rosamond took her glove to gently wipe the lipstick off his face. "I hate to go out into the office with my hair like this," she said. Barking back, David said, "You always look rather like that!" They both laughed.

Rosamond left David, slipped past the secretaries, and went over to the *Copperfield* set where Little Billy was watching Freddie Bartholomew stagger and fall along George Cukor's nineteenth-century London streets while being drenched by rain from indoor sprinklers, blown by a wind machine, and scared to death by fake lightning. Cukor presided over the scene like an ogre. When Rosamond arrived, she found Little Billy wincing and screaming in horror, "I don't think the little boy likes it!"

Later that afternoon, Rosamond and Billy bought a Christmas tree and had it tied to the car. Recovered from her earlier drama, Rosamond went off to a dinner party that night with Freddie March, Myrna Loy, and the Selznicks. When she brought up having been on the *Copperfield* set that afternoon, David's wife, Irene, told the guests that George and David considered *Copperfield* not just a movie, but a mission. David's father, Lewis Selznick, had grown up in terrible poverty in Russia, she explained, where day after day he read Dickens to learn English so that one day he could come to America. Lewis worked so hard once he got here so that his son, David, wouldn't have to take the bus to and from Culver City. Things hadn't always been this good. David Copperfield wasn't just Dickens's story, Irene reminded them, it was the story of Lewis Selznick and boys all over the world.

On Christmas Day 1934, Elizabeth Arden sent Rosamond perfume from New York, the Selznicks sent her a purse, and George brought her a purring kitten he'd nicknamed "Mr. Cuke," although Mr. Cuke was a she. Rosamond didn't need a kitten so it wasn't much of a gift; in fact, it was more of a return volley since she'd sent him Miss Pinchot several

months earlier. Everyone sat down to Christmas dinner sporting paper hats. Zoe insisted on eating Christmas dinner out of Little Billy's baby bowl while Billy ate like a grown-up off her plate. Jimmy rushed from room to room dismantling the tree, demanding trains, and tearing at packages indiscriminately. A huge box of tuberoses arrived from Reinhardt with a message of affection. In the afternoon, the adults got tight on champagne and nibbled on imported cheeses. Going on and on about how glad she was to be away from New York, Dot Parker held court in a coat of red flannel and gray fur that Rosamond thought should have been hanging on the Christmas tree.

In the spring of 1935, Rosamond was still waiting for MGM to find her an assignment. One night at a party, she met Jed Harris, one of New York's most influential stage directors, who was in Hollywood waiting for his next big break. She was thirty years old and Harris was thirty-five. In the

Josef von Sternberg and Jed Harris

swing of the evening, Harris, who hated parties, crept behind a curtain to escape the fray. He hardly knew the hosts and wasn't prone to small talk, so as he stood behind the curtain contemplating his next move, he looked over and noticed someone else was standing beside him. It was Rosamond. They turned to each other, confessed their dismay at parties, and, as Isabel Wilder, the sister of Thornton Wilder, would later recount, Harris said, "You have two children, don't you?" Rosamond told him yes, she had two boys. Fussing with the curtain, she said "I hate them." "Nobody hates little boys," Harris said. "Well, I do," Rosamond said. "Well, I don't believe you. They must be very attractive little ones; imagine, boys with all their privileges." She insisted she hated the boys and didn't know how to be a mother and did not know what to do with them.

Jed Harris had children, too, but he didn't admit to not knowing what to do with them. He had a child named Abby by his second wife, Louise Platt, neither of whom spoke to him, and a son, whom he did not acknowledge, named Jones Harris, by the actress Ruth Gordon. It wasn't the time or place to tell her his name wasn't really Harris, that he was born Jacob Horowitz and had grown up in a slum in Newark. Or that he told people that he was born in 1900 in Vienna when he'd actually been born in Lemburg, a small town in southeast Austria. Whatever else Jed Harris was or said he was, most agreed he was one of the most brilliant, successful, manipulative, and infuriating producer-directors the American theater had ever seen. In September of 1928, he appeared on the cover of *Time* magazine. By the age of twenty-eight, he had produced four consecutive Broadway hits over the course of eighteen months. By thirty, he was a millionaire who was rumored to be making $40,000 a week. But in the process, he'd left dozens of members of New York's theatrical community screaming to the rafters and calling him a dirty, rotten crook. Sir Lawrence Olivier had used the word *diabolical* to describe him, while others applied terms like *consuming* and *devouring*.

When Rosamond met Jed that spring, he had recently completed two mediocre stage productions, *The Lake* starring Katharine Hepburn, about which Dot Parker wrote, "Miss Hepburn's performance ran the acting gamut from A to B," and *The Green Bay Tree* starring Olivier, which received solid reviews but closed several months later. Rehears-

als with Harris were notoriously tense, but Olivier's experience with Harris on *Green Bay Tree* was legendary. They'd never gotten along, and on opening night, as Olivier walked onstage, Harris whispered, "Good-bye, Larry, I hope I never see you again." Olivier managed to perform beautifully but vowed revenge. During rehearsals, Olivier watched Harris's every move, his every expression. One day, he swore, he'd use it.

MGM's six-month contract with Rosamond was almost up. By April, Selznick still hadn't found her a part, so she went east for three weeks with the boys. While in New York, RKO Pictures called and asked her to play Queen Anne in *The Three Musketeers,* a remake of the Alexandre Dumas classic, to be directed by Roland V. Lee and starring Walter Abel as D'Artagnan. Production was scheduled to start in June, so she left the boys with Gertrude and returned to California on the Union Pacific's Overland Route, stopping along the way in dusty towns like Ogden, Utah, and treeless waysides in the Nevada desert, where she walked her dog, Panella. On arrival, she wrote Cornelia, "Dearest Cornelia: I survived the trip. This afternoon Miss Panella and I arrive in California where we will be met by a sinister young man." The sinister young man was Jed Harris.

In her role as Queen Anne, Rosamond was cast as the unhappily married wife, this time of the French king Louis XIII. Instead of running off with the man she loves, the English prime minister, Duke of Buckingham, she sacrifices true love and the royal jewels for the sake of peace between France and England. During production, Rosamond's worst fears came true. She didn't look sleek. Thanks in part to the grand gowns and baroque jewelry designed by Hollywood costume designer Walter Plunkett, she described herself as looking like a mountain on legs. She was taller than the two men who played opposite her. The camera caught her looking matronly, hunching and uncomfortable. After filming finished, she wrote Aunt Cornelia, "I still feel very depressed about myself in the picture. In fact, it is all I can do to get myself into the projection room to see the rushes. The cameraman has done absolutely nothing to make any of the women in the picture look presentable." There was, however, one person who did look presentable: a tiny, blond tornado of an actress named Lucille Ball, who played Rosamond's lady-in-waiting.

While Rosamond was still in Hollywood working on *The Three Muske-*
teers, Jed Harris invited himself to Grey Towers to survey the manse and
meet the illustrious Pinchots. On July 2, 1935, Rosamond wrote a note to
Cornelia to follow up on the visit. "A very strange telegram," she wrote,
"couched in formal phrases, came from that weird pixy, Jed Harris, when
he was in Milford. I wish I could have seen him against the family back-
ground. Father's impression must have been amusing. Jed isn't exactly the
type he approves of, particularly for his hare-brained daughter."

In the late summer of 1935, with no contract renewal in sight, Rosa-
mond said farewell to Hollywood for good and joined the boys at 9 East
Eighty-first while Gertrude took a house in Tucson to recover from her
heart and lung conditions. Rosamond accepted a summer-stock engage-
ment to perform in the play *Petticoat Fever* in Falmouth, Massachusetts,
directed by her friend and admirer Alfred de Liagre. That fall she spent
more time with Jed Harris, who was still anxiously searching for the
perfect play.

The theater was filled with extreme personalities, and Harris was
one of them. He was known to be as recalcitrant as a child, retiring to
his bed on opening night until the performance was over. Jed had a
Svengali-like effect on women. There were women, smart women like
Isabel Wilder and Geraldine Morris, the wife of agent William Morris,
who excused the fact that he had infuriated half of Broadway because
he had a compelling wit, a discerning mind, and a superb knowledge of
the theater. Some thought it peculiar that he only whispered and forced
the listener to lean in to hear him, and they wondered if it was
manipulation—that is, until they learned that Harris was for the most
part deaf. As Rosamond grew more fond of Jed, she ignored the stories:
how he kept the poet E. E. Cummings waiting three hours outside his
office for a meeting; how he humiliated hopeful young writers by send-
ing them with their scripts to the office of his archrival, the "Great
Collaborator" George S. Kaufman. Harris knew Kaufman wouldn't
look at anything that came via Harris, so those young aspirants were
sent packing. How he'd cheated the director George Abbott in the af-
termath of their smash hit *Coquette,* changing the terms of their deal.
Harris was the only man George Abbott ever said he hated; and no

matter how fond Abbott was of Rosamond, he refused to be in the same room with Harris.

By the time Jed met Rosamond, he had formed a fascination for actresses who hailed from the American establishment, like the doe-eyed Margaret Sullavan and Katharine Hepburn; but those relationships had ended badly. So badly that Hepburn would never breathe the words *Jed* and *Harris* in public again. Jed hadn't found the play that would relaunch his career, but in 1935, he agreed to stage a comedy written by his sister, Mildred, *Life's Too Short*. The critics agreed that life was too short and ten performances were too long. Rosamond sat in on rehearsals and invited Cornelia to come to the opening, but Cornelia, who had met Harris when he invited himself to Milford, politely declined, citing "meetings" and a slight antipathy toward the young man. She wrote Rosamond, "I don't believe it means anything in Jed's young life whether I turn up or not. Otherwise I would try to manage it."

Cornelia wasn't making excuses. Between running for a congressional seat in Pennsylvania and helping her sister-in-law, Ruth, massage her membership application for the Colony Club—asking Ruth if she preferred to be an "Out of town member or a 100% bonafide, genuwine old New Yorker"—Cornelia was in fact busy. At Christmas, she bought Billy and his brother beautiful red sleds and sent them to the house on Eighty-first Street while they went to Tucson with Rosamond to celebrate the holidays with Gertrude. When she returned from the West, Rosamond bounded around as usual, attending parties with her friends, seeing Jed as time permitted, and frequently stowing the children with Cornelia or Miss Tuck, the boys' German nursemaid.

That winter, while Big Bill was working in Washington for the Roosevelt administration, he learned that his wife was consorting with Harris and there'd even been talk of marriage. Everyone knew Harris was a legend, and Bill knew that New York loved its spoiled little rich girls. *Social Register* or not, a Rosamond Pinchot marrying Jed Harris, formerly Jacob Horowitz, wasn't what New York's upper crust had in mind or what the Pinchot family needed in the way of publicity come the next Senate campaign. Bill might have been a philanderer of the highest order, but there was no law against philandering. Bill didn't want a divorce,

but if Rosamond did, then it would all come out in the press. Harris hadn't just made enemies: his ex-wives had cut Jed's face out of their scrapbooks, and his own daughter wouldn't speak with him. It was one thing for Big Bill to be seen with his women, but it was another thing for Rosamond to be cheating on him with Jed Harris and now wanting to marry him. He'd spread the rumors about her and Bobby Lehman, but this time he had her cornered.

For short stretches that winter, Rosamond left town, but for the sake of the children, she kept everyone, including Big Bill, apprised of her whereabouts. In late March of 1936, while she was away and the coast was clear, Big Bill broke into Gertrude's townhouse at 9 East Eighty-first Street and stole Rosamond's leather-bound diaries and her safe box. He called the diaries she'd been keeping since 1926 her "hate books," but he was searching for evidence of love. He planned to excise anything that made him look bad from the years of their cohabitation, no small menu of matrimony's dark side. If he had possession of the diaries, everything she'd say would be hearsay, inadmissible in a divorce proceeding. If Rosamond went through with the divorce, he'd send her "hate books" to the press or use them in court to show she hadn't been much of a mother, she'd been unfaithful to him, she'd called her bedroom her "gymnasium." What she wrote in her diaries would sink her. She'd sacrifice anything to protect the Pinchot name. If she wasn't careful, he'd give her publicity all right—just not the kind of publicity she wanted.

From June through August 1936, Rosamond went back to playing summer stock in New England. She played to rave reviews and then in the fall and winter, she and the boys went back to Tucson where they joined Gertrude in an unlikely landscape, but one in which she found a new kind of solace, the desert. Pale and tired, Rosamond loved the spare, rugged simplicity of Tucson enough to want to stay. She rode out in a beat-up pickup truck through the arroyos and up the mesas to look at real estate. In the vast expanses of cactus and sage, the Cinderella loneliness appeared then disappeared quickly. The desert wasn't lush or conducive to her beauty sessions so she wondered whether this was her place now, a landscape where the scale of emptiness reminded her that it was over between her and Big Bill.

There are places that show us who we are, bold and lovely, masculine and feminine. The place that made Big Bill who he was, was Crotch Island. It was the only place that made him happy. It was there he engaged the little things, the domestic earthy things, the cooking and gardening, the fishing and reading. Those things redeemed him, made him whole again and used him up. Those were the things she would always remember loving about him. But here, in the spiky gray desert in the winter of 1936, she remembered her trips back and forth across America, in part to forget him and to shed the Cinderella loneliness.

That winter, Reinhardt was back in New York assembling yet another massive spiritual production, *The Eternal Road*. Like *The Miracle,* the production got off to an agonizing start. It began one day in 1933, when a young Jewish producer, Meyer Weisgal, visited Reinhardt in Salzburg with the idea for a biblical drama. Weisgal idolized Reinhardt, stalked him in London, and eventually persuaded him to adapt a book written by Franz Werfel for the stage. The production, he hoped, would be like a Jewish *Miracle,* a spectacle to end all spectacles. While Reinhardt never fully embraced his Jewish heritage, Weisgal was a Zionist and wanted to bring *The Eternal Road* to Broadway as a full-throttle political response to the Nazis' vilification of the Old Testament and to the rise of anti-Semitism in Europe. Reinhardt did not immediately jump on Weisgal's bandwagon, but when he learned that the feisty young producer planned to bring together the best talent available, just as he and Gest had done for *The Miracle,* he was interested.

Werfel brought the ancient story of the Jews into a modern context for New York audiences. The play depicted a group of modern Jews huddling in a European synagogue to escape persecution. Screaming matches break out between doubters and the faithful. Meanwhile the Rabbi reads from the Torah and reminds the Jewish community of its eternal struggle, The Eternal Road. The performance moves back and forth between ancient biblical stories and modern scenes of kvetching and yelling. Eventually soldiers drive the Jews out of the synagogue. Amid tumult and grief, both the faithful and the doubtful are visited by the

Messiah, who reminds them that their suffering is not in vain. Darkness turns to light and all is well.

Once again, Reinhardt expressed his grand vision of the theater, sparing no expense. The musical score was produced by Kurt Weill. Norman Bel Geddes was recruited to build a five-story mountain in the Manhattan Opera House where the biblical stories would take place. He directed construction workers to drill down to bedrock to establish footings for his sets. He burned through his budget before realizing that he had forgotten to build the synagogue. The *New York Times* claimed that Bel Geddes, like Moses, had shown his genius and "struck water out of rock," when all Meyer Weisgal wanted was for him to show some restraint. Fights broke out between Reinhardt, Bel Geddes, and Kurt Weill, and by 1935 the production was in trouble. Albert Einstein was recruited for a fund-raising banquet at the Waldorf Astoria and saved the day when he mounted a podium to make the case for rescuing *The Eternal Road,* basically from itself. *The Eternal Road* was

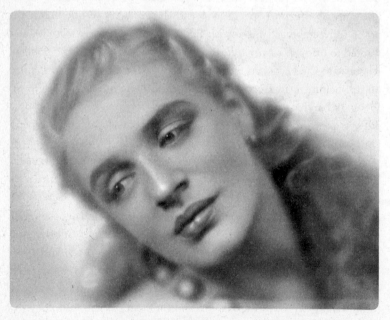

Rosamond as Bathsheba by Roberto Ida

a "great work," he proclaimed, and "true friends of culture" needed to support it.

This time Rosamond played the beautiful Bathsheba, otherwise known as the seventh daughter or the Daughter of the Oath. One day after rehearsals, Rosamond ran into an actor on the street she'd first met at the Pasadena Playhouse, a young Texan named Horton Foote. Foote wanted to attend the DeKanavas, the Russian School of Acting where Rosamond studied, but he was just starting out and didn't have the money, so Rosamond hired Foote to help her practice her lines for *Candida,* a play by George Bernard Shaw. Practicing in the parlor at 9 East Eighty-first Street, the two struck up a friendship. Rosamond introduced Foote to Max Reinhardt, and through her, Foote landed a small part in *The Eternal Road.* During production, Foote was awed by Reinhardt, Weill, and Bel Geddes, but he was personally smitten with Rosamond Pinchot. He knew of her reputation as the star of *The Miracle* and her status as an international beauty, but there wasn't one thing about her that was snobbish or affected or frivolous. One night, Jed Harris came to watch Rosamond rehearse at the Manhattan Opera House. After rehearsal, Rosamond introduced Harris to Foote, who immediately sensed something was wrong. In an act of spontaneous generosity, she had paid his tuition at the school of Russian acting and changed his life forever. Her kindness had meant a great deal to him. But now, he noticed, Rosamond, "a princess," had been taken over by an "evil monster."

After many delays, *The Eternal Road* finally opened at the Manhattan Opera House on January 4, 1937, thirteen years after *The Miracle.* On opening night, Cornelia was not there. She wrote to Rosamond that once again, she could not make the performance, but she was grateful for the gift Rosamond had sent: "The scarf you so unmorally sent me is too lovely. I look extremely swank in it—or rather I will, for I thought it was too nice to waste on Milford's unresponsive air and have not worn it yet. I shall read the theatrical review tomorrow with the keenest interest."

Opening night was, as expected, triumphant. Five-story sets extended over an acre of indoor space, twenty-six miles of wiring strung about the theater, with thousands of custom lights; the production used 1,772 costumes and had an indoor mountain that rose from twelve feet below the orchestra pit to thirty feet above. Bel Geddes and Reinhardt

had even thrown the forgotten synagogue into the orchestra pit at the last minute. The production lasted more than five hours, during which Rosamond and the huge cast performed flawlessly. Kurt Weill's musical score, the critics said, sent "shudders of eternity down the spine." Critics applauded Reinhardt's brute force, his artistry, the sets and costumes.

The Eternal Road hummed along for six months, but audiences had tired of Reinhardtian spectacles, and some suggested it closed because the message was markedly political. Not everyone in New York was enthralled with ancient stories of the Bible, or perhaps, for the ticket price, audiences didn't want to be reminded for five hours of what the Nazis might do to the Jews.

Amos Pinchot, for one, was quite uncertain about what the Nazis might do. Amos had won a reputation as a staunch pacifist, believing that America should not go ranging around the globe inserting itself in foreign wars. More concerned with internal enemies of the United States, Amos railed against monopolies and big business, insisting that they were the true enemy of the common man. Gifford, however, was vocal in his support of the Jewish people, and in 1933, he dispatched Cornelia to rallies and gatherings in New York to declare that Nazi oppression of the Jews would not be tolerated by the American public.

Ever the crusader, Amos had helped Rosamond escape Morris Gest but then she had fallen into the hands of Beelzebub. That marriage hadn't ended in disaster; it was a disaster that simply hadn't ended. Now she had a new man that most people found abominable but abominably successful, Harris, and there wasn't one thing anyone could do about it. When Rosamond went to the Pinchots with her plans to marry Harris, the Pinchots gave her their cautious nod. What could they say? She'd finally found a man to replace Big Bill, a man who was "man enough." Amos had put on the gloves with Gest and kept his distance with Beelzebub, but by 1937, Amos was busy fighting Franklin Roosevelt in full-page letters in the *New York Times,* opposing FDR's plans to reorganize the government, and the arms profiteers who would take a country to war.

After *The Eternal Road* closed in the summer of 1937, Rosamond spent the next spring in Tucson with her mother. Little Billy, eight years old by

Panella, Little Billy, and James, Tucson, 1937

then, dressed as a cowboy and rode in a rodeo for the first time while the boys' big white poodle, Miss Panella, won every ribbon a good-looking dog could win from the Tucson Kennel Club. But now, Rosamond was uncertain about buying the arroyo property because Jed had found the play he'd been waiting for and needed her help for an opening that winter.

In August, Rosamond and Harpo Marx were guests of the theater critic Alexander Woollcott at his island in Vermont. She swam and read, and after many years away from photography, she picked up a camera, taking candids of Harpo strumming a harp and Woollcott basking and sunning his rotund corpus on his long wooden dock. It had been thirteen years since Woollcott had written his glowing reviews of *The Miracle,* but he knew all the formidable directors who had influenced Rosamond's career in the meantime: Reinhardt and Cukor and Selznick and Harris and Zoe Akins. Woollcott admitted having little interest in riches, but for "fame, glamorously achieved, glamorously lost, or glamorously maintained, he had an undying fondness." That didn't apply, however, to one playwright Rosamond had worked with, Clare Boothe Brokaw. It was easy to dislike Clare. Off the record, Woollcott told Rosamond that "the seriousness with which Clare takes herself is convulsive." When it came to Zoe

Akins, Woollcott wasn't any more complimentary, writing that Akins was " a strange mixture of a dramatic poet and a romantical nursemaid." That was before she won her Pulitzer.

Given the ease of their friendship, it would have been natural for Woollcott and Harpo to lie around the dock, as they did that afternoon, kvetching and counseling Rosamond on what she should do next. Naturally, Rosamond had already made up her mind, having planned to spend the fall and winter helping Jed on two projects he was working on with the Pulitzer-winning novelist and playwright Thornton Wilder.

In the fall of 1937, with the loveliest woman in America on his arm, Jed was indeed poised for a comeback. He had found just the right play. In December of 1937, Harris met Wilder in Paris where he sealed a deal with the playwright for *Our Town,* a play in three acts.

That fall, Rosamond had returned to New York and rented Ballybrook, the estate of Mr. J. H. Alexandre on Valentine's Lane in Old Brookville, Long Island. Set in a serene neighborhood of old mansions and beautiful trees on the North Shore's Gold Coast, Ballybrook was within an easy drive of New York City. It was also just down the street from the exclusive Green Vale School where she would enroll the boys. Finally, it seemed, she would settle down in a beautiful farmhouse. She had her love for Harris, friends and family close at hand, and, at last, a position behind the scenes in technical production, something she had longed for.

Jed Harris and Thornton Wilder had crossed paths before. At Yale, Jed thought Thornton was a god. Wilder was sure-footed, curious, and cosmopolitan, spending part of his youth in China where his father had been a consular official. Conversely, Jed, from the Jewish neighborhoods of Newark, thought Yale was a horrific waste of time yet he stayed. Modest and lonely at Yale, he would sometimes reach out to finger Wilder's coat as the two passed in the crowded halls of their dormitory, wanting to soak in what someday he might become. Jacob Horowitz knew there'd come a day when he would become someone else.

In high school, Thornton kept tabs on French- and German-language theater, and in particular, the work of Max Reinhardt. After graduating from Yale in 1920, he took one year at the American Academy in Rome, then returned to teach French for three years at the Lawrenceville

Academy where his students affectionately named him "The Diction-ary." After receiving his master's degree in French from Princeton, he took a year off to write, and in early 1928, while returning on a train trip to Florida, a man approached him and said, "Aren't you Thornton Wilder?" It was Jed Harris. Before the two men got off the train that day, Jed had successfully turned on the charm, and the two animated giants discovered an extraordinary rapport. They would thrust and parry, add-ing this or that odd fact or interpretation to the other's superb knowledge of French novels or philosophy. Both were fully alive, passionate, and energetic; and although Jed was more quarrelsome than Thornton, and far less scholarly, his agile mind was finely tuned to the subtleties of cast-ing and scripts. Jed could be deferential when he wanted something. In 1928, *The Bridge of San Luis Rey* won Thornton Wilder the Pulitzer Prize, making Wilder a celebrity novelist, and by the fall of 1937, Thornton had something Jed wanted—badly.

In the winter of 1937, Thornton returned from Europe to com-plete *Our Town*. It was difficult to find solitude, but one day, Jed an-nounced that he had found Thornton the perfect, quiet place to write, an apartment over a garage in a rural neighborhood in Old Brookville, Long Island. At first Thornton thought Jed was trying to be helpful and agreed to the arrangement; but no sooner had he moved to Long Island than he discovered that without a car or public transportation, he couldn't even get out to lunch. He was completely at the mercy of Jed, who, for some reason, was frequently in the neighborhood and would come by to hover, which he hated. Thornton called the ar-rangement his prison and had no idea why he had been exiled to a neighborhood in the middle of nowhere until one day in the late fall, Harris and Wilder were driving around Old Brookville after lunch, when Thornton noticed the name on a mailbox a few doors down. The name read GASTON. Wilder knew he had been duped and sent to a suburban gulag for Jed's convenience. He didn't say anything to Jed but told his sister Isabel that he was furious with Jed for treating people like chess pieces. Shortly after noticing Rosamond's name on the mailbox, Wilder staged a revolt and returned to New York City, where Harris wouldn't bother him.

Someone else was infatuated with Rosamond at the time, the author Sinclair Lewis, who was twenty years her senior and married, with a child. With a Pulitzer he'd rejected and a Nobel he'd accepted, he was gunning for the much-coveted role as Stage Manager in *Our Town*. In the summer of 1937, Lewis began pestering Jed Harris for the part. Meanwhile, in late October, Rosamond received scintillating love notes from a not-so-scintillating part of the world where Lewis was lecturing in what he termed the "very red state" of Oklahoma and the lackluster hinterlands around Kansas City. Two years before, Lewis had written *It Can't Happen Here,* a novel about how fascism comes to America, "wrapped in the flag and carrying a cross," so his notes to Rosamond were laced with references to fundamentalism and fascism. In Tulsa, the newspapers found Lewis "stimulating and even witty." But he didn't find Kansas City stimulating at all. He wrote Rosamond that it "is entirely composed of chop suey joints and the $500,000 homes of ex-oil millionaires who are now washing dishes in the chop suey joints and the very

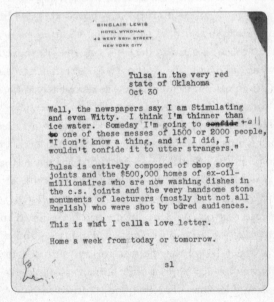

Note from Sinclair Lewis

handsome stone monuments of lecturers who were shot by bored audiences." According to Gloria Braggiotti, Lewis was in love with Rosamond. At the end of one of his notes, he wrote, "this is what I call a love letter." Whatever he called it, he'd missed his chance. Not only was he married, he'd somehow forgotten to mention her at all.

Later that fall, Rosamond received more charitable communication from Gloria Braggiotti and Alfred de Liagre, who were both troubled by her relationship with Jed Harris. De Liagre had befriended Rosamond's brother, Gifford, when Gifford had reduced his diet to nothing but oysters while training for the Yale crew. Like Horton Foote, de Liagre felt protective of Rosamond, knew Harris, and, like most people, had nothing good to say about him. Harris had once crept into a rehearsal of de Liagre's production *Three-Cornered Moon* to watch Harris's then girlfriend Ruth Gordon, and when de Liagre saw Harris skulking around, he tossed him out on his ear. So when he discovered that Rosamond was having an affair with Harris, de Liagre wasn't one to hold back, saying, "My God, Rosamond, what are you doing with that dreadful man?" Rosamond shrugged him off, "Oh, you're just jealous of him." "No, it's not a question of jealousy at all. I think he's just a very evil, sinister fellow. I have heard a great many reports about him from other actresses. He is cruel, ruthless and sadistic, and is very much disliked." De Liagre told her that Harris made his actresses repeat a scene two dozen times to their breaking point. But Rosamond defended Jed, "Oh, Delly, you don't understand. He's a really remarkable man—enormously talented." De Liagre had heard the defense before from Harris's lover Margaret Sullavan, who'd also said he was an extraordinary man. De Liagre concluded that the women who were attracted to Jed Harris must have a masochistic streak.

When Wilder was writing the script for *Our Town* in the summer of 1937, Harris was ecstatic. He told others that it was the best manuscript he had ever read. A one-night opening of the world premiere of *Our Town* was scheduled for the McCarter Theatre in Princeton, New Jersey, for Saturday, January 22, 1938. On Monday, January 24, it was to start a two-week engagement at Boston's Wilbur Theatre. Jed announced magnanimously, "If anything goes wrong with it, it will be my fault, not Wilder's."

Rehearsals in New York began shortly after Christmas 1937. Although Harris had approved the script, nothing stopped him from dabbling and shifting scenes around. Isabel Wilder, Thornton's sister and closest confidante, had only been to two rehearsals, but that was enough to see that the two men were warring and behaving like children. Skirmishes erupted, settled down, and then erupted again. Wilder was so put off by Jed's maneuvers that he concluded that Jed wanted to consume him and claim *Our Town* as his own. When Harris characteristically demanded he be named cowriter, Wilder threatened to quit, and Isabel stepped in to calm the situation, knowing that both men were indispensable to *Our Town*. But, she said, Jed, if forced, would destroy everything for not having written it.

While the two warring titans skirmished, Rosamond dutifully drove back and forth in her Chrysler on Long Island's burgeoning thoroughfares and over the shiny new Triborough Bridge. She was involved in productions in New York until all hours of the day and night while her boys spent their days down the street at the Green Vale Academy in Old Brookville and their evenings with Miss Tuck, their devoted nurse. There were no acting parts in *Our Town* for a tall, thirty-three-year-old leading lady, but Jed wanted Rosamond around, so he gave her the official title of "prop manager," if only to move chairs, buy umbrellas, and turn pages of the script. To the cast it was evident that she'd fallen deeply for Jed, who behaved like a man reborn.

When Thornton Wilder met Rosamond on the set of *Our Town,* he knew from Jed's shenanigans in Old Brookville that Rosamond was far more than the prop manager. Since there were virtually no props, there wasn't much for Rosamond to do, so she also took on sound effects, including train whistles, birdcalls, the ringing of the town clock, and the clomping of horses and bells. She was reported to have designed Emily's wedding dress, a simple white frock for a rural New Hampshire celebration in the early 1900s. Seeing Rosamond at rehearsals, Thornton and Isabel were reminded that Thornton had privately hoped Reinhardt would direct *Our Town,* but the play didn't rely on sets. Indeed, *Our Town*'s first four words, "No curtain, no scenery," warned audiences that they had left the land of Reinhardtian spectacles. Wilder wrote, "Our

claim, our hope, our despair are in the mind, not in scenery." And speaking of despair, Thornton said he thought that Rosamond was being shortchanged. Others thought her role as prop girl was a deliberately demeaning move on Harris's part. Hers wasn't a hard job but it was a symbolic one, as was the design of the wedding dress. Rumor had it, Jed and she planned to marry.

The night of Friday, January 21, 1938, was wet and snowy in Princeton. The cast arrived slipping and sliding down the sidewalks in front of McCarter Theatre, having trudged all the way out from New York. Adding misery to the miserable, a mistake in scheduling had occurred. That night McCarter Theatre was booked for a piano recital, so Jed directed the cast to reappear at 11:00 P.M. that night. When everyone sauntered back in, the cast learned that the lighting would require eight hours to set up, so once again, Jed told everyone to set their clocks, go back to bed, and return the next morning. Isabel Wilder described that night as the worst of all possible conditions and a drama within a drama. Much of the cast was making only $35 a week and had to find not only a place to stay but food when almost all the shops and restaurants in Princeton were closed. Everyone's nerves were stretched beyond breaking. Jed was high-strung and frantic.

Finally, at 11 o'clock on the morning of January 22, rehearsal went into full swing. The cast was exhausted, but Rosamond and Jed were ebullient and full of extraordinary energy. Jed spent the morning shouting directions, while Rosamond, positioned in the center aisle, took notes. At one point that morning, one of the actors leaned over to ask Rosamond how she managed to look so alive given their lack of sleep. She whispered that she and Jed had taken Benzedrine, an upper. They hadn't had a minute of sleep.

A single performance of *Our Town* opened on the night of January 22 to a full house. Despite the chaos of the two previous days, the production went remarkably well. The audience was largely made up of Princetonians, whom Wilder described as a "fashionable villa colony; academic bourgeoisie; and students." The program described the play as "The record of a tiny New Hampshire village as created by the lives of its most humble inhabitants." In one of the play's most memorable

scenes, Martha Scott as Emily stood in her white wedding dress against a backdrop of black umbrellas. Emily married, had children, died in childbirth, and was given a chance to come back to relive just one day of her life. She chose a day, an average day, when she was twelve years old, before her life had officially begun. "Live people don't understand do they?" she called out. "They're sort of shut up in little boxes."

After the final curtain, Harris turned to Wilder on the stairs above the dressing room and asked, "What did you think?" To Jed's surprise, Thornton agreed that it had gone well and praised Jed for his work but also said he thought some aspect of the last scene had not worked. "There was that one point you never understood," said Wilder. It was the last thing a director wanted to hear. The comment struck Harris in the chest. He flew into a rage, uttering a mouthful of foul words. He hadn't heard what was good.

Jed usually managed to seduce everyone, but that night he hadn't seduced Thornton Wilder. Jed made a quick exit from the theater while Thornton and Isabel wandered the deserted streets of Princeton looking for something to eat; they finally discovered a small one-window smoke shop on Nassau Street that sold newspapers and had a small soda fountain in the back. The owner was just closing up for the night but agreed to make them a sandwich. Isabel and Thornton went in, ordered, and as they were waiting for their food, they heard a voice coming from a phone booth at the back of the store, sounding like a man pleading for his life. It was Jed: "But Rosamond, no darling. Of course I love you but I can't, don't you see, I can't spend the night with you. Yes, I love you, it has nothing to do with not loving you."

Overhearing Jed's impassioned plea, Isabel sympathized with him, pleading as he was with a woman who was being impossible. Isabel thought Rosamond didn't understand what the director and producer were going through, what ghastly nights everyone had had. Rosamond, she thought, had no sense of these mens' responsibility. Listening to their phone call, Thornton felt differently. Thornton had seen both sides of the Jed Harris equation. He felt sorry for Rosamond, as he would have for anyone who found themselves in the clutches of Jed Harris.

Thornton and Isabel left the shop as quickly as possible with their sandwiches, leaving their half cups of coffee on the counter. Jed never knew they had come and gone. When they left the shop for the Nassau Inn, the storekeeper closed and locked the door behind them as Jed's voice got louder and louder. "Yes, I love you; of course, I love you."

Later that night, Jed picked up Rosamond and the two drove back to New York with Mildred, Jed's sister. Rosamond continued on to Long Island that night and made the decision that she would not go to Boston the next day.

Jed and the cast arrived by train in Boston at 2:00 P.M. on Sunday for a reading at the Wilbur Theatre. Later that afternoon, Thornton checked in at the Copley Plaza, then crossed the street with Isabel, who was staying on a church-mouse budget at the YWCA. Isabel checked in and went upstairs while Thornton bought a newspaper and sat down on a couch in the spare, dark lobby. When she joined him a few minutes later, Thornton was sitting frozen, as if in a paralysis. He had put down the paper, but Isabel could see the headlines on the front page:

LINK SUICIDE TO SHOW HERE
*Rosamond Pinchot Said to Have Been Brooding Over Failure
to Win Part in* Our Town

Shaken and trembling, Thornton and Isabel went into a shop on Stuart Street near the hotel to buy paper and an envelope so that they could write Jed a note. They found a coffee shop, sat down, and Thornton wrote Jed to please let him know if there was anything at all he could do. Thornton didn't go to the Wilbur Theatre, but Isabel did. When she arrived, Jed wasn't there. No one knew anything. The cast sat around the lobby of the Wilbur, despairing and waiting for instruction. When Jed finally arrived, he shook hands with everybody and told them, "A very sad thing has happened. I will be going back to New York and you should carry on without me. We will make the presumption that the play will go on as usual and the responsibility will fall to the play's stage

manager and Frank Craven." Harris said he didn't know what his next step would be. Thornton described Rosamond's death as "a bomb dropped on the cast."

After the opening in Princeton, Rosamond had arrived home in the middle of the night. The next day, Sunday, January 23, she spent quietly, taking a walk and dining at home with the children. Later, after the children had been put to bed and everyone was asleep, Rosamond left the old white farmhouse on Valentine's Lane and went for a drive. It was another snowy, icy night, and at three in the morning, she picked up a hitchhiker, Colonel Harold Hartney, a retired World War I flying ace with a lame leg. The colonel, who didn't drive, had been waiting for a friend to pick him up at Roosevelt Field where he had gone on business, but when the friend arrived, he was drunk, and Hartney refused to get in the car. After walking for some distance in the snow, he saw the lights of a car approaching. When it reached him, Rosamond rolled down the window and asked for identification before agreeing to give him a ride. Rosamond said she never allowed anyone to sit in front, but he could sit in the back and she would take him anywhere he wanted to go. He said he lived in Great Neck, so she turned the car around. They got to talking and discovered mutual friends when the colonel asked her why she was out so late. Rosamond said she was returning from Princeton but had been delayed by the bad roads. She said she had had a slight accident on the bridge and thought she would slide off. She laughed nervously. Then there was a silence. The colonel noticed that she handled the car well but that she was sitting tensely over the wheel, and when she slowed to light a cigarette, her hands were shaking. Then Rosamond broke the silence and said that she could not take him all the way to Great Neck and would let him off at the Roslyn train station because, she said, she had to get home to call her husband in Colorado. She was a pretty girl, the colonel noticed, and when she stopped to let him out, he told Rosamond that she had probably saved his life. He thanked her for everything and asked her for her name so that he could write a thank-you note. She turned around to look at him and said, "I am known as Rosamond Pinchot."

When Rosamond arrived back at Valentine's Lane, she pulled the Buick into the three-car garage. She went into the house and set two

notes on her bed. Sometime that night Miss Tuck, the boys' nurse, heard Rosamond go back to the garage. There she took a garden hose, connected it to the Chrysler's exhaust pipe, and led it through the left rear window into the passenger compartment. She chinked the opening with a piece of burlap so that the fumes would not escape, started the motor, and lay down on the backseat.

At 6:15 A.M., Ida Hanniven, the cook, found her dead dressed in a white evening gown with an ermine wrap. The two boys were asleep inside the house.

The Syosset precinct of the Nassau County Police was called to the scene. Amos was reached in New York and drove out to the house with Rosamond's friends Kay Halle and Gloria Braggiotti. Cornelia, staying at the Colony Club in New York, first called the house in Old Brookville and then spent forty-five minutes speaking with Gifford by phone in Washington. Amos identified the body. Inspector Harold King of Nassau County declared Rosamond's death a suicide on account of two notes found on her bed "confessing her suicidal intentions and distributing her property." The assistant medical examiner recorded the time of death as about 6:00 A.M. According to his report, Rosamond was "Working hard. Getting ready for production. Was taking Benzedrine tablets. Probable motive—committed in fit of reactionary depression from late hours and reaction following wearing off of drug." A blood test was taken, which revealed carbon monoxide poisoning. No autopsy was performed that might have revealed the level of Benzedrine in her blood or any other complicating factors, such as pregnancy or illness. No report was made confirming damage to the car or that Rosamond had been in a minor accident.

The Syosset police force, which had existed for only thirteen years at the time, banned the press from the estate, but the next morning, January 25, 1938, headlines screamed across the front pages of newspapers across the country and around the world. Across four columns of the *World-Telegram*: "Rosamond Pinchot Found Dead: Hose in Garage Indicates Suicide."

The first reports revealed that she had been discovered in a white evening gown with silver slippers and an ermine wrap, but Amos

corrected that account the next day when he released a different version to the *New York Times*: "Mrs. Gaston was found dead early this morning in the garage of her house at Old Brookville, Long Island. She was dressed in sports clothes and a sweater. She left a note of farewell for her parents and friends. The funeral will be held at 9 East 81st Street on Wednesday at 11 a.m."

On Wednesday, January 26, New York's *Daily Mirror* reported that Rosamond Pinchot's diary was "found" the day before. While the papers did not reveal who found it, they reported that she had made two notations that "may have indicated her thoughts had at last turned to divorce, which through five years of separation from her husband she

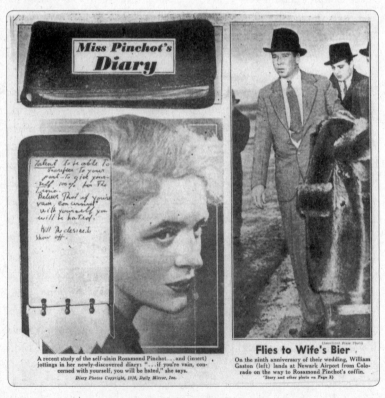

Flies to Wife's Bier

A recent study of the self-slain Rosamond Pinchot...and (insert) jottings in her newly-discovered diary: "...if you're vain, concerned with yourself, you will be hated," she says.
Diary Photos Copyright, 1938, Daily Mirror, Inc.

On the ninth anniversary of their wedding, William Gaston (left) lands at Newark Airport from Colorado on the way to Rosamond Pinchot's coffin.
Story and other photo on Page 3

Newspaper clipping, source unknown

had refused to contemplate." The paper went on to say that "William A. Gaston, who is the father of her two small sons, arrived here yesterday, after traveling by plane from Denver to Newark."

In the early-morning hours of January 24, Big Bill had been notified at his mountain retreat in Cascade, Colorado, just east of Colorado Springs, and quickly went to the airport to board a flight in Denver. A few minutes before the plane took off, Bill was reportedly in a very bad mood. Accompanied by an unidentified woman, he seized a sandwich from the lunch counter and stomped out of the café, throwing his money all over the floor. His plane landed in Cheyenne, where he made several phone calls and told reporters that Mrs. Gaston's death was "none of your business." He arrived at Newark the next day, wearing his raccoon coat. Appearing tired and bloated, he barked at reporters before taking a car to 9 East Eighty-first Street, where he barked again, "How would you like it if this happened to you?" When asked if he had had any recent communication with his wife, he quieted down and replied, "No comment."

Bill hadn't been back to 9 East Eighty-first Street for some time. He certainly hadn't been invited back after he broke in to steal Rosamond's diaries a year and a half before. On January 26, 1938, instead of spending the day on Pike's Peak, Bill spent the day in Rosamond's mother's house with his wife, who was dead. Jed Harris spent the day, no doubt, thinking about why Rosamond was wearing a white gown reminiscent of Emily's wedding dress, and whether it was a message meant for him. Bill and Jed probably couldn't face each other. And Amos probably spent the day blaming every last bit of Rosamond's troubled life on earth on himself. He'd been too busy fighting off the enemies of the state to realize that internal enemies had taken refuge inside his daughter.

On January 26 at 11 A.M., several hundred mourners, mostly women, crowded the corner of Eighty-first Street and Fifth Avenue. Held back by a detail of a dozen policemen, the onlookers were kept on the opposite side of the street so that Rosamond's friends and family could pass. The funeral was small, mainly for the family, but was also attended by forty of Rosamond's friends and associates, including Kay Halle, Gloria Braggiotti, Miriam Hopkins, Tilly Losch, Tommy Hitchcock and

Mrs. Hitchcock, Miss Chelle Janis, Dudley Field Malone, Lady Hubert Wilkins, the Thayers, the Damrosches, the photographer Cecil Beaton, and a friend of the family who offered to take the boys for the day, Miss Isabelle Pell.

Rosamond lay in her bed on the third floor. After the viewing, the group assembled on the second floor for a short Episcopal service officiated at by the Reverend Dr. Henry Sloane Coffin, president of the Union Theological Seminary. There was no eulogy and Dr. Coffin made no reference to Rosamond's death as a suicide. Big Bill was reported to have sobbed throughout. Amos leaned heavily on his cane. Governor Gifford's face was a "white mask." Cornelia looked like a steely-eyed Amazonian queen ready to defend the Pinchot name. Mary and Tony wept constantly. Jed Harris hid in the corner while Morris Gest ran outside to speak with reporters. "I cannot understand it," he said. "She was getting along so wonderfully well. She was devoted to her two lovely children." Gest paused and then exploded, "My God, she was dynamite. She could run faster than someone else could skate. She was so full of life." Amos Pinchot refused to say anything, as did the rest of the family.

That cold January afternoon, in a bronze casket covered with a carpet of snapdragons, white orchids, lilies, and branches of apple blossom, Rosamond was carried out of 9 East Eighty-first and taken to the little mausoleum at the top of the hill in the Milford Cemetery where she was laid to rest. No one had answers for what had brought her to that point. But many formed their conclusions when they learned in the press that on January 26, 1938, Rosamond Pinchot should have been celebrating her tenth wedding anniversary with her husband, Big Bill Gaston.

THE TOPOGRAPHY OF THE BRAIN

It would be convenient to attribute my abysmal choice of men to my father's disappearing act or my mother's self-destruction. But then, my father could blame his behavior on Rosamond's death and Big Bill's philandering. Ascending the paternal family tree, Rosamond could claim that her miserable marriage to Big Bill was due to the fact that Amos fooled around while married to Gertrude, and Amos could say he'd been miserable with Gertrude and possibly even more miserable with Ruth because his father, James Pinchot, crowned his brother, Gifford, king. The explanations would go on and on until I was left with a domino theory of wretched choices, a genealogy of unhappiness. But that wasn't very satisfying to me. What I wanted was a decent, honest, intelligent, attractive man in my life, one of Cornelia's breast-forward men. I suppose, perhaps, there was a reason that Gifford was king.

I had another alibi. I was in a deep sleep when I chose the men in my life. I was perfectly present, but my eyes and ears were closed to truths that others heard quite clearly. When I saw or heard things that didn't add up, I chose to call them something else. One could say it was denial. My lover wasn't bankrupt, he had financial issues. The torrid love letters I found in my boyfriend's desk drawer were notes from a friend. He didn't really love his ex-wife, he loved me. The truth of abandonment and loveless love was too much to bear, so I became very, very sleepy and closed my eyes.

My mother was convinced that, in order to solve my man problems, I should go to Mongolia. She didn't know that she was dying when she read about the latest

archaeological discoveries of the noble tyrant Genghis Khan in the New York Times *and suggested I go on an archaeological dig to retrieve his artifacts and fend off ennui. I think she wanted me to get out of Florida, where I was sad, where, on her last visit, we walked along a dismal network of streets, talking about love at right angles to the sea. She had decided that despite my romantic losses, I belonged to a race of conquerors and I would find a husband among huge men on horseback who galloped off into bleak and barren plains. A good man was waiting for me in Mongolia, she said, and all I needed to do was hop a plane, sift through a pit of shards, and find him.*

Three months before she died, my mother gave me a new identity. I suddenly became "her magical daughter." She sat in her little room in San Francisco where her voice was deteriorating from the cancer that riddled the delicate throat tissues of her esophagus. I read to her over the phone for hours and sent her books on the spirit and healing and a box of thumb-sized winged angels made from pipe cleaners and dressed in tutus. She marveled at my wandering the world, planting, restoring, and transforming myself time and time again through love affairs gone amuck. Through the years I rarely saw her but sent her what she loved most—postcards, small offerings of thought, words of love penned on the sleepless nights of my Bedouin existence. At the end, her words come back to me. The magical daughter appellation was her greatest gift, a tender bookend at the far side of our time together. The other bookend was the Hand of Fatima, of course, the talisman of protection she should have kept for herself.

When I was forty, the man I called my true love, the Irishman, walked off with another woman while my father was dying and I had gone to take care of him. Besides the memories of eight years together, the only thing he took with him was the Brooks Brothers suit I'd given him for his birthday, so I figured he must have had somewhere pretty important to go. But he didn't tell me where he was going, he just vanished, saying nothing except that I should read the story of Job and that I was so perfect he wanted to be me. He wasn't reading Job, he was reading The Power of Now *and* The Artist's Way *and had concluded that I didn't live in the present, so he was leaving me for a more glorious future. On his way out the door, I howled like a hyena. He stopped me in midhowl and said, "If you knew who you were, you wouldn't be begging me to stay."*

After my father died, I cried every night and every morning for about a year. I wanted to straighten something in the landscape or get on a horse with a brave Mongolian as he battled the wind, but instead, I woke up day after day to all the griefs

I'd ever had and let them sweep me away like a riptide takes someone out to sea. I knew not to resist a riptide, so it took me; and I remembered how my mother's bottomless grief over my father had made such a mess of her life. It occurred to me that it was better to get mad than sad, so I went to a Chinese doctor who put his fingers on my wrist and diagnosed me with broken-heart disease. I wasn't ready to move on. That was natural, he said.

Mine wasn't a lighthearted, I'm-a-bit-angry kind of angry. Easy anger is the understandable fit that subsides after a few weeks while female friends act as aides-de-camp in facilitating relationship demolition work, taking down the scaffolds of he said—she said, and proclaiming every nuance a victory for the embattled feminine. In time, what is awful is laughable and what is unforgivable becomes "experience." Easy anger merely skims the surface of pain. Hard anger, on the other hand, is when the list of things that don't add up ceases to fit a category or subside with platitudes. Arguments like "live and learn" go nowhere. The hard anger forced me to retrieve my list of flawed love stories and summon the courage to add things up. The fact was that most of the men I'd loved since I was twenty-three had been two-timing scoundrels. It was more than just bad luck; I was the common denominator and the stories all sounded the same.

I could have been like many women of Rosamond's and my mother's generations and put a pleasant public spin on my history of deceitful men by saying that there was something good about each and every one of them. I could have pretended that everything was just fine; but the timing of the departure was more than coincidental— it seemed designed for maximum shock.

What I came to realize was that the women in my family had self-destructed over men for three generations. They had imploded rather than exploded, and implosions hadn't just taken them out to sea for a few months; they had killed them or otherwise driven them from their brilliant and beautiful lives. A woman was supposed to sit quietly pretending nothing had happened or walk away at midlife from the man she thought she loved. If she couldn't talk about it, it would go away.

After Rosamond died, her friends and relatives found ways of adapting to the wrenching, horrible fact that the woman they thought was cheerful and bubbly had suffered terribly and that she'd left them all with one hell of a final act. She hadn't crept off into a desert arroyo and wailed like a coyote. She'd committed the biggest

public fuck-you imaginable. People thought she was crazy, when, in fact, she was angry and mostly at herself for a thought that wasn't entirely correct: she thought her life had been ruined by her abysmal choice of men. Perhaps, if she'd had the courage to tell the truth, that she'd given everything and gotten nothing, if she'd screamed that fact to the ceiling, she might have settled down. She might have been drowned out by the cackle and stories of the men and women who loved her. She might have fallen asleep to purring platitudes that ferried her through the night. If that hadn't worked, she might have granted herself the time to float back out to sea, to feel her justifiable rage, and to let the thought of suicide pass.

But women just didn't express that kind of anger, at least proper women didn't, so Rosamond didn't, and when she died, Cornelia instituted a full-court press of denial, insisting on the narrow explanation of the coroner's report. Rosamond, she announced, had simply been exhausted and had taken Benzedrine to stay awake. After keeping one up, Benzedrine could have a mean down. Case closed. Nothing to the white dress, nothing to the suicide note, nothing to the anniversary Rosamond should have spent with Big Bill, nothing to the missing diaries, nothing to the bizarre attraction and loyalty to the meanest man on Broadway. Nothing, nothing to it. Cornelia wrote to her friend Mildred Bliss at Dumbarton Oaks in Georgetown to thank her for the cyclamen, the extended letter, and phone call. She wrote Teddy Roosevelt, son of the president, ". . . what's the use of talking about it—there it is," insisting Teddy come up with Eleanor and his son to do some fishing in the spring.

In the days and weeks following Rosamond's death, Cornelia had her hands full negotiating with Bill over the care of the boys. The Pinchots had every intention of taking custody of the children, according to Rosamond's wishes. Final negotiations proceeded apace, until, according to Gifford's son, Gifford, something happened that would change the boys' lives forever. One day, something came up and things turned nasty over the phone between Amos and Big Bill. Suddenly plans were dropped. No one ever discussed whether the boys were going to live with the Pinchots or the Gastons. They were most definitely going to live with Big Bill. No questions asked. Cornelia arched her back and knew these were times that demanded the finesse of a woman. She took over all communications with Big Bill. Her letters to him regarding the boys were conciliatory, even generous.

Uncle Gifford didn't talk about Rosamond's death except to refer to it as a terrible tragedy. Gifford knew the best medicine was to carry on the good fight. He wrote his brother, Amos, on January 29 to congratulate him on his superb open letter

to FDR and to thank him for the nice words he'd included about the Forest Service and himself. "That was mighty fine," Gifford wrote, and signed his letter "Your loving brother." Meanwhile, Amos's grief at first caused temporary blindness. When he could, he responded to hundreds of condolence letters, describing his loss as irreparable and deep. Then he went back on the warpath, lambasting Franklin Delano Roosevelt with greater ferocity than ever. But he couldn't escape from the truth, that he had lost his dearest, kindest friend on earth. Two years later, on January 24, 1940, he wrote a tribute entitled "To Rosamond" and sent it to the Herald Tribune:

> Weep not, poor soul, nor ask to know what sun
> Doth course above that broad and shining land,
> Where she finds rest, and where full rivers run
> In silent splendor to the tidal sand.
> But ride as she did ride her steed in pride
> Across the hills. And give as she did give,
> To those whom God, prejudging, has denied
> Compassion and the generous strength to live.
> She was the glow of dawn that leaps afar
> O'er fertile fields to touch the barren height.
> She was the lovely discontented star
> That leans from heaven to give to earth her light
> And each forsaken creature man or beast,
> She loved the most as it became the least. A.P.

The day after her death, January 25, 1938, Jed Harris was reported to be "deeply shocked" at Rosamond's death, telling reporters that he had seen Rosamond on Saturday night in Princeton, where, he said, "She looked radiant and she seemed in the best of spirits."

Our Town opened at the Wilbur Theatre to mixed reviews and poor attendance. It closed after one week. Amid the chaos of Rosamond's death, Jed Harris scrambled to decide whether to rewrite the script or close the play altogether. In Boston, the play faced an uphill battle. Boston audiences knew Rosamond Pinchot. She was Rosamond Pinchot Gaston, estranged wife of the playboy grandson of the former governor of Massachusetts. What more did they need to know? Dead was dead, and tragedy was tragedy, even in the land of the stiff upper lip. Wilder wrote to his

friend, the decorator Sibyl Colefax, of the Boston opening: "Audiences heavily pa-
pered. Laughed and cried. The wife of the Governor of Mass. took it on her self to
telephone the box-office that the last act was too sad. She was right. Such sobbing
and nose-blowing you never heard. Matinee audience, mostly women, emerged red-
eyed, swollen faced, and mascara-stained. I never meant that; and direction is re-
sponsible for much of it; Jed is now wildly trying to sweeten and water down the
text."

At the advice of Alexander Woollcott and Marc Connelly, Our Town *moved to*
New York, where it played to an enthusiastic audience. Later that year, Thornton
Wilder won the Pulitzer Prize for the play, which, in turn, gave Harris the smash hit
he'd been waiting for. After the play closed, however, Harris never saw another hit.
Sir Laurence Olivier eventually got his revenge on Harris, claiming Harris as the
inspiration behind his performance of the diabolical King Richard III.

Eleanor Roosevelt *wrote in her March 1938 column that* Our Town *"depressed*
her beyond words," which prompted Woollcott to question her "progress as a play-
goer." Quoting the late producer Charles Frohman, Woollcott suggested that some-
times it wasn't the play that failed, it was the public, and that Mrs. Roosevelt should
"eat some lettuce . . . take a nap and go see Our Town *again." That same month,*
Thornton Wilder paid a visit to Gertrude in Tucson. Though she was in no shape to
do anything, she still offered to help him with various projects. Amos wrote Gertrude
frequently and worried about her deteriorating health. Gertrude became depressed
and told the press that Rosamond was one to make hasty decisions. Kay Francis,
who stayed friendly with Big Bill, scribbled a note in her desk diary on the night
Rosamond died, "Rosamond Pinchot suicide, got Bill G. on phone en route N.Y. at
Cheyenne." She took a sleeping pill and went to bed early.

Little Billy's *grades slipped from A's to C's at the Green Vale School, and the*
Pinchots said that they were most concerned about him because he was so sensitive.
Little Billy missed his mother terribly, but he didn't want to worry anyone, so he put
his mind on his puppies; but nothing could distract him, not even the attention of his
classmates. Like his grandfather Amos, Little Billy developed pain in his eyes and
Cornelia insisted Big Bill take him to the eye doctor, but no physical cause was found.

Friends of Rosamond's *from Rio de Janeiro to Hollywood were grief-stricken.*
They sent Amos tender, ethereal poetry and the words of philosophers who tried to
make sense of the senseless. Others sent donations to local charities where Rosamond
had donated her time and used coats. Mrs. Craft in her little goblin's hat in the

broken-down farm high above Grey Towers wrote the family to let them know that she would always cherish the memory of Rosamond as her dearest, most loyal friend. George Cukor and David O. Selznick went on with their lives, yelling and carrying on, this time on their largest production ever, Gone With the Wind, but Cukor was dismissed after two weeks for bad behavior.

Clare Boothe Brokaw became Clare Boothe Luce when she landed a seriously big fish, the publisher Henry Luce in 1935. She went on, in 1939, to garner wide publicity for MGM's film version of her play The Women, a satire on the lives of bitchy socialites. But in 1944, she lost her daughter to an automobile accident, explored religion and therapy and dedicated herself to a life of Catholicism and public service, representing Big Bill's district, Fairfield County, Connecticut, in the U.S. House of Representatives and serving as the American ambassador to Italy many years later.

And Big Bill, who wasn't one to waste time, went right on doing what he had always done, drinking, jumping, and sometimes marrying his women. Years later, he finally used his law degree as a strikebreaker in Stamford and ran for Congress. After a narrow loss to his opponent John Davis Lodge, who likened Big Bill's campaign to something out of vaudeville, Big Bill married Teddy Lynch Getty, a reporter and opera singer from an elegant Greenwich family who had been reporting from Rome when she landed in one of Mussolini's prisons. Big Bill met Teddy when she married one of his best friends, J. Paul Getty, and Big Bill had been Paul's best man.

Meanwhile, another Teddy, Teddy Roosevelt, whose father had contended with the Gastons in the ring at Harvard and the Pinchots in public life, wrote a condolence letter to Gifford from his home in Oyster Bay. He first dissected the news, then, sounding like his father, claimed Rosamond as a posthumous member of his own ideological posse. Rosamond wasn't part of Amos's "lunatic fringe," but had nonetheless strayed from the pack:

Dear Gifford,

I was shocked to hear today on my return from the West about Rosamond. Though I knew her only slightly I liked her greatly. I saw her mainly when I was up with you and she seemed to be a dear person who had somehow got into the wrong groove in life. It is hard to phrase but I think she was in her personal standards as conservative as you and Cornelia or Eleanor and I. Then she wished to be broadminded to others and did not get the two points

of view quite adjusted. Please give my love to Cornelia and don't bother to answer this.

Ted

Perhaps Max Reinhardt's telegram to Amos best captured the loss. He was, after all, the one who first discovered her:

Do let me try dear Mr. Pinchot to convey to you my inexpressible sympathy. I have always esteemed your daughter as one of the humanly and artistically most endowed creatures and am now terribly startled and sad.

Max Reinhardt

But as time passed, Amos couldn't be consoled. He spent the month of August 1942 alone in a darkened room at his uncle Will Eno's estate, Judah Rock, on Shore Road in Westport, Connecticut. One night he locked himself in the bathroom and slit his wrists. He lost so much blood, there was nothing to do but keep him confined and sedated for the two remaining years of his life. Ruth wrote Amos's brother, Gifford:

1165 Park Avenue #28, N. Y.
February 7, 1944

Dear Gifford:

Mary, Tony, Gifford, and I, after consultation among ourselves and with the doctors, decided against a lobotomy for Amos. Payne Whitney felt that they could no longer keep Amos and the Westchester branch of the N.Y. Hospital also refused him on the ground that he was a bed patient.

I visited a sanitarium in Astoria which seemed unsatisfactory, revisited West Hill sanitarium, and consulted with Dr. Labriskie again about the Hartford Retreat. Hartford Retreat will still take Amos; but it still seems too far away—and so Amos will return to West Hill by ambulance tomorrow to a pleasant little sunny room in the so-called Club House. Dr. Smith will assume charge with Dr. Labriskie as constant consultant.

I am sorry Payne Whitney didn't pan out in the way we all
hoped it might.

<div style="text-align: right">

Cordially yours,

Ruth

</div>

*After Rosamond died, everyone moved on in his or her own way, but two little boys
moved on when no one really knew where they were going. They grew up and took
their grief into the world, spreading it here and there. My father never talked about
his grief because he barely knew what happened. My father's brother knew more
because he had the diaries and the scrapbooks, but he'd never read them and would
never talk about Rosamond even if he had. In a universal haste to move on, Rosa-
mond's story and their story had never been told.*

*In the summer of 2000, my father called me to tell me he had only five months
to live. Up until that time, I hadn't bothered to dig up the past. After he died, I*

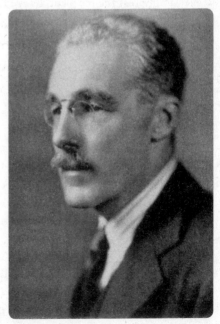

Amos Pinchot

realized that no one else was going to conduct the investigation, so I was going to have to do it myself. Rosamond's story lingered seventy years later, reverberated right in front of me. Her death was visible in generations of relatives who didn't speak to each other, in brothers who betrayed brothers, and sisters who betrayed sisters. In the places that had been allowed to sink into dishevelment. In all the things that didn't add up.

BILL: 1973-2001

One month before his forty-fourth birthday, three years after Big Bill died from alcoholism and diabetes, and thirty-five years after Rosamond had killed herself, my father sat in a rented flat in Tangier scouring the *Times of London*. It was time to craft his dispatch, so he pulled out Rosamond's Remington portable typewriter and put on his enchanting Little Billy self, the five-year-old self who asked a thousand million questions. His first choice wouldn't have been the Remington, except that he wanted to impress the recipient, Lady Diana Manners, who was said to be the most beautiful woman in Britain and had once described Rosamond as having "a strange face belonging to valleys and hills rather than gilded rooms and dance bands."

<div align="right">

5, Rue Balzac
Tangier, Morocco
6 December 1973

</div>

Dear Lady Cooper,

I imagine that in your lifetime you have received hundreds if not thousands of letters from persons whom you have never met nor heard of.

I came upon your name in the latest copy of the Sunday Times, not for the first time, for I had read excerpts from your memoirs (I think it was called) some years ago.

However, your name, even before the newspaper articles, was quite familiar to me. I cannot place the time when this became so, but it must have been very early in my life (I am now 44).

But, to get to the point, The Miracle often came up in conversation of my elders and I was given to understand that it was my mother that played the Madonna. Or was it the Nun, I do not know. The story was that, at about age 18, she was discovered by Max Reinhardt aboard a ship crossing the Atlantic and so captivated the producer that he cast her in The Miracle. Old photos and diaries (the latter long since vanished) show her to have been involved with persons and places German in the 20s, until she married my father in 1928. I hardly knew her, as I was just nine when she died. The rest of her life (after The Miracle) seemed to have been an anti-climax, an unsuccessful fling at Hollywood about 1934, followed by summer stock appearances during the next three years. Someone once told me she was "too tall" for the theatre, but I suspect there was a more complete explanation to it than that. Perhaps another case of "too much too soon." I do not say this critically, for could anyone, at her age, afford to reject what suddenly came her way? Rarely, in recent years, have I met anyone who knew her, and she has remained a stranger to her son.

So I hope you will not judge harshly this letter from a stranger, one who feels himself intimately tied to "The Miracle," its time and its participants.

<div style="text-align: right">Yours truly,
William Gaston</div>

<div style="text-align: right">10 Warwick Avenue W2</div>

My dear William,

I was devoted to your beautiful mother. All you say about Reinhardt seeing her on the ship is accurate. It must have been in 1923. We met at rehearsals. I immediately realized how right the professor was. I was engaged to play the Virgin and so was Maria Carmi, Princess Matchabelli. We were to act alternate nights. Your grandparents said that Rosamond, in that case, should only play alternate nights. They tried and failed to find another Nun for the other days so it was given to me to play her part when Maria Carmi was taking the Virgin's role. The Nun's was a grueling tour de force

involving running up and down the huge auditorium, miles a performance. When we took The Miracle to Dortmund in Germany it was shown in a vast sort of Madison Square place. We had a motor in the corridors to get us to the entrances in time. Then your mother sprained her ankle at the dress rehearsal. I was landed with both parts twice daily. It all but killed me. She was the perfect athletic Nun—with a coltish grace of extreme youth. No amateurs like her, me, Iris Tree and many others who took these two roles ever succeeded on the stage afterwards. I didn't try as I was married to a statesman and had a different task to deal with.

We played in New York and over the states for three seasons but I think your mother was not on the road with us. . . . To my sorrow, after the performance in Dortmund I lost sight of your mother. We were both pursuing our own fates. I knew your very good-looking father, also his brother and his wife. There was a man named Rudolph Kommer—known to us as Kaetchen who looked after us all and who we were all totally devoted to. He could have told you so much more but he like most of us are dead. He told me vaguely about Rosamond, but not much more than of her marriage, her 2 sons, her work with Reinhardt and others, her untimely end. I have photographs stuck into albums—I would so love to show them to you—do you ever come to Europe? I am so glad you wrote. Iris too is dead not so long ago. She loved Rosamond dearly. I wrote three books of memoirs under the name Diana Cooper. They were made into Penguins here also hard backs also in US—alas all out of print—the second volume will tell of all those days. You might get them second hand: The Rainbow Comes and Goes, The Light of Common Day, Trumpets From the Steep. Thank you again for your letter and putting me back into those far away adventurous days.

<div style="text-align: right;">

Yours,

Diana Cooper

</div>

As far as I know, my father never went to England to meet the Madonna and to see her albums. Back in New York, my mother's school

of attorneys was circling for the kill, so he stayed on in Tangier through the 1970s, resigning himself to Morocco's increasing Arab-ness, to its dusty plastic markets of kitchen utensils, heaps of cheap transistor radios from Taiwan, and faux Moroccan bags that never quite held up like the ones he'd bought with my mother. He had once loved most everything about Tangier, her bouillabaisse of cultures swirling through her white-washed streets, her incomparable setting high on the haunches of North Africa, and her light that made for his prizewinning pictures. Now he thought of Tangier as a snake pit in hell, but a snake pit in hell was better than facing my mother's attorneys whose primary mission he felt was to attach themselves to his prime asset, Rosamond's buildings. Eventually, however, he returned to face his fate in a New York City courtroom, lost his half of the buildings to his brother, and was granted a divorce.

I saw my father off and on through the 1970s and 1980s and never quite understood what he was doing. When I was asked, I'd say his work was related to ships, but most of his time seemed to be spent on legal matters. I didn't know that over the years, he made halfhearted attempts to discover who Rosamond was, attempts that never yielded much of anything. Clues would surface from time to time in the papers, then years would go by when nothing surfaced at all. The obituaries, in particular, were frustrating because they reminded him that it was too late to ask questions of the people who once knew her. As for the diaries and the scrapbooks, he assumed they had "long since vanished."

Finding his mother's name in the index, he bought an occasional book on Hollywood or Broadway in hopes that he would learn something new, but those books ended up in the fireplace because they referred to his mother by names she never used, like "Rosie," and spread prurient fairy tales about how she rode bareback by moonlight in the nude through the forest at Grey Towers. There were books that said Rosamond had received her master's degree in English when, to his knowledge, she had never been to college at all. He didn't know much about his mother but most of what there was, he said, was a "pack of lies." So many lies, in fact, he'd written to one editor offering to fact-check the next edition.

Sometime in 1982, my mother decided that my father worked for the

Central Intelligence Agency. She wasn't the only one who thought that might be the case, so one day, like a counterspy, I invited myself over to his basement apartment to investigate. His place was too small to snoop, so I planted myself on his couch, scanned the walls, and listened to him talk over classical music on the transistor radio. He went into his usual diatribes, how he was foiled by my mother's attorneys in their rotten games in court, how good wine was wasted on him. He poured me a glass of cheap Chilean swill, slapped a bologna sandwich together, and heated up a can of lima beans; I pretended to be listening when I noticed a colorful book holding down the end of his coffee table. The title was *Edie*. It was unusual to see a contemporary cover amid my father's stack of dog-eared legal files, old Peugeot manuals, and dusty classics. "It's the story of your great-great-grandmother's family and a woman by the name of Edie that was my mother's cousin," he explained. He said the book was about two very rich and famous families, the Minturns and the Sedgwicks, who had seen their share of glory and tragedy. "Have you ever heard of them?" he asked. Naturally, I hadn't, so he gave me a book report, including how the authors, George Plimpton and Jean Stein, circled the families like sharks and found a desperately wounded creature, Edie, at the center.

During the years of my clandestine visits to see my father, *Edie* would always be sitting on his coffee table, but I never so much as dared peek inside that book for fear my mother would hear about it. If I had, I would have seen the photos of the glam, long-legged Edie Sedgwick, the four fabulous Minturn sisters in full turn-of-the century plumage, and, ten pages later, a stunningly modern portrait of Rosamond. It was only years later that I bought the *Edie* book myself and learned that Edie's grandmother, Sarah May Minturn, and Rosamond's mother, Gertrude, were sisters. Although Edie Sedgwick and Rosamond were cousins a generation apart, there was an uncanny similarity to their lives. Like Rosamond, Edie came from a childhood of extreme privilege, and after a mediocre performance at a small private finishing school, she spun through parties in Boston and New York and landed at Andy Warhol's "factory" on Union Square. She was promptly proclaimed Manhattan's "it girl" thanks to Warhol's publicity machine and became a centripetal force in his short-

lived artistic bacchanal, which included "happenings" and short films in which Edie appeared in various states of undress. The painter Robert Rauschenberg said that he found that her "physicality was so refreshing that she exposed all the dishonesty in the room." She was reported to have been the inspiration behind Bob Dylan's "Just Like a Woman," "Like a Rolling Stone," and "Leopardskin Pillbox Hat." According to Jonathan Sedgwick, Edie's brother, Edie was madly in love with Dylan, became pregnant with his child, and lost her mind when she decided to abort. No one knew if it was Dylan who drove Edie over the edge, or Warhol, or Edie herself. She plunged into depression, was institutionalized, and died of a drug overdose in 1971. In the aftermath of her death, Truman Capote said, "Andy Warhol would like to have been Edie Sedgwick. . . . He would like to have been a charming well-born debutante from Boston. He would have liked to have been anybody but Andy Warhol."

In the spring of 1986, my father and I both received phone calls from his first cousin, Nancy Pittman, the daughter of Tony Bradlee, Rosamond's half-sister. Nancy had been hired by my father's brother, James Gaston, to write a book about his mother. James had given her a salary and an apartment in one of Rosamond's buildings in New York. We met in a restaurant, where she asked me questions about Big Bill. I barely knew my grandfather, and when the subject turned to Rosamond, I knew even less. I had just seen the advertisement for the Hupmobile on her sister Rosamond Casey's wall in Charlottesville that summer, but still knew almost nothing. That summer, Nancy also interviewed my father, who gave her a startling account of his fearful childhood with Big Bill, mentioning that he and James were immediately sent to the Pell family on Long Island in the days following Rosamond's death, and, after that, they were shuttled from house to house before my father was eventually sent off to Kent School. He didn't learn during that interview that his brother had the diaries and the scrapbooks.

During his interview, my father veered off the central topic of Rosamond to talk about his divorce, which, he explained, had destroyed the family. He told Nancy that two of his three children had stuck by their mother, vigorously defending her through years of legal wrangling, but that there was one child he was close to, me. He had attended my

graduation that spring, he said, and I had said something that touched him deeply. I had told him that since I'd left for college I had nowhere to return to, no home. I didn't belong anywhere. He told Nancy that this was tragic; even he had had a home with Big Bill after Rosamond died. It wasn't much of a home, he reported, and he didn't want to go back there, but his daughter had none at all.

In June of 1986, my father was distributing parts to his clients' aging diesel behemoths around the globe and adding to his sad little pile of Rosamond-related clippings, when he stumbled across Lady Diana Manners's obituary in the *Washington Post*. She had died at ninety-three at her home in London and the *Post* reported on a life that was similar to Rosamond's:

> In order to maintain the lifestyle she so much enjoyed, Lady Diana turned to acting. She starred on the silent screen in several less than memorable films, though they achieved great popularity because of Lady Diana's beauty. Her deep blue eyes, flawless complexion and delicate features led the poet Hilaire Belloc to enthuse that she possessed a "perfected face immutable," while photographer Cecil Beaton compared her to Helen of Troy, Cleopatra and other great goddesses of beauty. "Why I was chosen remains a mystery and a miracle," she once wrote.

That same year, after the launch of the good ship *Aung,* my father barreled his way down to Boston in his swift, white Thunderbird to attend his thirty-fifth college reunion at Harvard. That fall, wanting to address his classmates' thirty-five-year-old curiosity, he provided a biographical sketch clarifying his activities for the Class of 1951's Anniversary Report. He took the assignment seriously and what resulted was equal parts reportage, history lesson, and manifesto. Sandwiched between notices of cheerful asset managers, the boring travelogues of attorneys, and sobering names of the deceased, he wrote:

> To claim that a career emerged from "Fender Alley" may strike classmates—and others of our institution of higher learning—as

unlikely, if not preposterous. Yet, in my case, it is true for it was in that narrow lane that I developed an affinity for things mechanical while nursing a succession of antique vehicles, including a Model T Ford, Pierce-Arrow and Willys Whippet to mention just three.

From "Fender Alley" life's path went by a long circuitous route, including running a Jeep business in Tangier, Morocco, to a firm I head which specializes in ship's diesel engines formerly manufactured in the USA. Such names as Busch-Sulzer, Nordberg, Baldwin-Hamilton are now unfamiliar to most persons, but during the heyday of American heavy industry these very large diesel engines powered the majority of non steam-propelled American civilian and military ships. The survivors are now largely operated in foreign countries and this fact has taken me, in recent years, to Junk Bay in Hong Kong, Cebu in the Phillipines [sic], and to various ports in South America, some of which I prefer to forget. A ship's engine room is "home" to this Harvard grad and entering into an engine— possible in the case of the real behemoth—is an experience I delight in. Who said we would all grow up to be doctors and lawyers?

If my father wasn't an attorney, he certainly fooled a good number of people, except my mother's attorneys, who stayed for what seemed like forever on retainer. His pro se legal maneuvers became an obsession. My mother, he had decided, was a victim of her own attorneys. She had emerged from her divorce settlement with absolutely nothing. He wasn't out to get her anymore or to avoid his responsibilities; he'd chosen a far bigger fish to fry, the attorneys themselves. Having lost her father at a young age, my mother had transferred her faith to the legal profession, he claimed. So she hadn't kept track of where the so-called Gaston money and the Gaston property had gone. She wasn't keeping track of the lawyers' bills, either. They were.

My father's battles weren't confined to my mother or her attorneys. In the mid-1980s, he also decided to confront his cousin, Rosamond's half-sister, Tony Bradlee on a matter she probably preferred to forget. Tony came away with what might have been his, had it not been for his dreadful stepgrandmother, Ruth, and his rotten luck:

<div align="right">21 February 1987</div>

Dear Tony:

The other day a gentleman here in the District told me of the millions in furniture and cash (from sale of the apartment) which flowed from 1165 Park following the death of your mother Ruth. I do not believe any of the fortune had its origins in Elmira, New York.

Amos, I have read, spent most of his life battling injustices as he saw them. Somehow, I think he would be surprised (if not appalled) at the inequitable division between his direct descendants of property that once was his. The beneficiaries of a distant divorce and a subsequent suicide fared very well as fate had it, and none of them could be described as needy.

There are those of Amos' descendants (and I do not count myself amongst them) who have nothing. I suppose it is fortunate that this is not a close family; if it were, there are those who would (or should) feel uncomfortable with the treasure that cascaded upon them.

<div align="right">Bill</div>

In 1989, deciding there was no place like home, my father gathered up his clippings and his legal briefs into green plastic garbage bags and moved back to the Old Mill. He was on a mission to rescue his beloved from his renters, a band of attractive but clueless Princeton co-eds who never fully appreciated the glories of the Moat. From his reestablished base camp at the Old Mill, he could motor into New York's law library in his convertible Peugeot, do a brisk business in diesel engine parts, and continue besieging the wretched, corrupt attorneys with motions he filed himself.

As the keeper of the Old Mill, his days were filled with the mundane. He diligently mowed her mole-infested lawns and tended to dead things around the grounds. He kept his muscles toned at the gym and his romantic life a secret. For a time, no one knew that he had found what his Little Billy self had always half hoped for. In the 1970s, he had met a tall, blondish, olive-skinned woman at the Moroccan embassy who pushed him in the direction of her friends, but he wasn't interested. He liked her tenacity and her teasing, and he rolled his eyes when she insisted she wasn't Moroccan, but French.

When I first met the Moroccan, he said he had known her for thirty years, and she reengineered his sentence by adding "as friends." It didn't matter to me, I was glad to see anyone in the family having a good time. She cooked spice-laden dishes with aromas that wafted through the Old Mill like something burning in the souk and sat by his side to giggle at *Seinfeld*. They'd make fun of people who were ugly or fat. She bought supersized underwear to string up on the clothesline, which embarrassed my father in front of his rural neighbors. She was practical and intrepid and bombed around the Old Mill with her throw rugs, and she disposed of things when he wasn't looking. She'd complain that the place hadn't seen a single update since the 1960s, which it hadn't. In the summer, they'd head up to Maine in her late-model Jeep and she'd prove she could be what every Gaston man wanted, a cross between Marilyn Monroe and an Amazon. She'd yank mussels from the rocks and roll up her sleeves to dig for clams and make the best of a driftwood bunk in Shack that he insisted was a luxury accommodation. Meanwhile, he kept watch over the ship, insisting on sleeping with his "true love," *Aung,* a hundred yards away. Their voices traveled over the water to say goodnight and both knew a little separation was good. She'd call him "Monsieur Gaston" and he'd call her "Mademoiselle," and the world seemed complete.

I saw my father only three times in the 1990s when I broke free from projects in Oregon, flew east, and hired myself a lobsterman to take me out to the islands. Circumnavigating the coves and inlets to see whose boat was anchored where, I'd find my father floating in the back cove of Crotch Island or in the long harbor at Crane, leaning back in an orange plastic desk chair with his feet propped up on the gunwales and reading last week's *New York Times*. It seemed to me he'd been waiting and hoping I'd arrive, so that summer would begin.

My father presented himself with an air of formality when I'd first see him, and I thought of it as a by-product of coming from old speak-when-spoken-to families. I'd smile and tease his Little Billy self. "So where'd we get the designer furniture?" He'd smirk, pull his thick reading glasses down off his nose, put the paper aside, and say, "It floated up. Welllllllll, speaking of floating up, it's about time. What took you so

Crotch Island by Eliot Elisofon

long?" The *Times* went in the hold, the bananas came out of the Moroc-
can bag, and he'd offer me a warm beer he knew I wouldn't drink and
ask me what my plans were. "Plans?" I'd say. He was the organizer. I'd
never make plans. After routine housekeeping, he'd devise the next wa-
tery chapter of our brief days in Maine together.

He had improved his navigational skills, and with the purchase of
a secondhand depth finder, he was now mastering *Aung* and not the
other way around. In his late sixties, he was running and lifting weights
and fighting the war against fat so he could still leap from boat to boat
and row thirteen miles to the mainland and thirteen miles back. Once a
year, he circumnavigated Vinalhaven in his custom dinghy with only
one pit stop, at the rusticating relatives on North Haven. Without proper
warning, he'd row up to the bright shiny boats on Iron Point and after
making sure the coast was clear of a certain someone he wanted to
avoid, namely his brother, he'd tie off at his cousin Jennifer Cabot's
dock. He'd find his way up the path to his great-grandfather's Gaston
Cottage that wasn't a cottage at all, down an expensive dry martini, two
olives straight up, talk about the past no one remembered, say hello to

the Cabot children who inhabited the porch he grew up on, and row on, which meant rowing twenty-some odd miles around Vinalhaven, the long way, back to Crane and Crotch.

In the 1990s, what was once Big Bill's archipelago survived despite the war between my father and his brother. Thanks to the nonwarring half-brother, Tom, Crotch Island had seen something of a renaissance. However, none of the brothers had done anything about completing Big Bill's headstone, which stood on Crotch's northeasterly flank, facing the mainland. Big Bill had ordered up a respectable headstone before he died, and his boatman, Reddy Phillips, had installed it in a little corral with a split-rail fence that always reminded me of the Unicorn tapestry at the Cloisters in upper Manhattan. There was nothing of Big Bill himself at the gravesite, only his words carved in granite:

WILLIAM GASTON

ARRIVED HERE JUNE 1927

DIED OLD ENOUGH

BACCHUS VENUS THE UNDERDOG

INDIVIDUALISM THE STARS THIS WORLD ONLY

AND ALL ON TIME

Poor Bill, underdog or not, had died a miserable death from complications of alcoholism and diabetes. When his esophagus ruptured in 1970, he'd left a long, complicated will for Tom, his youngest son, to disentangle. In the will, some of the heirs were reminded of their flaws, and his distributions naturally reflected his paternal preferences, but when it was all said and done, his ashes were distributed off the rocks on the northwest flank of Crotch Island. Twenty-five years later, in keeping with the family's general pandemonium, marriages, divorces, feuds, stops, starts, and problems with finishing things, it was no surprise that a stone carver hadn't been recruited to inscribe the age at which he died, seventy-four. Anyone stumbling upon his headstone might assume that Big Bill had arrived in June 1927 and simply never left. If symbolism is any measure, the past hadn't exactly been buttoned up when Big Bill died.

The good old days were gone but apparently not forgotten. I kept an ear cocked for the stories of Crotch Island. There were stories of the "help" that Big Bill treated like family, and the family Big Bill treated like the "help." There was Lee Ping Quan, "The Chinaman" who was Calvin Coolidge's cook aboard the USS *Mayflower,* who lived in a closet off Big Bill's kitchen and wrote a cookbook full of recipes laced with booze. The Chinaman was more than just a cook—his ancestors were poets and philosophers—so he wrote, "It is not good to be without a cook, but it is very much worse to have a bad one." There were stories of Reddy Phillips, the boatman who really was red and was the brother Big Bill never had in his own brother and who ferried him through the bony spines of Crotch. There was John Barrymore, who'd drift over between productions in Hollywood, and Michael Strange, a strange name for a wife, and Bill Laurence, who Big Bill called his best friend, the Lithuanian-born *New York Times* correspondent who won the Pulitzer for reporting from a plane above Hiroshima but turned out was on the payroll of the feds, and Eliot Elisofon, the *Life* photographer who'd boat over to shoot Big Bill's Christmas card accompanied by his accomplice, the sizzling Gypsy Rose Lee; and of course there was the scheming, me-first Clare Boothe Luce, and Margaret Wise Brown who had a passion for Big Bill because a children's writer needed some grown-up fun. Big Bill thought he'd retreated to a private life, but he was frequently spotted by the lobstermen or the neighbors in varying degrees of undress, ferrying one nude woman in a canoe over to Vinalhaven and another woman in the nude on his way back. Through lots of hard work, he'd achieved a reputation for "boats, booze, and broads." No, the subsequent generations had never quite lived up to the stories of Crotch Island in the good old days. Not that they tried.

But the one name I never heard among the stories of the good old days was Rosamond.

By the 1990s, my father had stopped clipping the obituaries, but it took just a single swig at cocktail hour for me to know he was still mad as hell about his brother. His brother was hard to forget because the stone fortress he'd built on Hurricane Island was visible from practically every point in the Gaston archipelago. One summer, when I was

sprawled out like a dead bat in the sun on the lawn on Crotch Island with the *Times* in one hand and a Chivas in the other, my father interrupted to ask me the same damn question he'd always ask, whether his brother's house on Hurricane Island was as offensive close-up as it was from a distance. So I admitted having gone over to Hurricane in the mid-1990s with a group of conservationists who found the house unfinished and the condition of the island deplorable. I thought my father would disown me for stepping foot on enemy territory, but instead he said, "Really, tell me more." I didn't need to lie to him; everyone knew about the situation on Hurricane Island. For nearly twenty years, parts of the island were an embarrassment to the family and a professional embarrassment to me.

In the late 1800s, the island had been home to the Bodwell Granite Company, with a population of close to five hundred stonecutting families from Sweden and Italy, who carved granite columns, capitols, plinths, and pavers for buildings and streets in New York, Philadelphia, and Boston. After the quarries closed, the island sat dormant for some time before Outward Bound made the island its base of operations. During that time, James Pinchot Gaston had created such a mess on its south flank with paint cans, generators, heaps of construction debris, and abandoned plastic and garbage that nothing could explain or excuse what had happened to Hurricane Island, not in my view at least.

While Crotch Island had been resuscitated and Hurricane Island looked like the town dump, Crane Island settled into a modest retirement. From the looks of things, Crane was an uninhabited wild island, except for a strange graying structure enveloped in billowing masses of pink rugosa rose. Since the 1960s Shack had stood secure, fending off the tides, demure, but weary of her neighbors. She kept her double-holer windows wide open with one eye to the mainland and the other to the comings and goings on Crotch. My father penned a construction diary on the driftwood wall next to where he slept, recording each summer's minor modifications and maintenance. He thought it was useless to lock his Shack when he went away; intruders would only break in. So he replaced a typical lock with a twig from the forest. Finding Shack open and delightful, admirers stopped in, leaving necklaces of mussel shells and

love notes in bottles. Over the decades, old rusted chains and wreaths of seaweed festooned her walls. Twisted ropes and shards of tumbled glass drifted up to the beach and made their way onto the Gaston family's umbilicus mundi, the bar, fashioned from a single split log in the shape of an ironing board. Each year, Shack allowed her little beauty to slip, trading beauty for fearlessness and glamour for character.

My father's last addition to Crane Island was what he called a self-flushing toilet and what the town office called illegal. A short walk through the forest and over a rise facing the sea, he'd wedged a little driftwood landing between two granite ledges. With that, he installed a driftwood toilet seat, a handy little box to keep the toilet paper good and dry, and a saloon door so one could attend to one's business in private. Shack's sanitary accomplice looked sleek and California modern, thanks in part to a triangular tarpaper roof on which my father chalked a name for his entry, "2000." It wasn't the year 2000 when he chalked it, but he said that people would eventually come to see his entry to the outhouse competition as futuristic in its simplicity. When I said I didn't know there was an outhouse competition, he said there were no other entries; no one except he had realized it was a competition. "Oh, so it's a competition with yourself?" He replied, "You could say that."

Older now and less inclined toward ambitious projects, he put his faith in the rhythms of rustication, keeping busy until the bell chimed for cocktail hour, which he usually chimed himself. His ongoing project was the maintenance of a two-foot-wide path around the island's perimeter that he tended gingerly each summer, nipping a branch here and there to improve the view and keep things tidy. One of his rituals was to assemble the many vinyl buoys that floated up over the winter into a massive pyre on what he called "Styrofoam Beach." There, he would set off an annual conflagration of acrid black smoke and chlorofluorocarbons that could be seen all the way to the mainland. Returning an hour later, he'd pry a lump of plastic from the sand no bigger than a brick. I questioned the whole operation but he said it was a noble effort. Crane Island would be pristine, he said, even if it killed him.

· · ·

In the early summer of 2000, a flock of tiny screech owls landed in the queen palms on the front lawn of the Florida house. After the flock flew off, a single, sickly little owl stayed behind and made a home on the hurricane shutters where I lived with the Irishman. With its ruffled, matted feathers, and haunting groans, I interpreted its sounds as a death rattle. In transition that summer, I decided to pursue my abandoned love, photography on the coast of Maine, where I had studied fifteen years before. All summer long, I kept hoping my father would row up out of the fog to the dock in Rockport, that we'd scramble into his wooden punt and summer would begin. But things didn't turn out that way.

When I took the call, I was on the second floor of the Odd Fellows Hall of the Maine Photographic Workshop, looking over the balcony toward what had once been a stage and was now hung with holographic maps of the heavens. Constellations of gods and goddesses danced across a black backdrop of infinite space. Something didn't feel right; my father never called me, he always just showed up. Between images of the constellations, the world pivoted and spun on the smallest particle of silver. I remembered that the photographer spent the dark winter months in Maine battling depression and stayed despite doctor's advice to go to a sunnier place. His winters were spent crossing days off a calendar of darkness, waiting for winter to turn to spring, waiting for spring to give way to summer, waiting for summer mornings of what the locals called thick-a-fog to break at midday, giving way to summer afternoons that offered him, as payment for all his waiting, a few precious hours of Maine's incomparable light.

I picked up the phone. "Bibi, this is your father," he said. Of course it is, I thought, what are we doing on the phone? "It looks like I'm not going to be making it up this summer." "Oh, why? You want to avoid a 'certain someone'?" He couldn't *not* show up, I thought. We can't miss each other again. Ten minutes could turn into ten years. It was my first summer back in Maine in years and I was waiting for him. His words flooded my ear, rolled around the room, bounced off the ceiling, and landed in my solar plexus. "No, that's not it. I have a brain tumor," he said. "Not one of the good ones. I have five months, if I'm lucky."

He didn't need to say anymore. He wasn't lucky. I wanted him to

stop. I felt sick. In that moment, I knew that the story of my father was over and my family's game of hating him was up. But before I could say anything, he told me that he needed me to relate the news to the few people who should know: my mother; his half-brother, Tom; and his half-sister, Gigi; her mother, Teddy, in California; and my siblings. I told him I would make the calls and we'd figure this out. I started using the *we* word that day so he knew I was part of his fight.

That fall, I sprung into action, as if the last five months of his life would make up for the thirty-odd years he'd been absent from mine. I called the Irishman to enlist his support and told him I needed to quickly learn everything I could about brain tumors. One weekend, still in Maine, I took the ferry to North Haven to visit Jennifer Cabot, my father's cousin, at the rambling Gaston Cottage. I barely knew Jennifer when I blurted the news of my father's condition. She said matter-of-factly, "Oh, I had a brain tumor—they put in a stent—and my sister Judy died of one, of course, you must know that, so apparently they run in the family." I didn't know that, I didn't know anything about these Gastons.

I spent much of the weekend on the sprawling deck at my great-great-grandfather's massive shingle manse, where Big Bill's sisters had once sat overlooking the Thoroughfare, commenting on the *Crotch Island Crab*. While the kitchen staff arranged triangular cucumber sandwiches on attractive porcelain plates, Jennifer shared bits and pieces of the Gaston family history. For the first time, I learned about Colonel Gaston and his wife, May Lockwood, about Big Bill's siblings Hope, Ruth, and John, to whom he virtually never spoke. One wall of the house was hung with photos and memorabilia, including an article about Mrs. Gaston's new hat shop in Boston, and a photograph taken in North Haven at a birthday party for Aunt Higgie in November 1931, a costume event, where Rosamond was in a long, full gown and Big Bill was dressed as a priest.

Over the weekend, I wondered at the little I knew of my own family, its history of drinking, feuds, and now, apparently, brain disorders. I knew that one person in the Gaston family usually managed to wrangle the inheritance, leaving the others angry and barely speaking to each

other except through high-priced attorneys. So I asked Jennifer what she thought of the feuds that distinguished the family, why it always seemed to come down to war. "Oh, I'd always heard that your grandfather was an embarrassment, I suppose you might say that he was the black sheep of the family, but," she said, "the final falling out was over furniture. It ended up in court." "Furniture?" I said. "That's interesting, why furniture?"

I had to catch my breath before deciding whether to disclose my father's bad behavior on my first state visit. Then I told myself, my father has a brain tumor for God's sake, what could be worse than that? So I told her, "My father got so angry during his divorce from my mother that he moved all of the furniture out of the Old Mill. We were just children. My mother had to go to court to get the furniture back. Kind of a mean and odd thing to do, don't you think?" "Probably not," she said, sounding like such things came naturally. "If brain problems can run in the family, and anger and drinking, I suppose fighting over furniture can."

That night I called the Irishman back in Florida to describe the Gaston Cottage and how I'd learned about my family's brain tumors and furniture wars. We decided that the best thing would be for me to spend the next four or five months with my father. It was the most important thing I could do, he said. He announced that he would be a rock of Gibraltar and we'd make it through the time apart.

In late September of 2000, my sister staged her wedding on the lawn on Crotch Island. On a cold, blustery afternoon, my father arrived in Rockland with the Moroccan, who decided she'd skip the festivities. My father shuttled over from the mainland and arrived at Crotch Island knowing that, barring a miracle, it would be the last time he'd set foot there again. The wedding festivities took a backseat to the reunion of three people who hadn't seen or spoken to one another in twenty-five years, my father, my mother, and James Gaston. As if it was the second-to-last act in a play, they were somehow summoned to convene without their attorneys on Big Bill's bumpy lawn to celebrate something none of them had been particularly good at, marriage. Miraculously, they all showed up.

That day, I indulged the fantasy that my mother and father would

meet each other again on Crotch Island, and that their reunion would be like Odysseus finally returning to Penelope. I would maneuver over the rocks to get the best view, and the scene would unfold. My parents would be together in the same place, at the same time, and behave civilly toward each other. So there it was, in bas-relief like a Grecian frieze that no one saw but me.

While everyone shivered and looked up at the sky, my father and I stood next to the spruce that he and I argued about each summer. I saw a boat approaching and I said to him, "There she is; that's Mother on that boat full of people." Without a moment's hesitation, he turned like a warrior and headed straight for the dock. He was off to greet the only woman he had ever loved enough to call his wife, I told myself, in the place he said was the greatest setting on earth. As I watched him move down the path, I saw my mother spring from the launch, virtually pushing people aside to make her way toward the only man she'd ever loved enough to call her husband, although she'd also called him a rake and he'd scared her to death for most of her life. Nothing in my imagination prepared me for their running toward each other. No one else was watching, but then no one else knew what I knew, that all that fighting and warring wasn't about ending the relationship, it was about keeping it alive the only way they knew how.

They met each other for the last time beneath a frail umbrella of spruce. My father would have walked right past my mother on the path had she not cleared her throat as if to say, stop, I know you. He stopped to look at a wisp of a woman he'd imagined for twenty-five years as all-powerful. She uttered his name in a little, gravelly voice he'd never heard before. "Mr. Gaston?" she asked. He responded, "Yes, and you are?" I intervened to stem my mother's embarrassment and found myself introducing my mother to my father as if they were strangers. My mother laughed. "This is your ex-wife, Frances, my mother," I told my father. "I'm so sorry," he said. "Excuse me, you don't, you've, uh, you look, uh, it's been so long, you are shorter than I remember." She laughed again, knowing she'd let her little beauty go. In the sound of her laughter, they both felt relief. "You don't look . . ." she began, but she wouldn't say it. The fight had been going on for so long, they had both forgotten what the enemy looked like.

My father's half-brother, Uncle Tom, was standing nearby and suggested we go up to the house, where there was a cocktail party, followed by the ceremony, followed by dinner and lobsters, as big as domesticated animals, the way Big Bill liked them, cooked under seaweed.

That night, in a seedy motel room in Rockland, my father told the Moroccan what she'd missed. He dispensed with stories of the lobsters and the wedding, knowing that no marriage had ended particularly well in the Gaston family. Between big baleful wailing cries of grief, he told the Moroccan that for the first time in over twenty years, he'd seen his ex-wife Frances, the family he'd run from, and the brother who hadn't been a brother. For the first and last time, people who had spent a lifetime hating one another and speaking through attorneys were in Big Bill's Great Hall on Crotch. There'd been no rehearsal, but at the last minute, he found himself walking his daughter down the aisle. Later that afternoon, my friend Silvia and I joined my father's brother Tom to sweep out the Shack on Crane. My father thought he'd live forever, but the end had found him and beat him to the finish line in a way he could never have imagined. He'd never see Crotch Island, the *Aung,* and Crane or the Shack again. What would become of *Aung* and Shack?

The next day, I packed my bags, said good-bye to the islands and drove from Maine to New Jersey to help prepare my father for surgery. It was to be the first night I spent in the Old Mill since I was ten. That fall, yellow jackets staged an invasion of the living room. They followed tiny pilot holes cored by the heat-seeking tendrils of English ivy, nature's own diamond drill bit. A glioblastoma multiforma grows in the brain the way ivy grows in the landscape, rapacious, suffocating, and undaunted. I had seen ivy blanket fields and forests and comfortably sit there for generations, but with a glioblastoma inhabiting a brain, one rarely survives for long because the brain is bounded by the skull, and very quickly there is nowhere for all that rapaciousness to go. Doctors stage a counterattack they know in 99 percent of cases is futile.

Sometime that fall I started thinking of the brain as a rugged and beautiful landscape. It was probably when I watched the nurses paint little black dots on my father's shaved head. In their dulcet tones, the

nurses did their best to reassure me, but like my father, I wasn't convinced. Just as I had learned to survey the land, they were building a three-dimensional topographic map of a brain, and the little black dots were used to calibrate the million-dollar imaging equipment with the tumor that sat in a ravine between the hills and fissures of his left temporal lobe. His brain wasn't just mapped to pinpoint the location of the enemy but to extract it from its position without disturbing the neighboring terrain. In the end, though, nothing slows a glioblastoma. Its tendrils make forays into adjacent territory. It masters the topography and gets away. My father had done his research and insisted on the truth. No one, he said, should waste a lot of time heeing and hawing over his "predicament." There was no wheedling out of this by improvising an escape in the Jeep, not that he wouldn't try.

A week or so after we returned from Maine, my father and I went to see a small-town attorney who asked him whom he wanted to be his executor. He said, "Why Patricia here," and pointed at me. "Who else would I ask?" We looked at each other, and I knew he had no one else. I said I didn't exactly look forward to the assignment because my brother and sister, I knew, would be difficult. "How difficult could they be?" he growled. "I'm dividing everything in three," he said. I looked at him, wincing, "The only reason I'm doing this is because you have asked me to."

The day before he went into surgery in New York, I saw James Gaston at Rosamond's buildings. He wasn't a conversationalist, and as I sat awkwardly with him at his bar, Hurricane Island, on Third Avenue, he warned me that after surgery my father would spend the rest of his life, what was left of it, institutionalized. Staring straight ahead and in a tone devoid of emotion, he told me that I'd be unable to take care of him so he'd end his life in a "home." Simple as that. I didn't know how to respond. A few moments later, stunned, I got up and walked away. His was the worst bedside manner I could imagine from a surgeon, much less my father's so-called brother.

That afternoon, just before their offices closed, I overheard my father on the phone with the office of the chief counsel of the Disciplinary Committee for the First Judicial Department in New York, following

up on his most recent complaint against my mother's attorneys. I could virtually hear the tendrils wrapping around his brain as he made his tragic last phone call. I didn't want to dissuade a dying man from pursuing his obsession until the end, so I said nothing. That night the Irishman and a group of newfound friends in Florida shouted "good luck" over the phone, and the next morning, my father went into brain surgery performed by Sloan Kettering's chief of neurosurgery. After five hours, the surgeon came out to report that the procedure went remarkably well. My father woke up in intensive care speaking Spanish to the neurology students and Arabic to the nurses. Between dozing and seizures, he demanded his *New York Times* and a banana.

In the days after my father's surgery, the Moroccan and I jumped on the conveyor belt of caretaking, and, like it or not, we were a team. She cooked and served him little bits of exotic food, and over the months, we shared the thankless tasks of caregiving. When I wasn't busy, I was disoriented, so I cased the Old Mill trying to figure out what I was doing there. At night, I paced the halls, looked in cupboards, and scanned the bookshelves, and in the morning I ran out into the woods thinking the answers were where the chestnut orchard had been or near the stream where I'd played alone with my crawdads and rocks. The landmarks of my childhood were still there, and one by one my father's great big dramatic names for places came back to me: the river, the little bridge, giant rock, the dungeon, the weeping willow, the moat, the fort, the wall, the fence. On excursions into the woods, the landscape seemed smaller now, compressed into mature green rooms. Still, a sharp aroma drifted through the field where my father had once planted sunflowers and buried dead pets. The trees, however, had grown up and puffed out, reaching for light, scrapping and fighting for the sky.

Several times that fall, I loaded up the Moroccan bag with my father's Rolleiflex and his bananas, pulled his World War II army Jeep out of the old red shed, dusted her off, and took my father for a spin. I commandeered "Jeepsy" like a chariot through the fading yellow hickory forests of western New Jersey. We must have looked quite the sight all dressed up for World War II without the war, me in my long golden scarf that matched the leaves and flapped in the wind, and he in his

turban of bandages. For the first time since our trip back to Tangier in 1981, my father sat in the passenger seat clutching whatever he could, barking directions, "slow down, speed up, watch out for that rock." Jeepsy wouldn't top twenty-five miles per hour, so I let him know he needed to settle down. He smiled, wincing at my grinding downshifts. During our last tour, we were driving along when he got a certain look on his face as if he wanted to turn around and go home. I asked him what was wrong. Staring out into the forest, he asked me what would happen if he just walked off into the Sourlands and vanished behind a rock. I turned to him and asked him what he was talking about. "What are the Sourlands?" I said. As we pulled into the driveway, he said "Whaaaaat? You don't know about the SOURlands, where have you been all your life?" I had grown up in the Sourlands, he said, New Jersey's only chain of mountains. They were just bumps compared to Morocco's Rif, he told me, but they were all New Jersey had to offer. "Take them or leave them," he said. I decided to leave them. They were suddenly important to him, though. He'd been thinking about a disappearing act, his last.

He had a gun in the house, a .45, the one he'd bought for self-defense during "an unnamed incident" when a friend from Kent played a nasty trick on him and the FBI pointed the finger at my father instead of the friend. One day the gun became a big issue. He had forgotten where he'd hidden it and he was frantic. I didn't know him well enough to rule anything out and it occurred to me that perhaps he'd use it on himself and I'd be on the receiving end of yet another family mess, like someone accusing me of murder. Later that day when we found it under my mattress on the top floor of the Old Mill, I took it and locked it in his desk. His memory was slipping, and he never asked me about the gun again. A thousand ways of vanishing had dwindled down to one.

In late October my father staged several fits of discouragement when it finally dawned on him that "we" had nowhere to go and nothing to do but sit and wait for the end. After a life of hurrying and moving on, there wasn't a goddamned thing he could do. So at night, he stopped turning off the light by his bed because, he said, if he could just keep his eyes open, he wouldn't die. It's what he had done when he was a child.

I'd sometimes imagine how my father might die. Like drafting a disaster plan for a category five hurricane when nothing survives a category five hurricane, I imagined he'd go down in a boating incident in the fog off the Maine coast and no one would ever hear from him again. The boat would hit a rock at full speed and explode in flames. Without life preservers or flares, he would try to prop the boat up with an oar like Ahab until the tide finally swept him away. Mr. Philadelphia and I had watched that very scene unfold one night during a hurricane on Crotch, so my imaginings probably seemed dramatic, but, minus the conflagration, they really weren't all that far off.

One October morning, abjectly bored with his convalescence, my father emerged from his room carrying his oldest Moroccan bag, the one I'd last seen in Tangier. All he had to do, he said, was fill it with the requisites—a fresh copy of the *New York Times,* several trusty bananas, and the leather-cased German Rolleiflex he bought in Malaga—and we'd be off. He was well past the sardine days, when several of the raft-shaped tins kicked around at the bottom of the bag waiting to be deployed in case of extreme hunger. Those days had officially ended, he said, in some port like Cartagena or Cebu in the 1990s, when there had been what he called a "bad experience," a sort of bitter divorce from his once beloved meal in a can. I miss the sardine days, especially now.

By the time he came downstairs he had already considered many things, such as the relative imperfection of the day. It wasn't the most beautiful day, he said—that was yesterday—but it was damned close and this was the last chance, so we'd be leaving for Milford in half an hour. I didn't have a Moroccan bag, but I did have a camera. That day in Milford I would take the first and last pictures I'd ever take of my father.

The day was cool and bright. We drove up through the Delaware Water Gap talking about the landscape and agreeing, as we usually did, about beauty. To me, the Water Gap was like the Columbia River Gorge, but he said no, the Gorge, woefully, was far more impressive than the Gap. He'd only been there once but that was enough to know. If it came down to a waterfall competition, the Gorge would win and the Gap would lose. Sorry, he said, the Gorge is in a league of its own. But I wasn't sorry, I was glad we saw things the same way.

It was on that trip, the last time he'd see his beloved Milford, that he first took me to the little mausoleum at the top of the hill in the Milford Cemetery. I didn't ask him why his family, the illustrious Pinchots, had been buried in two cemeteries, not one. But no matter what he might have said on that not quite perfect day, I had a notion that what separated the cemeteries was not time or space, but grief. I didn't know for sure, but I imagined there had been so much grief after Rosamond died that it couldn't all fit on the old family plot below the château at Grey Towers, so the family exported it across town and buried it somewhere else.

While the first generations of Pinchots were buried over at Grey Towers, he said that all the Pinchots he had known were either tucked inside the little gray mausoleum or buried within a stone's throw. The Pinchots were planners. They'd built the somber little structure with the Doric columns and Tiffany windows to match that of their Eno cousins in Simsbury, but in preparing for the inevitable, but they'd never planned for Rosamond to go first. And then Amos six years later, who never recovered from the grief. The next to go, my father told me, was Amos's brother, the good Governor Gifford, and then his excellent wife, Cornelia. Rumor had it that Grandfather James Pinchot had been moved to the little mausoleum, but my father didn't know for sure. Amos was in the crypt, but he also had a little headstone adorned with an American flag for his service in the Spanish American War. His service was the only thing he felt he had accomplished in life. His second wife, Ruth, was there by his side, but my father didn't have anything good to say about her. Typically, the mean ones outlasted everyone else, but there she was under a stone, which was fine by him. Then there was someone I'd never heard of at the time, Mary Pinchot Meyer, who also died young. My father said she'd been a mistress of President Kennedy's, maybe his favorite but definitely the smartest. She'd been shot on the towpath in Georgetown, he said. And finally, there were two more Giffs. There was Dr. Giff, the governor's only son, who'd decided to get out of crusading altogether and become a doctor, and there was another Giff, Rosamond's brother, Long Giff, who wasn't all that sensible. That was the Giff he'd run into in the nightclub when he'd played hooky from Kent School and hopped a plane for Havana. I'll probably never know

the whole story behind that episode, but my father assured me that it was the strangest coincidence of his life.

Beside the first and second generations of Frenchmen over at Grey Towers, the Pinchots were all there at the little mausoleum. But on that day in October of 2000, I had a feeling that my father had come to say good-bye to just one of the Pinchots, to Rosamond, and he wanted to be alone. So after he showed me around, I went back to the car and watched him circumnavigate the graves one last time, passing through a hopeless little line of disheveled hemlocks and scurrying up the steps to peer through the steel bars into the darkness of the crypt. As I watched him, I wondered if most of his life and the way he had lived it had to do with Rosamond.

Driving out of the cemetery, he asked me if I thought I would come back there without him, alone. I nodded, certain that I would. I asked him if he wanted to be buried there, and he told me he didn't know, he hadn't given it as much thought as the Moroccan had. "The Moroccan, what's she got to do with it?" I asked. He told me that the Moroccan didn't take much stock in the illustrious stories of the Pinchots, the history, and how beautiful Rosamond had been. She didn't believe much in names; her name was as good as his name. It hurt him, he said, that she didn't care about his past. But strangely enough, she often said she'd like to be buried next to Cyrille or Constantine, the French-born Pinchots, in the old cemetery with the obelisk below the château. It was odd, I thought, a Moroccan in the American cemetery of my French ancestors. I had always kept a journal, so that fall I added it to my list of things that didn't add up.

In Milford that day, we both knew he'd soon become too ill to negotiate the world. After our tour of the cemetery, we drove to Grey Towers and made our way to the Forester's Cottage. No one was around, so we pulled the old rattan chairs off the deck and sat beneath what he told me was Rosamond's room, the room with the tourette and the little balcony with James Pinchot's oak leaf and acorn railings from New Orleans. He asked me if I thought the little tower was beautiful. Oh, yes, I said, I could imagine her up there, like Rapunzel. She didn't have long hair, he said, she wore it short, they called it a shingle cut, something like that, like a boy. It was then I decided to ask him, one more time, about his mother.

"She spent the last full night of her life in Princeton," he told me, "with a man by the name of Harris, Jed Harris." I asked him why she did it. "You can never know; maybe she wanted to get back at Harris for firing her from the lighting of a play or props or something she'd been working on. There was some kind of fight, but I don't know, I suppose she'd lost it," he said. Lost what, I asked. Her beauty, she felt old, he replied. I asked him if he thought that it was selfish to take her life like that. I suppose you could say that, he said. "Was there a note?" I asked. "Not that I know of. I never saw one. I was first taken to the Pells on Long Island, then to various houses. My father would finally have his freedom." I didn't understand what he meant by that. The old man had been skiing in the West, he said. They had their own lives. He eventually came to pick me up, he said. I didn't understand why the Pinchots hadn't, why he had been left alone. He didn't, either. "My father had dirt on the Pinchots, maybe on my mother. I just don't know." Grey Towers was the place he came to in the summers with her and they'd sit just a few feet away. He pointed and said, "Right under that porch over there." I asked him if an awful lot of the mess and confusion in the family could be tied to what she'd done. Well, it certainly did no good, he said. She must have been very upset, I said, and he nodded. I looked over at him and his eyes were closed.

After lunch, we walked along the dormant flower borders of Cornelia's long gardens. I thought about how things got worse before they got better and how someday, perhaps, my father would still be around to watch me marry the Irishman at Grey Towers. We meandered down the rill, around the Finger Bowl, and he pointed to the bust of Lafayette in the niche and the tower room where he'd spent the summers as a child. We wandered back toward the Forester's Cottage and made our way through the green curtain of trees and onto the path that leads into the forest and down to the falls. He crept gingerly along, providing a description of how the forest once was, how much more lush, how once upon a time there'd been hemlocks, watercress, rhododendrons, azaleas, wild mushrooms, and ferns. There'd been birds, he told me, lots and lots of birds, but now the forest was in decline. His cousin Peter Pinchot,

one of the grandsons of the governor, was trying to bring it back. "The woods and the path are so wonderful. You had the best of both worlds," I said, "waterfalls and a forest in your backyard and perennial gardens lapping at the sides of the house." We walked along and I took several photographs, profiles of his Little Billy smile, now helpless, still alone. It was one thing to say good-bye to Crotch Island, the landscape of his father, but Milford was the landscape of his mother. He'd been dutiful and performed the pilgrimage every summer, but a lifetime wasn't time enough to know it. There was no way to fathom what it meant to leave this place.

One afternoon about a month later, my father said we should go up into the attic room at the Old Mill to throw things out. After sliding backward up each stair step, he pointed to a closet in the eave and directed me to haul out two green garbage bags. "Get rid of all that stuff, or keep it, I don't care," he said, "it's just junk." Sifting through the bags, I picked a dusty old letter and started reading it out loud. The letter was from Big Bill to my thirteen-year-old father at Kent School, advising him like an attorney on culinary matters:

Dear Billy,

Glad you liked the steak. It does seem to me, though, you were taking quite a chance cooking it in your room. What if you had been found out—where would you have said it came from? I certainly don't want to be known as being a party to breaking your rules there. Also, should think it would be more fun to cook outside anyway.

Will send you another one this Friday which will arrive Saturday morning. It may be what you call a "round steak," which is a little tougher and a little thinner than the other one, but buried in the freezer in the bulk storage department with a lot of other stuff belonging to other people. But we have been eating these other steaks and love them. After all, they are from the same animal, just a little further down the leg.

Hope you finish up well there this year—I really hope it sincerely.

I forgot, please promise me you'll cook this next steak outside somewhere.

See you soon.

<div style="text-align: right">

Love,

Pops

</div>

To me it sounded fatherly and funny, but my father got a pained look on his face. Throw that out, he told me; he didn't want to think about the "old man." I fished out another letter in beautiful penmanship that looked more cheery and read it to him:

Dear Mrs. Gaston:

Here's how Billy revealed real greatness. In his first lesson he was shown the correct way to hit a forehand. Then he never even touched the ball in 100 attempts to hit it. Yet he kept on swinging correctly. Undaunted by 100 failures, not even perturbed, he kept on swinging correctly. Knowing he was on the right track, I showed him how to hit a backhand. He missed fifty times before he hit one. 150 unsuccessful though correct swings yet he never lost his poise, determination or courage. Knowing some of his other characteristics, it's small wonder then that I confidently predict he'll be President say about 1981, and hereby put that prediction in writing on November 30, 1937.

<div style="text-align: right">

Sincerely,

Alexander Bannart

</div>

The Pinchots kept on swinging. But he couldn't. He had reached his limit of sorting and discarding, so he pulled himself to the ground. "Do what you want with it," he said. "I'm going for my siesta." The Moroccan told me that she had stopped my father from throwing everything out several years before. Together they had filled the green garbage bags, and when he moved back to the Mill, they'd stuffed the bags in the eave. That night, I transferred the contents into two small boxes. Someday I would have the courage to face it.

Several days before Thanksgiving, my aunt Gail Gaston called to say

that she and James planned to drive out to the Mill so that she could make sure her husband said good-bye to his brother. When I told my father his brother was coming, he gave me the tragic look. "Welllllllllll," he said. "Do I haaaaave to? What would I have to say to him?" He pointed to his mouth. "I can't speak." I told him, "He can't speak either, but perhaps he'll make up for the past twenty-five years when he could."

When James and Gail arrived, I led them to my father's room, the room that had been mine as a child. My uncle sat as if in a waiting room, fidgeting in a chair and eyeing the only thing on the wall, a colorized photograph of Rosamond. Meanwhile, Gail carried on in a light, pleasant banter to fill the stifling nothingness. My father was fine with small talk because he didn't feel humiliated by his speech. But after about five minutes, James was getting antsy, so he got up and walked over to the hospital bed to shake my father's hand good-bye. The right side of my father's face had dropped like he'd had a stroke, but he still smiled a handsome lopsided smile and strained to lift his right hand to meet his brother's. But in that instant, realizing his arm wasn't moving, he winced and looked down at his limp arm and took his left hand to hoist his right wrist. But when he looked up, his brother was gone. It was as if something in the bedroom shattered and split off. James had abruptly turned and fled my father's deathbed, mortified by what he thought was my father's last act, a refusal to shake his hand.

Realizing this was far too tragic for a last encounter, I jumped up from the foot of the bed and asked my father if he was all right. He shrugged his left shoulder, warped his mouth, looking perplexed, and asked in garbled words, "What happened?" I told him I didn't know, but I did know; I'd grown up with the story of the two brothers who ran off to their separate islands and wouldn't speak to each other. I followed my uncle down the long hall and into the living room where he stood stonefaced in front of the fireplace. Before I could explain that my father couldn't raise his right hand because of the tumor, he grunted, "It doesn't matter, it doesn't matter." I touched his shoulder and explained that the tumor was on the left, which meant that his right side was paralyzed, but he wasn't listening. "You are a doctor, you should

understand," I said insistently. But his brother barked in an even harsher tone and made himself perfectly clear as he left the living room, "It doesn't matter." I raised my voice as he left the room—he wasn't going to get away with it—"Yes, it does!"

He went downstairs and I heard him go into the garage below my father's room. Several days later he announced that after my father died, he'd like my father's plaque from the Society of the Cincinnati and the colorized portrait of Rosamond. I told him that as my brother's name was William Gaston, the first son of the first son, I planned as executor to offer it to him. The younger brother of a son couldn't become a Son of the Cincinnati if the first son was still alive. But he argued in a monotone, one could buy into the Cincinnati. I put my head in my hands. Was this a game of old-family Monopoly? He had maneuvered Hurricane Island, the largest island, then come away with Rosamond's property that would eventually be worth hundreds of millions of dollars, and now he wanted the title to first son. I thought about falling over, but instead, I joined my father, speechless.

A day or so before Thanksgiving, I admitted my father to a rehab facility for a short stay, where he was surrounded by doting nurses who gave him lessons on picking up paper clips and pronouncing words. He'd been there for only one day before cornering the most interesting person in the place, a 108-year-old woman who, he announced, was the oldest person in the county or the state or some jurisdiction. Within minutes, he'd managed to squeeze her story out of her despite her loss of hearing and his loss of speech. "She grew up in Prussia!" he exclaimed, fumbling with his paper clips. He said he was speechless, and I agreed. "What I mean," he insisted, stammering, "was that if she was that old, she would have seen the Kaiser's troops!" He was out of his mind with Little Billy curiosity and wanted to interrogate the woman, but, he said, she couldn't hear him and he couldn't speak. Between the two of them, all that history was gone forever.

A few days later, the Irishman came up to the Old Mill. On Thanksgiving Day, I sat next to the Irishman, and my father sat next to the Moroccan, and together we all pointed like children at my shiny capon with its mounds of chestnut stuffing. My father teased the Moroccan in

Arabic and French, and I suggested we all go to the pink house in Florida for Christmas where we could be together and my father could be warm and sit by the sea. He told us that he had once had a massive orange juice venture, a scheme to link the technological freezing prowess of Florida with the raw citrus genius of Morocco. He didn't take much stock in Florida or its oranges—Moroccan oranges were vastly superior, he said—but if it was an escape from his fate, then fine, he'd go to Florida for Christmas. But the Irishman dissuaded me, elbowing me and jabbing me with his foot under the table.

Over the next few days, the Irishman and I walked the lawns around the Old Mill where I described my recent adventures in mowing. I took him on a tour of my childhood landscapes, including the Moat, where creepy things happened, and Giant Rock, where I'd learned to be alone, and the former site of the chestnut orchard that had suffered a blight back in the 1970s; but he wasn't paying much attention. He was in a splendid mood. It didn't seem like the time to ask why he had jabbed me under the table. There was never a good time to talk about things or ruin a perfectly good time talking, when talking, he said, never got you anywhere. So I decided to just be grateful that he was there, that I was able to celebrate Thanksgiving with the two men who meant the most to me.

A week later, I answered the phone at the Old Mill. The Irishman began in a tone of voice I'd never heard before. "Are you sitting down?" he said. "I'm leaving you." As if I didn't know what that meant, he said, "And I'm not coming back." There were to be no questions and there was no reason to talk things through—we were over. I asked him if there was someone else, and he said no. I asked him, "Well, then why couldn't you have told me at Thanksgiving? You know, my father only has another month to live and then I'll be home. Why did you come to the Old Mill? Why couldn't you have waited?" There was nothing to say. "I just needed to be sure," he said.

"Of what?" I asked. He had no reply.

"So nothing," I said, "after almost eight years together?"

For the first hour, I was numb and went downstairs to the kitchen and pretended nothing had happened. I was alone with the Moroccan,

who regularly made light of others' emotions. She wasn't a good audience for a meltdown in progress, but she did notice I didn't look well and asked me what was wrong. Nothing, I said. For her sake, I made it easier to understand: after eight years, he'd broken up with me over the phone, that's all, I said. The Moroccan poured me the strongest drink in the house. I tried to call my mother, who had raved about the perfection of the Irishman. There was no answer in San Francisco, so I walked around in circles and fended off strange comments from the Moroccan. "You can't make a man stay if he wants to leave. Someday you'll laugh about this. Stop thinking about it. Move on." I felt as though I was about to drown. Move on? If this was some sordid, bloody short story by Paul Bowles set in the Maghreb where hawks picked the eyes out of human carrion, I'd move on. But I'd shared everything with this man, trusted him. We'd spoken of marriage that summer. He was living in my house with my cat!

I spent that night in the Old Mill, holding down my chest so it didn't heave through the ceiling. The next day I went to see my father at rehab and discovered him in his bed with his paper clips and scissors, happily mangling a copy of the *New York Times*. "Here, read this," he garbled. "Get yourself a new wardrobe, march back to New York, go back to the Park." "Central Park?" I said. "Read the article, you belong there," he sputtered. The piece was about a new administrator for Central Park, but he never explained why I belonged there, that the article referred to a family, the Minturns, his relatives, who had the first idea for the park.

A few weeks before Christmas, I was near collapse. I saw my brother at a Christmas party in New York and asked if he could spell me for a few days at the Old Mill while the Moroccan went to see her son in California and I went back to Florida to button up the house.

"You might hold some affection towards Papa, but I don't. What you are doing is your choice," my brother said. My father and he had spent time together in Maine in the last few years, and my brother had won the $10,000 bounty my father had set for the first grandchild. "If you won't help him, then think of it as helping me. Certainly he wasn't a good father," I said, "but that doesn't mean I can't be a good daughter." In what felt like the darkest days of my life, my brother never showed up. I saw, starkly, the wounds of family, and how the pattern repeated.

During his illness, everyone, it seemed, came forward with opinions. My mother's mother, who had always hated my father, said of his rare brain tumor, "Leave it to your father to come up with a glamorous way to die." My mother, on the other hand, staged a gallant effort at decency, rallied her circumspection, and understood exactly what I was doing. In her own inimitable way, she said it was she who belonged at my father's side, but since his girlfriend of thirty years was there, I was to act as my mother's emissary. She had finally found a reason to feel sorry for him again, and now that he was dying, she remembered how much fun they'd had together. "Oh," I said, "you just started remembering all that?" "Yes, I was crazy for him. I was so sheltered and he was so worldly and we were so young, just seventeen when we met." Every so often, she said, extenuating circumstances called for understanding, and death was one of those extenuating circumstances.

The phone rang a few days after Christmas. The Moroccan had left for California and my mother had learned the coast was clear, so she wanted to speak with my father. I handed him the phone. He told her he didn't really feel up to talking, but she carried on a sweetly nervous diatribe about the stolen Florida election and recent articles she'd read about various tragedies, never mentioning anything personal. She'd sent him a book, *Making Miracles Happen,* about a man who had beaten back a brain tumor by being pragmatic and positive, but he thought it was a load of bunk. He knew there were no miracles in his case. My mother hadn't lived in reality all those years, he said, so her call rattled him. That night, he was unusually sad and told me how sorry he was that he had left us as children, that my mother had been a good woman, a great beauty, but when she'd let herself go, he'd run away; he didn't know what for, he had just run. Later that night I found him staring at a photograph of the five of us at the wedding on Crotch Island. He couldn't maintain the regret for too long. "Your mother was such a brilliant woman, but for all that education," he said in his broken speech, "she wasn't very smart and was completely impractical. She signed everything over to the lawyers, to James Gaston, that belonged to you." I told him that it wasn't that she hadn't been smart, she had been an alcoholic and was busy destroying herself when she signed on the dotted line. I told him the brief story of growing up, the suicide threats, the bottles of vodka I poured

down the drain. The Gaston family scourge had found its way to her. He didn't know how bad it had become. Of course he didn't know, how could he, he'd vanished. The tendrils were making their way through the deep crevasses of his brain and firing up electrical charges. That night he had the first seizure since surgery.

On the day before Christmas, my father announced he would die. The doctors said he was plateauing down, surely, but they thought we would make it through Christmas, after which I could call hospice to get help. I was alone with him, and each night, after I put him to bed, I'd go back to my room, fall over exhausted, and cry myself to sleep. The only person I talked to was an eighty-year-old lady named Jane Carter, a Christian Scientist, a painter, who had been our next-door neighbor in Florida. Over the phone, she read to me from the Psalms every night explaining that, according to Psalm 91, I was protected and covered with wings and feathers and shields and bucklers. I'd been spared from a lifetime of misery when the Irishman left. "That wasn't love, but it was the greatest gift in your life," she said. "Your work now," she said, "is with your father."

On Christmas Eve, I set up a tree in the living room with giant lights and crumbling ornaments that looked like they came from a yard sale. I wrapped several gifts, a big beautiful book on landscapes and a CD of some mariachi music. He'd never had a filet mignon so I prepared one, cutting it into tiny chewable pieces. I'd called a photographer I knew in Maine, Paul Caponigro, and asked him if I could borrow a print of rocks from Brimstone, an island my father and I used to go to off the coast of Maine. "I can't afford a Caponigro unless it's to take one to lunch," I told Paul. The print arrived just in time for Christmas.

He couldn't read his *New York Times* anymore, and he'd choke on a banana, so on Christmas night, the two of us stayed up, he fidgeting by the fire and I writing in my journal about his Moroccan bag and his Rolleiflex. I could tell he wanted to talk, and though it was a struggle, he told me he was very sorry about what I had gone through with the Irishman, that I'd given up my work and my home to be with him at the Old Mill. "It must be very, very tough. We need each other now," he said. For the first time ever, I was moved by my father's tenderness, by the

words I had first heard from the Irishman. My mother had taught me that even if a man had behaved badly, there were extenuating circumstances to consider. No earthly circumstances would explain what the Irishman had done. So, I supposed it was a mystery. Meanwhile, I knew two things: the man I believed had failed me, and now my father, the man who had failed me, was the man I believed.

On Christmas night, my father told me that he hadn't gotten a chance to go shopping. "Instead," he said, "I want you to have something that belonged to my mother." He directed me to two colored German lithographs and a plaque hanging in the attic room. "What are they?" I asked. "They are from Austria. My mother received them for acting in a play called *The Miracle*." Looking at them carefully for the first time, I noticed mountains and lakes and a little fishing pavilion. A stadium with a horse that seemed to lead a rider around a ring. The two lithographs appeared old and dignified, but on closer inspection, the images seemed whimsical. The plaque had a date, 1925. I didn't understand German, but I was touched that he'd given me something of his mother's for Christmas.

On the day after Christmas, hospice staff came to the Old Mill and offered my father "spiritual counseling." I was surprised when he nodded in agreement, mumbling something about Kent School. The masses and the monks, he said, hadn't been all that bad, and who knew, it wouldn't hurt to boot up a late-life belief in God. The next day, a towering chaplain named Konrad Kaltenback arrived and seemed fascinated by the case, but because of my father's speech problems, he turned to me and asked me what it was my father loved. I smiled and told him that he loved women, of course, and ones who hadn't always been easy to love because they'd either killed themselves or gotten fat. He had once loved Morocco, but it had turned into Dante's fourth ring of hell. And oh, yes, there was a deserted island off the coast of Maine where he'd spent almost every summer of his life, where he had built a shack of driftwood with windows that looked like eyelids fashioned from a double-holer that had floated up at high tide. That was something that had never failed him. By twilight off the coast of Maine, I told Kaltenback, my father could be found performing minor surgery on "Old Faithful," his favorite

smoking, hissing outboard, after fishing her out of Crane's tiny harbor, after shoving her overboard in frustration.

The chaplain looked at me and said that it was far more stressful being a caregiver than a patient. But every few days he would appear unannounced and retreat into the back room for half an hour and cast what he called long lines to my father. In no time, the bait had landed, and the two men were equally charmed. My father would smile and gesticulate, but by that time, the tendrils had wrapped themselves around and up and over and through, controlling the hills and deep valleys of his brain, so there was barely a sentence that came out that didn't sound like a foreign language.

On one of his last visits, instead of being his usual jovial self, Kaltenback emerged dazed and speechless from the back room. He walked over to me, looked at me in dead seriousness, and said, "So who is going to write the book? It looks like it's going to be you." His sessions with my father were confidential so he couldn't tell me why he thought my father deserved a book written about him, but he did mention the colorized photograph of Rosamond hanging on the wall. Perhaps it wasn't just his book, it was to be a book about her as well.

After Kaltenback's last visit, I felt it my duty to snoop. I barely knew what my father had been doing all those years, because I had been afraid to ask. Despite his illness, his fax machine was still buzzing with orders for a rare piston or a screw, yellow legal papers decorated the floor in neat little stacks, and squadrons of bees dive-bombed the stacks and died there, belly-up, having lost their pilot holes to escape. There were desks filled with spark plugs and postcards I'd sent him many years earlier and photographs of boats and cars and desk journals he'd kept religiously that recorded the number of miles he'd run, the shower and shave at the club, and the futile jabs he'd made at the attorneys. In the back of some cabinets in the old country kitchen, I found pieces of English Cauldon white bone china with gold trim, stamped with a small gold owl and the words FAMA SEMPER VIVIT (Fame Lives Forever), the Gaston family motto. Also in the kitchen, wrapped in plastic, was an incomplete service of highly ornamented silver plate with the initials RPG. On the bookshelves were Kipling and Flaubert and Stevenson

and a fully illustrated edition from the thirties entitled, *Give Your Hair a Chance*. There were books by William L. Laurence on the atomic bomb, and there was the *Edie* book and the book of half-truths on Mary Pinchot Meyer, a collection of pocket dictionaries including the *Collins Spanish Gem* dictionary with my mother's handwriting in it, and the *Juncker's English-German Dictionary,* and the *Dictionnaire Francais-Anglais* by Ch. Cestre copyrighted in Paris in 1918 and a Turkish-English dictionary published by the Correspondence Institute Yayinlari with a word scribbled in the overleaf, *Istakoz,* the Turkish word for lobster. There was a wonderful old stamp collection that once belonged to someone named "Goldie," and a moth-eaten red fez with a rose on its label, and a gold-embossed leather journal with dates of what seemed to be parties held in New York and Hollywood with hundreds of handwritten names of attendees, separated into lists of men and women. The men included Count Ilya Tolstoy, Livingston Longfellow c/o Cass Gilbert, Maurice Chevalier, Robert Montgomery, Norman Bel Geddes, Cecil Beaton, Frederick Warburg, Rudolf Kommer, Richard Crane, Bennett Cerf, Conde Nast, Joseph von Sternberg, David O. Selznick, and Ed Knopf. The women's list included Toni Frissell, Fannie Hurst, Lillian Gish, Dorothy Parker, Betty Field, Helen Hayes, Kay Francis, Katharine Hepburn, and on and on. I had no idea to whom the book belonged.

During one of my snooping expeditions, I discovered a fax my father had sent to Harvard for the Fiftieth Anniversary Report and, as usual, he had taken the assignment seriously. He had signed the report on August 7, 2000, one day after he had called me in Maine to tell me he had only five months to live. He probably wouldn't have bothered writing anything at all, but as a practical man and staring his fate in the face, he decided that it was time to take the measure of who he was. So he asked himself perhaps the most pertinent question a man could ask himself: Was he on the right side during the battle? After he was gone, if it were up to others to summarize his life, who knows, he might be tagged a crackpot of the first order or one of the Gastons who had Dante's nine rings pretty well covered, particularly that dreaded fourth circle of greed and miserliness. So it made sense that the last installment went on a bit and repeated the story for the unenlightened; after all,

there would never be a family-wide truth-and-reconciliation commission to address each wrong, not while he was alive at least, so this would be the last dispatch from the front. This would be his obituary:

How to encapsulate the last 50 years, or even the last 25 years since the 1976 report. My interests and myself remain largely the same. People don't change much, only their surroundings. At college I acquired a taste for obsolete mechanisms (unrelated to any curriculum) which eventually led me into the business of World War II era ships diesel engines. At 71, I remain active, more or less, in the field having accumulated a lot of experience in engine rooms, the smell and the noises of which I find intoxicating stuff—"You went to where?" My mechanical aptitudes were revealed to me in "Fender Alley" (now grassed over) in '47 and '48. A few other classmates of the time, long before it became widespread, also caught the old car bug: Holly Robbins, Bradley Richardson, owner of a 1930 Studebaker "Dictator" and other names are forgotten. Much (too much) of my college career I spent nurturing my 26 Ford T, 28 Willys Whippet, 30 Pierce Arrow and many others now gone to the big Scrapman in the sky.

My other principal interest, since 1970 when I became the defendant in a monumental 8-year matrimonial lawsuit, has been the venality of the legal profession, that of my father, both grandfathers, and a great-grandfather, mostly Harvard men. I believe there was more rectitude in lawyering in their era than one sees today. At least there were far fewer practitioners of the "talkative and dubious trade" (Jefferson) who now overwhelm us with their numbers and chicanery. Those who perceive "justice" or recompense for perceived wrongs in court proceedings should know that courts exist primarily to protect and promote the interests of the judges and lawyers who labor therein. Anything beyond that is a windfall.

Another pearl of wisdom earned from personal experience in the practice of law—in a case where the stakes are high, there is no place for minnows or sole practitioners whatever be their virtues and talents. The small fox will by nature be devoured by the major law firms

who always have contacts in the judiciary. These contacts will be used when necessary. Simply put, the big firms by their size have political power, clout for which there is no substitute in litigation.

With that pearl I close and turn my thoughts to more felicitous matters, which include my three children and one grandchild, to whom I have become closer as life winds down.

Given the chance what would you do differently? "Avoid litigation and lawyers."

Of all your professional accomplishments or volunteer activities, which did you find most personally rewarding? "Distant business trips to South America and the Orient."

How would you like to be remembered? "He stood up to and attacked attorney and judicial misconduct rampant in that profession."

William A. Gaston, 7 August 2000

I had never known my father's birthday, so January 6 passed without fanfare. January, my mother reminded me, had always been a very bad month for him, the month when his mother died, and he was sure to get depressed. In early January, I received a phone call that something was amiss at the Florida house. Being one who is paid to envision disasters at their worst, I asked hospice if I could take a quick trip south to go take care of things that hadn't been cared for in five months. The hospice nurses said it was a risk and insisted I wrap up business as his executor just in case. So I put his papers in order and hid Rosamond's silver plate in the wheel well of one of his old cars. I went to the funeral home to arrange for his ashes to be placed in a black plastic box instead of a shiny marble urn, because my father wouldn't have paid one red cent on afterlife apparel. Once you were dead, you were dead.

I hemmed and hawed but on the morning of January 23, 2001, I felt a sudden urge to leave immediately. It felt as though a vacuum was sucking me out of the Old Mill. The night before I left, I awoke to the screech of a heron at midnight. I went downstairs to find a deer pawing at the front door to get in. The next day, practically sleepless, I told my father I would be back in four days, three if I was lucky. He waved his Little Billy wave

and smiled his Little Billy smile, but his last words to me were "Ha Ha Ha." People said they were coming back but never did.

I arrived in Florida on the afternoon of January 24. It was an unusual cold, gray day in Florida and my house had no heat. That evening, Uncle Tom had arrived at the Old Mill and was calling to tell me that since I'd left, my father had taken a turn for the worse. The hospice nurse had dosed him up on morphine. My sister and brother and the Moroccan had arrived, and no one expected him to make it through the night. Freezing and knowing almost no one in Florida, I called the Irishman and asked him if he could return the heater. I told him that my father was expected to die that night. "No, he's not, you are just manipulating me," he said. He said I wasn't taking care of my father, I was in New Jersey having an affair. I spent the night shivering under blankets and trying to get through to the Old Mill. Finally, Uncle Tom answered and held the phone to my father's ear so I could tell him for the last time that I loved him, I'd miss him, and things would be okay. He was loved.

He died that night, the twenty-fourth of January, 2001, at seventy-two years old, surrounded by the Moroccan, his half-brother Tom, and two children who he knew felt ambivalent about him at best and who, like me at the time, knew very little about him. They were assembled in the room I'd lived in as a child, above the garage, in the Old Mill, in the little town of Ringoes, at a low point in New Jersey's best-kept secret, a chain of mountains known to me now as the Sourlands, where none of us had been particularly good to each other, where we hadn't made enough of an effort at being all that happy or telling the truth in our brief lives together, where perhaps we managed as best we could but it wasn't enough. Perhaps it was where we just held on. It was where, in the words of Thornton Wilder's character Simon Stimson, we'd moved around in a cloud of ignorance and we'd spent and wasted time as if we had a million years, where I spent most of my hours by myself in the shadow of a big rock watching leaves drift down a creek and out of sight, where my father planted sunflowers and built a tree house, and where, after he left, I hid under the sheets from a tall, ghostly figure dressed in white who came down the hall and stood beside my bed. I'd never known why that figure visited me when I was a child; for years I thought

it was my father, but now I think it was Rosamond, roaming the world with unfinished business, looking for someone who would understand. I wasn't with him on the night he died, and I knew virtually nothing about Rosamond, and I'd never really believed in spirits, but her photo hung on the wall of his room and I felt her presence when I left him that day for the last time.

Only these six years later did I come to think it was indeed she who pulled me out of the Old Mill so that she could be with him on his final ride. She was like a force of nature, or like the wind. I can think of no better explanation. I'd done everything I could to care for him. I could leave and she'd take over. I learned several years after he died that January 24 was no ordinary night. My father died on the very same night Rosamond killed herself sixty-three years before. If I had known, I would have stayed to watch over him.

BEAUTY SESSIONS

In the last days of January 2001, a winter tornado spun through the woods of Crane Island. An old black spruce swayed on its frozen roots and toppled through the raspberry thicket, splitting the Shack in two. High winds demolished the better part of the path around the island as well. The storm was quite unusual and the timing was uncanny, to say the least, so I figured my father wasn't particularly happy with what had transpired back on Earth and was taking revenge on the tribe. I wasn't around to see the destruction of Shack but heard the details from a friend, how her floorboards had turned to matchsticks, her eyelids turned under, and her funny little roof buckled and caved in on itself. I didn't want to see her like that, not right away at least. Not until I could stage a rescue mission to straighten.

Shortly after my father died and I'd heard about the demise of his creation, I wrote him a letter, in part to remember the place where we spent our best days together, on the rim of Crane Island, in and around his beloved Shack. I also wanted to ask him just one question, the one I never had time to ask when I could have, on our last trip to Milford:

Dear Papa,

 I'm alone now, but there is a place between the islands where we would meet. We'd make a game of it and see who got there first. You'd take your white dinghy along the west side and I'd be on

foot. Passing Shack, which is gone now, and through the wild
raspberry thicket, I came to the little rise of land where the trunks
of dead spruce line the path and form a tunnel of light opening out
to the sea. Past the driftwood outhouse, at the end of the forest,
tufts of grass frame a threshold. I knew the spot for its headwind,
nothing else. That's where I turned and could see you rowing like
an Olympian, rounding the island's tip, where you made the best of
the tide by heading up into the currents close to shore.

It is there I fell behind because there wasn't really a path after
that, only the up and down of the rocks and ledges I'd known all
my life like a familiar hand with long, patrician fingers of clean,
sparkling granite. If I'd stopped on that bank of rocks, I could have
seen it all: through the gap in Spectacle, clear over to the Whites
that once belonged to the Lindberghs, past the quarried ledges of
Bald and to the south beach on Crotch. Over the white loaves of
Crane, I could have made out the north end of your brother's
Hurricane, looming with its watchtower, larger than the rest. There
is really no end to what I could have seen if I'd stopped to look. But
there wasn't time. This was a race and we always knew who would
get there first.

At the bottom of Crane's high cliff, the beach is hammered by
storms. You had a name for it. You called it Styrofoam Beach.
You'd never know what you would find there, and there was always
the chance of finding something good. In the corner of the beach,
at the base of Lover's Leap, emerging from the rock, there's a little
spruce with a curved trunk as wide as a bicycle tire. I photographed
it every summer and you kept the photograph on your bookshelf at
the Old Mill. I found it after you died. I guess you kept it because it
was like the Good Ship Rhododendron, a little tale of survival,
what it takes to stand up against the wind and the water with no
support at all. Each summer we'd check to make sure the tree was
still there, where you said it belonged, at the base of the Lover's
Leap. Last time I checked, it was hanging on, but it looked as if it
had given up its needles. It never had a name, so perhaps it was
ready to go.

Further along, the cliff performs a ninety-degree twist to become a grand promenade, as perfect as a sidewalk in New York or Paris. One perfect granite slab, no construction joints, no heaving, with the perfect pitch to drain. Off to the side where the water collects, there is a little black swamp in the shape of a triangle. You gave that a name, also, but I can't remember what it was. I could see you from there, where the quarriers made their probes, then vanished. You'd be gaining speed in the calm waters of the lee, so intent on winning, as usual. Everything was some sort of test for you, a competition. You lived your life that way. I never got to ask you why. But since you've been gone, I've been wondering about Rosamond. So now I'm coming to understand. That what it takes, perhaps all it takes, is learning about your mother.

At this place between the islands, we'd meet. We'd see each other there. Perhaps for who we were. It could be the saddest, loneliest place I'd ever known, with dark, birdless skies, or it could teem with so much life we couldn't hear each other. The world would spin to the cry of gulls and we'd just stand there, in the swirl of the wind, listening.

So I wonder now what you would tell me about Rosamond. Whether you loved your mother. I wonder if you would still tell me there was no point in it, not while there was world enough to forget about all that, about her, about the past. The tide would be up and if we weren't careful, time, too. You were always right, at least about the tide, and in this place between the islands, you taught me something you didn't mean to, how time determines everything. In this place, we watched the very breath of the world, watched how the sea brought things in and took them away and how things we think stay the same forever change constantly, imperceptibly, so there isn't time to dwell or linger on what hurts us or the people who leave. Not while there are places on this earth that allow us to forget, not while the landscape is still so grand and fascinating, like this place, which spends eternity protecting itself from the icy currents, knowing the sun but once a day. For those few minutes,

there is time enough and the tide's just right so toss the anchor overboard and let us find what we are looking for: shells and shards of smooth black granite, tiny sand dollars and red urchins that dwarf the head of a pin. You'd say that a boat, if not a beauty, is like a tool to win the race. Turn around and if you're not watching, she's gone, fifty yards out, and there's no swimming after her, not in these waters. So there's beauty and there's utility. If they're lucky, they find each other and stay together. That's what I learned in this place between the islands, so I imagine you probably wouldn't say anything about her still. Everything disappears in time. Thinking about her wasn't useful.

Here, the land and sea say yes to each other. It was here I first told you about the eagle's nest. You refused to believe there was an eagle's nest, saying you knew the place like the back of your hand and there was no such thing, you would have seen it. The nest was the oldest and most prolific on record. Marine biologists first knew about it in 1959, the year I was born. We were both right. For years the nest was abandoned, and then suddenly, as if everything were all right again, the eagles came back.

High in the North Atlantic between thousands of islands that dot the Maine coast, the birds enact an ancient dance. They swoop and soar and plunge and soar higher and plunge deeper until they at last lock talons, mating, rolling, falling in a death-defying free fall of bone, feather, and whistling air before disconnecting a wing's distance from the sea.

BIBI: 2000–2007

Two weeks after my father died, I packed a small brown traveling case with the gifts of three lovers and went back to the Sourland Mountains of west central New Jersey. It was time to say good-bye to many things, so, on a cold winter day, I put the Old Mill up for sale and sat on the stone bridge abutment between the road and Giant Rock, dangling my feet over the creek and mumbling words of farewell to my father. I had

decided to dispense with the memories of the Italian, the Irishman, and the man from Philadelphia, so it seemed practical to let go of their trinkets: shiny objets d'amour, crumpled love letters, photos, pearl rings, and odd little vessels of crocodile bone and onyx. One by one, I watched them twirl through the waters of Mill Creek, the waters that once fed the Moat, falling softly on the sandy bottom. Those that didn't sink disappeared downstream, where I had faith that someday, they would fit into some glorious or inglorious pattern where they belonged, or if not where they belonged, pretty close to where they started out.

The scenes surrounding my father's death fit into one of the inglorious Gaston patterns, scenes so predictable I now understand why Rosamond had written that the Gastons weren't good for the blossoming of the soul. When I returned from Florida, the Old Mill had been ransacked. My father's personal effects were strewn about and all but three pieces of furniture had vanished. As his executor, I had told my father that I would distribute his belongings equitably among his children, but they had already been distributed. His framed photographs of Morocco, the Gifford Pinchot paraphernalia, and the colorized portrait of Rosamond in his bedroom were all gone. The attorneys told me not to touch anything, but I knew who had done it. This had all the fingerprints of a family that had never learned what it meant to be a family. "Sure, we see cases like this every so often. Problems in families. Sometimes," they said, "they go on for generations."

I pulled up to the stairs of the Victorian funeral home on Main Street in Flemington, New Jersey, to pick up my father's ashes. The director met me on the steps. "Come in," he said. "Yes, there was someone here wanting half the ashes." I looked at the man in shock. "Why didn't they take two-thirds of the ashes since they represent two-thirds of his children?" I asked. "Well, I tell you, I don't know. But we can tell the ones who were around and the ones who weren't," he said. "What do you mean?" I asked. "Just that," he said. "You were the one who was with him, taking care of him, weren't you? We'll send your half of the ashes when we hear from the attorneys."

Six months later, I'd almost forgotten about my half of my father's ashes when they landed on my stoop in Florida. No note, no nothing,

simply a black plastic box with postage stamps slapped on the side and a label on the end that read REMAINS OF WILLIAM A. GASTON. I had no idea what to do with them in Florida, so I bought a green lacquered Chinese elephant with a platform atop its back and put the box of ashes there for the time being. But later that summer, I had a change of heart and felt guilty about keeping my father in a black plastic box on the back of a lacquered green elephant in a state to which he had no connection. I was determined to find a permanent place for him, and I suspected that that place was pretty close to where he'd started out.

I took him with me to Connecticut in August, and with the help of my friend Silvia I tracked down the number for the Pinchots in Milford and called the Forester's Cottage where Tony Bradlee picked up the phone and recognized my name. "I thought he called you Patricia," she said. "Yes, but I go by Bibi; he was just being formal. My brother called me Bibi because he couldn't say baby when I was born," I said. "Very well then, how is your father?" she asked. I told her that he had died, and she said, "I'm terribly sorry. Why don't you come see us? Stay for a few days."

A few days later I drove over to Milford, and just before town, I noticed the signs for the Milford Cemetery and the highway sign about Gifford Pinchot. I remembered my father having asked me whether I would go back to the cemetery by myself, so there I was, eight months later, with him in the box, making the turn into the Milford Cemetery.

As soon as I arrived at the top of the hill at the little mausoleum with the Doric columns and the inscription in the architrave that read PINCHOT, I saw that the area where the ancestors were buried could use a bit of straightening. It seemed that someone had thought that the Pinchot plot was the perfect place for a picnic, so I made three small midden mounds of garbage and just as I was finishing up I saw a worker in a pickup truck. I walked over to the truck, but the man barely rolled down his window. "Ma'am, we're supposed to leave the place alone," he said. "That's what they wanted, the way they left it. Natural." I said I didn't think that the picnic debris was what they meant by natural. Okay, he said, and rolled up his window and drove off. I drove off, too, to Grey Towers, thinking natural was best. I never liked plastic flowers or cheery

exotics. On my way across town, I looked down at my father in the black plastic box and wasn't sure that he wanted to be left at the Milford Cemetery. I thought he might grow depressed around all the tragic endings; besides, he was something of a stickler for maintenance.

James Pinchot's swooping entrance drive was under construction in August of 2001, so I found the back way my father had shown me and arrived at the Forester's Cottage just in time for lunch. Cousins filed in and out of the front door, the back door, the side door, and the yard, and I sank down into one of the rattan chairs where my father and I had sat eight months before. When Tony emerged, I introduced myself and told her I'd just come from the Pinchot mausoleum. "Oh, yes, we must get over there," she said. "We haven't been there for some time." I described my cleanup operation, and her eyes opened wide. "You didn't need to do that," she said, looking at me as if my activities were unladylike. She sat down in silence and gazed out over James Pinchot's walled garden, like so much of Grey Towers, a relic of grand plans and temps perdu. The garden was once crowded with hundreds of roses, including the ornamental Pinchot Rose, a perfumer's favorite, from the region of Grasse, but the roses had been gone for so long now that no one but Tony remembered anything besides what was there now, grass, a scattering of fruit trees, and terra-cotta urns. Tony still wasn't saying anything, so I looked around and noticed a few ladybugs, lost and wandering the cylindrical surface of Rosamond's turret room, and a book lying on the rattan ottoman about Richard Morris Hunt. I picked it up and thought of my mother and her heroes.

"You've come to talk about your grandmother," Tony said. I nodded yes, but that wasn't really why I'd come. It was strange to hear Rosamond called my grandmother when I'd never known her and she'd never had time to get old or fade like a traditional grandmother. But that was all Tony was going to say. The memory of Rosamond tripped off a string of things unspeakable. "Why don't you go for a swim and then we'll talk." I was gray from the heat, so cousin Rosamond, Tony's daughter, led me off the side of the house where my father had taken me, down the pine needle path into the forest. We made our way down to the lower pools of the Sawkill where we dove and splashed and then hiked up to a

string of upper pools that she told me were known as the "Forester's Pool" and had been the family's private swimming hole for five generations. That night, I thought about the Forester's Pool as a possible place to distribute my father and wondered if he had swum there. I was glad Tony was there to tell me that he had. "Everyone swam and played there together," she said.

The next morning dawned as hot as it gets in a Pocono summer, and a dense fog blanketed the lawns. I woke up in a sweat, jumped out of bed, and, in my nightgown, I tiptoed past Tony and the sleeping cousins into the forest. I made my way back to the high promontory where I had taken photographs of my father and where he had first told me about the Good Ship Rhododendron. He said it was given the name because it had survived an eternity in the wind and the water at the base of the falls, not that the Good Ship Rhododendron was what his mother had called it.

Barely awake, I stumbled upon a goat path that hugged the side of the canyon. Holding on like a spider in a skirt, I rappelled down the bank using fraying roots and branches as my ropes, eventually reaching a murky backwater where I shimmied under fallen hemlocks and scrambled through a dark soup of maple leaves and muck. I emerged on a little gravel beach where the river widened into a pool, and the banks were carpeted in luxuriant moss. I felt as though I'd been taken back to a place I had known intimately and once loved dearly, where I had made my home for many years and fallen in love, the Columbia River Gorge. Surrounded by water and moss, I had to remind myself that I was in Milford, at Rosamond's home and my father's home. It wasn't my home, but it could have been.

No one was around and the river looked inviting, but first I took off my nightgown and lay down on a sandy section of beach to take the sun. After a while, I entered the pool and swam up to a low cascade where the current played with a clump of twigs. Paddling and floating around for a bit, I gradually made my way upstream, to a narrow chasm just two and a half feet wide, where a funnel of water surged through the rock. The force of the river pushed against my chest and I struggled to keep afloat when something startled me. As if in a film, I remembered the day in 1963 when President Kennedy landed and we were all gathered

together on the lawn. I'd never pictured the scene before, or let myself remember it. I was being held in my father's arms, in that chasm, as a child.

Swimming hard against the current, I looked up toward the falls, and just for an instant, I saw her sitting on a ledge in the sun. She was wet and smiling with her arms and legs crossed in front of her. I had never had a vision of Rosamond before. I didn't even know what she looked like. But there she was, appearing and then disappearing in a split second.

After my vision at the falls, I decided that the Forester's Pool was the right place to leave my father's ashes. The next morning, I led a short ceremony with the relatives he barely knew: Cousin Rosamond; her husband, John Casey; Nancy Pinchot; and Tony Pinchot Bradlee. My friend Silvia joined us from Connecticut, having introduced me to Cousin Rosamond in Charlottesville fifteen years before. I read some passages I'd written about landscape and belonging and how from the little I knew, Grey Towers had been my father's home. No one there really knew him, and they hadn't seen him there but maybe once a year, but he thought of Grey Towers every day of his life and he thought of it as his home. Then I read from his mouse-eaten copy of Emerson's *Society and Solitude,* the same two passages I'd read to him before he died:

> The world is always equal to itself, and every man in moments of deeper thought is apprised that he is repeating the experiences of the people in the streets of Thebes or Byzantium. An everlasting Now reigns in Nature, which hangs the same roses on our bushes which charmed the Romans and the Chaldaean in their hanging gardens. "To what end, then," he asks, "should I study languages, and traverse countries, to learn so simple truths?"

I concluded with another, also by Emerson:

> Life is good only when it is magical and musical, a perfect timing and consent, and when we do not anatomise it. You must treat the

days respectfully, you must be a day yourself, and not interrogate it like a college professor. The world is enigmatical—everything said and everything known or done—and must not be taken literally but genially. We must be at the top of our condition to understand anything rightly. You must hear the bird's song without attempting to render it into nouns and verbs. Cannot we be a little bit abstemious? Cannot we let the morning be? Everything in life goes by indirection. . . . Such are the days,—the earth is the cup, the sky is the cover, of the immense beauty of Nature which is offered us for our daily aliment; but what a force of illusion begins life with us, and attends us to the end!

Nancy and Tony went back to the house while Rosamond, John, Silvia, and I climbed the narrow path to the Forester's Pool. I waded out into the shallows with the black plastic box and when I had my footing, I sprinkled the ashes of my father back into the waters of Rosamond and Amos and Gifford, the waters he played in as a child. As I looked down at the river, now white with bone, John looked up and called our attention to a bird that shot through the canyon walls, "You know what that was, don't you?"

At dinner that night, Nancy asked me if I knew that Rosamond had left a set of diaries. "Really?" I said. "Where are they?" "James Gaston has the originals. We have a transcribed copy from when he hired me to write a book. It's been twenty years. I'd have to dig it up. You could get the original diaries from him, I suppose; he has the scrapbooks also. Some sections of the diaries are exquisite, particularly when your grandmother wrote about nature and the falls." That night, having yet to see the diaries or the scrapbooks, and knowing nothing more than my two facts, I wondered if the story of Rosamond wasn't just the glamorous life that she'd lived. Perhaps the real story was what happened after she died and what happened to the generations she left behind. Particularly what happened to the two little boys who appeared in one brief sentence in the many news articles. Who did they become and what became of their children?

I didn't return to Milford the following summer. Through the chaotic

aftermath of my father's death, I forgot about the diaries. Meanwhile, I learned that my mother was dying from cancer of the esophagus. In late September I flew to see her at San Francisco General, a public hospital full of love and hope, and where, for the most part, people go when they are indigent. I spent three days with my mother, feeding her and setting up a little altar in her hospital room. On my last visit, she pulled me close so she could whisper in my ear, "I know what happened between you and your brother and sister. I know what betrayal is," she said. "My mother betrayed me, too. She was paying the attorneys to fight your father all those years when I thought they believed in me." My mother died a few weeks later. I never asked her exactly what she knew or meant by telling me about betrayal. She always left me with something to think about.

Two summers passed before I made my way back to Milford. When I called to tell Cousin Rosamond I was coming, she said she had something for me. I arrived, we went for a swim in the Forester's Pool, and that afternoon she put a box on my bed. I slept with the box at the end of the bed that night, too tired to move it and too scared to open it. I left Grey Towers in the morning in my rental car bearing the mysterious box as Cousin Rosamond urged me, once again, to come back the following summer. "Make it a tradition; after all, you are part of the family." I assured her I'd read what was in the box. I was off to Crotch Island, I told her, but I'd be back the following summer.

It was one of the hottest days anyone could remember on the coast of Maine. At dead low tide, my friends Val and Tyler from Cambridge met me at the dock in Camden and we crossed Penobscot Bay headed for Crotch. At noon, ready to wilt, we tied up at the dock and unloaded our gear. Val asked me what was in the box. "Oh, just a little light reading. A copy of my grandmother's diaries, a gift from my cousins in Milford," I said. "So if that's the Xerox," she said, "where are the originals?" I told her that they were in New York, with my uncle. "How'd he get them? Why had no one ever told you about them?" she asked. "I don't have the foggiest idea. You know how things go in families."

From the wharf at the tip of Crotch's easterly flank, I made my way up the narrow path with the diaries, weaving over granite outcrops and under the frail umbrella of spruce where Penelope and Odysseus met for the last time. I opened the house to air and light and set the diaries down on a bureau in my grandfather's bedroom. Val, Tyler, and I settled in, swam, and arranged a dinner of cold canapés from Cambridge, but I couldn't wait to climb into Big Bill's bed and open the box of Rosamond's diaries. So that night, after everyone went to bed, I turned off the propane lanterns, lit a candle, and gazed around Big Bill's bedroom. A large lithograph of a nude hung above the bureau: *Pandorre Avec Sa Boite.* According to the myth, Pandora could not help but peek into the lovely golden box that Mercury had filled with all the pains of the world. Her curiosity had unleashed every imaginable sorrow. But the gods, feeling compassion, decided to allow her one more look into the box where they had placed a last lonely creature, Hope, which floated out in the form of a moth and found its way into the world.

I wasn't a praying person, but the night felt oddly sacred. So I said a little prayer for Big Bill and for Rosamond, climbed into their high wooden bed, opened the box, and began to read. I thought of it as a strange and exciting reunion between my grandmother and grandfather in the place they had spent some of their finer hours.

In the first year, 1926, Rosamond had chosen her frontispiece:

If one looks at life in its true aspect then everything loses much of its unpleasant importance and the atmosphere becomes cleared of what are only unimportant mists that drift past in important shapes. When once the truth is grasped that one's own personality is only a ridiculous and aimless masquerade of something hopelessly unknown, the attainment of serenity is not far off. Then there remains nothing but to surrender to one's impulses, the fidelity to passing emotions which is perhaps a nearer approach to truth than any other philosophy of life.

She was twenty-one years old and had just finished performing in *The Miracle* and was seeing her counselor, Mrs. Witt, when she discovered the

Rosamond by Cecil Beaton

words of Conrad, sounding like an eastern mystic. She was about to em-
bark on her great adventure to California. The passage reminded me of
the quote my mother had given me by Bernard Berenson the year I
packed myself off to Italy at nineteen.

Within the first few moments of opening Rosamond's box, I knew
that understanding her life would help me to understand mine. I couldn't
say why at the moment. Perhaps it was hope. Hope that her diaries
might explain the warring tribes and the hoarding of furniture. Hope
that I would understand all the straightening, the abysmal choice of
men, all my moving about. The Buddhists say that a suicide affects a
family for ten generations. Understanding Rosamond's life and death
seemed to me like a prerequisite to hope. Or maybe it was hope. I blew
out the candle and drifted off to sleep thinking about Rosamond, Big
Bill, fidelity, and the fidelity to passing emotions.

Afterword

The diaries appeared at an auspicious moment in my life, at the mid-point of a journey lasting nearly seven years. There was something homeopathic about receiving a strong dose of sadness to relieve a strong dose of sadness. Still, the loss of my mother, my father, and the Irishman within eighteen months required several changes of scenery. Between bugs, ex-boyfriends, and terrorists training on flight simulators, I'd decided that one more day in Florida was too many. Thankfully, I found a perfect escape vehicle in an unlikely place. Beneath the palms on Ocean Drive in Palm Beach, shoehorned between the Bentleys, Jaguars, and convertible Mercedes, I spotted a pristine bright green 1966 Volkswagen camper van with vintage Oregon plates, and more important, a sign in its window that read FOR SALE. Two days later, I gave the owner a check, he gave me the keys, and I gave my car a name befitting its green-ness, the Turtle. I hadn't read far enough into the diaries to know Rosamond had named her bright green car "The Green Bug."

Oregon wasn't my first stop. In January 2003, I made my way to a little apartment facing the Flatiron range, in Boulder, Colorado, where I set up my library. In one corner, I kept books on spirits, saints, and the suicides of famous women. In another I assembled books on Broadway, birds, and Gifford Pinchot. I designed an altar to Rosamond that men found macabre and women found exciting. One day, I looked around and realized that I was living in a sarcophagus of family memorabilia. "So what are you going to do with all that stuff," someone asked me, "shove it in a drawer somewhere?" I didn't have drawers because I barely had furniture. I had bookshelves and piles on a drafting board.

One night, realizing there was no backing out, I sat down to write about my father, Rosamond, and what it meant to outlive the tragic legacy of talented and beautiful women in my family.

I wondered if the diaries might be the longest suicide note in history. Day by day, I discovered the opposite. At first, the names were a mystery. Who was George? Who was Liz? Who was Amos? As it turned out, George was George Cukor, the legendary director and Rosamond's most lovably annoying friend. Liz was the coy, irrepressible Elizabeth Arden. And Amos was Amos Pinchot, my great-grandfather, crusader for those less fortunate and, I was proud to learn, a man who defined Progressive politics in America. There was Mrs. Roosevelt who was, of course, Eleanor Roosevelt and Franklin, who called Rosamond by her first name. As I read on, I could hardly believe what a life Rosamond had lived in so few years. Was this indeed my grandmother? I had thought the only thing she'd ever done was to have committed suicide. I soon discovered the record of a fascinating life, but every bit as much of a surprise, I recognized myself in her words.

Rosamond's diary was her best friend, ever-present, and nonjudgmental. Like Rosamond, I picked her "book" up and put it down and laughed and cried. I copied certain passages. I went to sleep with special pages on my pillow thinking I would discover in sleep what Rosamond meant by the things she wrote. I liked Rosamond and then disliked her. Sometimes I felt embarrassed for her or angry with her and couldn't read on. She could be generous and compassionate, then nasty and critical. She judged her mother ruthlessly and evaluated her children the same way. She hated the Jews, she loved the Jews; she was disparaging toward people who were fat, yet she struggled with her own weight. She wrote about her cars, her Grasshopper and another she called the Green Bug. She wrote about loving mean, impossible men and knew that she could be mean and impossible herself. The torture of life with Big Bill was as bad as the torture of life without him. Her life was equal parts nirvana and a hell realm of hungry ghosts, and like me, she found the need to record it. Strangely enough, not one of her friends knew she kept a diary.

I discovered that the diaries themselves had been on quite a journey.

From Rosamond's desk they made their way into Big Bill's clutches in 1935. He read what he needed to, and then the diaries made their way back to 9 East Eighty-first. But it is unclear when and whether he returned them all or just some of them. Amos wrote a friend that he retrieved photographs and her diaries from 9 East Eighty-first Street following her death, so it was possible that Big Bill returned them the day of her funeral, this time as an invited guest. On March 16, 1938, just a week after Mary Pinchot Meyer wrote her poem "Requiem" in honor of her half-sister, Mary wrote in her own diary that Amos and Ruth had the diaries:

> Apparently Dad has asked Mother to read R.'s diary and take out parts from it that she thinks people (the family) would like to read. I think this is a very wrong plan, in fact it shocks me that they would even suggest such a thing. I know that R. wouldn't want it done, and I don't think anyone has a right to so much as glance through what she has written. They should be destroyed at once, and it worries me that they aren't. Mother has gone on reading R.'s diary and hasn't argued with Dad about it. I suppose she is right. He said that he just couldn't bring himself to burn them because they are so much a part of Rosamond and if he feels that way, I guess they should be kept. After all, it is more important to think of those who are still alive than the wishes of one who doesn't live anymore. But I know that she would want them destroyed.

Rosamond's diaries had somehow survived, except for the years 1935 to 1938. At some point, they'd been handed off to James Gaston who had them for nearly thirty years, barely telling anyone. When I asked him who had given them to him, he said he couldn't remember. Perhaps it was Dr. Giff, the governor's son, or Kay Halle, a longtime friend of Rosamond's and Big Bill's who, some believe, completed the scrapbooks Rosamond started for the boys. It struck me as strange that my uncle had hired someone to write a book about his mother and her diaries but could not remember where they had come from.

That fall, I unpacked the contents of my father's green garbage bags. Here again were artifacts from a life I knew vitually nothing about: report cards from the Green Vale School, ribbons from the Tucson Kennel

Club, dispatches to Richard St. Barbe Baker and his antidesertification caravanserai, and the correspondence to and from his father over Rosamond's money. There was the manuscript for the guidebook, impeccably typed on onion skin, fragile now; there were photographs of foreign women, pages from my mother's diaries, proof of her unhappiness, swiped during their divorce. And finally, the correspondence he initiated with Lady Diana Manners, wanting to know, at forty-four years old, about his mother.

At forty-four, I sat surrounded by the information that my father sought and, for many reasons, never found. For month after month, I drew up the master plan of three generations. Each draft showed Rosamond at the center of a family labyrinth. At the same time, I began contracting with an architectural firm in New York City and often went to visit my aunt Gail at Seventy-fifth Street where my uncle kept Rosamond's scrapbooks and the original diaries on the floor of the basement. It was better than the airplane hangars or the dusty closets, I suppose, but sometimes the basement flooded, so, while there, I put the diaries in a plastic box. One night, very animated, my uncle emerged from a crammed storeroom with a shoebox of curling, crumbling photographs. While he tossed the photographs around like a salad, a small piece of yellowed notepaper spun to the floor. I picked it up and read it out loud:

> Washington DC
> Mon. Sept 28, '36
> It has been more than six months since I last wrote regularly in the book. Now I shall make an effort to take it up again. That day that the Rat went into 9 East 81 St. and stole my safe box with all my diaries took them.

I knew that the note explained Rosamond's missing diaries. "The Rat" was Big Bill. He hadn't just taken her diaries, he'd also taken the evidence that he'd taken them. Her husband hadn't just been a bad husband, the Gastons weren't just bad for the blossoming of the soul, Big Bill had been a thief and had tried to ruin her.

His family hadn't done much better. They'd lived for decades with

Rosamond's diaries on the floor of a flooding basement, removing photographs from her scrapbooks. No one in the family asked why she had killed herself or how one of her children had come to live in the properties she'd bought with her earnings from *The Miracle,* and the other hadn't.

That night, I left Rosamond's property and headed down Seventy-fifth Street toward Central Park, inconsolable at generations of selfishness. I knew that Rosamond wasn't selfish and that she never could have imagined or supported such inequity. The light was fading through the elms on Fifth Avenue. I turned up Fifth and passed the southwest Metropolitan Museum of Art landscape where the transverse road dives deep into Manhattan schist, where I'd missed my father by ten minutes that became ten years. It was a beautiful pink-sky night in Manhattan. The streets were cool and the traffic had almost completely disappeared. There wasn't a soul in sight when I paused, lost in reverie, and looked up to see that I was at the corner of Eighty-first Street and Fifth Avenue, the very corner where a throng of women had gathered, as inconsolably as I, almost seventy years before.

I saw my father wandering Manhattan several times that summer, or at least I thought I did. The first time, he was at a deli counter staring out a window. The second time, he was darting in and out of a crowd at Grand Central Station like it was the medina. I followed him for blocks, thinking about what I'd do if it was actually him and he hadn't died after all. Later that summer, I saw him jogging around the Central Park reservoir where he and Rosamond, separated by forty years, ran to keep in shape. I was in heels so I couldn't keep up and I watched him disappear out of sight. I supposed it was just my way of missing him and my habit, like Great-Uncle Gifford and Rosamond, of longing and never letting go.

Looking for Rosamond and my father, I was slowly rediscovering my own life. Over the next two years, I continued to expand the sarcophagus of family memorabilia. In the summers, I'd visit Milford and spin up to Maine, enacting an abbreviated version of my father's annual pilgrimage. In the spirit of Rosamond, I discovered the joys of Medjool dates and the low-calorie delights of buttermilk and lettuce. I threw back Manhattans on autumn days in the theater district. I undertook modern dance and

learned how to stand on my head. In the winter of 2006, I was traveling back and forth between architectural offices in Manhattan, a French châ-teau in Beverly Hills, and my rug in Colorado. I became quite fond of one client, a former Israeli tank driver, who'd fly me to Los Angeles to talk about fruit trees and roses. When I arrived at his offices, he insisted I sample trays of elegant chocolates for his new Belgian chocolate boutique. We'd talk about his koi pond and debunk shubunkins, puny little koi wan-nabes inappropriate for the gods.

During the day, I was busy, but in the evenings I holed up at the swank Beverly Hilton where movie stars and wealthy blue dog politi-cians sashayed about the lobby. Soon enough, I felt like a spy, although a spy who left a trail of mud leading to her hotel room. Sometimes I was lonely and the decadence of Beverly Hills made me sad so I'd send for the car and cruise the neighborhoods, top down, nibbling dates at dusk, when the world was pink and Rosamond was hovering in the nebulae. Before Cinderella could set her hooks in me, I'd wander up to the Hol-lywood Bowl or through the streets lined with jacaranda and over to Venice Beach, where Big Bill's last wife Teddy Getty Gaston lived. At ninety-two, Teddy was insistent, "Your grandfather came from good stock, the best, he was an extraordinary man. I should know, I married him!" she crooned. "If he hadn't been such a drinker I would have stayed married to him. But your parents, it seems, did you a disservice. They loved each other, they were perfect for each other. Look at you, I'm proud of you. I was the same, parading around alone and brave. People thought Paul helped me financially, but the truth was, I did it all myself. He made me pay him back, for Christ's sake!" She showed me the canceled checks, it was true. It seemed to me that all the Gaston women who'd amounted to anything had done it by themselves.

One night, I headed over to the UCLA Film Archive where I or-dered up a copy of *The Three Musketeers* and saw Rosamond onscreen for the very first time. She was as beautiful as I'd imagined, but I knew she hadn't aspired to a film career. She'd wanted to bring Amos to California to lie down by the sea. Like my mother, she'd wanted to take her chil-dren camping, beat it for the West, to escape the Gastons. She had sold her "little beauty" to do it. First to Liz Arden, then to Selznick, and it

just went on and on until finally, she had nothing left to give or to sell. That left an opening in which Jed Harris came along to finish her off. I left the screening room wiping my tears.

That night, instead of going back to planning my client's roses and fruit trees, I perched myself in the lobby to watch the sashayers arrive in their elegant sports sedans, jewels, and high-flying agendas. From the diaries, I'd learned that Amos had told off J. P. Morgan on his yacht and that Rosamond wore no jewelry at all. In my bones, I knew what killed her. It wasn't just her abysmal choice of men. Certainly she'd lost Big Bill, but he had become like a bad habit, and Harris, a mean and temporary fix.

But before either of them, she'd lost herself in Joseph Conrad's "aimless masquerade." Perhaps her thoughts were to be found in the words of her frontispiece of 1926: "When once the truth is grasped that one's own personality is only a ridiculous and aimless masquerade of something hopelessly unknown, the attainment of serenity is not so far off." By the end of her life, she questioned who she was and whether she had "lost that old delight in nature." Not just any nature, Milford. She knew there are landscapes of memory, places of belonging, where we become who we really are, bold and lovely, masculine and feminine. She'd just allowed herself to forget:

Monday, June 12, 1933 Milford
Toni (Frissell), Billy and I went down to the Devil's Kitchen. Billy slipped on the pine needles. He was very courageous. The sun was hot by the water. Toni stripped and showed her amazing pregnant figure. Billy worked seriously taking stones from one side of the stream and piling them on the opposite bank. Once he fell and was quite angry. I swam up the Gorge to where the water comes through a gap two and a half feet wide. Hanging on to the rock in that bubbly live water I thought how like the sea it was. After lunch, Father's piece on Walter Lippman was read by Cornelia....Oscar flew around and lighted on the very top of the cedar tree. Strange place for a parrot. At 7:30 Toni and I went to fish. The stream was at its loveliest. All the Spring freshness is still there. I stood in the middle of the stream and cast a little spider fly.

Four nice trout were foiled. A whip-poor-will began and the other birds gradually quieted down. It grew cool. The night smells that I love so became noticeable. Toni drove the car home. I walked in the darkness. There were stars and fireflies. I went through the meadow where laurel shone white in the darkness.

Through Rosamond's diaries, I was reminded of something I knew all along and, like her, forgot. I was always searching for a home. I had once discovered a surrogate landscape, a landscape I remembered as a child, with water, friends, and a good dose of history. At the edge of the Oregon desert, where Lewis and Clark once camped and set out to calculate their "stupendious" cascades, where my mother celebrated her initial opening to the Pacific, I discovered, or rediscovered, a home I'd known all along. After seven years of piecing together the scattered story of my family, I went back, and there by a mossy trout stream with an old family name, Mill Creek, I made a decision. Part desert arroyo, part mossy canyon. Mill Creek was antidote. Rosamond never bought her arroyo property and my mother never opened her bookstore in Oregon. Certain, finally, that I would outlive the tragic lives of the women in my family, I could finally settle down, maybe someday open a bookstore, maybe learn to fish in the valley my father called Paradise.

In October of 2006, I flew to Florence, land of Bernard Berenson's "wee homunculus." I boarded a midnight train for Salzburg where, the next morning, I rented a bicycle and spun through the narrow streets of the Altstadt, the old city, in a white dress, without a headlight and without a map. I wandered through the markets, churches, and cemeteries tucked between Monchsberg Mountain and the broad Salzach River, through Max Reinhardt Platz, past the headquarters of the Salzburg Festival, and found myself in a spectacular arcaded theater carved out of the cliffs. I recognized the space as if in a dream. I had discovered the "Felsenreitschule," the riding school of the Archbishop Leopold, where Rosamond had performed in the summer of 1923. It was the inspiration for the lithograph Reinhardt had given her and my father gave me on his last Christmas.

The next morning, the sky was the color of the Mediterranean and the clouds flirted with the broad tip of Untersburg Mountain. I woke early and pedaled through the open meadows south of the city, down long allées of sycamores and around small, tidy castles. Thinking about Rosamond and Max, I finally arrived at the little lake, the Leopoldskroner Weiher, and Max's brilliant white palace, the Schloss Leopoldskron.

On that day in October in Salzburg, I felt closer to Rosamond than ever. She was at her best, free and mobile. She had loved deeply, and thought she would receive love in return. Guided by countless acts of generosity, she was remembered as vibrant and fully alive. But living vulnerably and loving bravely offered no guarantee. Still she died on her own schedule and, some might say, regardless of others. The effects of what she did would last ten generations unless her family was willing to learn the language of woundedness, and willing to discuss one of the most painful acts the human family will ever know, suicide. In the second generation, pain like that doesn't go away. In the third, the story is forgotten but the event still reverberates, manifesting in unconscious acts of selfishness and meanness. I'd come to think of a suicide like a diaspora, or a famine. For the ones left behind, there is a sense of unending privation. No matter the harvest, there is never enough.

I will never know exactly what it was like to be Rosamond Pinchot but I had come to believe that the soul desires peace, and peace is not only an internal affair, but an external one, found in the bones and flesh of the world, in wildness, in deep and adequate sleep, in exercise, in earth and duff, in potatoes and alyssum and sunflowers, in plays that torpedo. It can be found everywhere, even in the intermissions between sad, obsessive lives. Rosamond loved the Big Bills of the world, though what they had to give was far from simple or perfect. Gifts come in unlikely packages. Big Bill, my grandfather, as wild as the sea and as placid as a pool, didn't symbolize her deeper longing; he was her deeper longing. She and I longed to make sense of that which is senseless, that which comes and goes, of what is wild, dangerous, and rare.

In the afternoon, a young marketing woman took me on a personal tour of the Schloss, now the headquarters for the Salzburg Seminars, a

retreat for high-level executives, economists, and politicians. After the tour, she left me to my own devices, so naturally, I felt it my duty to snoop. I wandered from the paneled library, now full of scholars, through mirrored banquet rooms of kibitzing executives, to Max's cozy study where I found myself alone remembering that Max had advised Rosamond and her fellow actors to "follow the magic of one's life course."

I wandered the grounds of the Schloss that afternoon, deciding that the journey to know my grandmother ended where it began, in the place Max Reinhardt first envisioned his American Nun, in the days before she met Big Bill, before the tug of longing and before Cinderella's ennui set in. In June 1938, several months after Rosamond died, the Nazis turned the Schloss into their base of Austrian operations. Max Reinhardt never returned to his beloved castle again. Max had lost the most blessed things in life that year, his landscape and Rosamond Pinchot. It wasn't the divine intervention he had come to expect.

In the days before the Nazis rolled in to the Schloss, Max had experimented with the design of garden theaters in the woods adjacent to the lake. Aerial photographs from the 1930s showed vast garden openings punctuated by columns, stairs, and classical garden accoutrements. I wondered about Max's designs, so that afternoon I traipsed past the boring politicians on the terrace and headed into the forest to look for evidence of a proscenium or a stage. But all I could find were curtains and curtains of trees where the muscular Austrian vocabulary of chestnut, beech, and oak had grown back into a beautiful young forest. Frankly, I wanted to retrieve Max's massive theatrical vision and bring back his garden stage. I thought old Max's spread could use a bit of work. But that would have to wait for another day. A day not dedicated to Rosamond.

The ground was soggy, so I took off my shoes and felt the muddy clay between my toes. The afternoon was coming on fast so I continued along the narrowing trail and came to a gap in the trees by the lake where I found a wooden board. I thought of Gifford, who, I was told, used a block of wood for a pillow. Deciding it was time for a nap, I looked across the lake and all around, and as soon as the coast was clear,

I tore off my clothes to take the last of the sun. By the mirror at the foot of the Alps, where Max Reinhardt experimented with garden theaters, and Rosamond brought his experiments to life, I thought about what I'd come to believe, that there is no death, only the reappearance of the vast and mysterious pattern that is life. I was staging a beauty session where Rosamond had, and it was the finest tribute I could think of to honor her and the life she gave my father and me.

January 24, 2007

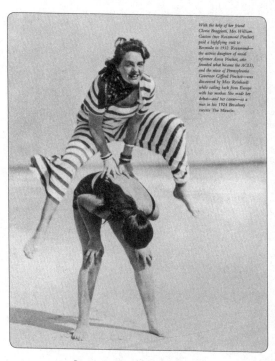

With the help of her friend Gloria Braggiotti, Mrs. William Gaston (nee Rosamond Pinchot) paid a highflying visit to Bermuda in 1932. Rosamond—the actress daughter of social reformer Amos Pinchot, who founded what became the ACLU, and the niece of Pennsylvania Governor Gifford Pinchot—was discovered by Max Reinhardt while sailing back from Europe with her mother. She made her debut—and her career—as a nun in his 1924 Broadway success The Miracle.

Rosamond in *Town & Country* magazine

Acknowledgments

Many thanks go to Rosamond Casey, John Casey, and Nancy Pinchot, who first told me that Rosamond had left diaries and who have lent their support every step of the way. Thanks also to Silvia Erskine, who first introduced me to my cousin Ros. It is doubtful that I would have discovered Rosamond or her diaries any other way. I am very grateful to my agent, Linda Loewenthal at the David Black Literary Agency, who understood Rosamond, my father, and me from the beginning, and to Carrie Feron at Morrow/HarperCollins, who believed in this project and took a chance, and to Tessa Woodward who helped move the book to publication.

Thanks to Morris and Ruth Beschloss for sharing their stories of my father, and to Professor Matthew Bruccoli, and his wife, Arlyn, who implored me, "If you don't write about Rosamond, the gods will weep." Many thanks to Sara Cedar Miller, Central Park historian. My thanks to Nick Rigos in New York, H. M. Jami (Jimmy) at the Hotel Continental in Tangier, and Greg Koester in Atlanta. In Boulder, thanks to Heidi Hillman, Bay Roberts, Engrid Winslow, Diane Starnick, Sher Saltucker, Sandy Gibson, Val Donham, Shelley Heller, Barbara Steiner, Wendy Clough, Tanja Pagevic, Nan Kenney, and Colleeen Corbo. In Hood River, Linda Maddox. And in Washington, special thanks to Tony Bradlee: I only wish we had more time.

Thanks to Elin Elisofon and the Estate of Eliot Elisofon and to Bert Dyer, Maine fisherman and friend to three generations of Gastons. Thanks to the Gastons: my brother, Bill Gaston; Amanda Gaston; Nancy Gaston; Gail Gaston; Janet, Hopie, and Rickie Cooper; Tom Gaston; Noni Gaston; and Teddy Getty Gaston.

Tremendous thanks to Kathryn Black in Boulder for her help in structuring

the story, to Susan Leon for fine-tuning, and Kenny Moratta in Charlottesville for timely encouragement. I am very indebted to Char Miller for sharing his encyclopedic knowledge of Gifford Pinchot, the Pinchot tribe, and what Gifford called "The Outfit," the USDA Forest Service. Thanks to Herbert Poetzl at the Special Collection of Max Reinhardt at the Library at SUNY, Binghamton. Thanks to the New York Society Library. Many thanks to Olga Bermosser at the Schloss Leopoldskron for her tour of the Schloss and for translating the work of Johnannes Hoffinger on Max Reinhardt. My thanks to Candace Lewis at the UCLA Film and Television Archive. I am most grateful to the staff at the Library of Congress Manuscript Division under the leadership of Bruce Kirby, including librarians Jeffrey Flannery, Jennifer Brathavde, Frederick J. Augustyn Jr., Ph.D., Lia Apodaca, Patrick Kerwin, and Joseph Jackson. Thanks to the Huntington Library, the Kay Francis Collection at the Wesleyan Film Archive in Middletown, Connecticut, and the staff of the Hollywood Bowl Museum. Very many thanks go to Robin and Tappan Wilder for sharing their knowledge of Thornton Wilder, Jed Harris, and the events surrounding the opening night of *Our Town*. And to Horton Foote for remembering Rosamond in a way that brought her to life. Special thanks also to John Guare, who insisted, "You are the denouement!"

Many thanks to Robert A. M. Stern. Thanks to the staff at Grey Towers. Special thanks to Lori McKean, and Rebecca Philpot, Museum Specialist. Thank you to Konrad Kaltenback and the Hunterdon County Hospice, Gayle Feldman, Roberta and Mike Hilbruner, the FDR Library, Scott O'Brien, and the Lincoln Center Library of the Performing Arts. Last, thanks to Jane Carter, who was my Bessie Marbury and died before the manuscript was born. She hoped telling Rosamond's story would change my life. Thanks to her, and many others, it has.

WEATHER
RAIN, CLEARING.
Much colder tonight.
High Low
in P.M. 3016 A.M. 28
Details on Page 2.

DAILY ● MIRROR
Member of The BRIEF COMPLETE Associated Press

Vol. 14. No. 185 RC New York, Tuesday, January 25, 1938 2 Cents IN CITY LIMITS | 4 CENTS Elsewhere

★★★★
FINAL
6 A.M.

'LOST' AIRLINER
LANDS SAFELY

Story for this headline on Page 2

In Ermine, Rosamond Pinchot Exits from Life

The girl who gave up a great stage career for love—and then lost that love—sat in a sealed car yesterday in ermine and evening gown and started the motor. A tube carried monoxide gas to her. She died quickly. She was Rosamond Pinchot, niece of Pennsylvania's one-time Governor, the girl who made the role of the nun famous in Reinhardt's "Miracle." She leaves two sons. This is one of her most recent photos. She left two notes, both secret. (Story and other photos on Page 3.)

Clipping, the *Daily Mirror*

ROSAMOND CUED HER OWN LAST CURTAIN

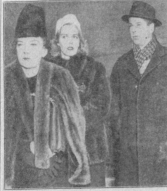

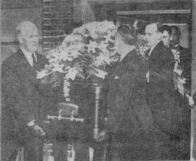

HER UNCLE

Gifford Pinchot, an uncle, goes to funeral services yesterday at home of niece, 9 E. 81st St.

FATHER

Amos Pinchot, father of suicide actress, accompanies her two half-sister, Antoinette (left) and Mary, to services.

HUSBAND MOURNS

(Ad News folio)

William Gaston, estranged husband of late Rosamond Pinchot, accompanies girl's aunt, Mrs. Gifford Pinchot (left), and a friend, Kay Heeller, to funeral. Miss Pinchot, mother of two children, committed suicide Monday, to seek happy future promised in play she was reading. —*Story on page 15.*

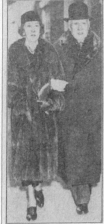

BODY GOES TO PENNSYLVANIA

Under a blanket of flowers, the body of the late Rosamond Pinchot is carried from her home, 9 E. 81st St., after funeral services yesterday, to be sent to her native Pennsylvania for burial.

HITCHCOCKS AT FUNERAL

Among the intimate friends of the actress who attended yesterday's rites were Thomas Hitchcock, polo player, and Mrs. Hitchcock.

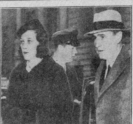

MOURNERS. Friendly through mutual love of music, Mr. and Mrs. Walter Damrosch attend last rites.

FRIEND

Miriam Hopkins, actress of stage and screen, leaves Pinchot home after yesterday's sad rites.

FINAL CURTAIN

**Play Sends Rosamond Pinchot to Death
. . . In Search of Peace?**

(NEWS foto)
Rosamond Pinchot, 33, turned to the stage for her last great scene. She sought the elusive peace of life after death—theme for a new drama—yesterday, in the garage of her home at Old Brookville, L. I. She was found dead of carbon monoxide poisoning. The actress is shown above reading script of "The Miracle," in which she had first great role, with Director Max Reinhardt in 1923.

PROPHECY? (By Associated Press) This foto was taken in happier days . . . the actress wore slacks when she died in her self-made auto death chamber. —*Stories on pages 3 and 5; other pictures on page 1.*

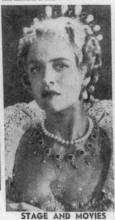

STAGE AND MOVIES
In 1935, Miss Pinchot was seen on movie screens in role of Queen Anne in "The Three Musketeers." Left, as she appeared in "The Eternal Road," Biblical play, at Manhattan Opera House in 1937.

CONCERT. (By Associated Press) With her uncle and aunt, Gov. and Mrs. Pinchot, Rosamond attended concert here in 1933.

Daily News, Jan 25, 1938

Clipping, the *Daily Mirror*

Notes

Because this is a memoir, much of the material assembled in this story comes from personal experience. I am grateful to have had my brother, Bill Gaston, who reviewed the manuscript for accuracy, as well as my cousins Nancy Pinchot, Rosamond Pinchot, and her husband, John Casey, who agreed to wade through earlier drafts.

Assembling the story of Rosamond and my father has been made possible thanks to three primary sources and many secondary sources. First among them are Rosamond's scrapbooks, which contain photographs, playbills, news articles, theatrical reviews, letters and notes, and of course her diaries, which begin with just a few pages in 1926 and "end" in the last extant book from 1934, comprising in total, more than one thousand single-spaced pages.

Other primary resources include a series of twenty-one taped interviews conducted by my cousin Nancy Pinchot in 1986. The list of those interviewed included: Geraldine Morris, Alice Leone Moates, Alfred de Liagre, Horton Foote, Iva Patcevich, Kitty Tacquey, Helen Stokes, Helen Brewer, Gloria Braggiotti, Mario Braggiotti, Isabel Wilder, Gifford Bryce Pinchot, Gifford Pinchot II, Jennifer Cabot, Katherine Walker MacKealy, Marguerite Courtney, Bill Roerick, George Abbott, Jim Beadley, William Gaston, my father, and myself.

My third primary resource in piecing together the story, particularly the social and political backdrop of Grey Towers, came from materials in the Manuscript Division at the Library of Congress that houses the Pinchot Collection, their second-largest collection of personal papers, divided into the records of Governor Gifford Pinchot, Amos Richards Eno Pinchot, and Cornelia Bryce Pinchot. I also used the New York Times Archive to confirm the whereabouts of many of the characters, as historical supplement, where Rosamond's diary entries and family letters were thin.

1. THE MIRACLE

Descriptions of Rosamond's discovery aboard the *Aquitania* are to be found in major newspapers of the day. I found her own description in a piece she wrote that was pasted into her scrapbook. I put together the plot of *The Miracle* and the events

surrounding opening night using news accounts, dramatic reviews, and Oliver Say-ler's handsome Regie Book, *Max Reinhardt and His Theatre: The Miracle Edition,* trans-lated from the German by Mariele S. Gudernatsch. I ordered the impressive volume from an antiquarian book dealer and the book arrived in a velvet sack as if sent by Gest himself, complete with his original signature. Rudolf Kommer's letter inducing Rosamond to come to Salzburg was pasted into Rosamond's scrapbook. For those readers who would like more information about the life of Kay Francis or to see her desk diaries and scrapbooks, they can be found at the Kay Francis Collection at the Wesleyan Cinema Archives in Middletown, Connecticut. For those interested in the life and work of Max Reinhardt, the Max Reinhardt Archives and Library are to be found in Special Collections at Binghamton University in Binghamton, New York. The entire letter from Mary Pinchot to Amos Pinchot describing young Rosamond as a "bewitching little coquette," as well as Amos Pinchot's letter to his sister Nettie in England regarding Gest, can be found in the Amos Pinchot Collection at the Manuscript Division of the Library of Congress as can many letters between Amos and Rosamond while she was at boarding school, on ships crossing the Atlantic, and from her days on the road with *The Miracle.* An excellent source of opinion and infor-mation on theaters, theater personalities, actors, actresses, and performances, in-cluding Franz Werfel's *Goat Song,* can be found in the various editions of Alexander Woollcott. I used *The Portable Woollcott and Long, Long Ago.* Reviews of Big Bill's play, *Damn the Tears,* the description of the 1926 Beaux Arts Ball at the Astor, and Bill and Rosamond's secret wedding in West Chester, Pennsylvania, are from press accounts found in Rosamond's scrapbook and the New York Times Archive. I found Cukor's telegram to Rosamond in her scrapbook.

2. THE LANDSCAPE OF MEMORY

Invaluable to me in placing Rosamond and her diary entries in the context of the Pinchot family and Grey Towers was Char Miller's *Gifford Pinchot: The Making of a Modern Environmentalist* and Char Miller himself, who kindly reviewed and made suggestions to early drafts of Chapter 2. Material related to the construction of Grey Towers was gathered from many sources, including Grey Towers and the USDA Forest Service, the Historic Structures Report, and a master's thesis for Cor-nell University by Amy L. Snyder entitled "Grey Towers National Historic Land-mark: Recreating a Historic Landscape." I discovered more than abundant detail on Cornelia's gardens, gardeners, designers, and horticultural practices in her volu-minous garden files in the Cornelia Bryce Pinchot Collection at the Manuscript Division of the Library of Congress. Part of my understanding of the development of the Finger Bowl came from an article by Barry W. Walsh in the *Journal of American Forestry,* "Grey Towers Celebrates a Centennial." Descriptions of both Grey Towers and Crotch Island are stitched together from interpreting early photographs and historical descriptions, as well as my own personal experience of the landscape. Sadly, Crotch Island no longer has the benefit of Big Bill's interior design. Burglars broke into the cabin in the late 1980s and stole almost every stick of furniture and artwork.

3. A CHRONOLOGY OF CHAOS

Readers interested in Bernard Berenson will find the record of a fascinating life in his autobiograohy, *Sketch for a Self-Portrait*.

4. A SYNONYM FOR LOVE

I found much of the information on the life, times, and essence of Clare Boothe Brokaw (née Luce) in *Rage for Fame: The Ascent of Clare Boothe Luce* by Sylvia Jukes Morris. The account of Clare's visit to Crotch Island is to be found in that volume, which dovetailed with Rosamond's diary entries. While Big Bill's reputation for womanizing was legendary in its day, the stories were substantiated by many sources including those of Clare and of Margaret Wise Brown, and of course the diary entries of Kay Francis. In addition, the legend lives on in an interview I conducted with Burt Dyer, the son of Les Dyer, a local fisherman who was one of Big Bill's best friends in Vinalhaven, Maine. The description of the Pageant of Romance at the Astor can be found in the New York Times Archive. Articles about Rosamond's work training women stump speakers can be found in many newspaper accounts of the day. The mysterious note from Eleanor Roosevelt was pasted into her diary. Rosamond's diary entries are the source of the White House scenes with Eleanor Roosevelt, as are the scenes with Bessie Marbury, and Liz Arden. I discovered only one article with Rosamond's byline published by the Universal Press during her coverage of FDR's inauguration, but more may exist. Scenes with Cukor and Selznick are directly from the diaries.

5. THE KING OF JEEPS

Most of Chapter 5 was assembled from the contents of my father's green garbage bags. Thanks to the Internet, I was able to contact several friends of my father's who substantiated his whereabouts and told me that they always suspected he was an intelligence operative. I do not believe that was the case, at least not in his latter years.

The information on the day at Grey Towers is detailed in a wonderful small volume, *When President Kennedy Visited Pike County* by Norman B. Lehde. No fully accurate biographical account exists of the life of Rosamond's half-sister Mary Pinchot Meyer. Her life and death are still clouded by speculation and misinformation.

6. PARADISE

Those who would like to know more about Anne Marie Wendell and Robert Bowne Minturn's central role in the plan to develop a "central park" for New York may wish to consult *The Park and the People: A History of Central Park* by Roy Rozensweig and Elizabeth Blackmar.

7. OUR TOWN

The details surrounding Rosamond's death on the opening night of *Our Town* are from taped interviews of Isabel Wilder, Horton Foote, Gloria Braggiotti, Alfred de Liagre, and Bill Roerick (who played a baseball player in *Our Town*) by my cousin Nancy Pittman Pinchot. While their memories of the events of January 22–26 appear to coincide with news articles and one another, the interviews were conducted nearly fifty years after the fact, so the precise details are open to a reasonable degree of question. The most unusual account of the night Rosamond died appeared about twenty years after the fact and out of the blue, in an article in Locust Valley's *North Shore Journal,* vol. 14, no. 1, by Edith Hay Wyckoff, "The Fabled Past—Rosamond Pinchot." My father may have said that the account wasn't worthy of the fireplace had he seen it. Nevertheless, I include it in the narrative because elements of the story are credible and the best account we have of Rosamond's struggle on the night she died.

I assembled many details surrounding *Our Town*'s opening nights in Princeton and Boston from the the the superb "Afterword" in the 2003 edition of *Our Town,* written by Tappan Wilder, Thornton Wilder's nephew. Tappan was a great help and support in my understanding of the personalities and events on that night, and the theater world in general. Those interested in the intersecting paths of Rosamond and Horton Foote may wish to read *Farewell: A Memoir of a Texas Childhood,* and *Beginnings: A Memoir by Horton Foote.*

I discovered the love notes from Sinclair Lewis in Rosamond's scrapbook. Rosamond's death certificate is in the Library of Congress, Manuscript Division, Amos Pinchot collection.

8. THE TOPOGRAPHY OF THE BRAIN

Information on the argument between Amos and Big Bill came from a taped interview with Gifford Bryce Pinchot by Nancy Pinchot. In the Amos Pinchot Collection, I also discovered a note on the back of an envelope in Amos's handwriting outlining the highlights of that phone conversation. I discovered the letters from Cornelia to Big Bill regarding the boys housed in the Cornelia Pinchot Collection. Eleanor Roosevelt's comments about *Our Town* can be found in the letters of Thornton Wilder and Gertrude Stein, part of the Henry McBride Series on Modernism. The letters from Teddy Roosevelt to Gifford and the letter from Max Reinhardt to Amos are in the Gifford Pinchot Collection and the Amos Pinchot Collection, respectively, at the Manuscript Division at the Library of Congress as was the letter from Ruth to Gifford regarding the hospitalization and treatment of Amos.

I found the correspondence between my father and Lady Diana Manners in the Old Mill in his green garbage bags. My father was also interviewed by Nancy Pinchot regarding his mother, which added to my understanding of his childhood with Big Bill and confirmed what I already knew of his relationship with the rest of the family. His letters to the Harvard Class of 1951 are from that class's Anniversary

Report. The letters he wrote to Tony Pinchot were also discovered among my father's personal effects. Readers interested in the history of Hurricane Island, its owners, and adjacent island lore with further photos of Big Bill may wish to consult *The Town That Disappeared* by Eleanor Richardson.

9. BEAUTY SESSIONS

The excerpt from the diary of Mary Pinchot Meyer came from Nancy Pittman Pinchot by way of her mother, Tony Bradlee. There are many film versions of *The Three Musketeers*. Rosamond played Queen Anne in the 1935 version, directed by Roland V. Lee. It is available for viewing at the UCLA Film Archive, by appointment only.

I spent many hours in Salzburg learning about Max Reinhardt and Rosamond's work at the Schloss Leopoldskron, which is closed to the general public. It is visible from across the lake on the Sound of Music Tour and available for special tours by appointment through the Salzburg Global Seminar.

Bibliography

Andrews, Ted. *Animal-Speak: The Spiritual and Magical Powers of Creatures Great and Small*. St. Paul, MN: Llewellyn Publications, 1993.

Auchincloss, Louis. *Vanderbilt Era: Profiles of a Gilded Age*. New York: Collier Books, 1989.

Behrens-Abouseif. *Beauty in Arabic Culture*. Princeton, NJ: Markus Wiener Publishers, 1999.

Berenson, Bernard. *Sketch for a Self-Portrait*. New York: Pantheon, 1949.

Box, Rob de La Rive. *The Complete Encyclopedia of Antique Cars*. Edison, NJ: Chartwell Books, 1998.

Brendon, Piers. *The Dark Valley: A Panorama of the 1930s*. New York: Vintage Books, 2000.

Brown, John Mason, and Joseph Hennessey. *The Portable Woollcott*. New York: The Viking Press, 1946.

Burleigh, Nina. *A Very Private Woman: The Life and Unsolved Murder of Presidential Mistress Mary Meyer*. New York: Bantam Books, 1998.

Bye, A. E. *Moods in the Landscape*. Cambridge, MA: Spacemaker Press, 1999.

Carley, Rachel, and Rosemary G. Rennicke. *A Guide to Biltmore Estate*. Asheville, NC: The Biltmore Company, 1990.

Charyn, Jerome. *Gangsters and Gold Diggers: Old New York, the Jazz Age and the Birth of Broadway*. New York: Thunder's Mouth Press, 2005.

Cooper, Diana. *Autobiography: The Rainbow Comes and Goes, The Lights of Common Day, Trumpets from the Steep*. New York: Carrol & Graf Publishers, 1985.

D'Alton, Martina. *The New York Obelisk or How Cleopatra's Needle Came to New York and What Happened When It Got Here*. New York: The Metropolitan Museum of Art/Abrams, 1993.

Danziger, James. *Beaton*. New York: The Viking Press, 1980.

Foote, Horton. *Beginnings: A Memoir*. New York: Scribner, 2001.

————. *The Young Man from Atlanta*. New York: Dutton, 1995.

Fowler, Gene. *Good Night Sweet Prince: The Life and Times of John Barrymore*. New York: The Viking Press, 1944.

Galloway, Priscilla, and Normand Cousineau. *Atalanta: The Fastest Runner in the World*. Buffalo, New York: Annick Press, 1995.

Gottfried, Martin. *The Curse of Genius*. New York: Little, Brown, 1984.

Gray, Christopher. *Streetscapes*. New York: Abrams, 2003.

Heilbrun, Carolyn G. *Writing a Woman's Life*. New York: Ballantine Books, 1988.

Heymann, C. David. *The Georgetown Ladies' Social Club: Power, Passion, and Politics in the Nation's Capital*. New York: Atria Books, 2003.

Hoffinger, Johannes. *Die Akte Leopoldskron*. Salzburg-Munchen: Verlag Anton Pustet, 2005.

Jamison, Kay Redfield. *Night Falls Fast: Understanding Suicide*. New York: Vintage Books, 1999.

————. *Touched with Fire: Manic Depressive Illness and the Artistic Temperament*. New York: Simon & Schuster, 1993.

Kanin, Garson. *Hollywood*. New York: The Viking Press, 1974.

Lehde, Norman B., ed. *When President Kennedy Visited Pike County*. Milford, PA: Pike County Chamber of Commerce, 1964.

Marcus, Leonard S. *Margaret Wise Brown: Awakened by the Moon*. New York: Quill, 1999.

Metropolitan Museum of Art. *The Metropolitan Museum of Art: An Architectural History*. New York: Metropolitan Museum of Art, 2004.

Miller, Char. *Gifford Pinchot and the Making of Modern Environmentalism*. Washington, DC: Island Press, 2001.

Mordden, Ethan. *Singing for Your Supper: The Broadway Musical in the 1930s*. New York: Palgrave Macmillan, 2005.

Morris, Lloyd. *Incredible New York: High Life and Low Life of the Last Hundred Years*. New York: Random House, 1951.

Morris, Sylvia Jukes. *Rage for Fame: The Ascent of Clare Booth Luce*. New York: Random House, 1997.

Mowry, George E. *The Era of Theodore Roosevelt and the Birth of Modern America 1900–1912*. New York: Harper Torchbooks, 1958.

Mullett, Mary B. "The Strange and True Story of One Modern Girl." *American Magazine*, June 1928, pp. 46–47.

O'Brien, Scott. *Kay Francis: I Can't Wait to Be Forgotten*. Boalsburg, PA: Bear Manor Media, 2006.

Patterson, Jerry E. *Fifth Avenue: The Best Address*. New York: Rizzoli, 1998.

Pinchot, Amos R. E., and Helene Brewer, eds. *History of the Progressive Party 1912–1916.* New York: New York University Press, 1958.

Pinchot, Gifford. *A Primer of Forestry: Part 1—The Forest.* Washington: Bulletin 24 Division of Forestry, U.S. Department of Agriculture, 1900.

———. *To the South Seas.* New York: Blue Ribbon Books, 1930.

Quan, Lee Ping, and Jim Miller. *To a President's Taste.* Emmaus, PA: Rodale Press, 1939.

Reinhardt, Gottfried. *The Genius: A Memoir of Max Reinhardt.* New York: Knopf, 1979.

Richardson, Eleanor Motley. *Hurricane Island: The Town That Disappeared.* Rockland, ME: The Island Institute, 1989.

Rosenzweig, Roy, and Elizabeth Blackmar. *The Park and the People: A History of Central Park.* Ithaca, NY: Cornell University Press, 1992.

Sayler, Oliver M., ed. *Max Reinhardt and His Theatre.* New York: Brentano's Inc., 1926.

Smith, Sally Bedell. *Grace and Power: The Private World of the Kennedy White House.* New York: Random House, 2004.

Snyder, Amy L. *Grey Towers National Historic Landmark: Recreating a Historic Landscape.* Master's thesis, Cornell University, January 1988.

St. Barbe Baker, Richard. *Among the Trees.* London: Men of the Trees, 1935.

Steen, Harold K., ed., *The Conservation Diaries of Gifford Pinchot.* Durham, NC: The Forest History Society, 2001.

Stein, Jean, and George Plimpton. *Edie: An American Biography.* New York: Knopf, 1982.

Thomas, Bob. *Selznick.* Beverly Hills, CA: New Millennium Press, 1970.

United States Department of Agriculture. *The USDA Forest Service—The First Century.* Washington, DC: The USDA Forest Service, July 2000.

Wallace, David. *Exiles in Hollywood.* Pompton Plains, NJ: Limelight Editions, 2006.

Walsh, Barry W. "Grey Towers Celebrates a Centennial." *Journal of American Forestry* 84, no. 8 (August 1, 1986): 24–29.

Wetzsteon, Ross. *Republic of Dreams, Greenwich Village; The American Bohemia 1910–1960.* New York: Simon & Schuster, 2002.

Wilder, Thornton. *Our Town.* New York: HarperCollins, 2003.

Woollcott, Alexander. *Long, Long Ago.* New York: The Viking Press, 1943.